CW01391287

The **COLD WAR** had a profound effect
on **BRITAIN**, defining its history in the
second half of the twentieth century.

In this compelling account, Fraser McCallum explores
the history, politics, literature and popular culture that
characterised the Cold War era in Britain. Matching
richly detailed narrative storytelling with scholarly
analysis and visually stunning photography from the
archives of the Imperial War Museum, *Cold War
Britain* gives a fascinating insight into a period
that shaped the fabric of British society.

Prepare to be fascinated by the untold stories
of cooperation and conflict, fear and hope,
suppression and resistance, and the terrible
burden of living in the shadow of the bomb.

Published by Collins

An imprint of HarperCollins *Publishers*
1 Robroyston Gate
Glasgow G33 1JN

HarperCollins *Publishers*
Macken House, 39/40 Mayor Street Upper
Dublin 1, D01 C9W8, Ireland

collins.reference@harpercollins.co.uk
www.collins.co.uk

In partnership with
Imperial War Museums
Lambeth Road
London SE1 6HZ
www.iwm.org.uk

First published 2025
© HarperCollins *Publishers* 2025

Place names in the publication follow Collins Bartholomew policy.

A catalogue record for this book is available from the British Library.

ISBN 978-0-00-874399-4

10 9 8 7 6 5 4 3 2 1

Printed in India

MIX
Paper | Supporting
responsible forestry
FSC™ C007454

This book contains FSC™ certified paper and other controlled sources to ensure responsible forest management.

For more information visit:
www.harpercollins.co.uk/green

Collins

IN PARTNERSHIP WITH

COLD WAR BRITAIN

FIFTY YEARS IN THE SHADOW OF THE BOMB

FRASER McCALLUM

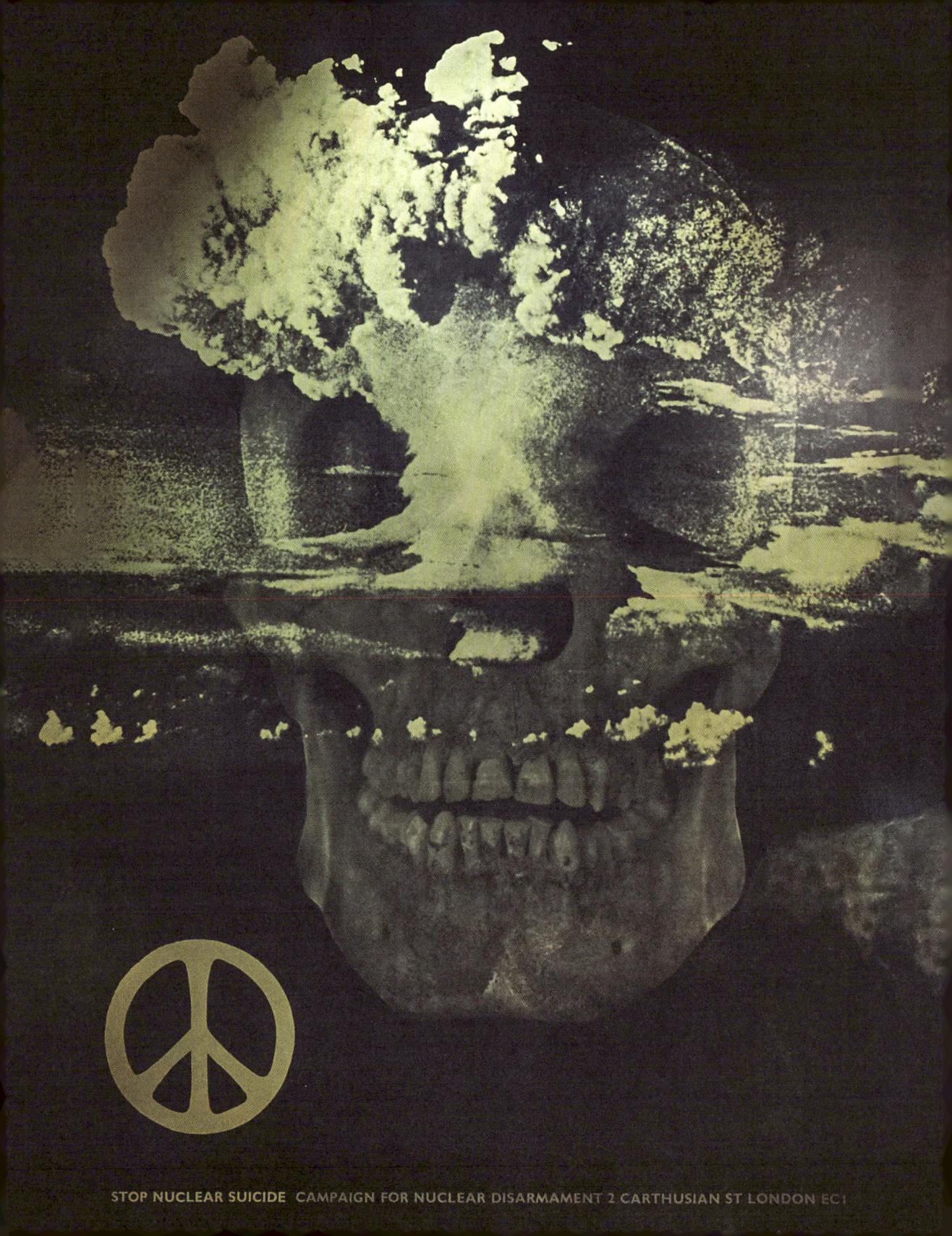

STOP NUCLEAR SUICIDE CAMPAIGN FOR NUCLEAR DISARMAMENT 2 CARTHUSIAN ST LONDON EC1

CONTENTS

COLD WAR TIMELINE

1917
Russian Revolution, in which Vladimir Lenin's Bolsheviks overthrow the Provisional Government and establish Soviet Russia

Britain sends troops to support anti-Bolshevik forces in the Russian Civil War

1924
Vladimir Lenin dies and Joseph Stalin begins consolidating power

Britain grants diplomatic recognition to the USSR

1939
Second World War begins

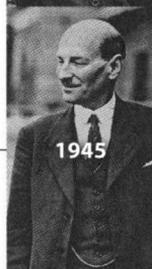

1941
Germany invades the Soviet Union

The MAUD report prompts the formation of Britain's nuclear weapons programme, codenamed 'Tube Alloys'

Japan attacks Pearl Harbor, bringing the United States into the war

1943
The German army retreats from Stalingrad after two years of siege

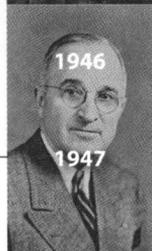

Tehran Conference

1945
Yalta and Potsdam Conferences

The Labour Party win a landslide election, with Clement Attlee replacing Winston Churchill as Prime Minister

Franklin D. Roosevelt dies and is replaced as US President by Harry S. Truman

United States drops atomic bombs on Hiroshima and Nagasaki

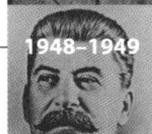

1946
Churchill delivers 'Iron Curtain' speech

1947
Truman Doctrine of containment of communism announced

Post-war Britain receives Marshall Plan aid but struggles with economic hardships

Marshall Plan launched to rebuild Europe

1948–1949
Communist East Germany blockades Western supply lines to Berlin

RAF and USAF supply Berlin by air

1949
Soviet Union detonates RDS-1, its first successful atomic bomb test

George Orwell publishes *Nineteen Eighty-Fo*

NATO alliance formed with Britain as a founder member

		
Korean War between communist North and capitalist South	**1950–1953**	British troops join UN forces in Korea
	1952	Operation Hurricane marks the first British nuclear bomb test
Death of Stalin; Nikita Khrushchev begins leadership of the Soviet Union	**1953**	
Warsaw Pact formed as a counterbalance to NATO	**1955**	Winston Churchill retires from his second stint as Prime Minister and is replaced by Anthony Eden
Hungarian Revolution brutally suppressed by Soviet forces	**1956**	Suez Crisis marks Britain's decline as a world power
Launch of Sputnik by the USSR, starting the Space Race	**1957**	Calder Hall is the first nuclear power station to supply electricity commercially
	1958	First CND march to Aldermaston
Berlin Wall constructed Bay of Pigs invasion fails	**1961**	US Polaris base at Holy Loch established
Cuban Missile Crisis, the closest the world comes to nuclear war	**1962**	
Nuclear Test Ban Treaty signed John F. Kennedy assassinated	**1963**	'Profumo Affair' scandal heightens Cold War paranoia
Khrushchev ousted; Brezhnev takes control in the Soviet Union Escalation of US involvement in Vietnam after the Gulf of Tonkin incident	**1964**	MI5 and MI6 extract confessions from two of the Cambridge Five Labour return to power under Harold Wilson

Left	Year	Right
Prague Spring crushed by Warsaw Pact troops	**1968**	Enoch Powell delivers 'Rivers of Blood' speech, influenced by Cold War migration
NASA Apollo 11 mission lands first man on the moon	**1969**	The Battle of the Bogside marks the moment the Troubles take hold of Northern Ireland
Détente begins, easing Cold War tensions	**1971**	105 Soviet diplomats accused of espionage are expelled from the UK
Yom Kippur War	**1973**	
Soviet invasion of Afghanistan	**1979**	Margaret Thatcher elected Prime Minister
Solidarity movement rises in Poland, led by Lech Wałęsa	**1980**	
	1981	Greenham Common Women's Peace Camp established
Leonid Brezhnev dies	**1982**	UK fights Argentina in the Falklands War
NATO's Able Archer exercise is misinterpreted by the USSR as a potential nuclear strike	**1983**	
	1984	Margaret Thatcher survives an IRA bomb targeting her in Brighton
Ronald Reagan begins a second term as US President	**1985**	
Mikhail Gorbachev succeeds Konstantin Chernenko as leader of the Soviet Union		
	1986	Chernobyl disaster raises questions about Soviet transparency
The fall of the Berlin Wall marks the symbolic end of the Cold War	**1989**	British diplomacy supports German reunification efforts
	1990	Margaret Thatcher resigns, leaving a legacy as a key Western Cold War figure

Dissolution of the Soviet Union — **1991**
officially ends the Cold War

Bill Clinton is inaugurated — **1993**
as US President

European Union expands to include — **1995**
Austria, Finland, and Sweden

1997 — Tony Blair becomes Prime
Minister after Labour win
a landslide election victory

Vladimir Putin becomes President — **2000**
of Russia for the first time, starting a
period of control as either president or
Prime Minister that continues today

European Union expands to include — **2004**
Czechia (Czech Republic), Estonia,
Hungary, Latvia, Lithuania, Poland,
and Slovakia

2006 — Alexander Litvinenko is poisoned
with polonium-210 in London

Xi Jinping becomes — **2012**
the premier of China

2018 — Attempted assassination of Sergei
and Yulia Skripal with Novichok
nerve agent in Salisbury

Russian forces invade eastern — **2022**
Ukraine in a major escalation
of a conflict that had started
with the occupation of Crimea
in 2014

KEY COLD WAR LOCATIONS ACROSS THE BRITISH ISLES

Shetland Islands **2**

Orkney Islands **26**

3

ATLANTIC OCEAN

Outer Hebrides

SCOTLAND

Aberdeen

Dundee

17 18

Glasgow

Edinburgh

North Sea

Newcastle upon Tyne

Sunderland

Middlesbrough

1

York

Kingston upon Hull

NORTHERN IRELAND

Belfast

Isle of Man

25

Irish Sea

Blackpool

Preston

Bradford

Leeds

Bolton

Manchester

Stockport

Sheffield

Liverpool

23

IRELAND

ENGLAND

Stoke-on-Trent

Derby

Nottingham

Telford

Walsall

Leicester

Peterborough

Norwich

Dudley

Birmingham

Coventry

Northampton

Cambridge

Ipswich

15

27

WALES

Cheltenham

Gloucester

11

19 Milton Keynes

Luton

Colchester

Oxford

Watford

20 21

Swindon

Reading

16

24

London

Southend-on-Sea

Swansea

Newport

Cardiff

Bristol

22

Crawley

Celtic Sea

Southampton

Brighton

Eastbourne

Exeter

Poole

Portsmouth

Bournemouth

14

Plymouth

English Channel

FRANCE

Isles of Scilly **6**

5

4

Channel Islands

Keeping Watch

- **RAF Fylingdales**
 Part of the Ballistic Missile Early Warning System (BMEWS)
- **Saxa Vord Radar Station**
 Part of the NATO radar early warning network
- **Aird Uig Radar Station**
 Surveillance station for the Atlantic approaches
- **Les Landes**
 Coastal surveillance and early warning
- **Fort Hommet**
 WWII German gun emplacement converted into a monitoring post during the Cold War
- **Hugh Town Radar Station**
 Strategic coverage of the Atlantic approaches

Secrets and Spies

- **54 Broadway**
 MI6 Headquarters, the heart of Britain's foreign intelligence operations, from 1924 to 1966
- **Century House**
 MI6 Headquarters from 1966 to 1995
- **Leconfield House**
 The home of MI5, Britain's internal security service, from 1945 to 1976
- **10. 14 Gower Street**
 MI5 Headquarters from 1976 to 1994

11. **Government Communications Headquarters (GCHQ)**
 Britain's code-breaking and signals intelligence centre
12. **The Admiralty**
 Where John Vassall operated as a Soviet spy
13. **Wimpole Mews**
 The home of Stephen Ward, where Christine Keeler met both Yevgeny Ivanov, a Soviet naval attaché and suspected spy, and John Profumo, the Secretary of State for War
14. **Portland Naval Base**
 The site at the heart of the Portland Spy Ring

Air and Sea Defences

15. **RAF Mildenhall and RAF Lakenheath**
 US Air Force bases that played critical roles in nuclear deterrence and air support
16. **RAF Greenham Common**
 Known for housing American cruise missiles and the focus of anti-nuclear protests
17. **Holy Loch**
 US Navy submarine base used for Polaris missile submarines
18. **HMNB Clyde**
 Commonly referred to as Faslane, the home of Britain's current nuclear missile submarine fleet

19. **RAF Upper Heyford**
 Hosted strategic bombers and tactical reconnaissance aircraft
20. **NATO Headquarters, Northwood**
 Principal maritime command for NATO in the UK

Planning for All-Out War

21. **Kelvedon Hatch**
 Cold War bunker built to house RAF Fighter Command
22. **The Corsham Bunker**
 Central Government War Headquarters designed for use in the event of nuclear war
23. **Rhydymwyn Valley Works**
 Location of early work on the UK's nuclear weapons project, Tube Alloys
24. **The Atomic Weapons Research Establishment**
 The centre of Britain's nuclear weapons research and development
25. **Windscale**
 Where plutonium was enriched for Britain's first nuclear weapons, later renamed Sellafield
26. **Dounreay**
 Experimental reactor site linked to the development of nuclear energy and weapons
27. **Orford Ness**
 Site for testing radar, nuclear bombs, and secret military projects

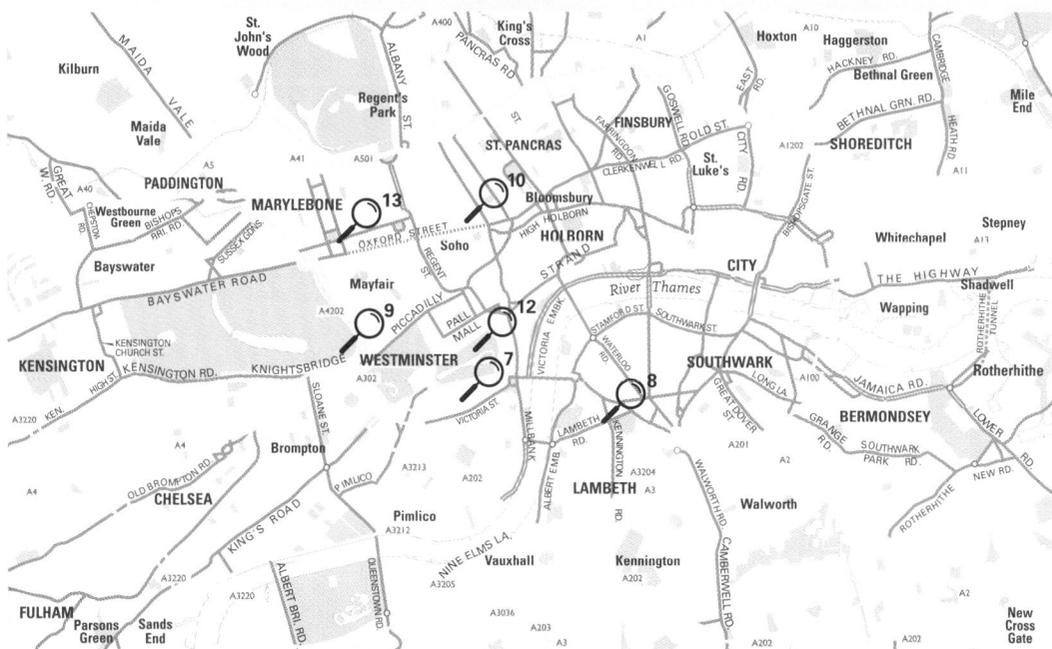

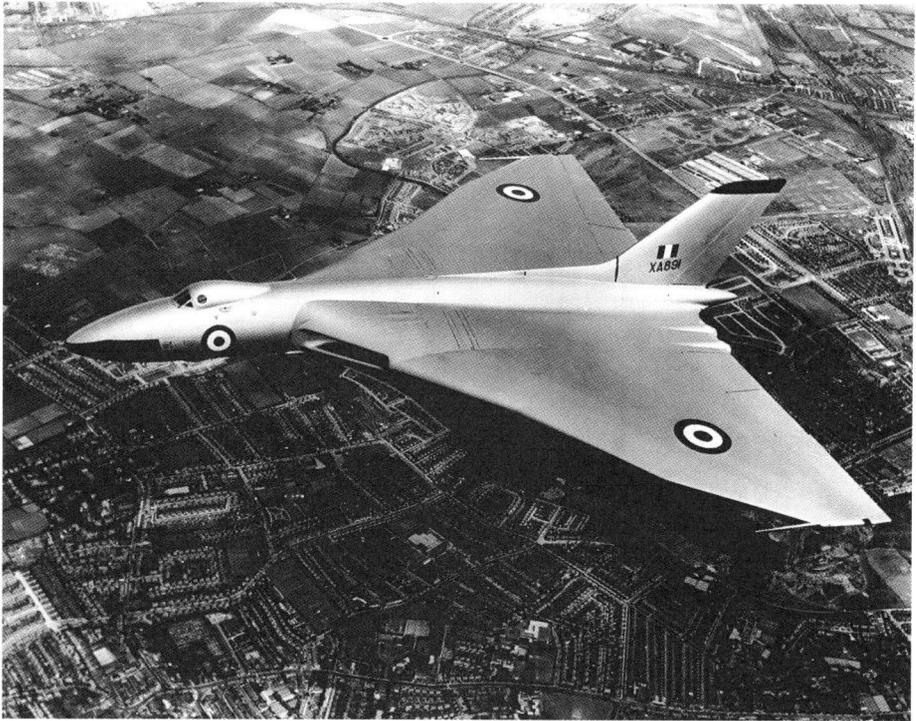

*An Avro Vulcan bomber being demonstrated
at the Farnborough Airshow in 1956.*

INTRODUCTION

The Cold War defined much of the twentieth century, shaping geopolitics, cultural currents, and societal anxieties across the globe. For Britain, this ideological struggle between East and West was a backdrop against which the nation navigated a rapidly changing world. From the shadow of its waning empire to its emergence as a junior partner in the transatlantic alliance, Britain's role in the Cold War was complex and multifaceted. It was marked by high-stakes diplomacy, covert operations, cultural exports, and popular resistance – all underscored by the looming spectre of nuclear annihilation.

Cold War Britain is an attempt to unravel these layers, tracing the nation's journey through one of history's most fraught and fascinating periods and offering insights into the political, military, cultural, and social dimensions that defined the era. Chapter One begins by exploring the early stages of the Cold War, born in an anxious post-war world as the uneasy alliance that had defeated Nazi Germany gave way to the realities of division and suspicion. Chapter Two turns to the atomic bomb and its profound impact on Britain's defence policy and international standing, as well as public reactions to the arms race.

In Chapter Three we venture into the murky world of espionage and scandal, where spies, double agents, and ideological betrayals captured public imagination and political concern. The chapter revisits infamous cases, such as the Cambridge Five and John Vassall, and analyses the cultural impact of fictional spies like James Bond and George Smiley as real-world intrigues blurred into cinematic escapism. Chapter Four looks at Britain's involvement in Cold War conflicts, from Korea and Malaya to Kenya and Cyprus. These 'hot' wars, fought in the arena of superpower competition, represent attempts to maintain global influence despite Britain's declining imperial power, while conflicts closer to home, such as the Troubles in Northern Ireland, reveal internal divisions that left Britain vulnerable.

Chapter Five explores how the Cold War shaped public protest, art, and popular culture in Britain. From the rise of the Campaign for Nuclear Disarmament to the influence of American music, films, and consumer goods, British life was held in tension between resistance and assimilation. Finally, in Chapter Six we

examine the Cold War's conclusion, from the fall of the Berlin Wall and the dissolution of the Soviet Union to Britain's role in a transformed twenty-first century global order.

Though never a physical battleground, Britain was deeply embroiled in the ideological, cultural, and political struggles of the Cold War. Its cities hosted American military bases, its skies witnessed flights of strategic bombers, and its political establishment was infiltrated by spies. The streets of London, Glasgow, and Manchester became sites of protest, as activists marched against nuclear weapons and Western interventionism. Meanwhile, British artists, writers, and musicians grappled with the existential dilemmas posed by the atomic age, producing works that questioned authority, celebrated peace, and occasionally indulged in dystopian pessimism.

Britain's position was paradoxical. As a junior partner to the United States, it often aligned with American Cold War strategies, even as it struggled to assert its independence on the world stage. At the same time, the nation harboured a vibrant anti-war movement that rejected both American imperialism and Soviet authoritarianism, creating a unique cultural and political landscape.

The Cold War's end in 1989 did not mark the end of its impact. Britain today continues to grapple with the legacies of this period, from the presence of American military bases to its cautious relationship with Russia. The anxieties of the nuclear age echo in debates about energy policy, climate change, and global security. Cultural artefacts from the Cold War era – novels, films, songs – remain deeply embedded in the nation's consciousness, shaping how Britons understand their past and envision their future.

The political analysis, cultural history and personal stories that follow illuminate the ways in which the Cold War shaped and was shaped by Britain. This is a story of contradictions: of cooperation and conflict, fear and hope, suppression and resistance. Above all, it is a story of a nation navigating a divided world, striving to balance its ideals with the stark realities of the nuclear age.

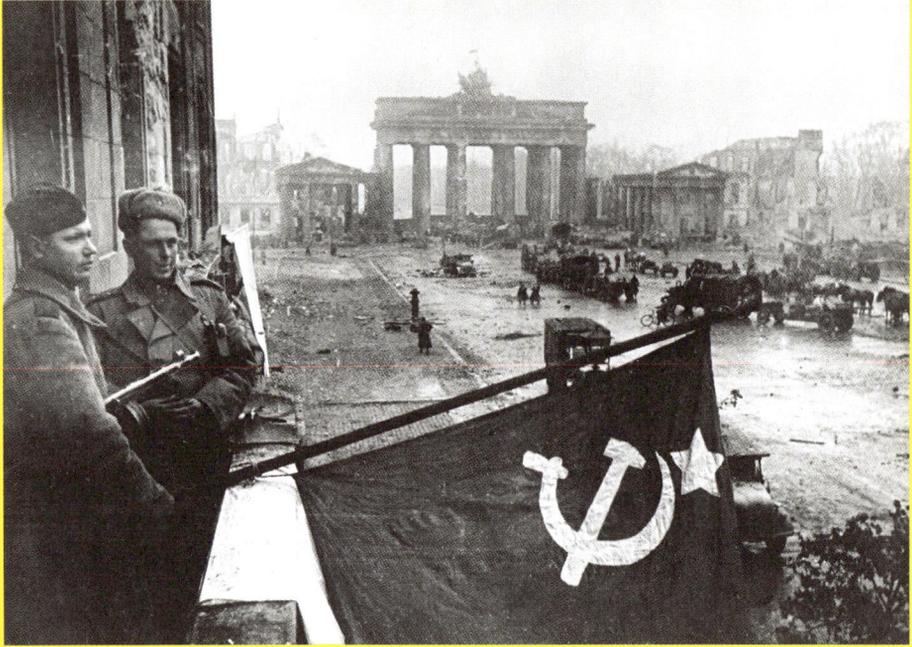

Victorious Red Army soldiers hoist the Soviet flag from the balcony of the Hotel Adlon in front of Soviet units gathering at the Brandenburg Gate in Berlin, Germany, 1945.

CHAPTER 1

A PEACE THAT IS NO PEACE

Moscow, 9 October 1944. Six men meet deep inside the Kremlin. Two of them – Winston Churchill and Joseph Stalin – are war-weary leaders representing two-thirds of the Grand Alliance. With them are their respective Foreign Secretaries, Anthony Eden, Churchill's heir apparent, and Vyacheslav Molotov, who had given his name to the ill-fated pact between Germany and the Soviet Union (or USSR, abbreviated from the Union of Soviet Socialist Republics), and two interpreters, Arthur Birse and Vladimir Pavlov. Conspicuously absent from the discussion was any American representation. On the agenda: the future of Eastern Europe. This Anglo-Soviet summit, codenamed 'Tolstoy', birthed the Percentages Agreement, one of the most infamous deals in diplomatic history, and a foundational moment in the Cold War.

Of all the belligerents in the Second World War, Poland had an outsized influence, and its place in the international order was pivotal in discussions around the post-war settlement. Churchill and Stalin had already broached the future of Poland at the Tehran Conference, Franklin Roosevelt having excused himself from such

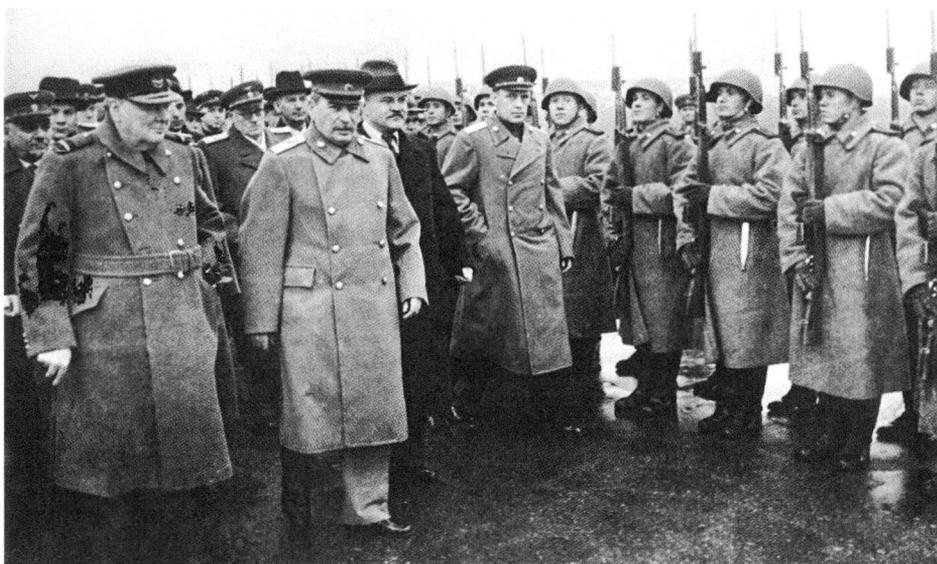

Winston Churchill and Marshal Joseph Stalin, in the company of Soviet Foreign Commissar Molotov, inspecting the Red Army guard of honour on Moscow airport, 9 October 1944.

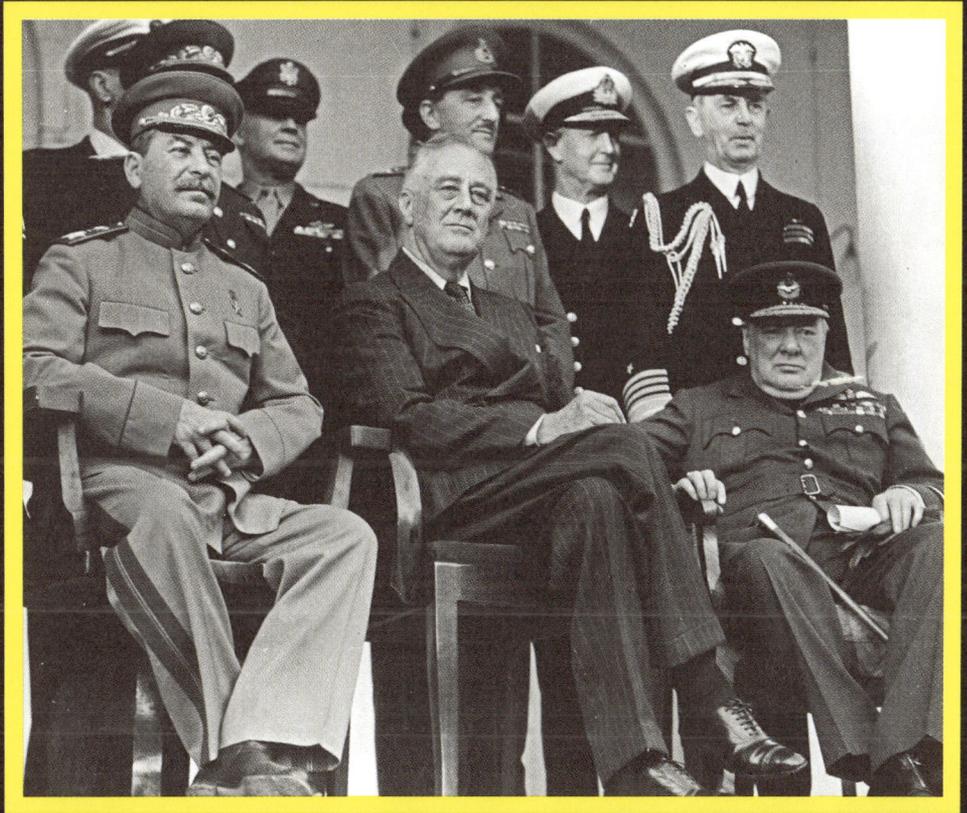

The meeting of Stalin, Roosevelt, and Churchill in Tehran resulted in a joint declaration. In it, they stated that they had coordinated plans for the destruction of German forces and acknowledged their supreme responsibility for ensuring an enduring peace in the future.

discussions. As early as 1919, as the dust settled from the First World War, the Soviet Union and the Second Polish Republic proposed the Curzon Line, the demarcation for establishing the post-war makeup of Poland. This was controversial, as the Polish government-in-exile in London preferred an alternative, the Riga Line, which would see the Poles cede less territory to the Soviet Union in the East.

Poland was fundamental to British involvement in the Second World War. It was, after all, the threat to Polish sovereignty that had compelled Neville Chamberlain to issue a belated final warning in 1939. Germany's disregard for this ultimatum caused the declaration of war on 3 September. By 1944, however, the geopolitical landscape had undergone such seismic shifts that Poland's border was once again in play on the global chessboard, but there was a European piece that Churchill valued more. This prize was Greece, and with it renewed British access to the Mediterranean and the Suez Canal.

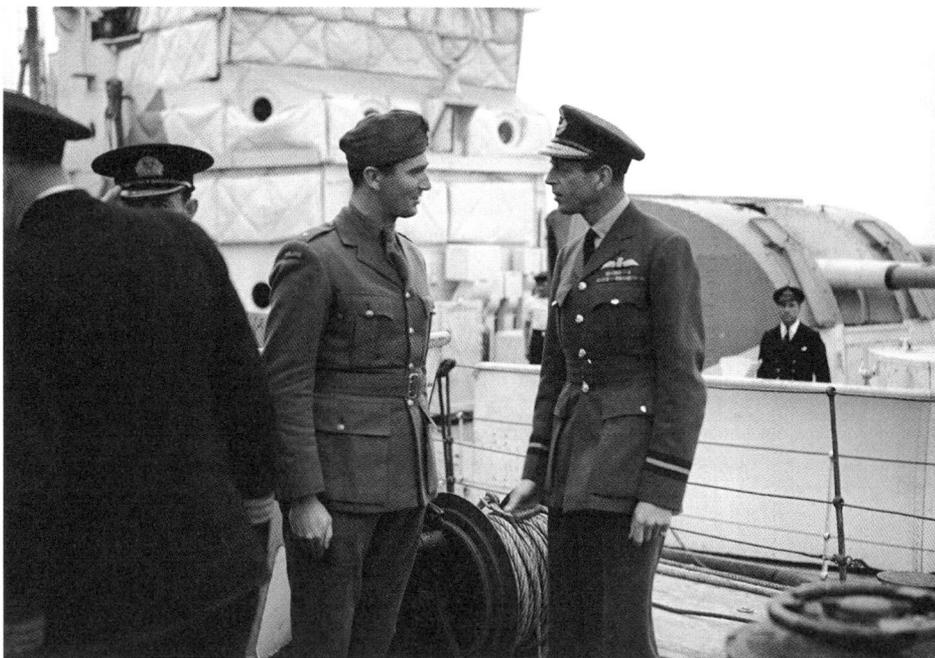

Prince George, Duke of Kent, meets with Polish naval officers on an inspection of the destroyer ORP Krakowiak at Plymouth on 11 July 1942. Poland was key to Britain's declaration of war in 1939. By 1945, it had become a political bargaining chip.

'Tolstoy' was largely triggered by concerns surrounding Bulgaria, particularly the possibility of a 'greater Bulgaria' falling within the Soviet sphere of influence after the war. Additionally, there was apprehension that the entire Balkans, along with Hungary, might soon be occupied by the Red Army. Until this point in the war, Roosevelt had overlooked the Balkans, but by October 1944, he had started to show interest in the region. He was, however, deeply involved in a domestic re-election campaign, seeking an unprecedented fourth term, which made it impossible for him to attend the Moscow summit as he had hoped. In a telegram to Stalin on 4 October, Roosevelt expressed his regret that his campaign obligations prevented his attendance but emphasised that 'in this global war there is literally no question, political or military, in which the United States is not interested'. He requested that the American ambassador to the Soviet Union, W. Averell Harriman, be allowed to attend the summit as his observer, but Stalin declined, stating that Harriman could only attend as Roosevelt's official representative.

Without Roosevelt's permission or Harriman's knowledge, Churchill proposed an agreement in which Britain and the USSR would divide Europe into 'spheres of influence', with each having predominance in certain regions. Churchill's main aim was to keep the communist Greek resistance group, EAM-ELAS, out of power, and to persuade Stalin to withdraw his rhetorical support for them. Churchill did not want disagreements over Greece to spark a clash of interests in the Balkans. According to the British transcript of the discussions, Churchill's primary concern was the imminent prospect of civil war which he feared could lead to an Anglo-Soviet conflict, with the Soviets backing EAM-ELAS and the British supporting the Greek king.

According to Churchill's account of the meeting, he proposed that the Soviet Union should have 90 per cent influence in Romania and 75 per cent in Bulgaria, while the United Kingdom should have 90 per cent influence in Greece. They would share influence equally, at 50 per cent each, in Hungary and Yugoslavia. Churchill wrote these percentages on a piece of paper, which he handed to Stalin, who marked the agreement with a large tick and returned it.

The Percentages Agreement – Churchill and Stalin's
'naughty document' indicating the proposed carve-up
of Europe between Britain and the Soviet Union. The
large tick was Stalin's mark of approval.

Churchill referred to the note as a 'naughty document' and suggested to Stalin that they destroy the incriminating piece of paper. Stalin demurred, and suggested Churchill keep it. Churchill knew the evidence that he and Stalin had so casually decided the fate of millions between themselves would be problematic, not least with Roosevelt and the Americans. Yet while the document never made it into the official record of events, the piece of paper itself survived and was to have a profound impact. The Percentages Agreement has come to symbolise the fate of post-war Europe. From one perspective, it represents Stalin's betrayal of the revolution in Greece and, by extension, Western Europe. From another, it is the story of Churchill sacrificing Eastern European freedom to protect British strategic and imperial interests. Most fundamentally, however, it was the last-ditch effort to avoid confronting the reality of Britain's declining influence in the face of the Soviet Union's rising power in the Balkans and America's increasing dominance over the Western side of the Grand Alliance.

Stalin was broadly satisfied with the agreement. He had obtained the concessions he wanted and had given away very little. Churchill initially saw the agreement as a pragmatic way to maintain British influence. His main objective had been to secure that influence over Greece, and he had achieved that without giving up anything he hadn't assumed Stalin would take anyway. While the Americans would profess horror at the agreement, they were as much aggrieved at being outmanoeuvred by Churchill and Stalin as they were anything else, given the other distractions they faced domestically, and in the Pacific. In fact, the real lasting impact of the Percentages Agreement was on Churchill himself. Churchill's acquiescence to Stalin and betrayal of the Poles soon began to look like a misstep. Both Churchill and his Foreign Secretary, Anthony Eden, seem to have been beguiled by Stalin, convinced that he had no intention of imposing Soviet rule on the Eastern European nations. While there is no clear evidence that Winston Churchill explicitly regretted the Percentages Agreement, his late and post-war concerns about Soviet behaviour suggest that he may have underestimated the long-term consequences of the agreement and the extent of Soviet domination in Eastern Europe.

In many respects, the agreement was redundant for the Soviets. The Red Army was going to occupy much of Eastern Europe regardless, barring the kind of military intervention that was beyond British capabilities. Nevertheless, tentative plans to combat Soviet domination were drawn up by the British Chiefs of Staff Committee (CSC) under Churchill's direction. Operation Unthinkable was the name given to these hypothetical plans, which envisioned two distinct scenarios, one defensive, the other offensive. The offensive plan was especially ambitious, calling for a surprise attack on Soviet forces in Germany to 'impose the will of the United States and British Empire upon Russia'. The CSC planned for an invasion of Eastern Europe to commence on 1 July 1945 involving a coalition of Western Allied forces, supplemented by rearmed German soldiers, to counter Soviet military dominance. Even with the proposed 47 divisions, however, the Western forces would still have been outmanned by 2½ to 1. As such, and coupled with the lack of political will among the Allies, the plan was deemed impractical. With the Americans keen to demobilise out of Europe, Washington was not even consulted. Given the CSC's appraisal that without US involvement, 'it would be beyond our power to win a quick but limited success, and we would be committed to a protracted war against heavy odds', the plan was dropped, kept secret, and not revealed to the public until 1998.

The Polish city of Biała after its capture by the Soviet army.

THE DECLINE OF THE UK AS A WORLD POWER
1900-45

The early twentieth century saw the gradual decline of the United Kingdom as a dominant world power, shaped by a confluence of political, economic and social factors. At the turn of the century, the UK was at the zenith of its imperial power, commanding a vast empire that spanned continents. However, the First World War (1914–18) placed unprecedented strain on British resources, both human and financial, and heralded the emergence of the United States and the Soviet Union as superpowers.

The economic downturn of the Great Depression in the 1930s exacerbated social unrest and diminished Britain's capacity to manage its empire effectively. Unemployment surged, industrial productivity plummeted and movements for self-determination gained momentum in India, Egypt, and across Africa.

The rise of nationalist movements was not merely a reaction to economic difficulties; it was also a response to changing global ideologies surrounding democracy and self-governance. Leaders like Mahatma Gandhi in India mobilised mass support against colonial rule, and the often repressive British response only fuelled further resentment and resistance.

The Second World War (1939–45) marked the culmination of Britain's decline. The UK's reliance on American support became increasingly apparent, and the financial burdens of the war effort resulted in a post-war landscape in which the UK struggled to rebuild.

Additionally, the end of the war cemented the United States and the Soviet Union as superpowers, while the establishment of the United Nations and various international institutions further diminished the UK's previously unassailable role in global governance. The decolonisation process accelerated post-1945, with many territories gaining independence in the wake of the war, further illustrating the dismantling of British imperial power. These transformations laid the groundwork for a new global order where Britain found itself grappling with its reduced status in a rapidly changing world.

The Big Three would meet twice more, firstly at Yalta in Crimea and then at Potsdam. With the end of the war in sight, the Yalta Conference, held from 4–11 February 1945, saw Roosevelt, Churchill, and Stalin agree on the division of Germany, the establishment of the United Nations, and the Declaration on Liberated Europe, which promised free elections in Eastern Europe. Roosevelt and Churchill were particularly keen to emphasise Polish sovereignty and the right to free and fair elections. The wily Stalin and Molotov succeeded in diluting the language of the agreement so that, as Roosevelt conceded, Stalin could 'stretch it all the way from Yalta to Washington without ever technically breaking it'. For his part, Churchill believed he could trust Stalin when it came to Poland, famously stating, 'Poor Neville Chamberlain thought he could trust Hitler. He was wrong. But I don't think I am wrong about Stalin.'

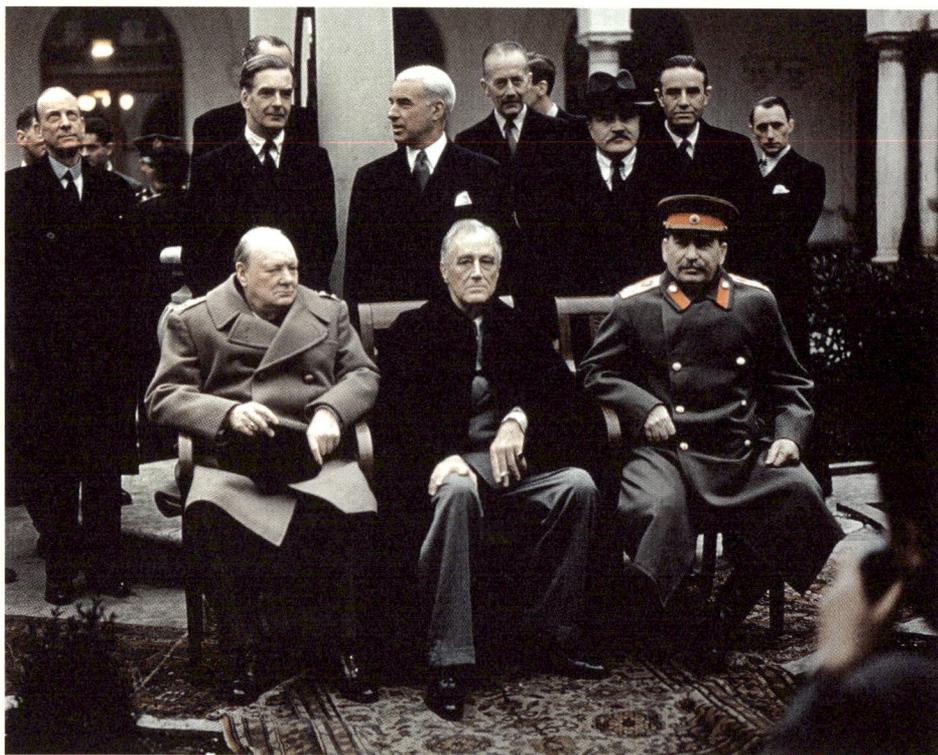

Churchill, Roosevelt, and Stalin – the Big Three – meet at the Yalta Conference in February 1945 to shape the post-war settlement.

Churchill faced opposition at home, with many MPs voicing criticism of the Yalta agreements, particularly regarding Poland. A group of 25 MPs even drafted an amendment to a confidence vote protesting against the terms of the agreement. Their concerns were vindicated when, after the war, a communist government was installed in Poland, leaving many Poles feeling betrayed by their wartime allies.

The concessions to Stalin at Yalta damaged the cordial relations that had developed between Britain and the Soviet Union. By the time the Grand Alliance reconvened at Potsdam between 17 July and 2 August, almost everything had changed. Franklin Roosevelt, who had been visibly ailing during the Yalta Conference, died on 12 April 1945, and was replaced by his Vice-President, Harry S. Truman. Roosevelt's Vice-President throughout the war had been Henry A. Wallace, but Democratic Party leaders conspired to have Wallace removed from the ticket before Roosevelt ran for his fourth term, in part due to his perceived pro-Soviet leanings. Truman, a former haberdasher, was a compromise candidate who helped Roosevelt win a landslide election, but Roosevelt rarely consulted him on the war once in office. Indeed, it was only on acceding to the presidency that Truman was informed of the existence of an advanced new weapon being developed in the New Mexico desert.

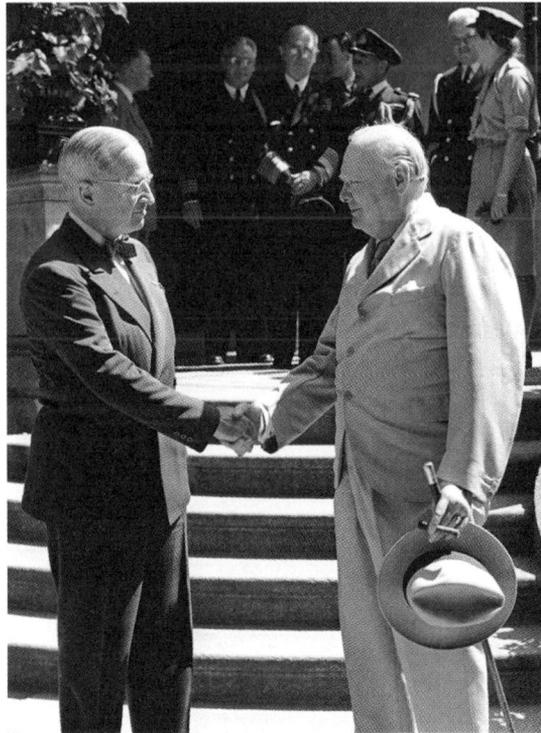

Winston Churchill meets the new US President Harry S. Truman, here shaking hands on the steps of Truman's residence, 'The White House', at Kaiserstraße, Babelsberg, Germany, on 16 July 1945.

DAILY EXPRESS

No. 14,091 — Lighting-up: 9.46 pm to 4.27 am — FRIDAY AUGUST 3 1945 — Weather: Fine, very warm — One Penny

REICH WILL GET A GOVERNMENT AND PEACE TREATY—WHEN SHE HAS WORKED HER PASSAGE

London Council of Ministers to make peace plans for Italy and the satellites

THE PACT OF POTSDAM

NO planes, NO ships, and NO arms for Germany

RUSSIA AND POLAND TAKE SHARES OF EAST PRUSSIA

Express Diplomatic Correspondent GUY EDEN

THE PACT OF POTSDAM, ON WHICH WILL BE FOUNDED THE PEACE OF EUROPE, TAKES ITS PLACE TODAY AS ONE OF THE HISTORIC DOCUMENTS OF THE WORLD. IN A STATEMENT OF 6,000 WORDS THE BIG THREE POWERS—BRITAIN, AMERICA, RUSSIA—ANNOUNCE THEIR PLANS TO SOLVE THE PROBLEMS OF THE POST-WAR WORLD.

THE LAST 21 WORDS
MILITARY TALKS SECRET

'Keep out' notice to Franco

Peace treaty for Italy: Colonies hold-up

Gold buttons smuggled

Stalin DID tour Berlin

Laval won't be shaved

The big Prussia carve-up

PETAIN SESSION ENDS IN PANDEMONIUM

Laval in court this afternoon

From GORDON YOUNG

Another duel

WHAT THE BIG 3 SAY ABOUT —

Like chocolate

MAY-STRIKE RAIL MEN MEET TODAY

Still no solution at peace talks

By TREVOR EVANS

HEAT WAVE FOR BANK HOLIDAY

BRIGHTON ACTS ON CAFE QUEUES

German outrage kills 50

Churchill tribute ruled out

BEVAN MAY BE NEW HEALTH MINISTER

Express Political Correspondent

Attlee sleeps at No. 10

ALEXANDER BACK?

End of a Hitler whim

'DEMOB 15,000 MINERS —NOW'

Minister may seek work guarantee

2 a.m. LATEST

JAPS LOSE TEN MORE SHIPS

LOWEST LEVEL

Banker (38) will help businesses

HEINZ 57 will return to the home front
Always ready to serve

"When the boys come marching home!"

The Potsdam Conference saw the victorious Allied leaders Truman, Stalin, and Attlee finalise post-war arrangements, including Germany's division, reparations, and Japan's surrender ultimatum.

Even more than the change in president, it was the development of the atomic bomb that changed the nature of the final Big Three conference. While at Potsdam, Truman learned of the successful Trinity test on 16 July. Truman hinted to Stalin that the US was likely to use a new weapon against the Japanese; in fact, thanks to Soviet espionage, Stalin knew of the existence of the bomb before Truman did. Then by 28 July, confirmation of a shock almost as seismic as the detonation of Trinity: Winston Churchill had been ousted as British Prime Minister, replaced by his Deputy, Labour's Clement Attlee. Potsdam was primarily focused on prosecuting the war with Japan to an unconditional surrender, but crucially also saw the conformation of the division of Germany as a whole, and Berlin in particular, into four occupied zones, to be controlled by the US, Britain, the Soviet Union, and France. It also saw de facto control of Poland finally given to the Soviets. The Provisional Government of National Unity, a Soviet creation, was recognised by the Big Three, while Poland's borders were officially redrawn. Free, democratic elections were promised, but by this point, there were few doubts as to Stalin's intentions. By the end of the war, Stalin had in fact obtained all that Churchill and he had laid out in the Percentages Agreement of October 1944.

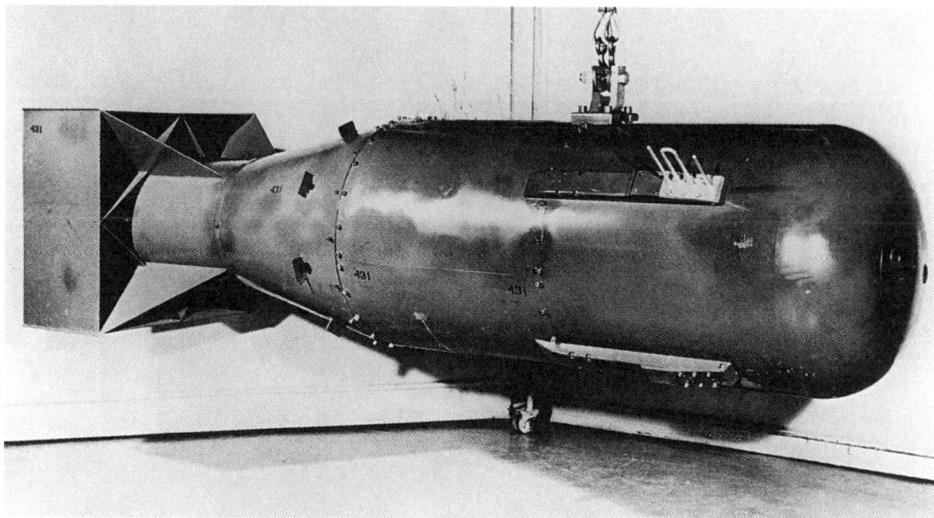

*The 'Little Boy' bomb, dropped on Hiroshima in August
1945, marked a devastating turning point in warfare,
heralding the dawn of the nuclear age.*

In the immediate aftermath of the war, broader relations between Britain and the USSR seemed to be more positive than might have been feared. Despite mutual mistrust between the politicians, the British public felt broadly warm towards their wartime allies. Churchill's wartime government had expended not insignificant effort in promoting the undoubted bravery and sacrifice of the Russian people and the Soviet military in fighting off the Nazi enemy in the East. The Ministry of Information published a booklet refuting many ideological arguments against Bolshevism, which stretched to outright falsehoods, such as claiming that Stalin's Red Terror and the purges were examples of Nazi propaganda, and that the Germans had staged the Katyn Massacre of 22,000 Poles, a verifiable Soviet war crime. Domestically, membership of the Communist Party of Great Britain peaked in 1945 with 56,000 subscribed members, and the party recorded a record vote share in that year's General Election of 0.4 per cent, equating to 97,945 votes and returning two Members of Parliament to Westminster. Most significantly, the 1945 election, the first in a decade, saw Winston Churchill and his Conservative Party ousted by the Labour Party in a remarkable landslide.

The alliance against Nazi Germany was militarily strong but beset with internal fractures that arguably made post-war conflict inevitable.

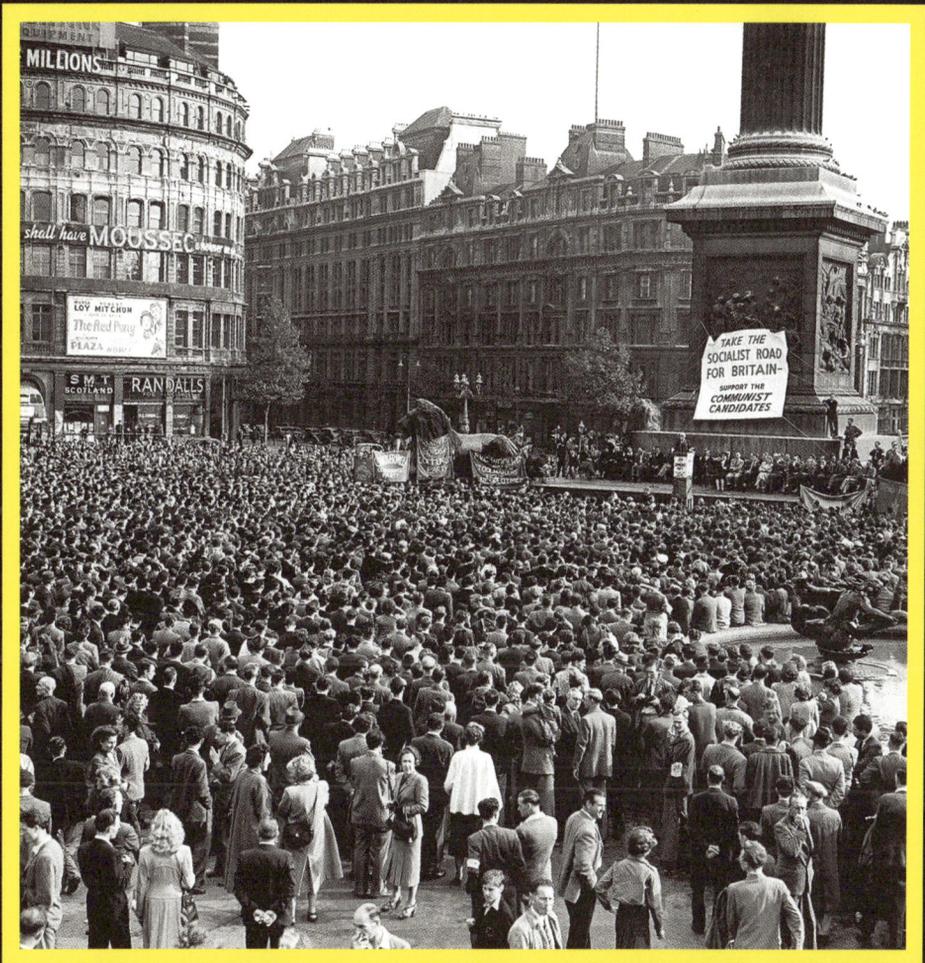

Crowds gather in London's Trafalgar Square as Communist Party of Great Britain MP Willie Gallacher launches the party's election campaign.

THE SOVIET UNION
1917-45

The Russian monarchy was overthrown in the February Revolution of 1917, and then the Bolshevik Revolution in the October of that same year saw the establishment of a communist regime led by Vladimir Lenin. These revolutions were driven by widespread discontent with the existing political order. After the hardships of the First World War Lenin and the Bolsheviks promised 'peace, land, and bread', but not before a brutal five years of civil war, which left deep scars and a society grappling with the ramifications of revolutionary change.

Lenin instigated significant social and economic reforms but faced criticism from more radical elements within the Communist Party. After Lenin's death in 1924, Joseph Stalin gradually rose to power, marking a shift towards a more authoritarian regime. His aggressive economic policy, prioritising rapid industrialisation and collectivisation of agriculture, aimed to transform the USSR into a major industrial power. Stalin also orchestrated mass man-made famine, causing the deaths of millions across the grain-producing areas of the Soviet Union, with an especially large death toll in Ukraine. This was accompanied by a wave of political repression known as the Great Purge. With show trials, executions, and the establishment of the Gulag system, paranoia and fear permeated every level of society.

Despite these internal challenges, the Soviet Union began to emerge as a formidable international power. Stalin's controversial non-aggression pact with Nazi Germany allowed the Soviet Union to annex parts of Poland and the Baltic States, temporarily avoiding conflict with Germany, but in June 1941 Nazi Germany invaded the Soviet Union. Despite suffering staggering casualties in the initial months of the war, the Soviet response, characterised by fierce resistance and mobilisation of its vast population, gradually turned the tide.

By the end of the Second World War, the Soviet Union had not only emerged as a victor militarily but was also expanding its influence over Eastern Europe and inspiring communist revolutions in strategically important locations around the world.

It was into this generally favourable atmosphere that Dynamo Moscow, the football league champions of the Soviet Union, landed at Croydon Airport on 4 November 1945. The Soviet team had been invited to tour the United Kingdom in the spirit of friendship and camaraderie that existed in the afterglow of the Allied victory. The idea had been hatched by Stanley Rous, the Secretary of the Football Association (FA), who quickly convinced the Russian embassy's sports emissary to seek the approval of his superiors back in Moscow.

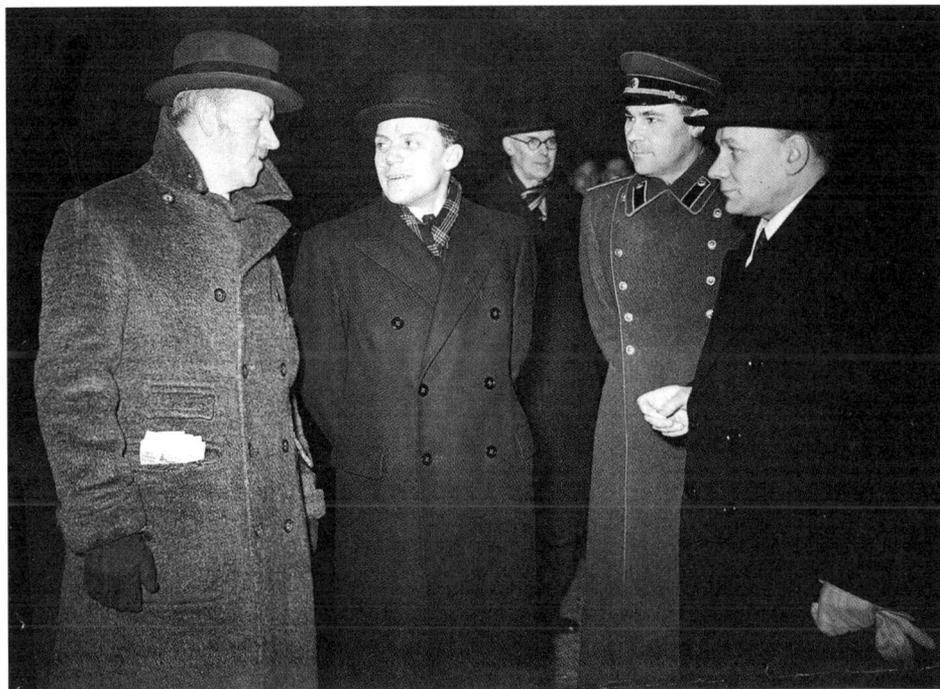

Football Association president Stanley Rous with Soviet apparatchik accompanying Dynamo Moscow on their 1945 tour of Britain.

The tour started chaotically. While the Dynamo players landed at Croydon, Rous and the FA welcoming committee instead went to meet them at RAF Northolt. When the Soviet team were driven to their accommodation, they were horrified to be taken to Wellington Barracks. Surrounded by uniformed Coldstream Guards, the players feared they had been tricked and placed in a British gulag. The FA had seemingly forgotten to provide bed sheets and pillows. Alternative lodgings were

soon found in the Imperial Hotel in Russell Square. Negotiations with the Soviet team over the rest of the tour arrangements had also proven more difficult than first imagined. The Dynamo players were thrilled at the chance to play in Britain, the home of football, whose teams were regarded as the best in the world. Before departing for London, however, the players were summoned to visit Stalin and the sinister apparatchik Lavrentiy Beria, head of the People's Commissariat for Internal Affairs (NKVD). Beria was Dynamo's most high-profile patron, and he and Stalin underlined the importance of not losing to their capitalist opponents. Dynamo officials then presented the FA with a list of 14 demands for the tour, including that they play Arsenal. This touching request to play one of England's most famous clubs belies the rest of the list, which was suffused with paranoia over status and fairness. The English FA was affronted that the Soviets had the temerity to demand anything of the founders of the 'beautiful game'. They capitulated, however, to all but two of the demands.

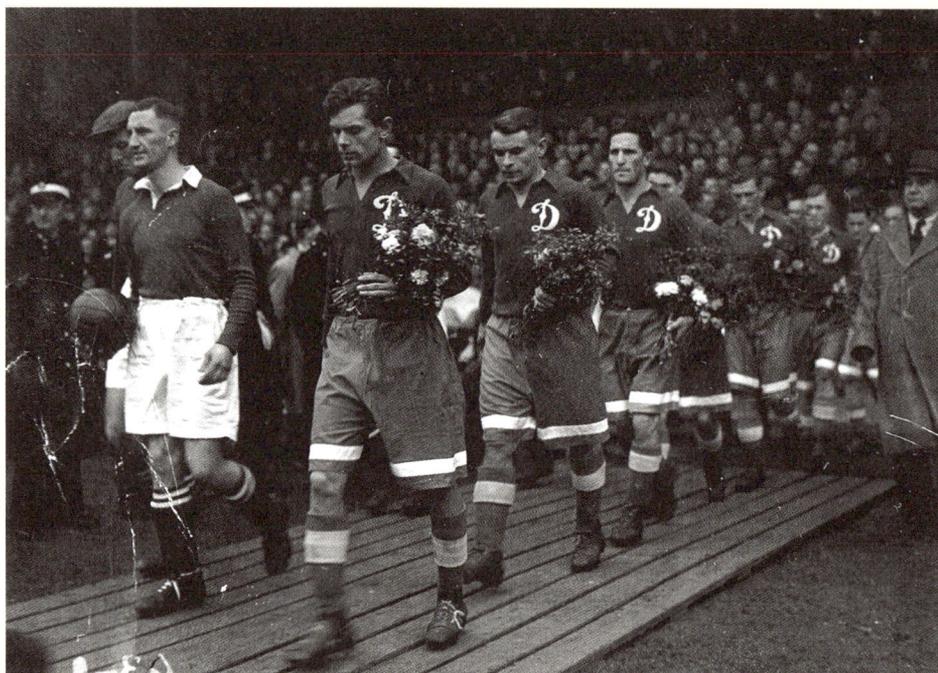

Dynamo Moscow's tour began with a match against Chelsea at Stamford Bridge in front of a huge crowd. The final score was 3–3.

For all the background problems, the tour was greeted with great enthusiasm. Rous's belief that football could be a unifying force was correct. By the 1930s, football had already established itself as Britain's most popular sport and was the major working-class pastime, with a deep connection forged between clubs and their local communities. Huge crowds regularly attended matches, with top clubs such as Arsenal, Everton, and Sunderland in England, and the Glasgow giants Rangers and Celtic in Scotland, drawing tens of thousands of fans to games. Although the outbreak of war had largely halted competitive football, wartime matches, often featuring guest players from various clubs, drew crowds and helped maintain public morale. These matches, though unofficial, kept the sport in the public eye, and football retained its popularity despite the war's disruptions. With the leagues due to return in 1946, football was poised to regain its position as a cornerstone of British life. The same was true in the Soviet Union, where, famously, football continued throughout the brutal Siege of Leningrad between 1941 and 1944 in what came to be seen as an act of supreme defiance. Given all this, demand for tickets was high.

The first game of the tournament took place against Chelsea on 13 November 1945. The official attendance was 74,496 but contemporary reports and newsreel footage allows us to estimate an actual attendance in excess of 100,000 spectators, some of whom made their way onto the roof of the stands. If that was quite the spectacle, what happened on the pitch was unlike anything British fans had ever seen. Not only did Dynamo conduct a warm-up on the pitch, which no English side ever did, they presented their opponents with flowers before kick-off, which was a common pre-match courtesy in the Soviet league. More striking was the style of play employed by the visitors – an attacking approach defined by intricate, quick passing that the Russians called *Passovotchka*. The match with Chelsea finished 3–3, perhaps fitting for a friendly between wartime allies. Reaction to the Russians and their performance was effusive. Chelsea centre-forward Tommy Lawton said, 'Dynamo were one of the fastest teams I have ever seen in my life. They flash the ball from man to man in bewildering fashion, often while standing still.' The home crowd were so smitten with their guests they even celebrated the Soviets' equalising goal, and at full time supporters

streamed onto the pitch and carried several Muscovites to the player's tunnel. Some even waved the red flag in the stands.

Tensions began to creep in following the next match on the tour. A visit to Wales to play third division Cardiff City began promisingly with a civic reception which saw the hammer and sickle raised over City Hall. But on the pitch, Dynamo did not reciprocate their host's warm welcome, thrashing the Welsh side 1–10, by far the heaviest lost any British team had suffered against foreign opposition. The press began to turn on the Soviets, questioning how they could be so fit and fearsome when they were supposedly a war-ravaged nation, and railing against the unsportsmanlike behaviour of mercilessly embarrassing their hosts.

British pride was expected to be restored in the third game. Facing the mighty Arsenal as per their request, the Soviets were disappointed at being denied the chance to play at Arsenal's famous Highbury Stadium, which was still under requisition by the Ministry of Defence. The club was forced to use White Hart Lane, the home of their arch-rivals Tottenham Hotspur, for the match. This contest was mired in controversy and tensions were high going into the game, not that this, nor the thick fog enveloping London, deterred supporters. The Soviet champions won a bad-tempered contest 4–3 which fully turned the British press against the tour. Reports suggested that the Dynamo players were overly physical, engaged in time-wasting, and used psychological gamesmanship to unsettle their British opponents. These accusations were part of a broader narrative that painted the Soviets as playing by different rules, mirroring the growing political discourse. The Soviet players were depicted as symbols of communistic discipline and collectivism, in contrast to the press's praise for the skilled individualism of the British players.

A final match took place in Glasgow against Rangers. Anticipation for another feisty encounter was high and tickets at Ibrox Stadium changed hands at ten times their original cost, with 90,000 packing into the stadium. The match finished in a 2–2 draw, and despite attempts to organise a fifth, deciding, game, the tour was over, with Dynamo summoned back to Moscow.

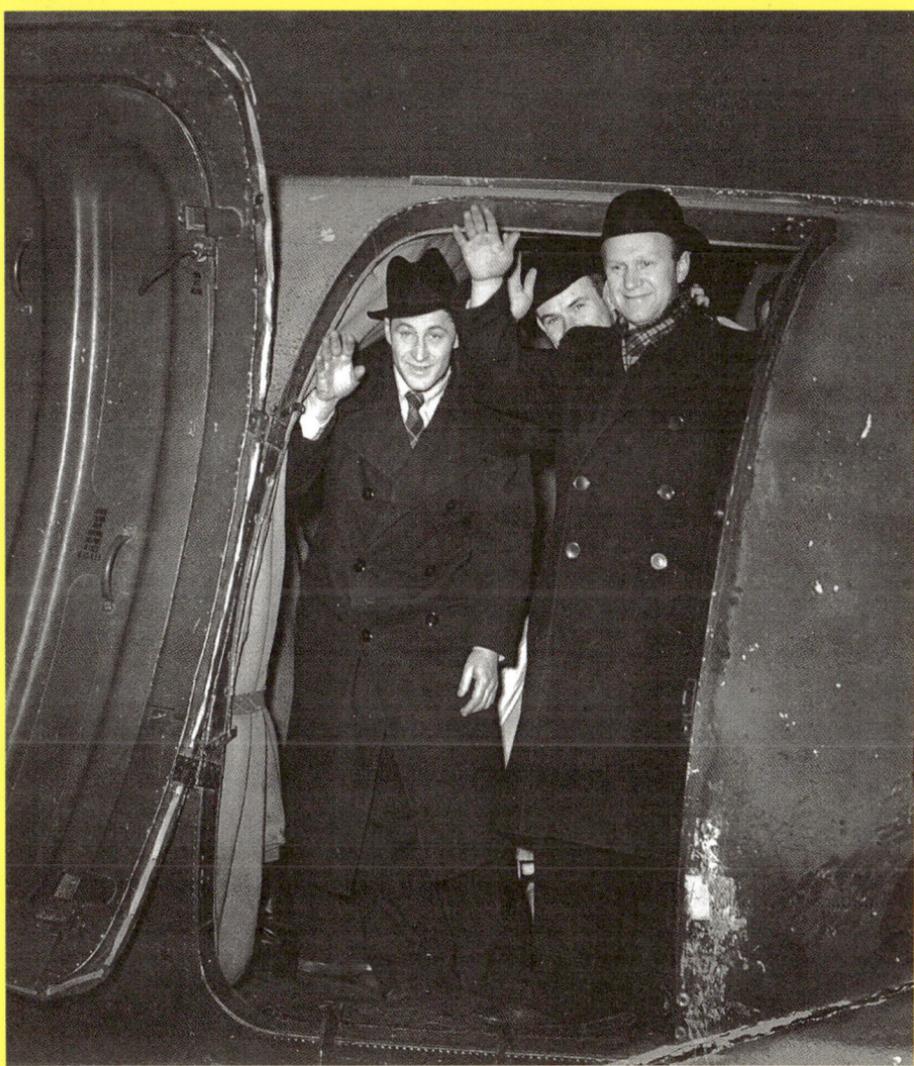

Dynamo Moscow players depart Britain from Northolt on 7 December 1945. A tour that began in the spirit of friendship ended in tension and suspicion.

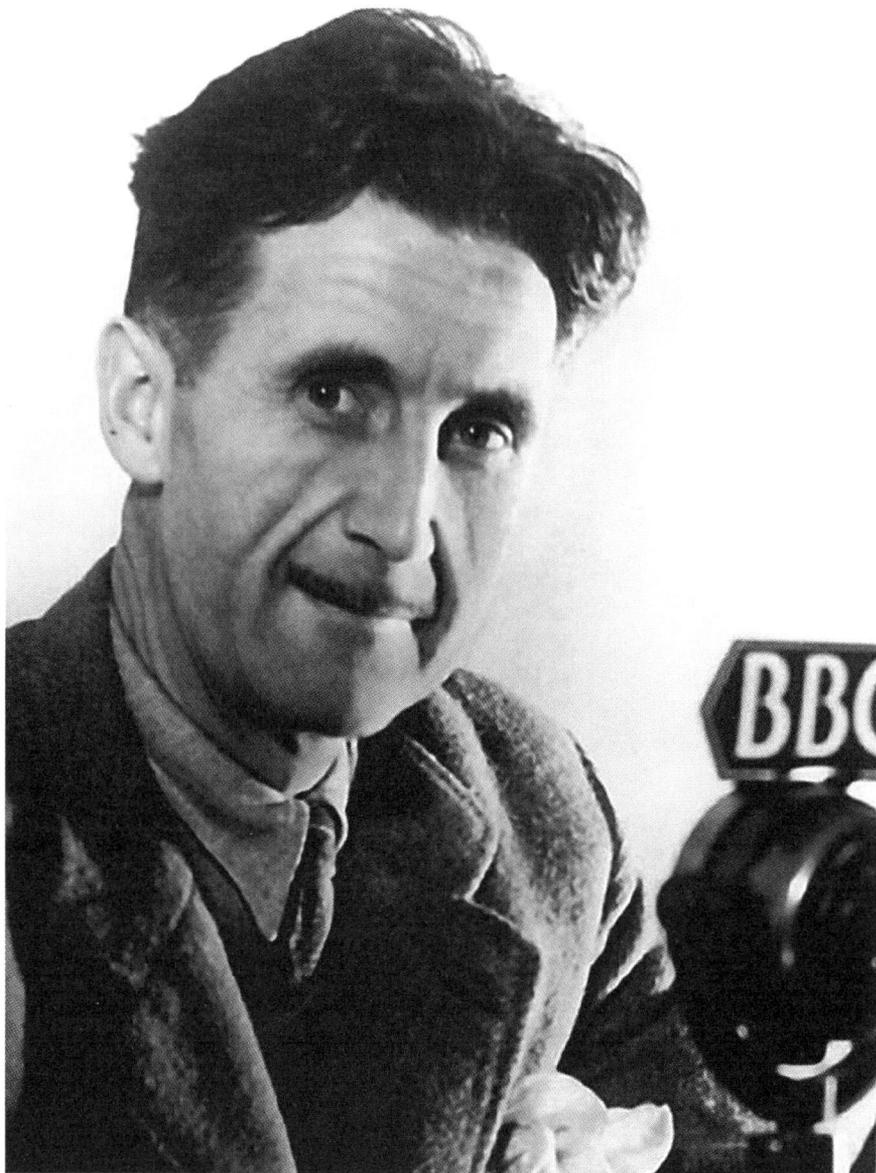

Eric Arthur Blair, better known as George Orwell. Orwell's writing captured the growing tensions at the outset of the Cold War.

If the Dynamo tour ended with a bitter, unspoken sense of resentment, that feeling was put into words by one of Britain's great men of letters. George Orwell was a writer shaped by war. Born Eric Arthur Blair, Orwell's politics were rooted in a complex blend of democratic socialism, anti-totalitarianism, and a deep commitment to individual liberty and social justice. His socialism advocated for a system that would ensure political freedoms alongside economic reforms and his fierce opposition to totalitarianism was central to his political thought, as seen in his most famous works, *Animal Farm* (1945) and *Nineteen Eighty-Four* (1949). He was particularly critical of the oppressive nature of the Soviet Union under Stalin, which he viewed as a betrayal of the socialist ideals he supported. His experiences fighting against Francisco Franco's fascist forces during the Spanish Civil War, as recounted in *Homage to Catalonia* (1938), solidified his disdain for both fascist and communist totalitarianism. Orwell saw such regimes – whether on the political right or the left – as threats to truth, individual autonomy, and freedom of thought, through their use of propaganda, surveillance, and brutal repression to maintain power.

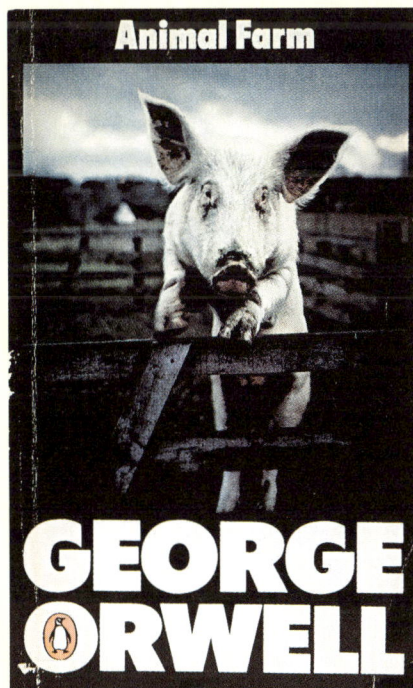

George Orwell's allegorical fable, Animal Farm, *was a scathing critique of the Soviet Union and a warning to the British left.*

Published in the left-wing newspaper, *Tribune*, on 14 December 1945, and following the departure of the Soviet footballers, Orwell's essay, 'The Sporting Spirit' opened with this salvo:

> *Now that the brief visit of the Dynamo football team has come to an end, it is possible to say publicly what many thinking people were saying privately before the Dynamos ever arrived. That is, that sport is an unfailing cause of ill-will, and that if such a visit as this had any effect at all on Anglo-Soviet relations, it could only be to make them slightly worse than before.*

Highlighting the heightened tensions and aggressive flag-waving in the press and among fans during and following the Dynamos' tour, Orwell argues that far from fostering camaraderie and goodwill, organised sports provoke aggression, hostility, and nationalism, and that international competition, even on the field of play, will heighten tribalism and animosity between nations. 'You play to win', he writes, 'and … at the international level sport is frankly mimic warfare.' His observations on the Dynamo tour are especially pointed, noting that the behaviour of spectators changed as tensions rose, but also that they participated in the stoking of discord, by insulting and jeering the opposition. Sport was, for Orwell, 'war minus the shooting'.

Like much of Orwell's prose, this pithy line entered the lexicon and was a piece of imagery that would recur throughout the Cold War. Yet this was far from Orwell's only contribution to the conflict. Arguably, he gave it its name. In his essay of 19 October 1945, 'You and the Atomic Bomb', also published in *Tribune*, he warned readers of an oncoming 'permanent state of "cold war"'. While the phrase was popularised two years later by Harry S. Truman's representative to the United Nations Atomic Energy Commission, Bernard Baruch, and then by US journalist Walter Lippmann, it was the British writer who first coined the phrase.

Orwell wasn't the only notable Brit who helped define the Cold War through language. Winston Churchill, perhaps more than any other individual, articulated the state of the post-war world. In early October 1945, Churchill received the

George Orwell's Nineteen Eighty-Four *endures as a depiction of a dystopian society of surveillance, propaganda, and repression.*

offer of a speaking engagement at Westminster College, in the unassuming town of Fulton, Missouri. The typed invitation was adorned with a handwritten addendum, praising the school, imploring Churchill's attendance, and promising a personal introduction. Of course, the author wasn't just anybody; the note had been penned by the most important Missourian in the world at that time, President Harry S. Truman. Despondent at having been unceremoniously ejected from office, and anxious to be back on the world stage, Churchill gladly accepted, and the trip was planned for March 1946.

If Churchill had developed a close relationship with Roosevelt, he knew little of his successor. Truman, however, revered Churchill for his contribution to the Second World War, appreciated his vast experience, and valued his perspective on the Soviet threat. Famously, the President insisted the former Prime Minister call him 'Harry' but felt uncomfortable honouring Churchill's reciprocal request to be addressed as 'Winston'. So absolute was Truman's respect for his guest, that he initially refused to read through Churchill's speech to give it his pre-approval. According to his aide, Clark Clifford, however, curiosity overtook the President, who felt the speech was stirring, important, correct in its assertions, and likely to cause a stir.

At 3.30 p.m. on 5 March 1946, in the gymnasium of Westminster College, Winston Churchill, introduced as promised by President Truman in what he called one of the great privileges of his life, gave the speech that would define the Cold War. Officially titled 'The Sinews of Peace', the address to 2,800 people has come to be better known by a phrase from within the text:

From Stettin in the Baltic to Trieste in the Adriatic, an iron curtain has descended across the Continent. Behind that line lie all the capitals of the ancient states of Central and Eastern Europe. Warsaw, Berlin, Prague, Vienna, Budapest, Belgrade, Bucharest and Sofia; all these famous cities and the populations around them lie in what I must call the Soviet sphere, and all are subject, in one form or another, not only to Soviet influence but to a very high and in some cases increasing measure of control from Moscow.

THE RISE OF THE UNITED STATES AS AN INTERNATIONAL POWER 1900-45

At the turn of the twentieth century, the US was emerging as an industrial powerhouse, fuelled by rapid economic expansion and technological advancements. By 1910, the country was producing a significant portion of the world's steel and coal, and its economy was becoming increasingly interconnected with global markets. This industrial might laid the foundation for American influence abroad.

US foreign policy gained importance following the Spanish–American War of 1898, after which the US acquired territories such as Puerto Rico, Guam, and the Philippines. A desire for economic expansion was accompanied by strategic military positioning and a belief in American exceptionalism. President Theodore Roosevelt's intervention in the construction of the Panama Canal highlighted the US commitment to projecting power in the Western Hemisphere.

The First World War (1914–18) marked a turning point for the US. Initially neutral, the Americans entered the war in 1917. US troops played a decisive role in the conflict, and after the war, President Woodrow Wilson championed the idea of a League of Nations, advocating for collective security and international cooperation led by Washington. The US also came out of from the war economically strengthened, in contrast to Europe, which faced widespread devastation.

Despite economic challenges in the interwar years, including the Great Depression, the United States remained a critical economic player. With the onset of the Second World War, the US initially maintained a policy of neutrality, but increasingly supported the Allies economically. The attack on Pearl Harbor in December 1941 forced the Americans to fully engage in the conflict. US military and industrial capabilities became crucial in the defeat of the Axis powers. By the war's end in 1945, the United States had established itself as a dominant global power, with unparalleled military strength and economic resources, enabling its status as a principal architect of the post-war order.

Winston Churchill's 'Iron Curtain' speech, delivered at Westminster College in Fulton, Missouri on 5 March 1946, was a defining moment of the early Cold War.

The 'Iron Curtain' speech was a watershed moment in the early Cold War. Receiving widespread coverage in the US, the Soviet Union, and at home, the speech was as impactful as Truman predicted, and Churchill intended. In the United States, the response was generally positive. Some national newspapers, such as the *Chicago Sun* and *The Nation* were critical, but support was found in the pages of the *New York Times* and the *Wall Street Journal*. Truman himself claimed to the press, falsely, that he had not read the speech in advance, giving him some political cover. Yet he had tacitly endorsed Churchill's remarks at every turn. In the USSR, the Soviet press uniformly denounced Churchill's speech as provocative. Soviet newspapers portrayed Churchill as a warmonger trying to divide Europe and revive fascism. The term 'Iron Curtain' itself was interpreted as a direct accusation against the Soviet Union's policies in Eastern Europe, and the speech solidified the Soviet view that the West was planning to isolate and encircle the USSR. Stalin saw the speech as a declaration of ideological and political war, exacerbating the already growing tensions between East and West. He publicly condemned the speech, comparing Churchill's rhetoric to that of Adolf Hitler and accusing him of seeking to establish an Anglo-American bloc to oppose the USSR.

In the UK, the government led by Prime Minister Clement Attlee was less enthusiastic than the US. While Churchill was still respected, the Labour government, which was more focused on post-war reconstruction and maintaining peace, was cautious about openly supporting such a stark anti-Soviet message. Attlee and other officials distanced themselves from Churchill's rhetoric, viewing it as potentially inflammatory. What passed without comment, of course, was Churchill's own role in allowing the Soviet Union to dominate an entire sphere of Europe. His secret deal with Stalin would not become widely known until the early 1950s, when Churchill himself would disclose it in his memoirs.

By this time, the United States had adopted the Truman Doctrine, a pledge that the US would offer 'support for democracies against authoritarian threats', something Churchill saw as justification for his strategic gamesmanship with Stalin. Events were beginning to coalesce. Just weeks before Churchill delivered his address in Fulton, George Kennan, a chargé d'affaires for the US State Department in

The Attlee-led Labour government of 1945 has been much mythologised but undoubtedly did a great deal to change post-war Britain.

Moscow, had composed and sent a 5,000-word message to his superiors. This 'Long Telegram' laid out the history, current affairs, and future ambitions of the Soviet Union, detailing the threat the USSR posed to the Western world. Many of the themes espoused by Kennan were echoed by Churchill. In July of 1947, Kennan's article was published in *Foreign Affairs*, the journal of the Council on Foreign Relations, as 'The Sources of Soviet Conduct', under the pseudonym X. When the *New York Times*, and then other outlets, picked up the story, it caused a sensation. The Truman Doctrine had been announced before the article came to public attention, but the feeling that the two were linked was inescapable. In fact, Kennan's final draft was delivered one month after Truman had announced his new policy. Nevertheless, thanks in part to the public pronouncements of Truman and Kennan, and Churchill and Orwell, there could be no doubt that by the summer of 1947, the Cold War had begun.

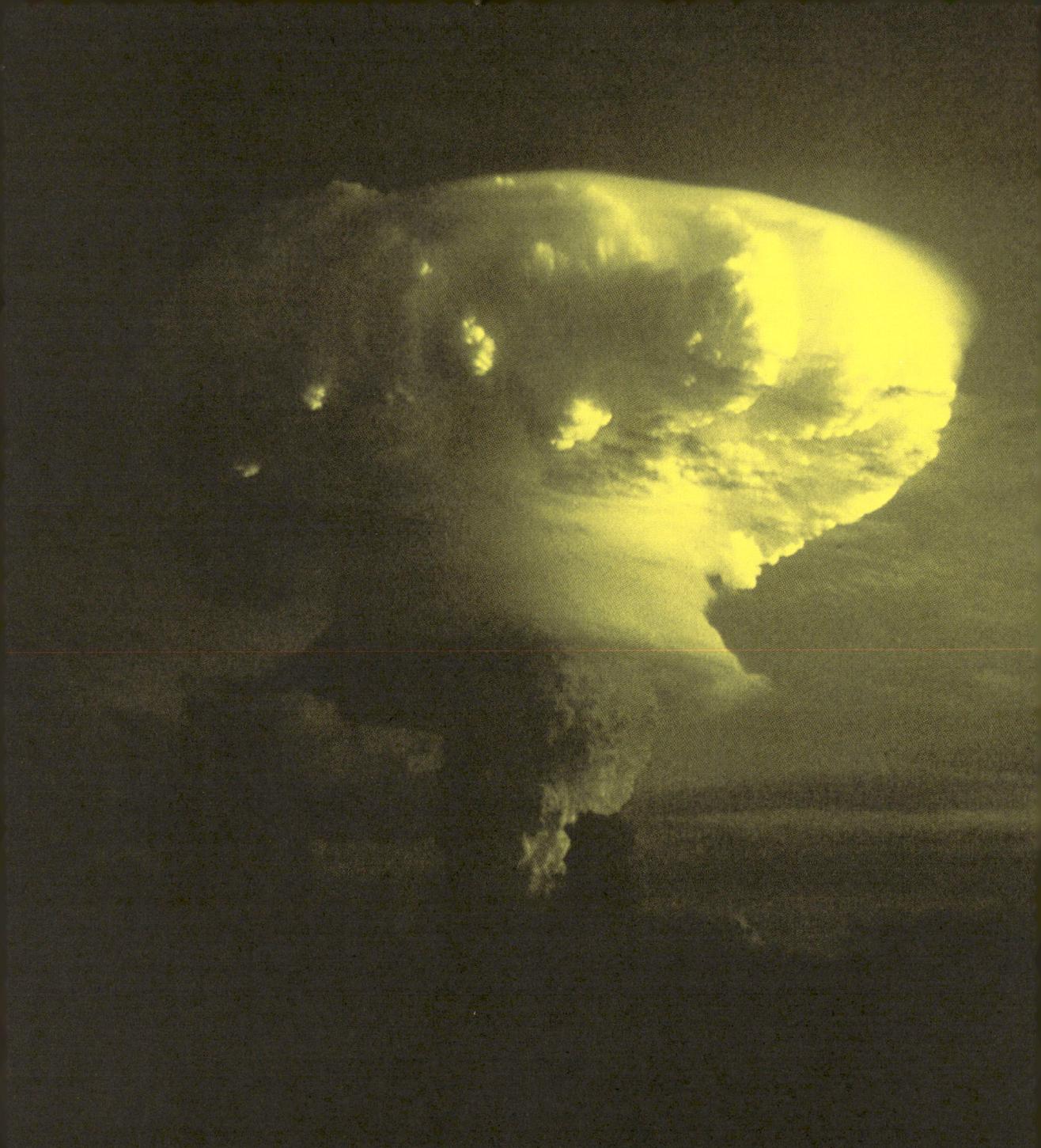

The mushroom cloud of a hydrogen bomb ascends into the skies above Christmas Island following a successful British test.

CHAPTER 2

THE SPECIAL RELATIONSHIP AND THE BOMB

Winston Churchill's speech at Westminster College has become known for the idiom, the 'Iron Curtain'. Buried deeper within the address, however, was another turn of phrase that arguably had as great an influence on the Cold War, and one that still holds significant political and cultural meaning in the twenty-first century: the 'Special Relationship'.

When Churchill spoke of 'a special relationship between the British Commonwealth and Empire and the United States', he was referring specifically to the events of the Second World War, but he was also drawing upon a long history of shared culture, religion, and language. It is not coincidental that around the time of the Iron Curtain speech, Churchill was putting the finishing touches to his multi-volume *A History of the English-Speaking Peoples*. Churchill was also half American by birth, and despite being an unabashedly patriotic British imperialist, he had an optimistic, albeit occasionally critical, view of the United States. Given the political

Vol. One READY NOW

The CHARTWELL Edition of

Sir Winston Churchill's *latest and greatest work*

A History of the English-Speaking Peoples

Here is history in the Churchill tradition, history with the vigour, the insight and command of language which gives perfect and exciting pen pictures of historical events throughout the ages. It is not only a history of Great Britain but of all English-speaking countries—the United States, Canada, Australia, South Africa, the Dominions, the

Colonies. There has never been a history like this: the inspiration and descriptive power of the writing leaves one breathless. Sir Winston has excelled himself.

This great new CHARTWELL edition is the ONLY FULL ILLUSTRATED edition. There are 4 superbly printed and bound volumes in all, to be published at intervals—the first is ready NOW. Fill in the coupon below for further details RIGHT AWAY.

The only fully illustrated edition of the Book of the Century

SPECIAL SUBSCRIPTION TERMS AVAILABLE

WRITE NOW FOR FULL DETAILS

FILL IN THIS COUPON TODAY

To: THE EDUCATIONAL BOOK CO., LTD., TALLIS HOUSE, TALLIS ST., LONDON, E.C.4. Please send details about A HISTORY OF THE ENGLISH SPEAKING PEOPLES

Name ...

Address ..

...

...
EV. 6

THE BIRTH OF BRITAIN

Winston Churchill was a prolific author and recipient of the Nobel Prize in Literature. A History of the English-Speaking Peoples is a four-volume history of Britain and its former colonial possessions.

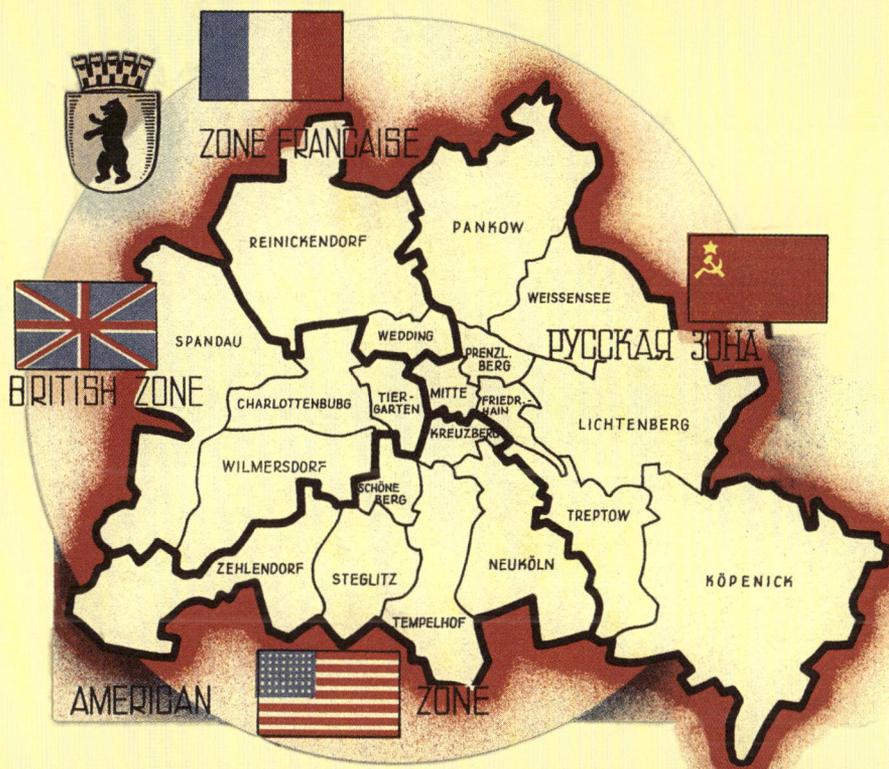

In 1945, Berlin was divided into four sectors controlled by the US, USSR, Britain, and France, symbolising the city's central role in Cold War tensions.

Warning sign, indicating the border of the British Sector, Berlin.

and economic challenges faced by Britain in the early months and years of the Cold War, it is not surprising that Churchill, having done so much to engage the United States in the last war, should wish his nation to stick ever closer with the great power across the Atlantic.

Indeed, the early stages of the Cold War saw the two nations work together, with some notable success. Berlin would be a constant hot spot throughout the Cold War. The Potsdam Agreement had called for the temporary division of Germany into occupied zones controlled by each of the Allied powers: the United States, the Soviet Union, France, and the United Kingdom. Berlin was 100 miles inside the Soviet occupied zone, but as the base of the Allied Control Council, was also divided into four zones on the same principle. Both the Soviet Union and the Western Allies viewed Germany as a key strategic piece on the post-war, European chess board – for the Soviet Union, it was both a defence against future German aggression and an inroad into Central Europe; for the US and Britain, Berlin was an impediment to further Soviet expansionism and a symbol of Western democracy and freedom. Soon, these ideological differences would fracture any ideas of unity in both the country and the city. As the Soviet Union promoted communism and a state-controlled economy, the Western Allies introduced free market economics, leading to fiscal instability and political strife across all four sectors. Matters came to a head when currency reform was enacted in the western sphere with the introduction of the Deutsche Mark. Designed to stabilise the Germany economy, the move infuriated Moscow, who viewed it as the first step in a Western attempt to establish control over all occupied Germany. In response, Stalin ordered all land and water routes into West Berlin closed in June 1948, hoping to starve the Western sectors and force the Allies to abandon the city. The Western Allies, led by the United States and Britain, responded with the Berlin Airlift.

Rather than retreating from Berlin or engaging in military confrontation with the Soviets, the Western Allies decided to supply the city by air. The idea was initially seen as improbable, as it required flying in enough supplies to feed and fuel a large urban population for an indefinite period. However, the US military governor in Germany, General Lucius D. Clay, and British counterparts believed

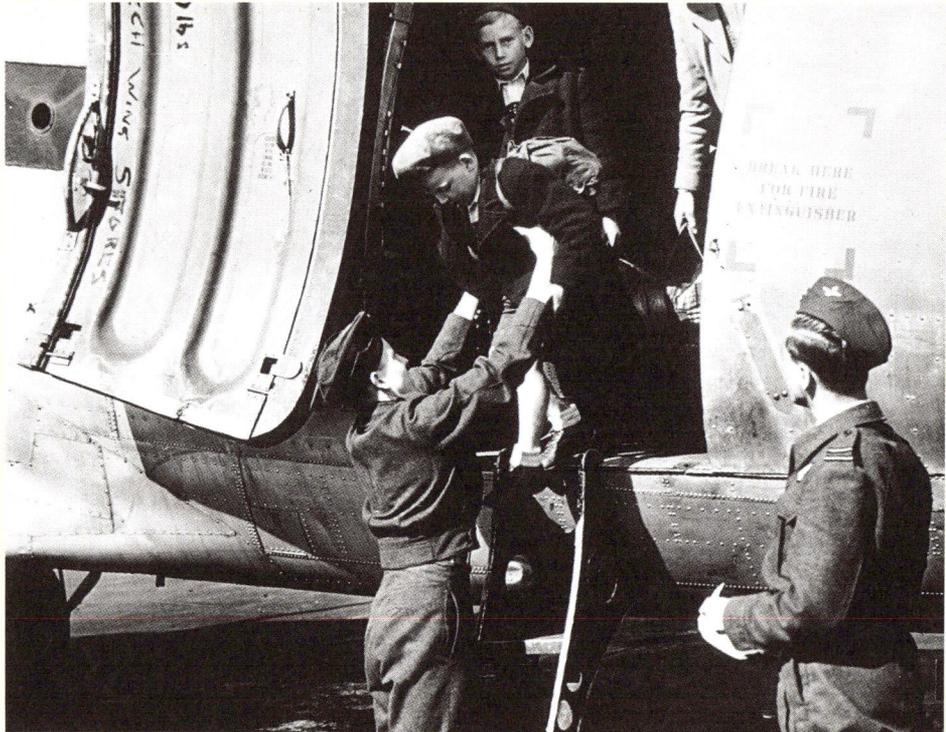

The Royal Air Force evacuates sick children from Berlin, 1948

that it was possible. The US Air Force and the Royal Air Force quickly mobilised their resources and on 26 June 1948, the airlift began. Aircraft, primarily American C-47 Skytrains and British Avro Yorks, started making regular flights into Berlin. At first, the operation struggled to meet the necessary supply levels, but over time it became increasingly efficient. At its peak, an aircraft landed in Berlin every 30 seconds, delivering essentials such as food, coal, and medicine.

The Americans referred to the airlift as 'Operation Vittles', while the British named their part 'Operation Plainfare'. The success of the airlift was a testament to the logistical skill of the Allies. They supplied more than 4,000 tons of goods per day, eventually reaching a daily peak of 12,000 tons. The airlift involved thousands of flights and was conducted under extremely challenging conditions, including

harsh winter weather and Soviet harassment, such as buzzing aircraft with Soviet fighters. One of the airlift's symbolic moments was the efforts of US pilot Gail Halvorsen, who became known as the 'Candy Bomber' for dropping sweets to Berlin's children. His gesture humanised the airlift and boosted morale in the beleaguered city.

The Soviet blockade failed to achieve its objective. The Western Allies demonstrated that they could sustain Berlin indefinitely via air and on 12 May 1949, Stalin lifted the blockade. The airlift continued until September 1949 to build up reserves in the city in case of future blockades.

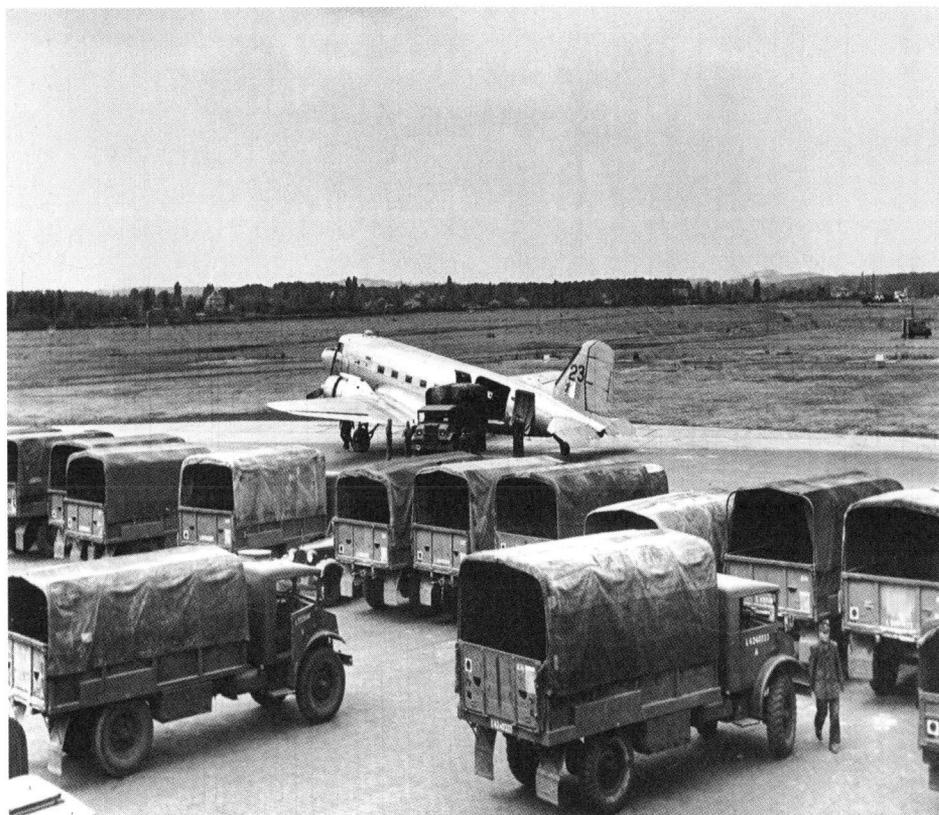

An RAF Dakota being unloaded at Tempelhof airfield as
army lorries stand by to take supplies into Berlin.

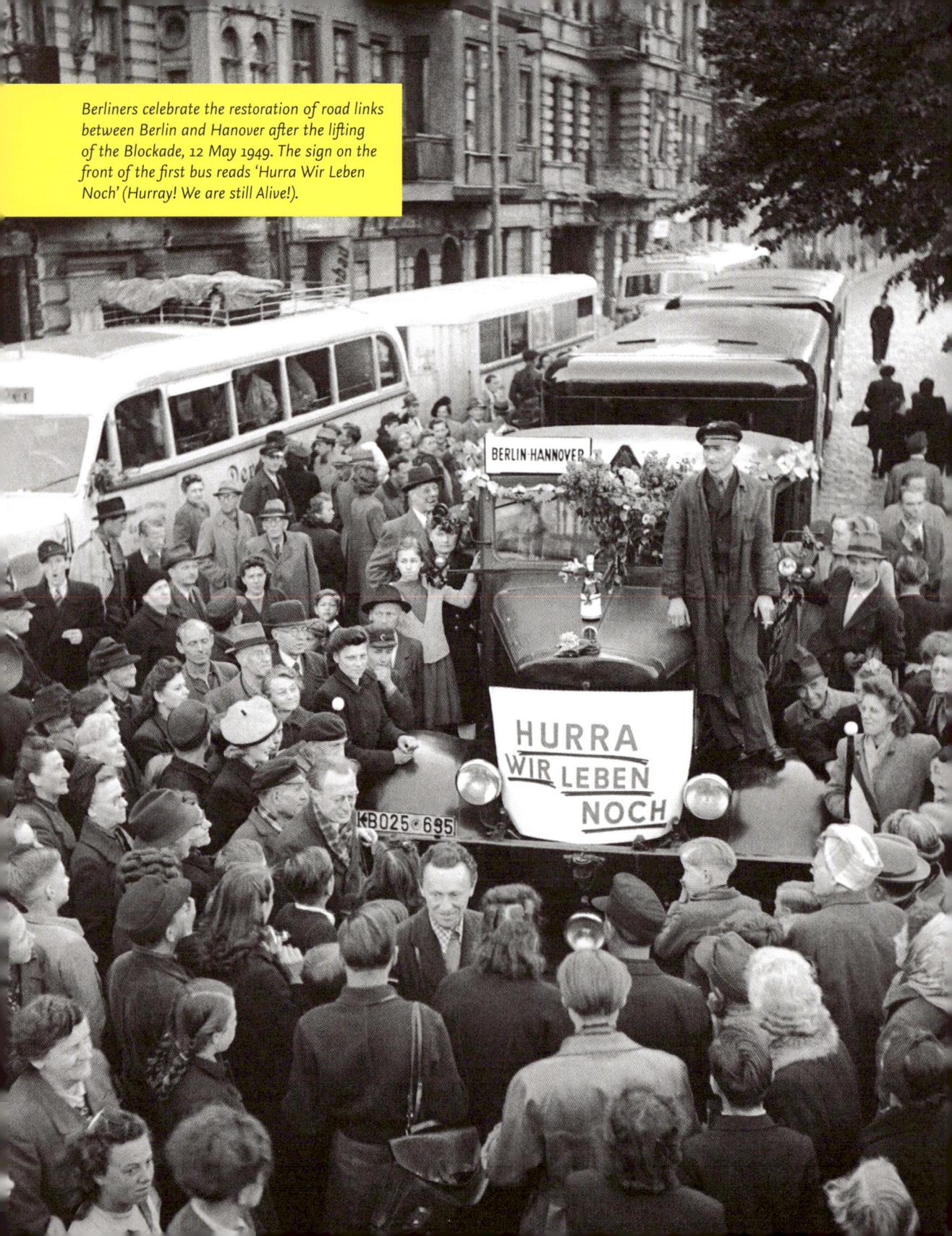

Berliners celebrate the restoration of road links between Berlin and Hanover after the lifting of the Blockade, 12 May 1949. The sign on the front of the first bus reads 'Hurra Wir Leben Noch' (Hurray! We are still Alive!).

The Berlin Airlift was one of the first major confrontations of the Cold War, and it highlighted the ideological divide between the Soviet Union and the Western Allies. This successful cooperation between the United States and Britain was evidence of the Special Relationship in action. Yet it belied a more complex shift in the post-war dynamic between the two powers, one complicated by a concurrent movement towards greater cooperation between the independent European states.

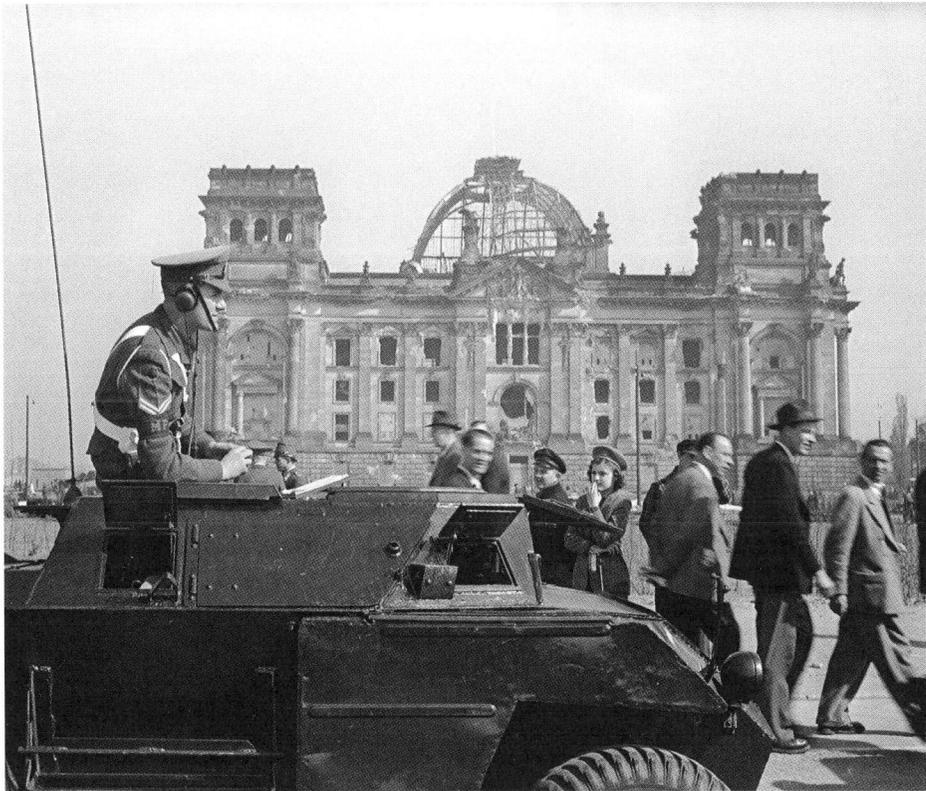

From his armoured car in front of the ruins of the Reichstag,
a military policeman of 247 (Berlin) Provost Company,
2 Regiment, Corps of Royal Military Police monitors
pedestrians in the British sector of Berlin on May Day 1950.

Greater European integration was not a new idea in the 1940s. Serious debates around the proposal of a European federation emerged in the nineteenth century, and had been discussed as early as the 1600s. The idea of a united Europe took on greater significance in the aftermath of the First World War, before the Great Depression and the rise of totalitarian, nationalistic politics laid waste to the prospect. The vision of a codified transnational European structure re-emerged from the ashes of the Second World War, ranging from a federated European superstate to less revolutionary formal alliances and shared institutions.

Winston Churchill leaned towards the more radical stance. Despite his pro-American rhetoric, Churchill – and by extension Britain – had to navigate a fine balance between the New World and the Old. He championed both European integration and the Anglo-American alliance, famously calling for a 'United States of Europe' in 1946, just months after his Iron Curtain speech praised the Special Relationship. This dual allegiance underscored his attempt at a triangulated foreign policy, positioning Britain and its empire between Europe and the US. However, Churchill was no longer in power, and his outlook diverged from mainstream British politics.

His successor, Clement Attlee, was more sceptical of Europe. Although often the target of Churchill's sharp wit, Attlee shared many fundamental beliefs with him: both were monarchists, had a paternalistic view of the British Empire, and were deeply patriotic. They also agreed that the US was Britain's key post-war partner. Attlee, though, summed up his European scepticism in his final speech, reflecting on the European Common Market: 'Know them all well. Very recently this country spent a great deal of blood and treasure rescuing four of them from attacks by the other two.'

While Churchill coined the term, Attlee pursued the Special Relationship just as vigorously. Attlee's personal aversion to European politics wasn't the only reason. The prime driver was the very real threat of economic ruin. The war had ravaged Britain's finances, as it had in most of Europe. In 1945, the United States ended the Lend-Lease deal that had helped sustain Britain through the war. With no

exports to speak of due to the destruction of conflict, and an economy geared towards war production, Britain was in danger of starvation. Attlee dispatched the economist John Maynard Keynes to negotiate a bailout. Keynes secured a loan that, while advantageous against market rates, was significantly less favourable than many in Britain were expecting.

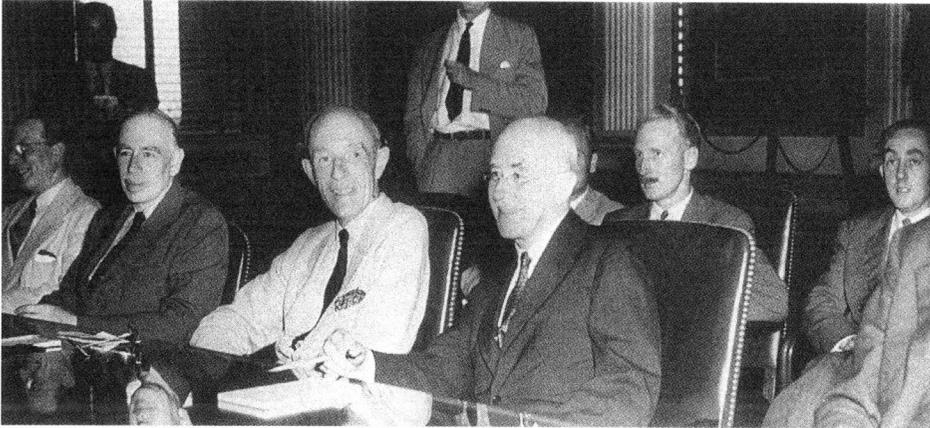

John Maynard Keynes led the British delegation at the Anglo-American Economic Conference in September of 1945. He succeeded in obtaining preferential terms from the United States to help rebuild Britain's economy.

Despite this perceived setback, Attlee was savvy enough to keep in good graces with the Americans, soothing American ire over the UK's decision to sell to the USSR 25 Rolls-Royce Nene jet engines. Ostensibly for commercial use only, these were reverse engineered and used to power the Soviet MiG-15 fighter plane, an aircraft that UK and US forces would be forced to confront during the Cold War. Attlee kept relations with the Americans positive enough, in that he was able to navigate British cooperation with the signing of the North Atlantic Treaty, the subsequent entry into NATO, and the acceptance of further American economic aid via the Marshall Plan. Both NATO and the Marshall Plan helped bind Western Europe together in the face of the Soviet threat, but they also helped underline the British reliance on the Special Relationship.

THE MARSHALL PLAN
1947-52

At the end of the Second World War, European cities lay in rubble, industries were paralysed, and millions faced poverty and hunger. The political landscape was volatile, with fears that economic instability might fuel the spread of communism. In June 1947, US Secretary of State George C. Marshall proposed a plan to provide large-scale financial aid to European economies, to foster political stability against growing Soviet influence. The offer of assistance was extended to all European nations, including those within the Eastern Bloc, though under pressure from Moscow the latter ultimately declined to participate.

The United States provided approximately $13 billion (equivalent to over $150 billion today) in grants and loans to 16 countries. These funds were used to rebuild infrastructure, modernise industry and stabilise currencies. Recipients included the major powers as well as smaller nations such as the Netherlands and Greece, each tailoring their economic strategies to local needs.

Beyond financial assistance, the Marshall Plan promoted collaboration and economic integration among European nations, laying the groundwork for the European Economic Community. By the early 1950s, Western Europe's economies had recovered to pre-war levels, with industrial production increasing by over 40 per cent. In West Germany this laid the foundations for its post-war 'economic miracle'. Politically, the Marshall Plan helped to counter the appeal of communist parties, particularly in France and Italy, whilst economically, it provided stable, friendly trading partners for the United States.

From a British perspective, the Marshall Plan was both a lifeline and a turning point. Britain received more aid than any other nation, at a time when the empire was in decline. Its growing reliance on American support symbolised the shift in global power from London to Washington. The plan also marked a shift in US foreign policy from isolationism to active engagement in international affairs. American industries benefited significantly, as much of the aid was spent on US goods and services, reinforcing transatlantic economic ties.

The key to the importance of the Special Relationship in the early years of the Cold War was the issue that dominated international relations for the latter half of the twentieth century. It was also the issue that would most stringently test the strength of the relationship, as well as indicate how one-sided it could be. The atomic bomb, and the even more deadly hydrogen bomb, cast a dark shadow over the Cold War era. These weapons defined the very essence of the conflict, and they impacted every facet of society, politics, economics, and culture. Nuclear weapons are often thought of as an American invention, dreamt up by scientists in the New Mexico desert under the watchful gaze of uniformed generals and shady government operatives. And while it is true that it was the Manhattan Project under the guidance of J. Robert Oppenheimer that completed and delivered the world's first atomic weapons, Britain had an essential role in the early stages of development.

Hiroshima, following the dropping of the atomic bomb on 6 August 1945.
The domed building in the foreground was the Industry Promotional Hall,
which has been preserved in its ruined state as a peace memorial.

Indeed, the very term 'atomic bomb' was coined by the British science-fiction author, H. G. Wells, who used it in his 1914 novel, *The World Set Free*. Long before this, John Dalton first explained his ideas on atomic theory in Manchester in 1804, while the New Zealand-born physicist Ernest Rutherford conducted groundbreaking research into the nature of the atom while working at British universities in the early part of the twentieth century. In Germany, much progress was being achieved by Jewish scientists, but the rising tide of Nazi antisemitism drove many to Britain, where their knowledge enhanced and emboldened the growing idea that the basic building blocks of the universe could be harnessed in hitherto unfathomable ways.

British and refugee scientists including James Chadwick, Joseph Rotblat, George Paget Thomson, and William Lawrence Bragg all furthered the research effort, but at this point the chances of successfully developing an atomic bomb were estimated to be 100,000 to 1. In 1940, two German refugee scientists in Britain, Otto Frisch and Rudolf Peierls, produced a memorandum that outlined the theoretical possibility of building an atomic bomb using uranium-235. The Frisch-Peierls Memorandum gained government attention and led to the establishment of the MAUD Committee in April 1940, tasked with investigating the feasibility of developing an atomic bomb. The committee and its work were top secret, and only British-born scientists were permitted to participate, with even Frisch and Peierls excluded on the grounds of security concerns. Its final report, submitted in 1941, concluded that not only was the development of an atomic bomb possible, but it was also essential for Britain's war effort. The MAUD Report laid the foundation for Britain's early nuclear weapons programme, codenamed 'Tube Alloys'.

Tube Alloys predated the Manhattan Project and was the world's first functional nuclear weapons programme. However, Britain simply lacked the economic resources and industrial capacity to independently develop an atomic bomb during the war. Under the rationale that Britain's pioneering work was quickly becoming an obsolete asset, Churchill initiated secret negotiations with the United States in 1943, leading to the signing of the Quebec Agreement. Under this agreement, Britain and the United States agreed to collaborate on the

development of atomic weapons, sharing research and technology. Britain's role in the Manhattan Project remained significant. British intervention brought the great Danish physicist Niels Bohr onto the project, smuggling him out of Sweden to Scotland on a de Havilland Mosquito aircraft. Other British and British-resident contributors included Frisch and Peierls, James Chadwick, William Penney, and Klaus Fuchs. Leslie Groves, the US leader of the Manhattan Project, claimed that the United States would have succeeded in developing the bomb alone, but in his memoir of the project he admitted that without British help, there would have been no atomic bomb by August of 1945.

Despite British contributions to the Manhattan Project, the post-war period saw a shift in Anglo-American relations concerning nuclear cooperation. In 1946, the United States Congress passed the Atomic Energy Act, also known as the McMahon Act, which restricted the sharing of nuclear technology and information, even with close allies like Britain. This act effectively froze Britain out of the atomic club, leaving it to develop an independent nuclear weapons programme if it wished to remain a global power. Faced with the prospect of losing its position in world

Artistic representation of the dropping of the 'Fat Man' bomb on Nagasaki, by British mixed-media artist, Graham Ashton.

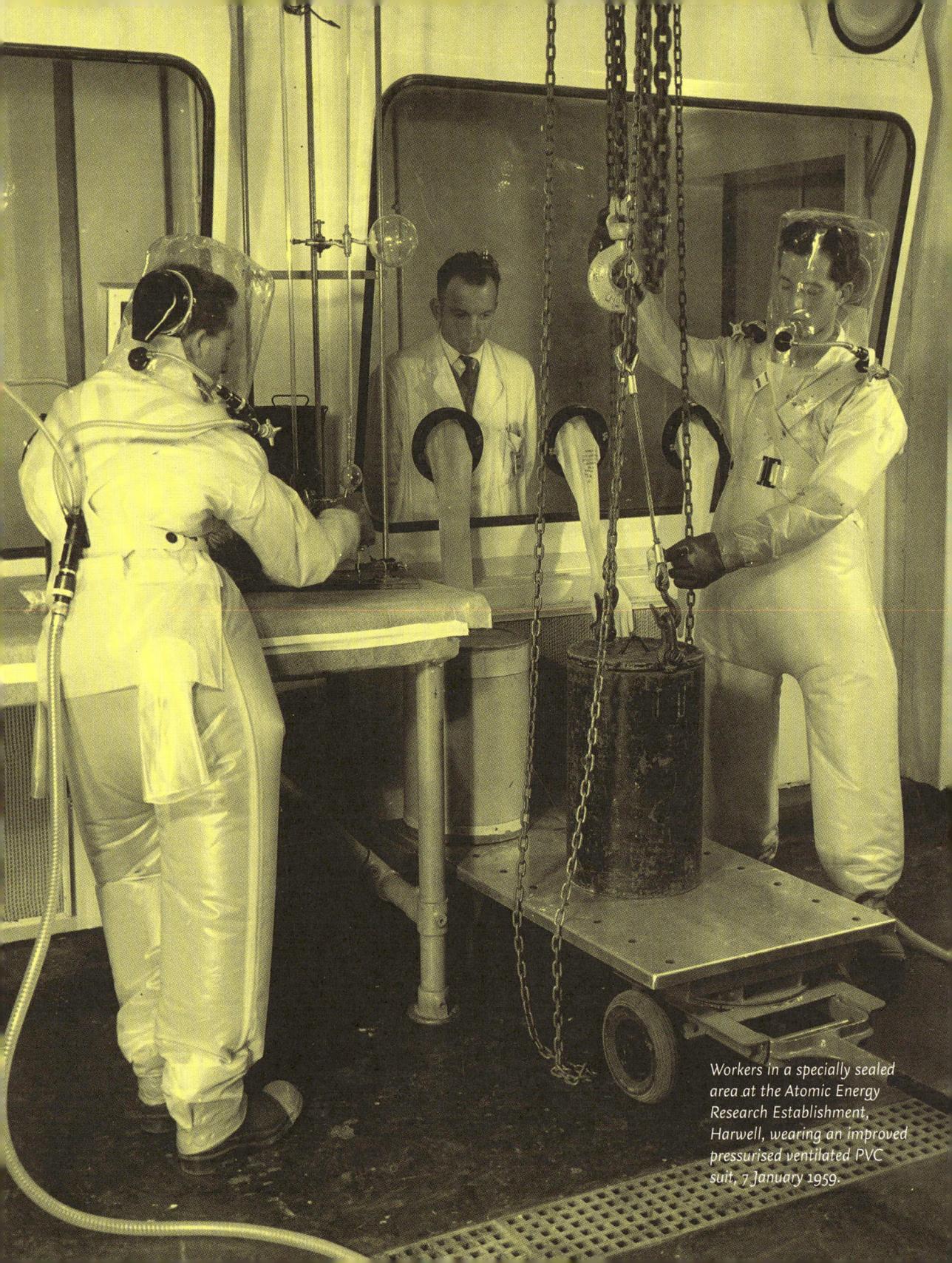

Workers in a specially sealed area at the Atomic Energy Research Establishment, Harwell, wearing an improved pressurised ventilated PVC suit, 7 January 1959.

THE MANHATTAN PROJECT
1939-45

In 1939, scientists including Albert Einstein and Leó Szilárd warned the United States of Nazi Germany's progress in nuclear research. This prompted the US government to launch a secret initiative to harness the power of atomic energy for warfare. By 1942, under the leadership of American physicist J. Robert Oppenheimer and military commander General Leslie Groves, the Manhattan Project was fully underway.

The scale of the project was extraordinary, involving over 130,000 personnel across multiple sites in the United States, including Los Alamos in New Mexico, Oak Ridge in Tennessee, and Hanford in Washington state. British and Canadian scientists also contributed, and in 1943 their efforts were formally merged under the Quebec Agreement.

Theoretical physics gave way to practical engineering as researchers developed methods to produce the fissile materials necessary for a nuclear chain reaction. By mid-1945, the team had succeeded in creating two distinct bomb designs: 'Little Boy', which used uranium, and 'Fat Man', which employed plutonium. The first successful test, codenamed 'Trinity', took place on 16 July 1945 in the desert of New Mexico. The detonation, equivalent to 20 kilotons of TNT, marked the culmination of years of intense effort, but also the beginning of profound moral dilemmas.

Although the project was initially motivated by the threat of Nazi Germany, by the time of the Trinity test, the European war had ended. Instead, in August 1945, the two bombs were dropped on the Japanese cities of Hiroshima and Nagasaki, resulting in unprecedented destruction and the deaths of over 200,000 people. These events directly precipitated Japan's surrender and the end of the Second World War, but they also ushered in a new and precarious era of geopolitics.

The programme ultimately cemented the United States' dominance in nuclear technology, sidelining its wartime allies. In the years that followed, the secrecy surrounding atomic weapons deepened tensions between erstwhile partners, sowing seeds of mistrust that would flourish during the Cold War.

affairs and vulnerable to Soviet nuclear advancements, the Attlee government resolved to pursue an independent nuclear deterrent. In 1946, Britain established the Atomic Energy Research Establishment (AERE) at Harwell, which became the centre of its nuclear research efforts. The British government justified its pursuit of nuclear weapons on several grounds: ensuring national security, maintaining its global influence, and securing a seat at the table with the United States and the Soviet Union. After a particularly bruising debate on nuclear cooperation with his transatlantic counterpart, British Foreign Secretary Ernest Bevin told the cabinet in no uncertain terms that, 'We've got to have this thing over here whatever it costs, and we've got to have the bloody Union Jack on top of it.' This became especially pressing once the Soviet Union successfully tested their own atomic bomb in 1949. The Attlee government was decidedly anti-Soviet Union. The Prime Minister himself was more open to the idea of a cordial relationship with the USSR, warning that treating the Soviets as an enemy would simply turn them into one, but Bevin, a hardline anti-communist from his Trade Union days, dominated the cabinet and soon turned Attlee to his cause.

The British atomic bomb project, codenamed 'High Explosive Research', was launched in 1947 under the direction of William Penney. Despite limited resources, Britain made rapid progress in developing the technology required for an atomic bomb. On 3 October 1952, the culmination of these efforts was realised when Britain successfully tested its first atomic bomb, codenamed 'Hurricane', off the coast of the Montebello Islands in Australia. This test, the detonation of a 25-kiloton bomb on board the frigate HMS *Plym*, took place at 9.30 a.m. local time, 400 metres off the coast of the island of Trimouille. The island remained prohibited to visitors until 1992, thanks to the presence of radiated fragments of HMS *Plym*. This successful test made Britain the third country in the world to possess nuclear weapons, following the United States and the Soviet Union.

Britain's pursuit of an independent nuclear deterrent during the 1950s was driven by the desire for strategic autonomy, but it also came at great financial cost. In twenty-first-century Britain, the Attlee ministry has been mythologised and somewhat rose-tinted, in large part due to its creation of the National Health

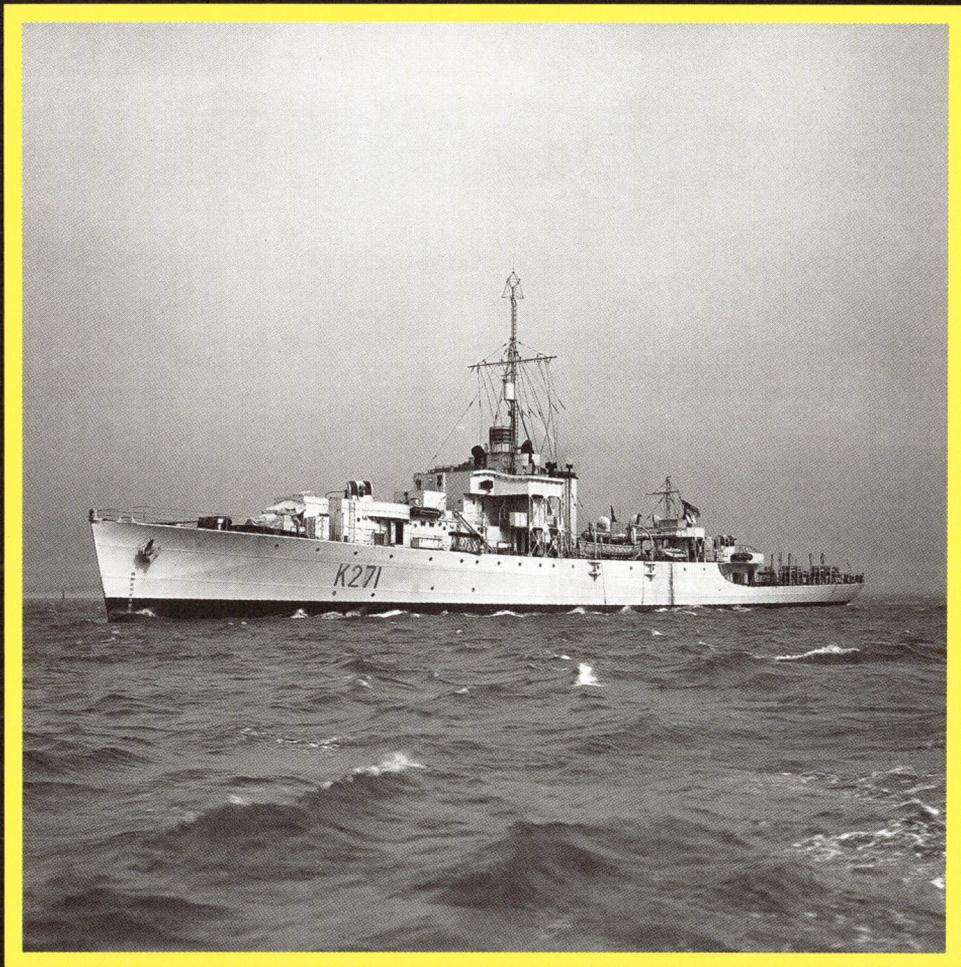

HMS Plym (K271) was a River-class frigate that served in the Royal Navy from 1943 to 1952. The ship was vapourised during the United Kingdom's first nuclear weapons test, Operation Hurricane, in 1952.

Service and its enduring place in the hearts and minds of the British people. It is important to remember, then, that the government was prepared to balance the social reforms for which it is rightly remembered with a bellicose approach to national defence that seems more befitting of Attlee's predecessor. Operation Hurricane cost an estimated £100 million in 1952, roughly £4 billion today. As a result, the Labour government was forced to compromise some of its ideals, for example introducing prescription charges for dental care and spectacles, laying the groundwork for a generation of interparty conflict.

THE NEW

NATIONAL

HEALTH

SERVICE

*

Your new National Health Service begins on 5th July. What is it? How do you get it?

It will provide you with all medical, dental, and nursing care. Everyone—rich or poor, man, woman or child—can use it or any part of it. There are no charges, except for a few special items. There are no insurance qualifications. But it is not a "charity". You are all paying for it, mainly as taxpayers, and it will relieve your money worries in time of illness.

Introduced by the Attlee government in 1945, the National Health Service maintains an important role in British public life, and the national psyche.

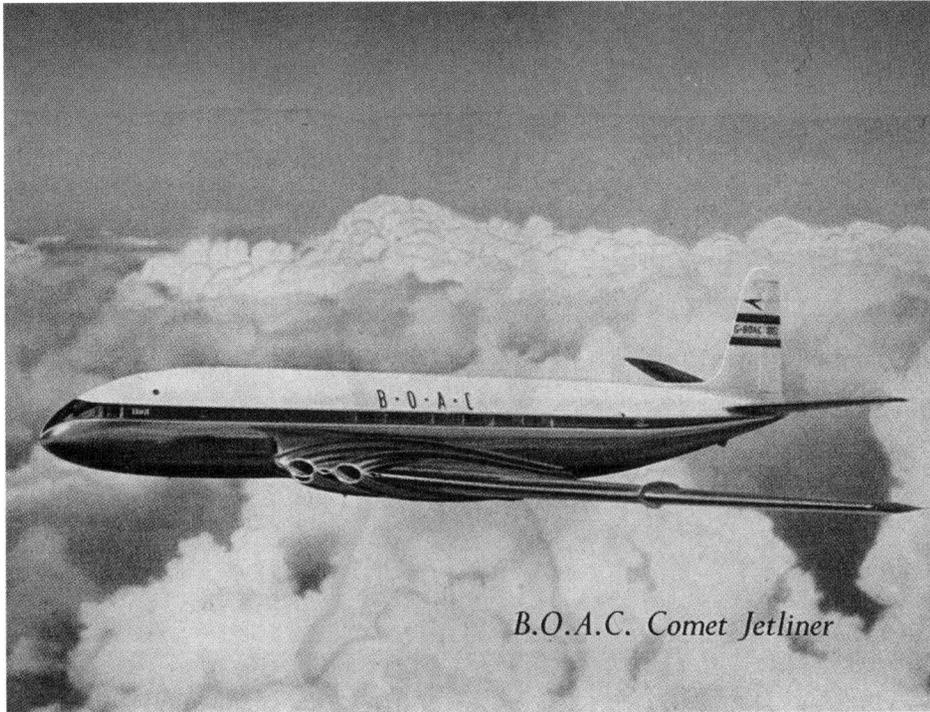

The world's first commercial jet airliner, the de Havilland Comet briefly promised to position Britain at the vanguard of the jet age.

Expensive atomic weapons needed expensive new technologies to deliver them. The Second World War had seen British aviation achieve some remarkable feats of derring-do and the Supermarine Spitfire, powered by the Rolls-Royce Merlin engine, was the most heralded fighter of the war. The Spitfire remained in service until the 1950s, but technology had surpassed the piston engine. This was now the jet age. Proposed and developed in Britain by Sir Frank Whittle, the turbojet engine was faster, more dynamic, and perfect for the post-war world. For a time in the 1940s and 1950s, Britain led the way in the field, designing and producing the most advanced aircraft the world had seen. In civilian aviation, the de Havilland Comet was the world's first commercial jet airliner, pointing the way to the future.

The English Electric Lightning served as an interceptor fighter aircraft across three decades of the Cold War.

In military aviation terms, the future looked even brighter for Britain. The Gloster Javelin and English Electric Lightning were the fighter aircraft that could capture the imagination of a new generation of enthusiasts and Airfix modellers, just as the Spitfire and Hurricane had. Innovative, supersonic aircraft such as the Fairey Delta 2 promised new achievements that seemed drawn more from the science fiction of Wells than from the last war. These advancements in Cold War aeronautics came despite an inauspicious start. During the early 1950s, the UK relied heavily on the Gloster Meteor, a late Second World War aircraft. Two such squadrons were based at RAF Duxford. However, the Meteor was inadequate for intercepting Soviet bombers, far less stopping them, leaving Britain's aerial deterrent more of a bluff than a reality. It wasn't until the introduction of the NF.14 Meteor, and its eventual replacement by the Javelin and the Hawker Hunter for all-weather and daytime interception respectively, that Britain developed a credible defence capability.

More than any other aeronautical achievement, however, it was the development of Britain's V-bombers that truly established Britain as a Cold War player. The need for a strategic bomber fleet arose as Britain sought to maintain its position as a major military power and adapt to the new reality of nuclear warfare. In 1946, the British government issued a specification for a new class of aircraft capable of carrying nuclear bombs over long distances. The design had to accommodate both conventional and nuclear payloads and be capable of reaching targets within the Soviet Union. Several manufacturers submitted proposals, and the result was the development of three distinctive bombers: the Valiant, Vulcan, and Victor, which came to be known collectively as the V-bombers.

The Vickers Valiant was the first of the V-bombers to enter service, in 1955. As a relatively straightforward and conventional aircraft, it was the most conservative of the three designs. The Valiant was a solid, dependable platform, capable of carrying the early British nuclear bombs, such as Blue Danube. It was also used for conventional bombing missions and played a key role in Britain's nuclear testing programme. The Valiant's operational life was cut short, however, due to structural fatigue issues and it was retired in 1965. The Handley Page Victor was the last of the V-bombers to enter service, in 1957. Its crescent-shaped wings gave

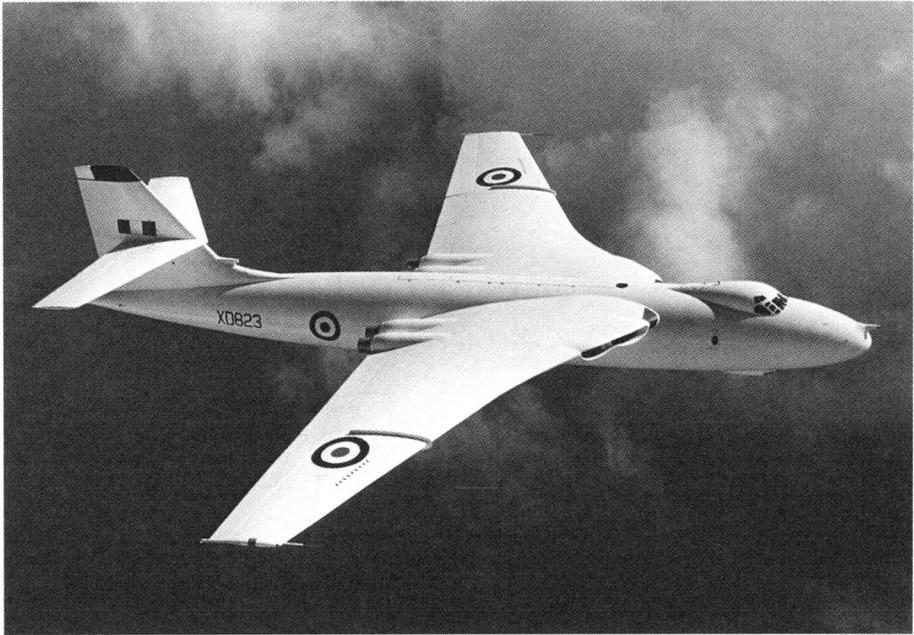

*A Vickers Valiant Mk 1 bomber painted in anti-flash white.
From above, its relatively conventional design is obvious.*

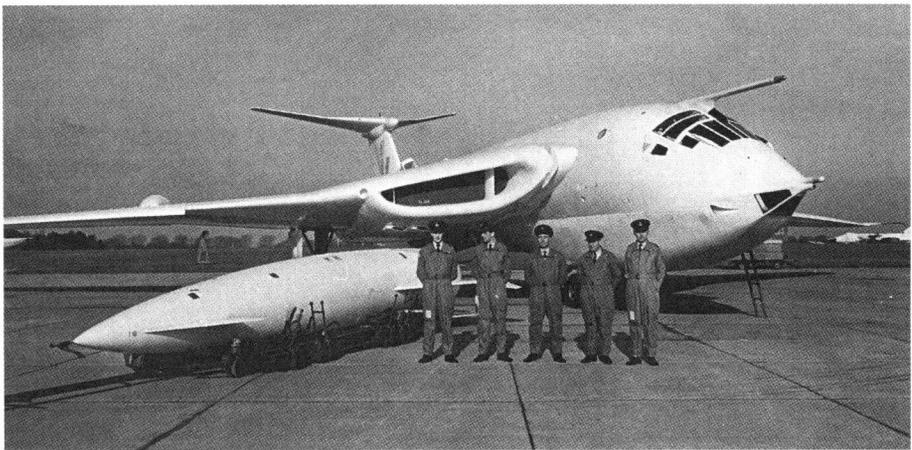

*A Handley Page Victor bomber and crew, pictured
with Blue Steel missile on a 1964 press tour.*

it a unique appearance and allowed for greater range and fuel efficiency. Like the Vulcan, the Victor was designed for high-altitude nuclear strikes but was later adapted for low-level missions. The Victor, however, had a longer operational life than its counterparts, remaining in service as a refuelling tanker until 1993, long after its role as a nuclear bomber had ended.

The Avro Vulcan is perhaps the most iconic of the V-bombers, with its distinctive delta wing design and futuristic appearance. Entering service in 1956, the Vulcan was a technological leap forward, offering superior speed, range, and altitude compared to the Valiant. The aircraft was designed to penetrate Soviet air defences by flying at high altitudes, although it was later modified for low-altitude

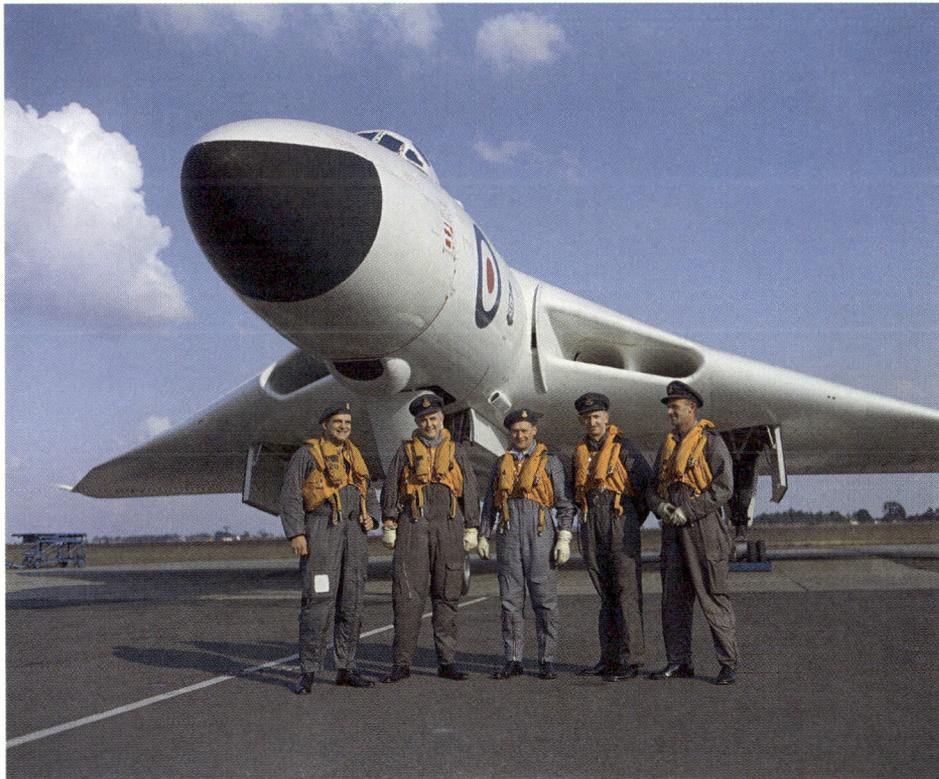

The crew of an Avro Vulcan B.1 bomber pose in front of their aircraft, here painted in anti-flash white.

Playing cards depicting the Avro Vulcan. For many, the Vulcan captured the imagination with its futuristic design, seemingly placing Britain at the forefront of modernity.

missions to evade surface-to-air missiles as air defence systems evolved. The Vulcan remained in service as a nuclear bomber until 1969, though it continued to serve in other roles, including in the Falklands Conflict, where it conducted conventional bombing raids. Its legacy was further secured thanks to its Rolls-Royce Olympus engines, later versions of which would go on to power the iconic supersonic airliner, Concorde. Together, The V-bombers formed the core of Britain's nuclear deterrent force during the 1950s and early 1960s. In the event of a Soviet attack, these aircraft were expected to deliver retaliatory nuclear strikes, thus ensuring the principle of mutually assured destruction, better known by the ironic acronym, MAD. The bomb bays on all three aircraft were designed to carry a free-fall bomb, Blue Danube, the first UK-built nuclear deterrent. A Vickers Valiant painted in anti-flash white, which was thought to protect the aircraft and its crew from thermal radiation, successfully released the weapon in a test on 11 October 1956, becoming the first RAF aircraft to drop an atomic bomb.

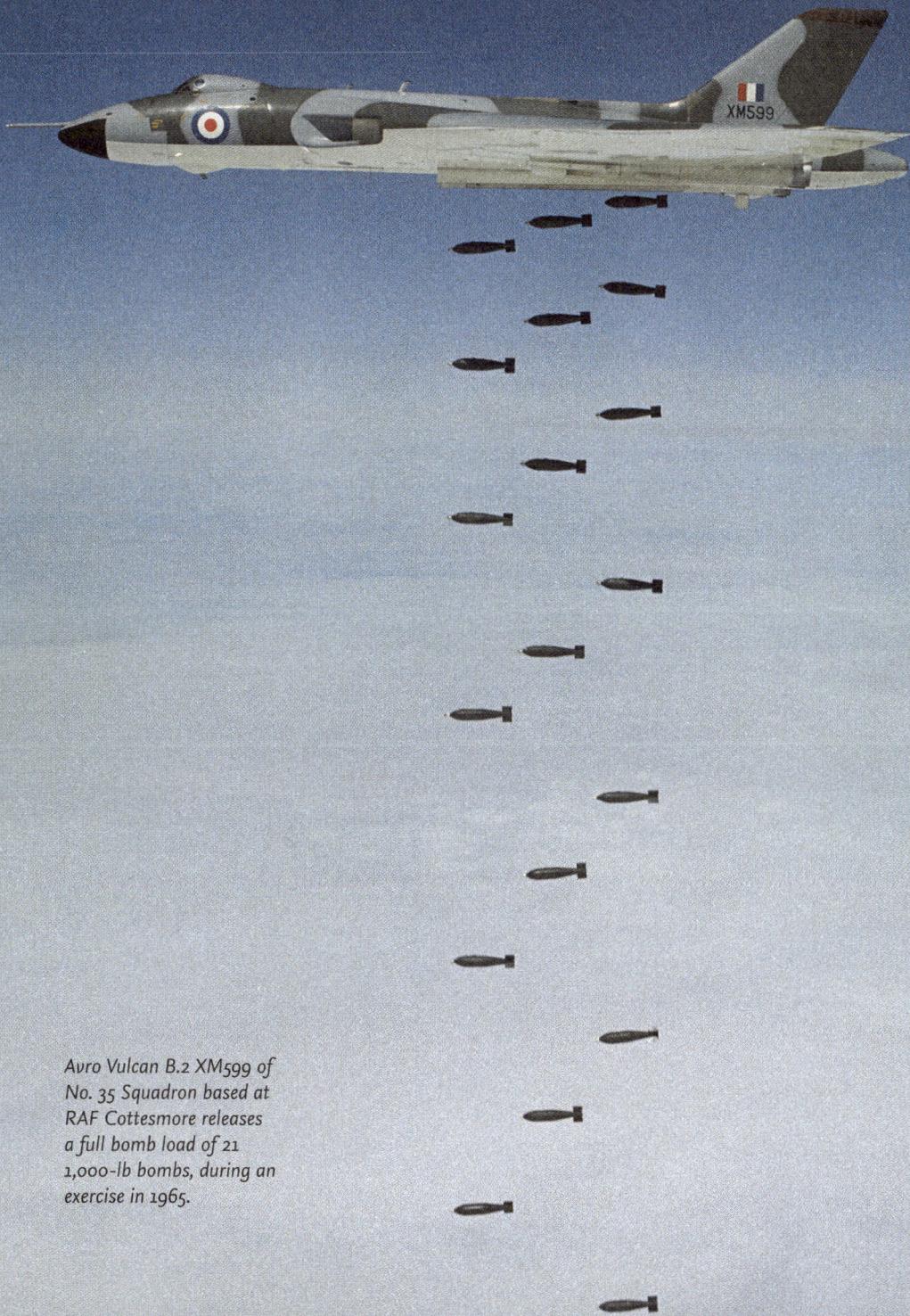

*Avro Vulcan B.2 XM599 of
No. 35 Squadron based at
RAF Cottesmore releases
a full bomb load of 21
1,000-lb bombs, during an
exercise in 1965.*

Although an Anglo-French project, Concorde was seen as a triumph of British innovation thanks to ultra-modern design and supersonic speed.

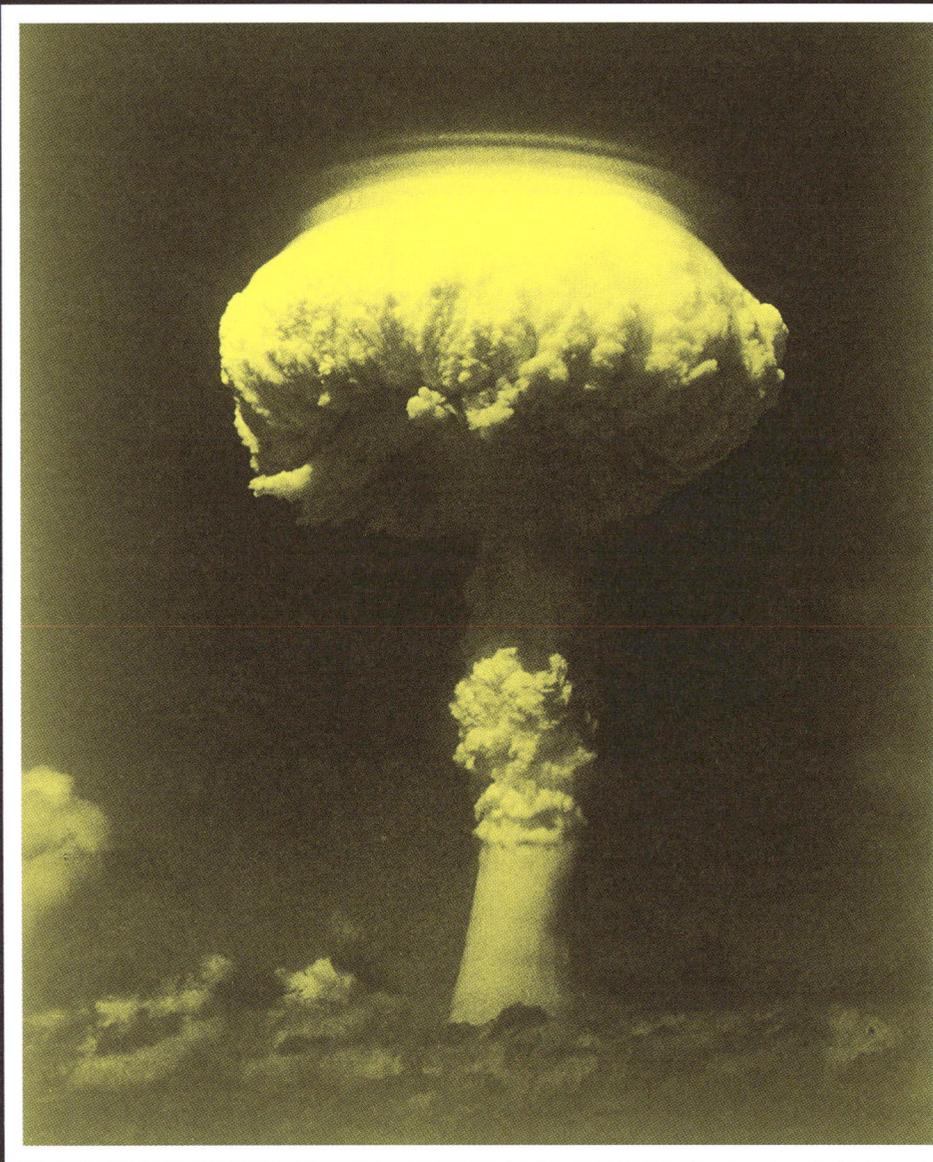

The mushroom cloud generated during Britain's first hydrogen bomb test on 15 May 1957. The weapon was dropped high over Malden Island in the Central Pacific by Vickers Valiant B(K).1 XD818 of No. 49 Squadron RAF, piloted by Wing Commander Kenneth Hubbard.

While the successful detonation of an atomic bomb marked a significant achievement for Britain, the international landscape was already shifting towards the development of even more powerful nuclear weapons. In 1952, the United States tested the first hydrogen or thermonuclear bomb, a 10.4 megaton weapon 1,000 times more destructive than the atomic bombs dropped on Hiroshima and Nagasaki. The Soviet Union followed suit in 1953 with its own hydrogen bomb test, creating a new arms race between the superpowers.

Faced with the prospect of being left behind once again, the British government, with Winston Churchill back at the helm, made the decision to pursue a hydrogen bomb programme. The decision to develop thermonuclear weapons was highly controversial, both within the government and among the British public. Critics argued that Britain's resources would be better spent on conventional defence, while others feared that the development of hydrogen bombs would only escalate the arms race and increase the risk of nuclear war.

Nonetheless, the programme moved forward, and in 1957, Britain successfully tested its first thermonuclear device during 'Operation Grapple', over Christmas Island in the Pacific Ocean. Although a moment of national pride for many, the destructive potential of the 'H-bomb' captivated the public's imagination in darker ways, fostering an existential dread which quickly filtered into popular culture. British sci-fi and horror films of this period frequently channelled fears of nuclear annihilation, contamination, and societal collapse. Films such as *The Quatermass Xperiment* (1955) and *X the Unknown* (1956) tapped into the fear of radiation and mutation – a recurrent theme in nuclear-age horror. These films explored alien and monstrous forces unleashed or mutated by nuclear radiation, symbolising humanity's deep-seated fears about uncontrollable scientific advancements and the hubris of tampering with forces beyond understanding. This cycle culminated with *The Day the Earth Caught Fire* (1961), which portrayed a world thrown into chaos by a human-made environmental disaster, implicitly tied to the nuclear arms race and its consequences.

Released in 1956 by Hammer Film Productions, X the Unknown is one of many science-fiction films of the period to allegorise Cold War nuclear anxieties.

The Day the Earth Caught Fire (1961) – this apocalyptic science-fiction film was more grounded than many other examples of the cycle.

In reality, the Grapple tests revealed that Britain's early thermonuclear designs were less efficient than those developed by the United States and the Soviet Union. This prompted further testing and refinement of Britain's nuclear arsenal. The development and testing of nuclear weapons placed a significant burden on the British economy, and maintaining an independent nuclear programme strained Britain's defence budget. The push for the H-bomb doubled the cost of Britain's nuclear research, despite research overlapping with the initial atomic bomb project. As a result, by the late 1950s, the British government began to seek renewed nuclear cooperation with the United States.

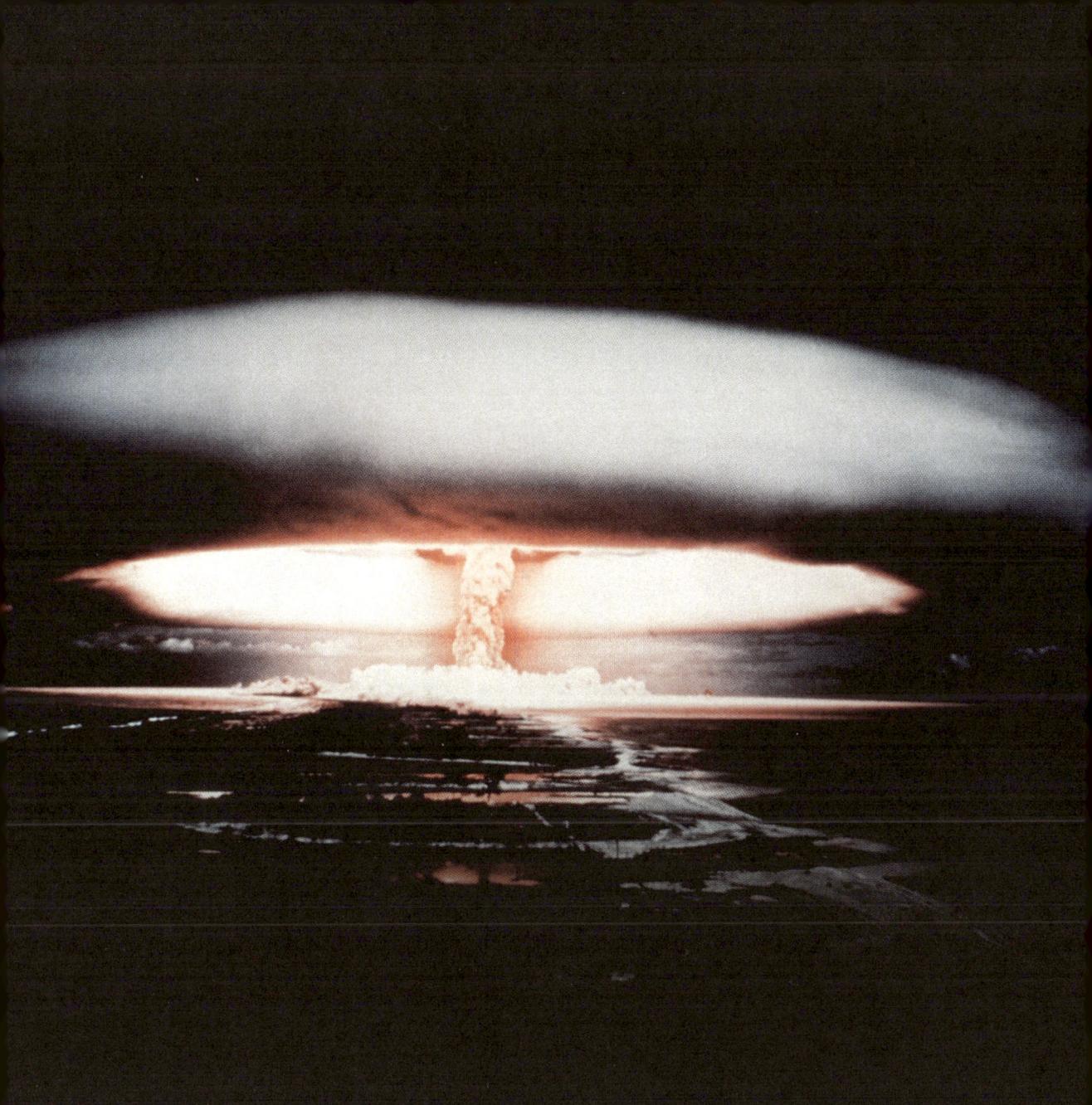

A large mushroom cloud from a British nuclear weapon test near
Christmas Island (Kiritimati) in the Central Pacific, in the late 1950s.

In 1958, following extensive diplomatic negotiations, the United States and Britain signed the Mutual Defence Agreement, which restored nuclear cooperation between the two countries. The agreement allowed Britain to access American nuclear technology and materials, including designs for more advanced thermonuclear weapons. This marked a significant shift in Britain's nuclear strategy, as it became increasingly reliant on American support to maintain and modernise its nuclear arsenal. Part of this modernisation was an upgrade to British weaponry. The V-bomber nuclear deterrent was by now hopelessly out of date. Originally designed to carry free-fall gravity bombs, like Blue Danube, the aircraft

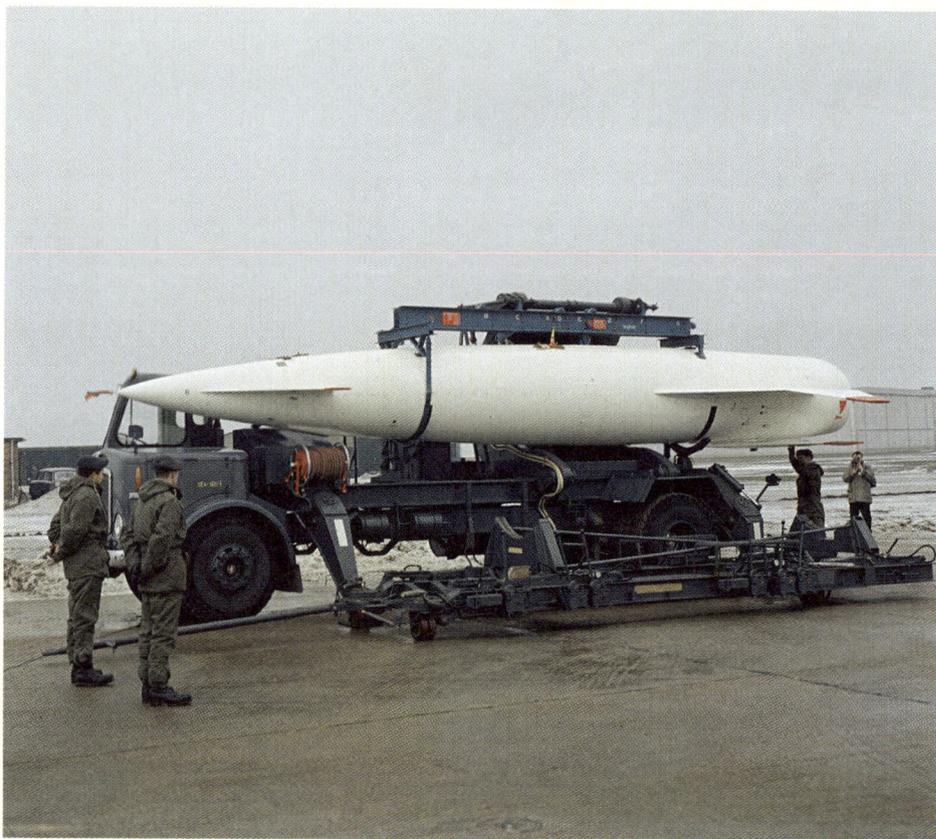

An Avro Blue Steel stand-off nuclear bomb is lowered from its conveyor vehicle onto an awaiting 'dolly' for transfer to an Avro Vulcan B.2A. Taken at RAF Scampton, Lincolnshire, home of No. 617 Squadron.

were hastily refitted to carry a cruise missile, Blue Steel, that was necessary to evade improving radar technology and advances in missile technology defences, such as surface-to-air missiles (SAMs).

Britain also attempted to develop its own intermediate-range ballistic missile (IRBM) named Blue Streak. This was a project beset by delays, political in-fighting, and spiralling costs. The estimated price tag for the system was £50 million in 1955; by 1959 this had ballooned to £300 million, with conservative estimates for completion at twice that. The technology was also becoming outdated with every passing year, and ultimately the project was cancelled. Concurrently, plans were afoot to develop Blue Steel II, an upgrade to the cruise missile weapons deployed by the Vulcan and Victor. To save both face and exorbitantly rising costs, Britain turned to its American ally, agreeing to purchase its in-development Douglas GAM-87 Skybolt system, a hypersonic air-launched ballistic missile (ALBM). The Americans were not immune to the problems of cost overruns, political pressures, and uncooperative technology, however, and Skybolt was cancelled by President John F. Kennedy in December of 1962.

This created the very real possibility that Britain would be left reliant on the outdated, bomber-launched, Blue Steel system. Again, the Anglo-American relationship intervened. If the idea of the Special Relationship still holds political currency today, so does the impact of the Polaris naval nuclear missile system. Polaris had been promoted by many in the US as the system of the future, and the Eisenhower administration had tried in vain to sell it to Harold Macmillan's government during the Skybolt negotiations. Part of the Skybolt deal included permission for the Americans to base their Polaris-equipped submarines in the Holy Loch in Scotland. The UK government had rejected Polaris as untested, delaying interest in the programme until the 1970s, but the failure of Skybolt, along with lobbying from the Royal Navy, accelerated British adoption of Polaris.

Entering service in 1968, and launched from underwater, Polaris meant Britain now possessed the ability to retaliate even in the event of a cataclysmic nuclear attack destroying any land-based nuclear force. The UK's Polaris system was

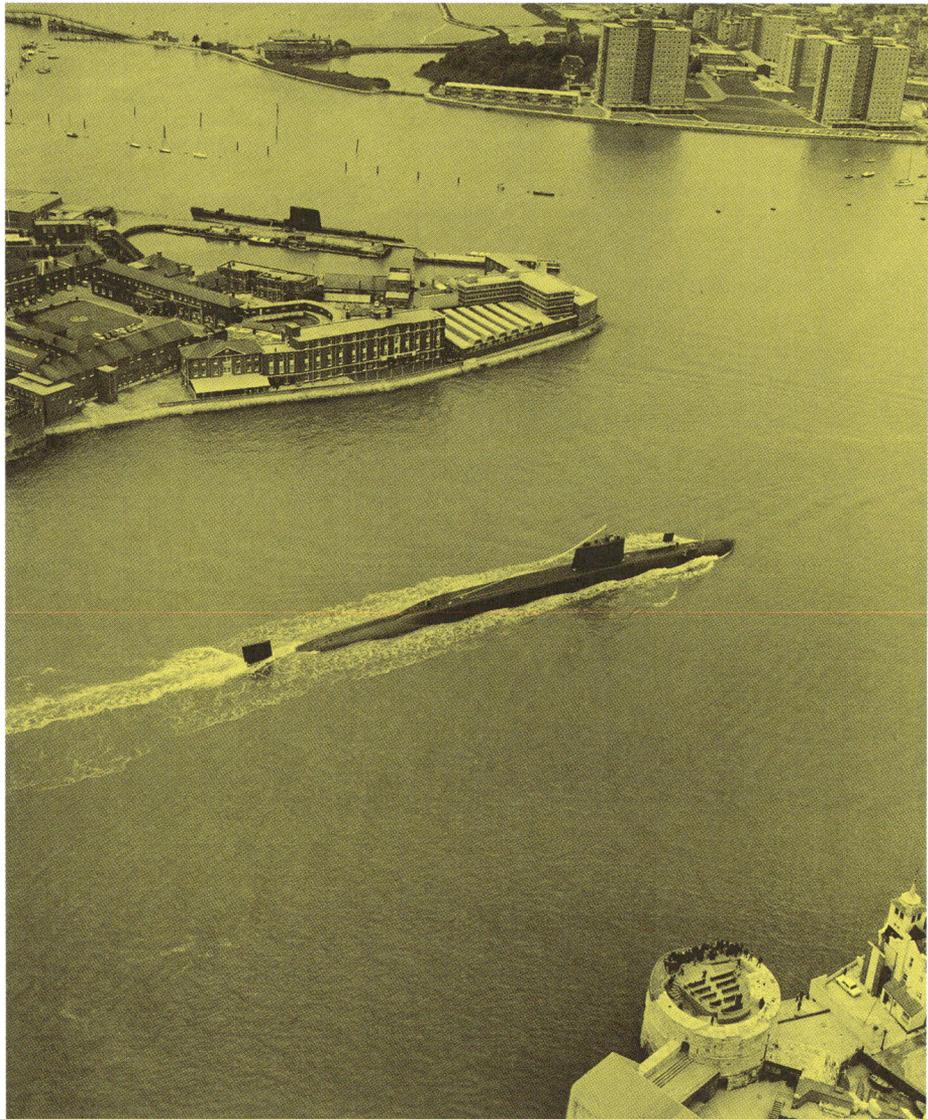

HMS Resolution, the United Kingdom's first nuclear-powered ballistic missile submarine, enters Portsmouth Harbour on 22 May 1967.

COLD WAR BRITAIN

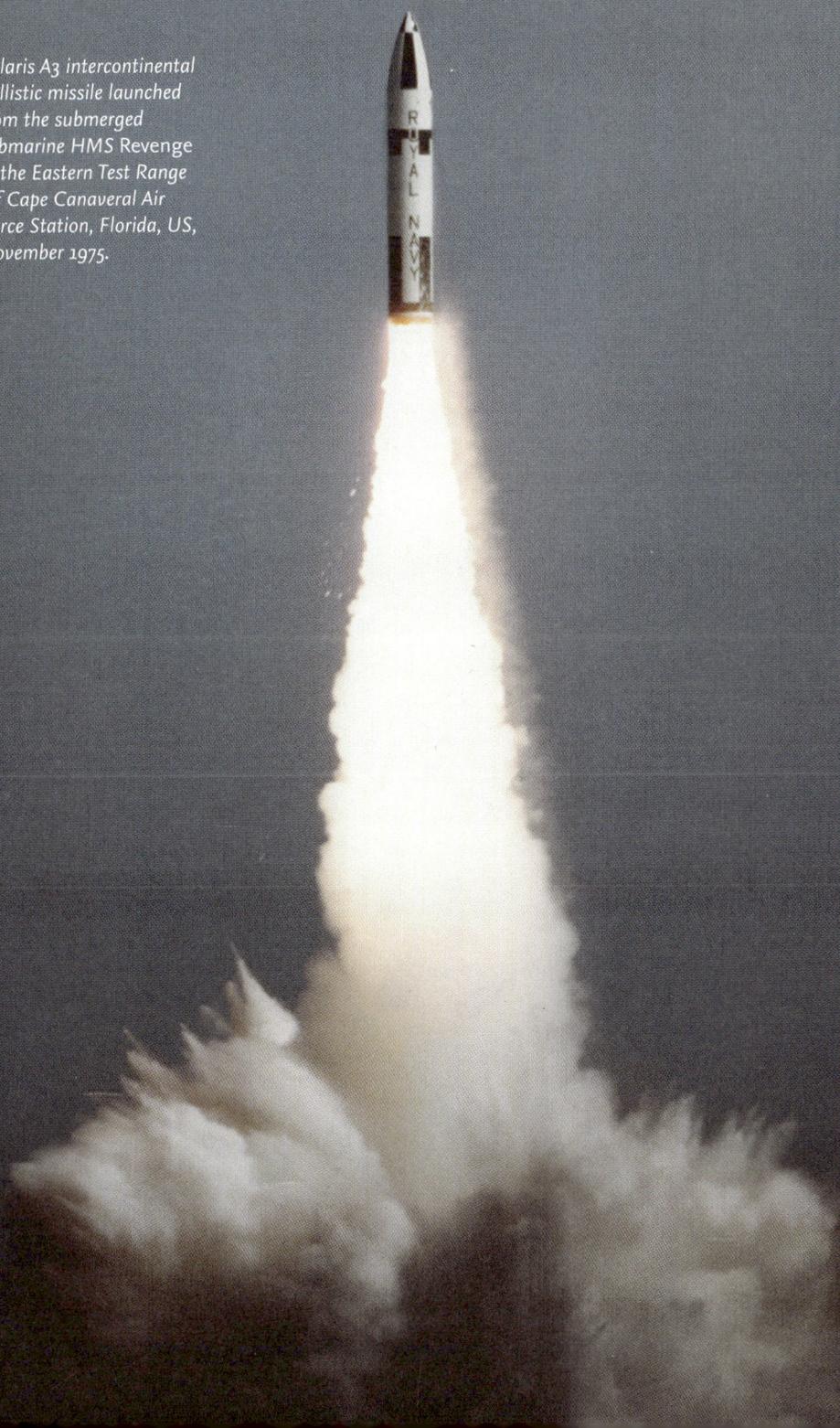

Polaris A3 intercontinental
ballistic missile launched
from the submerged
submarine HMS Revenge
in the Eastern Test Range
off Cape Canaveral Air
Force Station, Florida, US,
November 1975.

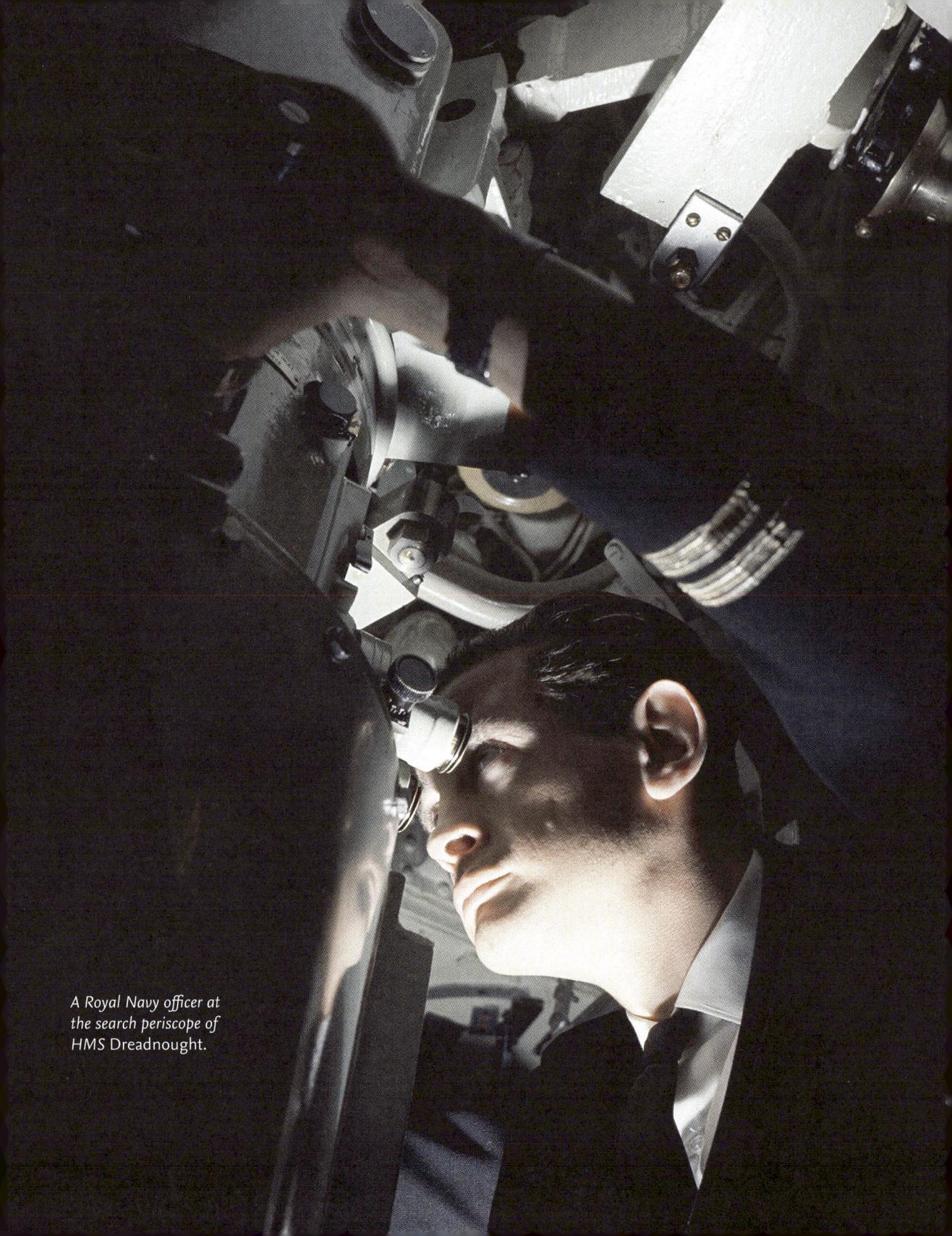

A Royal Navy officer at
the search periscope of
HMS Dreadnought.

another exemplar of the Special Relationship. However, the extent to which this was a truly independent nuclear deterrent is still debated. The missiles were American, as were the guidance systems. The warheads, meanwhile, were developed at Aldermaston by the Atomic Weapons Establishment (AWE) and were carried by four British-built Resolution-class nuclear submarines – HMS *Resolution*, HMS *Repulse*, HMS *Renown*, and HMS *Revenge* – with each carrying 16 missiles. The UK independently developed the Chevaline system in the late 1970s and 1980s, an upgrade to the Polaris missiles that included counter-measures to penetrate Soviet anti-ballistic missile defences. The submarines themselves were based at HMNB Clyde, more commonly known as Faslane, just 10 miles from the US submarines at Holy Loch. Polaris was Britain's main nuclear deterrent for the remainder of the Cold War and the V-bombers were withdrawn from their nuclear role. Polaris was replaced by the more modern Trident system in the early 1990s and continues to be based at Faslane.

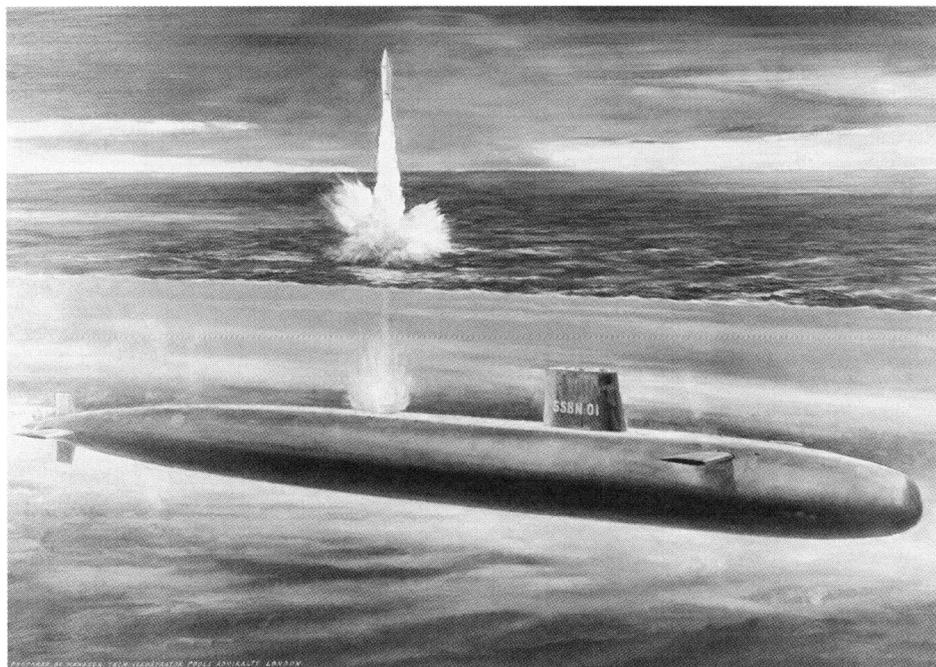

Artist's impression of Britain's first Polaris submarine, February 1963.

The spectre of atomic warfare dominated political thinking in Britain throughout the 1950s and 1960s, and this could not help but seep into the broader public consciousness. This was never truer than during the Cuban Missile Crisis. On 15 October 1962, the Kennedy administration concluded from photographs taken by a U-2 reconnaissance flight that the Soviet Union had deployed nuclear missiles in Cuba, itself a communist nation, less than 140 miles from the US mainland. This triggered a 13-day standoff between the US and the Soviet Union, bringing the world to the brink of nuclear war.

Britain, as a close ally of the United States and a leading member of NATO, was deeply concerned about the crisis. The UK's nuclear deterrent was already integrated into the broader Western alliance, and it had strong political, military, and strategic ties to the US. At the time, Prime Minister Harold Macmillan was leading the British government and he maintained a close personal relationship with US President John F. Kennedy. Macmillan's government viewed the situation in Cuba as a direct threat to Western security and stood firmly alongside the Americans throughout.

During the 13-day crisis, Britain adopted a supportive and advisory role. Macmillan and his government were kept informed by the Kennedy administration, receiving classified updates on the developing situation. The British government recognised that the crisis could escalate into a nuclear conflict, one in which Britain would be directly involved, given its membership of NATO and its role as a nuclear power with US Polaris missiles on the horizon, although these were not yet operational.

Macmillan played an important part in encouraging diplomatic efforts and keeping open channels of communication between the US and the Soviet Union. The British government supported Kennedy's naval blockade of Cuba, officially termed a 'quarantine', intended to prevent further Soviet missiles from reaching the island. Behind the scenes, British diplomats and officials were in regular contact with both Washington and Moscow, seeking to calm tensions and promote a peaceful resolution.

Despite this cooperation, Britain was not in the inner circle of US decision-making during the crisis. Kennedy's primary focus was on handling direct negotiations with the Soviet Union and managing the situation within his own military and government. The United States had little need to involve Britain in military planning because it could confront the Soviet Union on its own terms. Still, the UK's loyalty and moral support were vital to maintaining NATO unity.

At the time, public opinion in Britain reflected the growing anxiety over the prospect of nuclear war. The possibility of a nuclear exchange between the superpowers loomed large, and British citizens followed the crisis with a mixture of fear and fascination. Civil defence drills and discussions about the potential for nuclear fallout were prevalent in the media. While the Cuban Missile Crisis was geographically distant, its consequences would have been felt globally, including in Britain.

President John F. Kennedy announces the US naval blockade of Cuba to a nationwide television audience on 22 October 1963.

CONFIDENTIAL

THIS DOCUMENT IS THE PROPERTY OF HER BRITANNIC MAJESTY'S GOVERNMENT

Printed for the Cabinet. October 1963

C. (63) 180 Copy No. **60**
9th October, 1963

CABINET

NUCLEAR TESTS

NOTE BY THE PRIME MINISTER

My colleagues may be interested to see the text of a message which I to-day received from President Kennedy.

Dear Friend,

This morning, as I signed the instrument of ratification of the Nuclear Test Ban Treaty, I could not but reflect on the extent to which your steadfastness of commitment and determined perseverance made this Treaty possible. Thanks to your never flagging interest, we were ready with our views when the Soviets decided they were ready to negotiate. If humanity is to be spared further radioactive contamination of the atmosphere, if the nuclear arms race is to be slowed down, if we are to make more rapid progress toward lasting stability in international affairs, it will be in no small measure due to your own deep concern and long labor. History will eventually record your indispensable role in bringing about the limitation of nuclear testing; but I cannot let this moment pass without expressing to you my own keen appreciation of your signal contribution to world peace.

With warm regards,

Sincerely,

JOHN F. KENNEDY.

CONFIDENTIAL

John F. Kennedy and the United States were clearly the senior partner, but the President maintained close links with the UK and Prime Minister Harold Macmillan, who saw himself as the 'Greek' to JFK's 'Roman'.

The crisis ended on 28 October 1962, when Soviet Premier Nikita Khrushchev agreed to remove the missiles from Cuba in exchange for a US promise not to invade the island, along with a secret agreement to remove American missiles from Turkey. Britain, like the rest of the world, breathed a sigh of relief as the immediate threat of nuclear war receded. For Britain, the Cuban Missile Crisis underscored the importance of maintaining strong transatlantic ties and highlighted the potential for nuclear conflict, reinforcing the country's commitment to its own deterrent and its alliance with the United States.

Dr. Strangelove or: How I Learned to Stop Worrying and Love the Bomb – *Stanley Kubrick's classic 1964 film satirises Cold War fears of a nuclear conflict between the USSR and the United States.*

For the public, however, the idea that nuclear Armageddon could be imminent, endured. The very concept of world destruction brought about by miscommunication or lack of understanding struck many as not only terrifying, but preposterous. There is no better reflection of this than Stanley Kubrick's black comedy, *Dr. Strangelove or: How I Learned to Stop Worrying and Love the Bomb*. Kubrick was an American but an Anglophile who made his home in England.

Released in 1964, with the Cuban Missile Crisis fresh in the memory, the film satirises MAD, belligerent generals, hapless politicos, and the entire notion of the Cold War. Three roles were played by British comic Peter Sellers in a bravura performance, including the titular Strangelove, an allegedly reformed Nazi scientist. For all its classic one-liners and comic set-pieces, the movie ends with a B-52 bomber pilot straddling a falling atomic bomb while waving a cowboy hat, before cutting to a montage of nuclear explosions soundtracked to Vera Lynn singing, *We'll Meet Again*. It is a scene that retains the ability to leave an audience in stunned silence.

The atomic destruction in *Dr. Strangelove* may have been staged for comedic and dramatic effect, but the threat of annihilation felt very real during this period. This fear permeated every strand of British life. The closeness with America brought comfort in many ways, but also anxiety, with many fearing a loss of British identity as the Americanisation of culture continued apace. This was the era of paranoia, something that began back in the early days of the atomic weapons programmes. For all the British incredulity at the security measures the Americans had insisted on at Los Alamos during the Manhattan Project, it turned out these were justified. Klaus Fuchs had been a Soviet spy and had likely helped accelerate the Soviet nuclear programme. The atomic era made information an even more valuable military asset than bombs. In doing so, it supercharged the spy game.

Actor Slim Pickens as Major 'King' Kong riding a nuclear bomb to oblivion in the 1964 film Dr. Strangelove.

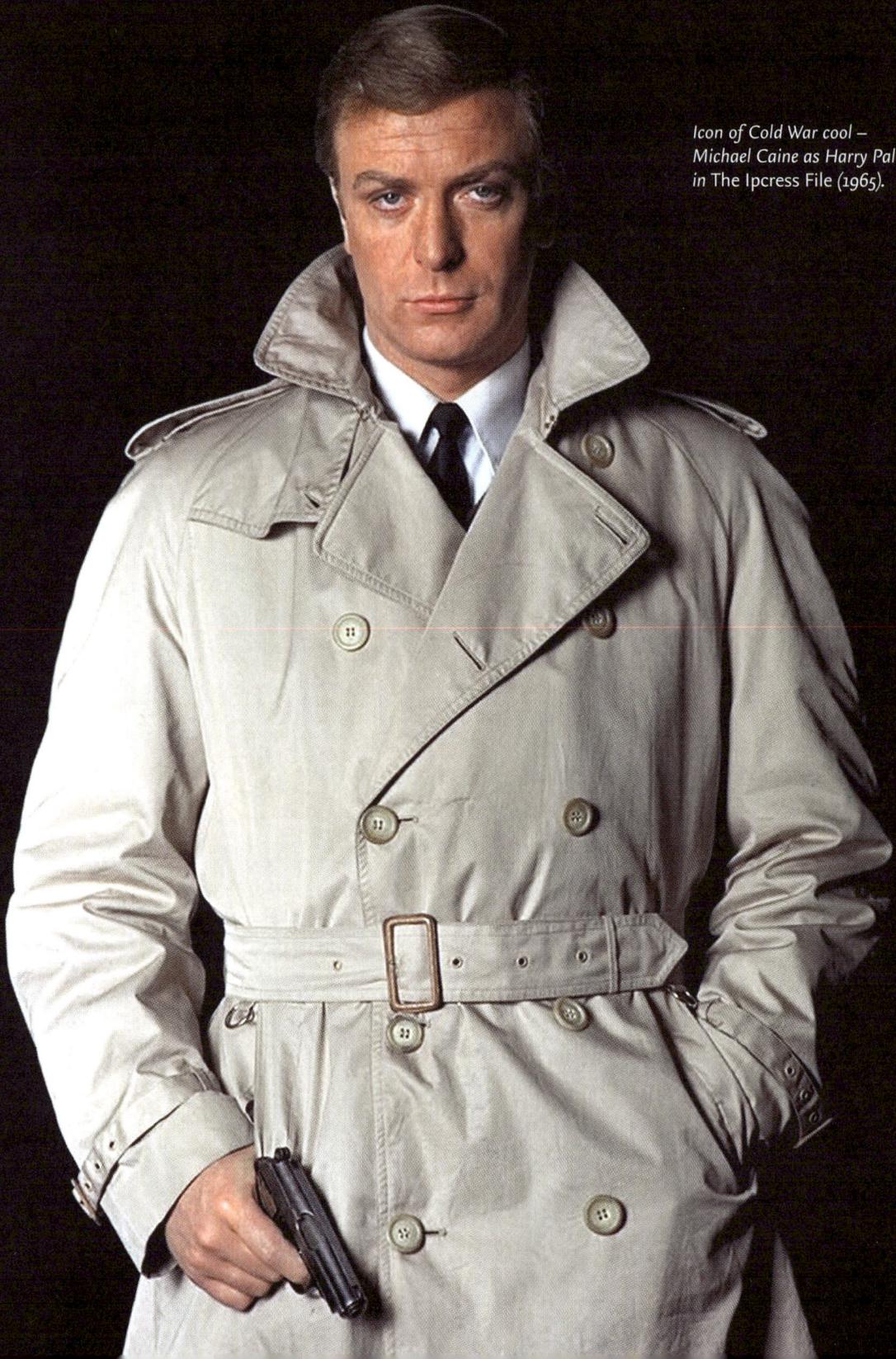

CHAPTER 3

SEX, SCANDAL AND SPY GAMES

In late January 1950, Klaus Fuchs was under immense strain. The German-born scientist was a respected theoretical physicist. A naturalised British citizen, having fled Germany upon Hitler's rise to power, Fuchs had made significant contributions to the Manhattan Project, the Allied effort to develop the atomic bomb during the war. His primary expertise centred on solving the challenge of imploding the fissionable core of the plutonium bomb. He developed techniques including the Fuchs-Nordheim method, which remains essential for predicting and analysing electron emission, while his report on blast waves continues to be regarded as a classic in the field. Fuchs was among the many Los Alamos scientists who witnessed the Trinity test on 16 July 1945. During the late 1940s, however, US and British intelligence agencies were working on decrypting Soviet communications in a secret project called 'Venona'. The Venona decrypts revealed coded messages between Soviet agents and their handlers in Moscow. Among these messages were references to an unidentified spy in the Manhattan Project. The coded messages described an individual with access to high-level scientific research, pointing towards someone within the nuclear programme.

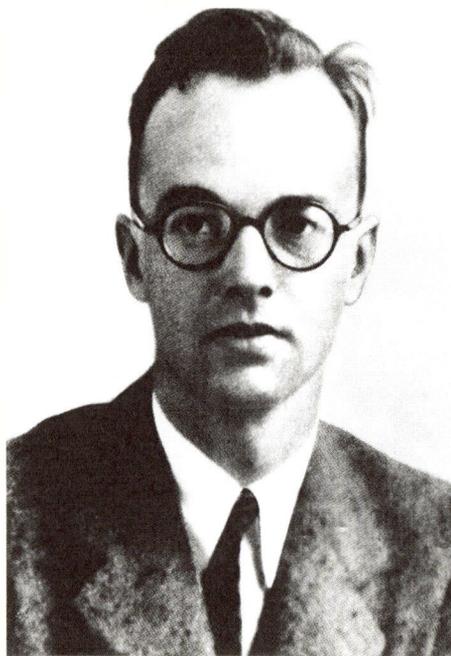

Klaus Fuchs: The German-born physicist who betrayed Britain by passing nuclear secrets to the Soviet Union, exposing vulnerabilities in British intelligence.

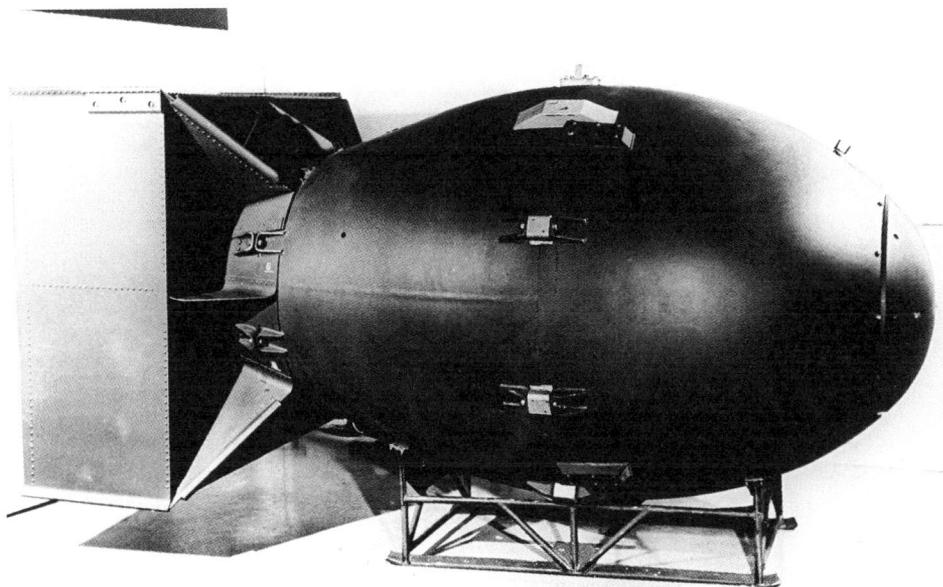

'Fat Man', the 22-kiloton atomic bomb that was dropped on Nagasaki on 9 August 1945.

By September 1949, the British were near certain that Fuchs was that spy, and by December, William 'Jim' Skardon, an officer in the Security Service (MI5) had begun a series of informal meetings with Fuchs. Exhibiting a rapidly deteriorating mental state, by 24 January 1950 Fuchs confessed, admitting to passing crucial information about the development of the atomic bomb to Soviet intelligence between 1942 and 1949. Assessments vary over the impact of Fuchs's espionage, largely due to the paranoia of the Soviet intelligence agency, NKVD, who ran the Soviet atomic programme and largely distrusted intelligence from overseas agents. Nevertheless, it is known that Fuchs shared the theoretical and technical designs of the plutonium-based 'Fat Man' bomb dropped on Nagasaki, a design more complex than other early atomic bomb designs. He also relayed information on calculations for nuclear chain reactions, uranium enrichment, and the properties of plutonium, providing the Soviet scientists with shortcuts in solving key scientific and engineering challenges.

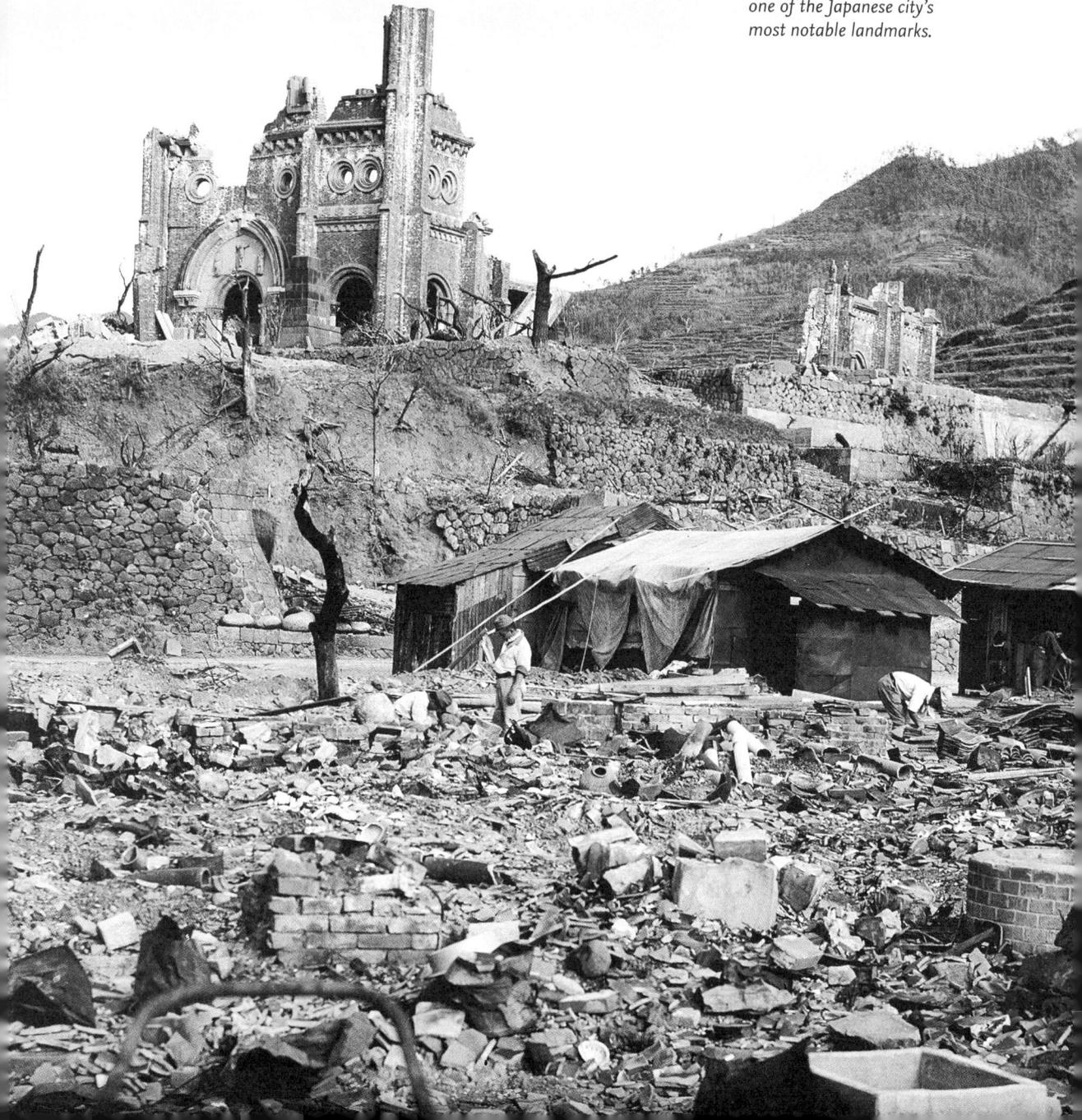

Nagasaki in the aftermath of the 'Fat Man' atomic bomb. Prominent are the ruins of the Roman Catholic Cathedral, which had been one of the Japanese city's most notable landmarks.

In his own mind, Fuchs was sure he had helped the Soviets obtain their own nuclear bomb much more quickly than they could have done without his subterfuge, perhaps by years. Certainly, this was a view shared by many within the United States. The US political Establishment and public alike reacted with shock when the Soviet Union detonated its first atomic bomb, RDS-1, on 29 August 1949, having believed their nation had a monopoly on this new superweapon. The successful Soviet test was a turning point in the nascent Cold War. The establishment of nuclear parity between the superpowers entrenched the mutual feelings of mistrust, leading to ever more aggressive posturing, increased military spending, and a greater focus on intelligence-gathering, empowering the recently formed Central Intelligence Agency (CIA). The Soviet atomic test also deepened US commitments to NATO and ushered in the policy of 'containment', formalised in the National Security Council document NSC-68, which called for a build-up of US forces hitherto unfathomable in what was technically peacetime.

When Fuchs's complicity was confirmed, it also increased the rift that had opened between the United States and the United Kingdom over nuclear weapons. The McMahon Act had already damaged relations, and the revelation of Fuchs's treachery delayed any rapprochement. Fuchs was convicted on 1 March 1950 of four counts of breaking the Official Secrets Act. Having pleaded guilty at a trial lasting just 90 minutes, Fuchs was sentenced to 14 years' imprisonment in Wakefield Prison and stripped of his British citizenship. He served two-thirds of his sentence before being released on the grounds of good behaviour, and emigrated to the German Democratic Republic. Until his dying day, Fuchs believed he had acted honourably, that atomic secrets in the hands of one nation were dangerous, and they should be shared for the benefit of humanity.

The case of Klaus Fuchs was the first in a series of spy scandals that would shock the British Establishment to its very core. At the same time, they would titillate the population, ignite the rise of the modern tabloid press, and illustrate the changing nature of British society, politics and culture. In many ways, the spy scandals and their impact say more about the differences between the two sides in the Cold War than any comparison of economic plans ever could.

Jim Skardon parlayed his role in the Fuchs scandal into a healthy career in MI5, developing a reputation as a noted interrogator of suspected turncoats. In truth, Skardon's own report admitted that eliciting a confession from Fuchs had been rather easy due to the suspect's mental state. Nevertheless, Skardon was now a key player in monitoring Soviet espionage activities. One of the most dramatic Cold War spy scandals was the revelation that five, apparently upstanding, young men from upper-middle-class backgrounds, pillars of the Establishment who had attended one of the country's most prestigious universities, were in fact traitors.

Klaus Fuchs (left) arrives in East Berlin, 23 June 1959, after serving 9½ years in prison for leaking British and American nuclear secrets to the Soviet Union.

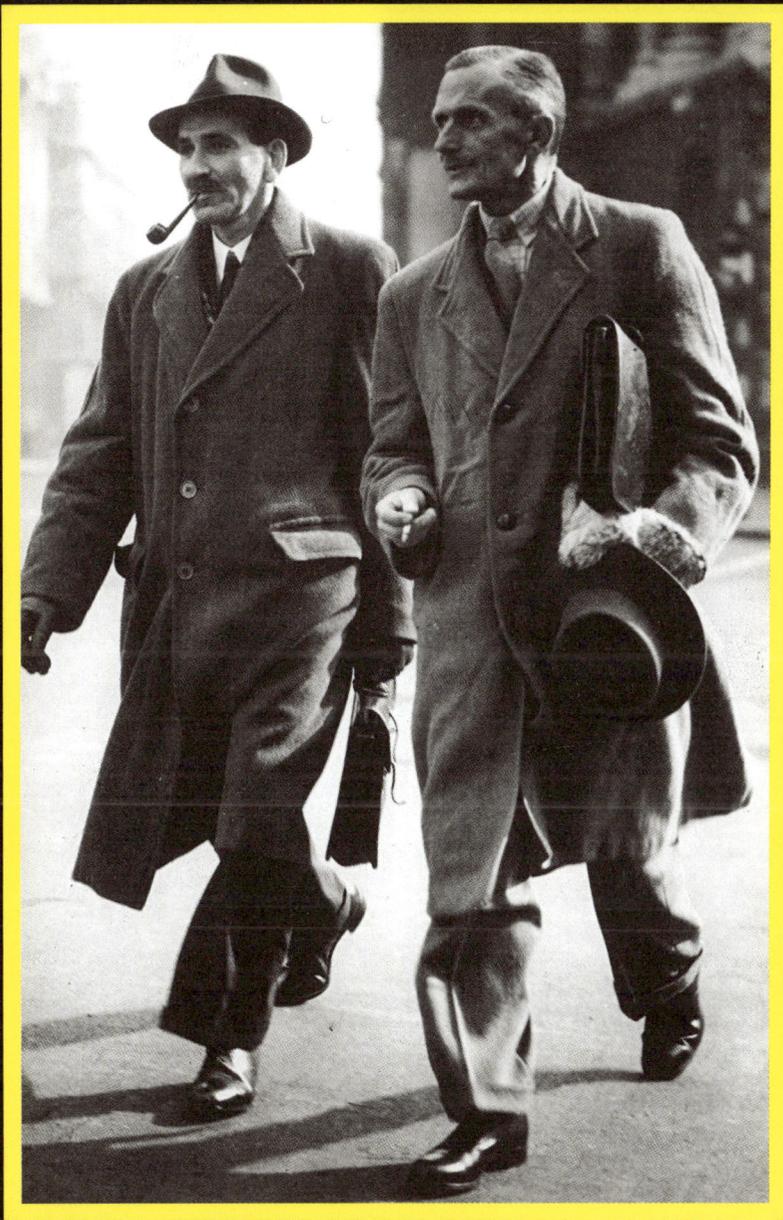

William 'Jim' Skardon, officer of the Security Service (left) and Wing Commander Henry Arnold, Ministry of Supply security officer at AERE Harwell, leave the Old Bailey following Fuchs's sentencing.

Four of the notorious Cambridge Five. Clockwise from top left:
Anthony Blunt, Donald Maclean, Harold 'Kim' Philby, and Guy Burgess.

The Cambridge Five were one of the most notorious and consequential spy rings of the twentieth century, operating at the heart of Britain's intelligence establishment during and after the Second World War. Comprising five Cambridge University graduates – Harold 'Kim' Philby, Donald Maclean, Guy Burgess, Anthony Blunt, and John Cairncross – this group operated as Soviet agents for two decades, providing Moscow with highly sensitive information at the peak of the Cold War. Their betrayal shook the intelligence communities of Britain and the United States, as both sought to comprehend how their most closely guarded secrets had been compromised so completely.

The origins of the Cambridge Five lie in the turbulent political climate of the 1930s. Many young intellectuals in Britain, particularly at Cambridge, were disillusioned by the rise of fascism in Europe and the apparent failure of Western democracies to address the threat posed by Hitler. For some, communism seemed an attractive alternative, offering the promise of a supposedly more just society. Among those drawn to these ideals were the men who would become Soviet spies. Philby, Maclean, Burgess, Blunt, and Cairncross were each recruited by Soviet intelligence while studying at Cambridge, convinced they could aid in the creation of a world where fascism and inequality would no longer exist. The Soviet Union, eager to expand its intelligence network, saw an unprecedented opportunity in these well-educated and well-connected young men.

During the 1940s and 1950s, as Britain and the United States formed closer ties in intelligence sharing, the Cambridge Five worked their way into highly influential positions in and around the British government. Philby, for instance, rose to become head of British counter-intelligence operations pertaining to the Soviet Union and the senior liaison officer with the CIA. His placement enabled him to pass crucial intelligence directly to the Soviets, often undermining Western operations before they could even begin. Maclean, a high-ranking diplomat, provided Moscow with key diplomatic and military secrets, including vital information on Anglo-American atomic energy cooperation; while Burgess, a well-connected broadcaster and diplomat, acted as a courier, transporting messages and securing contacts.

Kim Philby and the last of his four wives, Rufina Pukhova,
are given a tour of the Bratsk hydro-electric dam in 1971.

Blunt's role was equally important, albeit more subtle. An art historian who later became Surveyor of the Queen's Pictures, Blunt was less visible in intelligence circles but still played a role in identifying British nationals with pro-Soviet sympathies. Cairncross worked within the British Treasury and the Government Code and Cypher School at Bletchley Park, providing the Soviets with critical information on wartime code-breaking and early atomic research.

The activities of the Cambridge Five not only bolstered Soviet espionage efforts but also critically undermined Western intelligence operations. Kim Philby's influence was especially devastating; his access to top-level American and British intelligence allowed him to warn the Soviets of covert Western initiatives in Eastern Europe, leading to the capture, torture, and execution of countless anti-Soviet operatives. He helped cripple efforts to curtail Soviet influence and kept Moscow well-informed about the West's intentions. Maclean's access to atomic

secrets, meanwhile, ensured that the Soviet Union was not blindsided by Western advances in nuclear technology. In this way, the actions of the Cambridge Five contributed to the rapid arms race that characterised the Cold War as much as Fuchs did.

It was only in the early 1950s that the deception came to light. The defection of Igor Gouzenko, a Soviet cipher clerk in Canada, provided Western intelligence with the first solid evidence of a major espionage ring within its own ranks. As suspicion mounted, Maclean and Burgess fled to the Soviet Union in 1951, fearing exposure. Their sudden departure brought public attention to the possibility of high-level infiltration, sparking a crisis of confidence within the British intelligence services. Philby, who was already under suspicion, narrowly escaped arrest due to a lack of concrete evidence. His reputation, however, was severely tarnished, and he was forced to leave MI6.

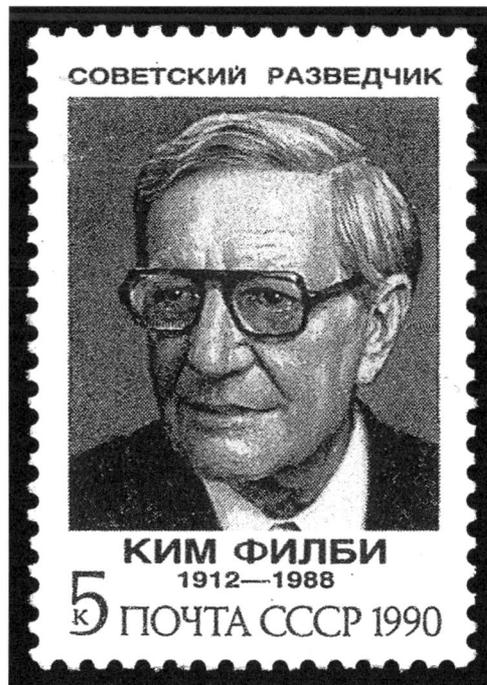

Traitors to Britain, defectors were revered in the USSR. Here, Kim Philby adorns a Soviet postage stamp from 1990.

In 1961, a major in the KGB (the Soviet Union's intelligence agency), Anatoliy Golitsyn, defected to the CIA and was debriefed by the agency's counter-intelligence chief, James Jesus Angleton. As a result, more information around Philby's involvement was deduced, although his name remained elusive until 1963, when he too defected to Moscow. This revelation shattered any remaining illusions within the British government about the extent of Soviet penetration. The fact that Philby, a man trusted with the highest level of intelligence, had been a Soviet agent for so long struck a severe blow to Britain's international standing. Public confidence in MI6 plummeted, and relations with the CIA soured as American officials began to question Britain's ability to safeguard sensitive information. In an era defined by the looming threat of nuclear conflict, the idea that high-level agents could be operating undetected was a significant threat to Western power structures.

Golitsyn had revealed to the CIA the existence of a 'Ring of Five', naming Burgess and Maclean as two certain members, while indicating that Philby was probably a third. He could not identify the other two. The 'fourth man', Blunt, was finally exposed in 1979 after a separate investigation, forcing Prime Minister Margaret Thatcher to admit the truth to the House of Commons. The revelation was particularly embarrassing given Blunt's association with the Crown, and his ongoing place in the most refined of social circles. Unlike his compatriots, however, Blunt avoided public trial due to a secret confession made to MI5 in 1964 in exchange for immunity. Nevertheless, his exposure brought renewed outrage and raised questions over how many more spies remained undetected within British ranks. This led to the uncovering of the 'fifth man', Cairncross. Like Blunt, he had been caught in 1964 and received immunity in exchange for information.

The legacy of the Cambridge Five haunted British intelligence for years, causing a major rift with American intelligence agencies, who were reluctant to share sensitive material with a service that had harboured traitors for decades. And yet, they were far from being the only traitors operating within the intelligence service.

THE SUNDAY TIMES

No. 7531 1 October 1967 Twopence

Inside the Vatican
in full colour
in today's MAGAZINE

Philby: I spied for Russia from 1933

INSIGHT reveals that top Russian spy was being groomed to head Britain's Secret Service

THIS IS THE FIRST picture to be taken of the British master-spy "Kim" Philby since he vanished from Beirut in January, 1963. Philby, relaxed and looking less than his 55 years, is standing in Red Square, Moscow. The dark mass on the right of the picture is the wall of the Kremlin.

The picture, taken two weeks ago, was obtained during the course of an INSIGHT investigation which has demonstrated that "Kim" Philby was, by a shatteringly wide margin, the most important Soviet agent ever to penetrate the Western intelligence system. He was groomed as head of Britain's intelligence system, and as link man with the American Central Intelligence Agency had almost total knowledge of all Western intelligence operations against Russia.

This picture was taken by Philby's eldest son, John, a British photo-journalist, who made a trip to Moscow two weeks ago. Philby explained to his son that his real allegiance had been to the Soviet Union most of his adult life. He made several fascinating disclosures.

In Red Square—the biggest spy in British history

Labour clash on Common Market

By James Margach, Political Correspondent

Scarborough, Saturday

Viet voting challenged

Students stop B.B.C. concert

Mao emerges

14 Britons die in bus crash

By Geoffrey Sumner

Smith triumphs

By Ronald Legge

Salisbury, Saturday

STARTS NEXT SUNDAY — an Insight documented series: How Britain's security forces were penetrated in the crucial cold war years

The Philby story... landmarks in the thirty-year career of a Soviet superspy

1951	1955	1967 Philby, in Moscow, says that he was a Russian agent from 1933 onwards

Four years after Kim Philby's defection, the full story of his activities
was splashed across the front pages of Britain's newspapers.

THE ORIGINS OF MI5 AND MI6: BRITAIN'S SECRET SERVICES

Established in 1909 as part of the Secret Service Bureau, the UK's intelligence services were conceived in response to growing fears of German espionage. Britain's position as a global power made it an attractive target for foreign intelligence efforts, and the government recognised the need for a dedicated body to protect national security and gather intelligence abroad.

Initially, the Secret Service Bureau was a single organisation with two distinct mandates. The domestic arm, which would later become MI5, was tasked with identifying and neutralising German spies thought to be operating on British soil. The foreign arm, eventually formalised as MI6, was responsible for intelligence-gathering outside the United Kingdom, monitoring threats to British interests around the world.

During the First World War, both agencies grew in scope and influence. MI5's efforts were instrumental in protecting military secrets and maintaining domestic security. Meanwhile, MI6, under the leadership of Mansfield Cumming – who famously signed his documents with the letter 'C' – established a network of operatives across Europe and beyond. In the interwar years, MI5 turned its attention to monitoring subversive domestic elements, including communist sympathisers and fascist groups, while MI6 expanded its operations globally.

The Second World War marked a high point for both agencies. MI5's counter-intelligence operations successfully turned German agents into British assets, feeding false information back to the Axis powers. MI6 provided critical intelligence that supported Allied military strategy, often at great personal risk to its operatives.

The agencies' influence extended into popular culture, inspiring two of the twentieth century's most celebrated writers; Ian Fleming worked as a naval intelligence officer during the Second World War, and John le Carré served in both MI5 and MI6. Born out of necessity in a period of looming conflict, the agencies' mystique was cemented not only by their real-world exploits but also by the stories they inspired.

George Blake's story is one of deep-seated ideological conflict. Born in the Netherlands and interned during the Nazi occupation, Blake fled to Britain, where he joined the intelligence services. He seemed an ideal asset: fluent in several languages, deeply loyal to Britain, and determined to resist any totalitarian regime. However, his experiences during the Korean War profoundly changed him. Captured by North Korean forces in 1950, Blake was exposed to communist ideology and witnessed what he saw as the hypocrisy of Western powers. These experiences sparked an ideological transformation, ultimately leading him to offer his services to the newly formed KGB.

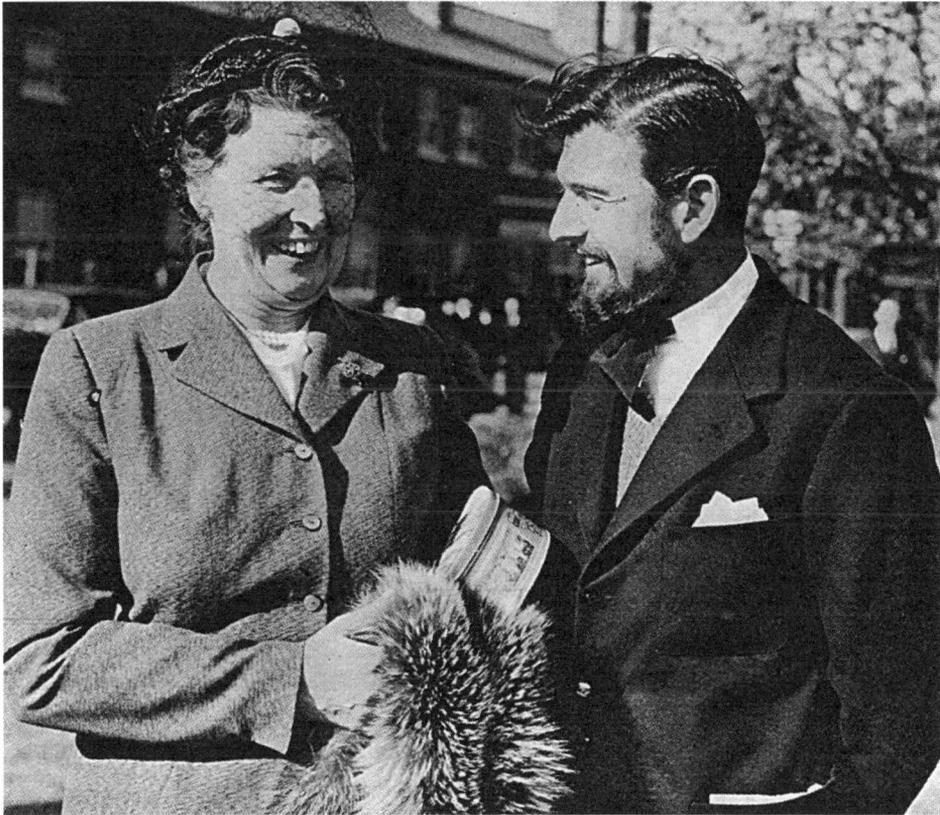

MI6 agent George Blake pictured with his mother on his return to Britain after internment in North Korea during the Korean War. Later posted to Berlin, Blake would subsequently be exposed as a double agent.

By the mid-1950s, Blake was positioned in Berlin, where he was part of a covert MI6 operation that targeted Soviet communications. This operation, a joint venture with the CIA, involved tunnelling into East Berlin to tap Soviet and East German military phone lines. Although immensely valuable to the West, this operation was doomed from the start, as Blake, a Soviet double agent, informed the KGB of every detail. Instead of shutting down the operation immediately, the KGB used it to their advantage, feeding the West false information for nearly a year.

Blake's treachery ran deep. Over nearly a decade, he betrayed the identities of numerous Western agents operating in Eastern Europe, many of whom were imprisoned, tortured, or executed as a result. His ability to navigate MI6 undetected meant that Soviet intelligence enjoyed a remarkable advantage in counter-intelligence. Yet, it was only after the defection of a Polish intelligence officer, who revealed a high-level mole within MI6, that Blake came under serious scrutiny. Arrested in 1961, Blake confessed to his activities, admitting to passing extensive intelligence to the Soviets out of ideological conviction. He was sentenced to 42 years in prison, one of the harshest sentences handed down in a British espionage case. However, in 1966, Blake escaped from Wormwood Scrubs prison with the help of anti-nuclear campaigners sympathetic to his beliefs, eventually fleeing to Moscow, where he remained until his death in 2020.

The Portland Spy Ring scandal unfolded simultaneously with the Blake case, further underscoring Britain's struggles with Soviet infiltration. This ring operated from the Royal Navy's Underwater Weapons Establishment in Portland, Dorset, a facility that housed classified research on submarine detection, sonar technology, and torpedoes. In the hands of the Soviets, this information provided a tactical edge that threatened the security of NATO's naval forces, placing Allied submarines at risk of detection and compromising their defensive strategies.

At the heart of this spy ring were Harry Houghton and Ethel Gee, two British nationals working at the Portland facility. In 1951, during a posting in Poland, Houghton had contacted the Soviet embassy, later returning to Britain as a KGB asset. Gee, a colleague in Portland, became his partner both in espionage

Reg No 3075 Name Blake Prison Brixton

a double life. The second was that I got engaged to and married to a girl with whom I was in love but whom I knew would have no sympathy with my political views and whom I could never make a partner to my secret. My wife comes from a conventional English family, her father is a retired Army officer, she is conservative in her political outlook and she was a secretary in my department. She was in love with me and I with her and we drifted in a relationship the natural outcome of which was marriage. There was no reason why we should not get married except one which I could not tell her. Had I done so it would have placed too heavy burden on her loyalties. I put my conscience at rest by saying to myself that I was like a soldier in a war, who might well be killed but that did not prevent soldiers from marrying. This of course was no really a correct analogy for in this case my wife did not know there was a war on and that I was in it, nor, had she known, would we have been on the same side. When she wanted to have children, again I had no good reason which I could give for not having them and I used the same argument to put my conscience at rest. It will cause no surprise that this contradiction in my life became ever greater and an increasing strain. Here I was building with one hand a happy family life with its roots firmly attached to this country and with the other hand I was pulling the foundations from underneath it so that it might crumble any moment. The only way out would have been flight to the Soviet Union but again there were two reasons which made it difficult to do this. One that almost certainly it would have meant parting with my family for good. The other that I felt it was cowardly to give up the work I had voluntary undertaken with such profession of high idealism without being actually in real danger.

I jumped at it therefore when a way out presented itself in autumn 1958. While I was still in Berlin my service suggested that I should go the following October to the Lebanon to learn Arabic, a course which would last a year and a half.

Document no: 46602/B

Handwritten statement made by George Blake explaining his decision to spy for the Soviet Union. In 'other points' he claims that the nature of his work for the Secret Intelligence Service had altered the way he felt about betrayal.

and in life, assisting him in collecting sensitive documents and photographs for his Soviet handlers.

Their activities might have continued undetected if not for a tip-off from Michal Goleniewski, a Polish intelligence officer who defected to the CIA in 1961. MI5 launched a surveillance operation on Houghton and Gee. Over time, they observed the pair meeting regularly with Peter and Helen Kroger, an unassuming couple running a bookshop in London. The 'Krogers' were actually Morris and Lona Cohen, American-born KGB agents operating under false identities. The Cohens served as a vital link in transmitting stolen documents from Houghton and Gee back to Moscow, using microdots concealed in books to avoid detection.

Peter Kroger stands at the centre of a tea party in the garden of a house at Ruislip Gardens, London, in the 1950s.

In January 1961, MI5 executed a carefully planned raid on the Cohens' residence, uncovering extensive evidence of espionage equipment, including radio transmitters, coded messages, and photography devices. Their findings confirmed the Cohens' Soviet ties and revealed the scale of the Portland spy network's operations. All four members of the ring were arrested and subsequently tried.

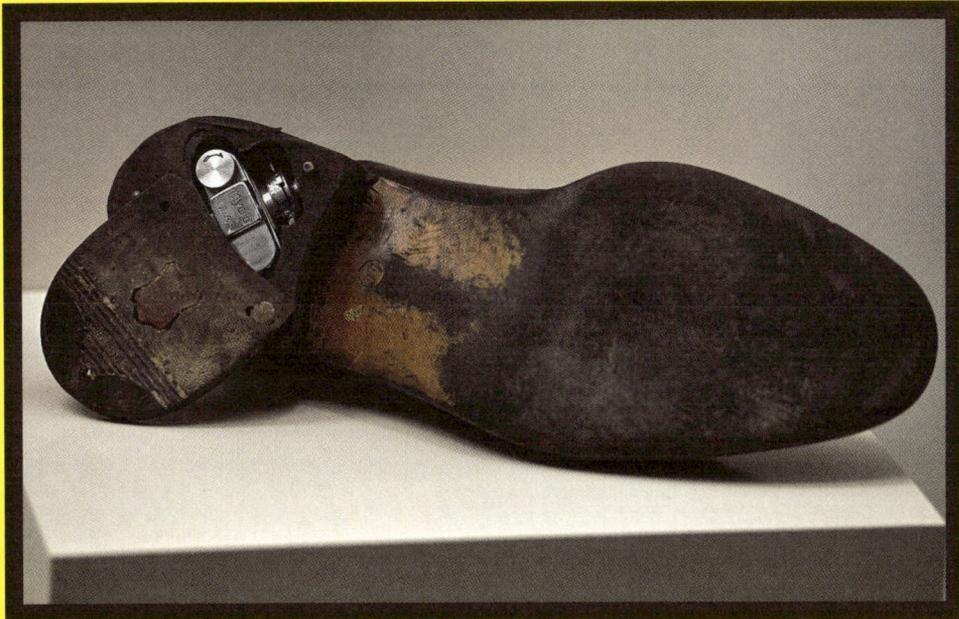

This Soviet men's shoe had a miniature spy camera concealed witin the heel.

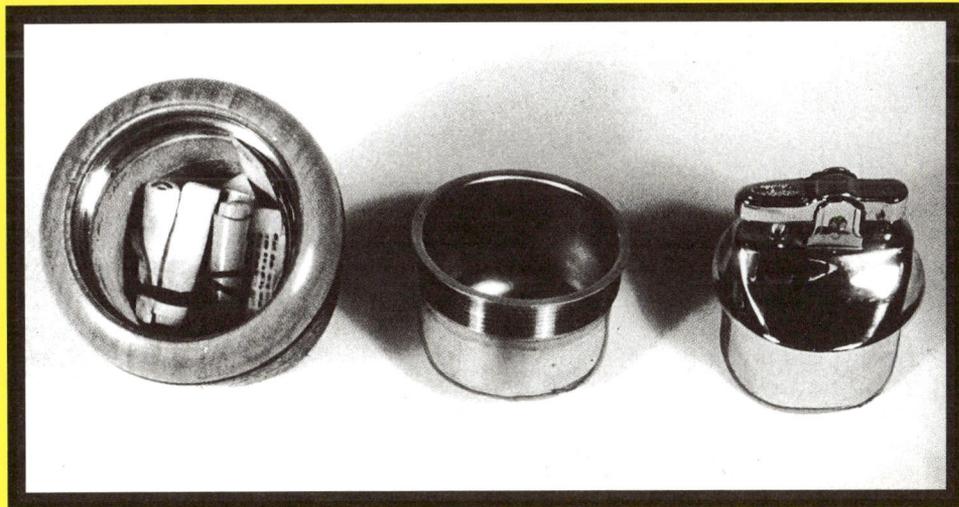

Table cigarette lighter found at the home of Peter and Helen Kroger, with messages found in the false bottom.

Houghton and Gee received sentences of 15 years, while the Cohens were sentenced to 20 years for their role in transmitting secrets. The Portland Spy Ring was not only another major embarrassment for British intelligence but it also exposed serious flaws in security procedures at critical military installations.

These scandals took place at a time when Britain was on the cusp of a new wave of societal change, but traditional class structures, gender politics, and cultural mores hadn't yet shifted in the ways promised by the post-war reforms of the Attlee administration. The subsequent years fell into a quiet conservatism defined by an affluence unimaginable during 1939–45. The spy scandals threw some of this into sharp focus. It was notable that many of those found guilty of spying against their nation were drawn from the Establishment, helping to shatter ideas of 'social betters'. The key area that ties espionage to the shifting social mores of the 1950s and 1960s, however, is sex.

The spy scandals were perfect fodder for the growing tabloid newspaper market, and sex was a significant part of the heady mix, particularly if it was of the illicit sort. One of the aspects of the Cambridge Five that caught the imagination of the press was the sexuality of the members. Burgess and Blunt were both homosexual, while Maclean had a complex personal life and was rumoured to be bisexual. In the largely homophobic 1950s, Burgess's unconcealed gay lifestyle and Blunt's very private orientation were scrutinised by the press, fuelling sensationalist narratives equating homosexuality with disloyalty and moral 'deviance'. The idea that gay men were outsiders with divided loyalties, who could be seduced into betraying their country, reinforced stereotypes that stigmatised homosexuality in Britain's repressed and security-sensitive culture of the time.

Of course, this is at best broadly ridiculous now; it is a notion which is abhorrent to modern sensibilities. Yet it is true that being homosexual in a security-sensitive job made some men vulnerable to being turned by enemy intelligence agents at a time when gay sex was still illegal. John Vassall was one such man. A civil servant in the British Admiralty, Vassall's journey to espionage began when he was posted to the British embassy in Moscow in the 1950s. There, he was ensnared by the KGB

in a classic honeytrap operation. The KGB gathered compromising photographs of Vassall and used them as leverage to blackmail him. Facing the threat of exposure and public disgrace, Vassall reluctantly agreed to spy for the Soviet Union, thus beginning his double life as an Admiralty clerk by day and Soviet agent by night.

Vassall's position in the Admiralty gave him access to a range of classified naval documents, including details of NATO and British naval plans, submarine designs, and equipment specifications. Over the years, he provided the Soviets with thousands of sensitive documents, most of which he secretly photographed and handed over during clandestine meetings with his Soviet handlers. The information he leaked is believed to have aided the Soviet Union's naval capabilities significantly, giving them insight into British strategies and technologies.

The scandal only came to light in 1962 when British counter-intelligence began investigating Vassall's lavish lifestyle, which far exceeded the modest means of

"And to which blind eye did that fine old traditionalist, the Director of Naval Intelligence, have his spy-glass glued?"

"You wouldn't by any chance be working in a highly confidential job at the Admiralty, would you?"

This cartoon first appeared in the Daily Express, and was reprinted in newspapers around the world as an illustration of the Admiralty's oversight.

807, HOOD HOUSE,
DOLPHIN SQUARE,
LONDON, S.W.1.
VICTORIA 3800

16. VIII. 1962.

Dear Sir,

Would you by any chance
have a double bedroom with bath
for the week-end Friday,
31st August until 2nd Sunday of
September. If that is
impossible would you have
two single rooms, for
Mr. Hicks and myself?

Yours faithfully,
W. J. C. Vassall

The Manager,
Ingoldisthorpe Manor,
Nr. Sandringham,
Norfolk.

*Every inch of John Vassall's personal life became
the subject of scrutiny and speculation, such as this
letter to a hotel from earlier in 1962.*

a civil servant. His expensive tastes, designer clothes, and high-flying social life raised suspicions. Surveillance and investigation soon revealed his contacts with Soviet agents, and Vassall was arrested. Under interrogation, he confessed to his espionage activities, detailing how he was blackmailed into betraying his country and had spied for the Soviets over several years.

The exposure of Vassall sent shockwaves through Britain and was especially damaging to the Admiralty and intelligence services, which had failed to detect a mole within their ranks. It prompted an official inquiry, revealing serious lapses in security and oversight within the Admiralty and exposing the vulnerability of government officials to blackmail. The scandal led to public accusations of incompetence among high-ranking officials, as well as questions about the vetting process for government employees with access to classified information. The inquiry, however, was criticised for being overly lenient on senior officials, sparking widespread anger and a sense that the Establishment was protecting its own.

The media seized upon the case, and the Vassall scandal became a tabloid sensation. Rumours of widespread Soviet infiltration circulated, while public mistrust in government officials and intelligence agencies reached new heights. In the wake of the scandal, the British government tightened security protocols, revising its vetting process and making efforts to minimise vulnerabilities to blackmail among civil servants. Vassall was sentenced to 18 years in prison, of which he served 10 before being released.

Vassall was naïve, a vain elitist, and self-serving in many ways. Yet there is a tragedy here too. Had Britain been less repressive, particularly around homosexuality, it would have been more difficult for foreign agents to honeytrap John Vassall and others. This is despite the establishment in 1954 of the Wolfenden Committee, which was tasked with examining laws around homosexuality and prostitution, following increasing concerns about morality and crime. At the time, homosexual acts between men were criminal offences, and many people faced prosecution, public disgrace, and prison sentences as a result. The committee sought to address whether such private behaviours should remain criminalised in a modern society.

The resulting Wolfenden Report, published in 1957, was revolutionary for its time: it recommended that 'homosexual behaviour between consenting adults in private should no longer be a criminal offence'. This stance was grounded in the principle that the law should not interfere in private moral conduct between adults unless it caused harm to others. The report argued that criminal law was ill-suited to regulate private morality and that police resources would be better allocated elsewhere. Though the report advocated for the abolition of state punishment, it did not encourage social acceptance. The change in the law did not come until 1967 in England and Wales. The Wolfenden Report is now considered a milestone in British social reform and a significant step towards the recognition of LGBTQ+ rights, reflecting a pivotal shift in attitudes towards personal liberty and the role of the state in moral issues. Unfortunately, it came too late for John Vassall.

Meanwhile, another episode tying sex, scandal, and spying together came to dominate the headlines. The Profumo Affair remains one of the most sensational political stories in British history. Centred on John Profumo, Secretary of State for War, the scandal revealed not only an illicit affair but also a potential security breach, sparking media frenzy, parliamentary inquiries, and a dramatic downfall for all involved.

The scandal began innocuously enough in 1961 when Profumo, a rising star in the Conservative Party, met a young model named Christine Keeler, at a party hosted by Stephen Ward, a well-connected society osteopath. Ward's social circle included politicians, celebrities, and diplomats, and his gatherings attracted a wide range of people from elite and underworld circles alike. At one such party across the weekend of 8–9 July at Cliveden, the home of the Viscount Astor, Profumo encountered Keeler, then 19 years old, and began a brief affair with her. What appeared to be a personal indiscretion soon developed into a national crisis.

The potential for a security threat became clear when it emerged that Keeler was simultaneously involved with Yevgeny Ivanov, a naval attaché at the Soviet embassy in London who was suspected of Soviet intelligence links. The affair raised grave concerns: a British minister, with access to sensitive defence information, was

unwittingly mingling with someone who also had ties to a Soviet representative. In the tense Cold War atmosphere, and with fears of Soviet espionage at an all-time high, the possibility of compromised secrets set off alarms within intelligence and government circles. Although there is no evidence that Profumo shared classified information with Keeler, or that she passed anything to Ivanov, the risk of blackmail and security compromise was undeniable.

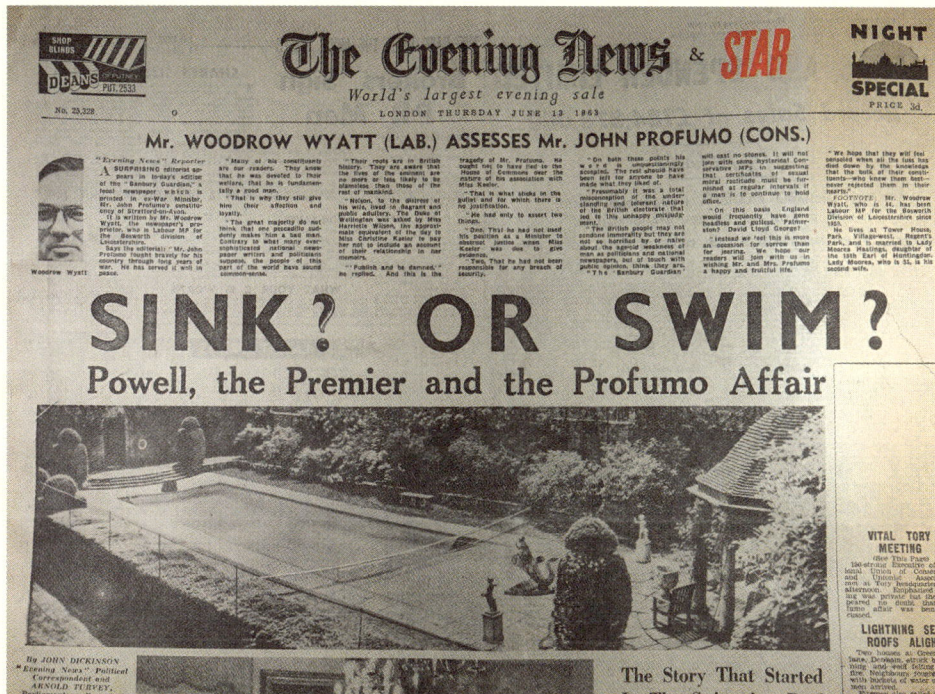

The Profumo Affair's cocktail of sex, society, and spying dominated headlines and caused irrevocable harm to the British government of the day.

In March 1963, rumours of Profumo's connection with Keeler began to surface in the press, prompting him to address the matter in the House of Commons. Profumo categorically denied the affair, stating, 'There was no impropriety whatsoever in my acquaintanceship with Miss Keeler.' However, within months, new evidence emerged, contradicting his claims. Realising his position was untenable, Profumo admitted he had lied to Parliament. In June 1963, he resigned from his ministerial

post and left public life, an act that deeply embarrassed the government and led to calls for accountability within the ruling Conservative Party. Ward, through whom they had met, was made the scapegoat for the entire affair and was charged with prostitution offences. Damned by prosecuting counsel Mervyn Griffith-Jones as a man who represented 'the very depths of lechery and depravity … a thoroughly filthy fellow', Ward took his own life by overdosing on sleeping tablets. He was found guilty *in absentia*.

The impact of the debacle extended well beyond Profumo and Ward. Harold Macmillan, already facing criticism over a stagnant economy and internal divisions within the Conservative Party, faced mounting pressure to address the scandal. The media frenzy surrounding the affair painted Macmillan as out of touch with both his ministers and the realities of public opinion, and the following year the Conservatives were defeated in the 1964 General Election, bringing an end to 13 years of Conservative rule.

An inquiry led by Lord Denning concluded that there had been no national security breach, though it criticised the behaviour of high society figures involved in the affair, and exposed the salacious undercurrents within elite London society, where politicians and figures of influence mingled freely with people from far more controversial backgrounds. The report became a bestseller, as the public sought to consume every detail of the scandal that had unravelled the Conservative government's image.

In the years following his resignation, Profumo quietly dedicated himself to charity work, rehabilitating his reputation through years of service. His work earned him respect from those who once condemned him. Keeler, immortalised by Lewis Morley's photograph of her seemingly nude and astride an imitation Arne Jacobsen chair, struggled with the notoriety the affair had brought her, and faced ongoing media scrutiny for the remainder of her life.

The Profumo Affair, with its mix of sex, politics, and espionage, stands as a defining scandal of the Cold War era. It revealed the vulnerabilities of the

Christine Keeler: At the heart of the Profumo Affair, her scandalous connections with political and Soviet figures in 1963 rocked British society, exposing secrets and shaking the foundations of government.

THE FIRST JAMES BOND FILM ADVENTURE!
(AGENT 007)

NOW...MEET THE MOST EXTRAORDINARY GENTLEMAN SPY IN ALL FICTION..

007
The double "O" means he has a license to kill when he chooses...where he chooses...whom he chooses!

Negro Star JOHN KITZMILLER and Jamaican Nature Girl Assist BOND in His Hunt For Master Spy "DR. NO."

Now the famed master of the fine arts of love, espionage...and murder bursts out of the bestsellers and onto the screen!

IAN FLEMING'S

Dr. No

starring
SEAN CONNERY as
and URSULA ANDRESS
JOSEPH WISEMAN

TECHNICOLOR

Poster for Dr. No. This first James Bond film launched a sensation.

British Establishment and contributed to a shift in the public's expectations of transparency and accountability from their leaders. It was also a harbinger of the changes in British society. The media coverage of the Profumo Affair was relentless, with newspapers and tabloids publishing sensational stories, some exaggerated, about the private lives of the powerful. The rigid post-war deference to authority was eroding, and the press seized this moment to scrutinise, criticise, and mock the political class. In 1989, the film *Scandal* showed the events still had the power to grip the public imagination. Profumo's downfall and Macmillan's subsequent resignation marked a turning point in British culture.

Other markers of this liberalisation included the *Lady Chatterley's Lover* obscenity trial and the introduction of the contraceptive pill. At the same time, popular culture was also undergoing a radical change. On 5 October 1962, two works of entertainment were released that would help define the 1960s, re-establishing Britain's influence in the world in a way no politician or army could match. It is a curious accident of history that both the first Beatles single, *Love Me Do*, and the first James Bond feature film, *Dr. No*, were released on the same day. The Beatles, of course, would dominate popular culture in the 1960s, and their influence on music is untouched in the pop and rock pantheon. In terms of commercial success at least, the James Bond series is still going strong over 60 years, 25 movies, and £11 billion in box office takings later.

James Bond was, of course, the creation of Ian Fleming. A complex character, Fleming came from a wealthy family, with his father a prominent figure in British society. He was educated at prestigious institutions including Eton and Sandhurst but was known more for his rebellious nature and charm than for academic achievements. A natural born elitist with a colourful private life, he first attempted a career in journalism and eventually joined British Naval Intelligence during the Second World War. After the war, he turned to writing spy novels, beginning with *Casino Royale* in 1952. Critical reaction to the novel was mixed, but sales were strong, and Bond became a series. As popular as the books were, however, it was the film adaptations that made James Bond a household name.

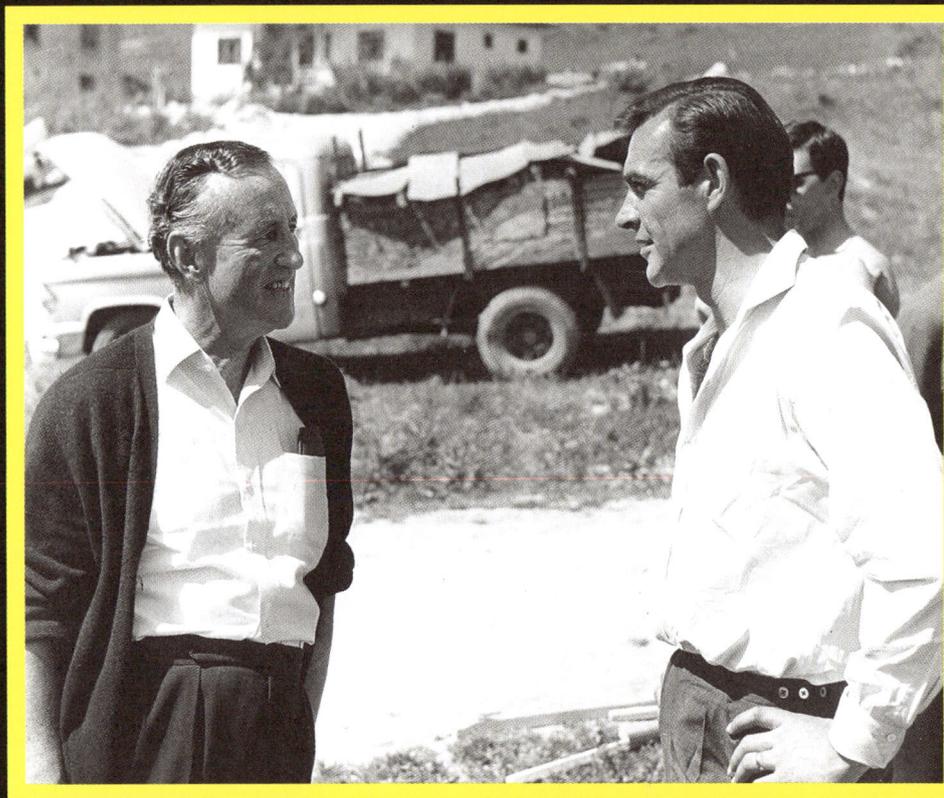

Scottish actor Sean Connery was key to the
success of the Bond films. Here he converses
on-set with Bond author Ian Fleming.

Against the backdrop of nuclear brinkmanship, espionage scandals, and shifting allegiances, the Bond films emerged as a cultural reflection of Cold War tensions. Released in 1962, the same year as the Cuban Missile Crisis, *Dr. No* introduced audiences to a hero whose very identity seemed forged in the crucible of East–West rivalry. Bond's world was one where good and evil were framed not just in terms of morality but as a struggle between opposing ideologies. Bond himself became an avatar of British values: suave, resourceful, and unapologetically nationalist, tasked with defending the 'Free World' against shadowy forces that alluded to the communist threat, albeit through a fictional organisation, SPECTRE. The casting of Sean Connery was key, the actor bringing to the role an easy charm and knowing sense of humour alongside his physical prowess and good looks.

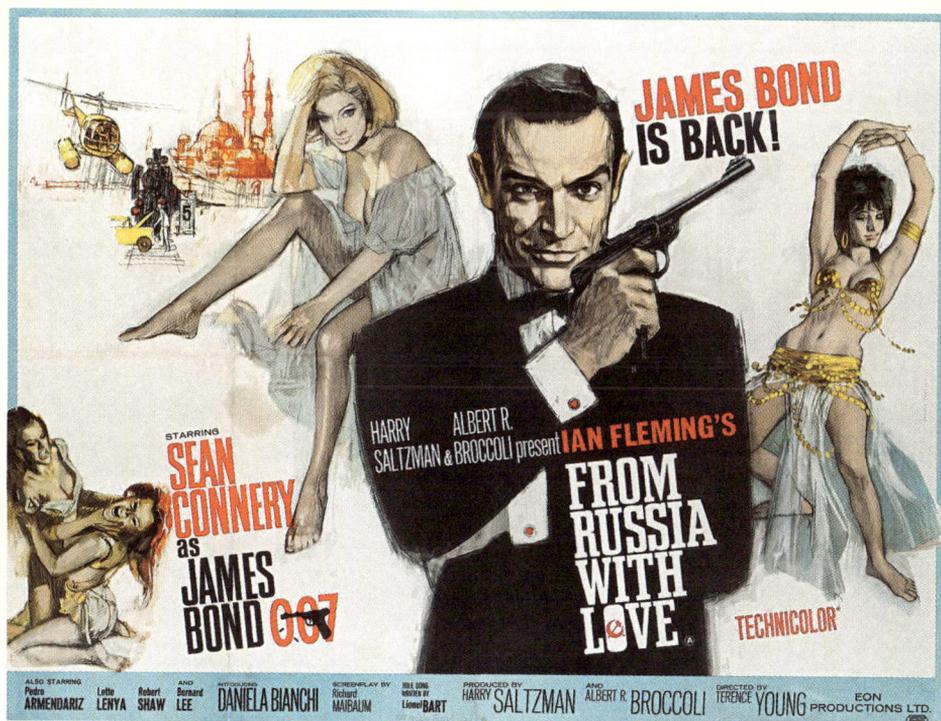

The second Bond adaptation, From Russia With Love, *is the most grounded Cold War thriller of the series. The novel was a favourite of John F. Kennedy.*

With *From Russia with Love* (1963), Bond's antagonists moved even closer to Cold War dynamics. Here, Bond's mission centres around securing a decoding device from the Soviet Union, a plot that echoed real-world conflicts over information, surveillance, and state secrets. The film's success rested in its ability to capitalise on contemporary headlines, providing a cinematic catharsis for audiences concerned about Soviet encroachment.

The Bond films also became an unexpected platform for British 'soft power'. Bond's adventures painted a vision of British ingenuity and resilience that resonated globally. His Aston Martin, high-tech gadgets, and Savile Row suits became symbols not just of British style but of a sophisticated approach to espionage, contrasting with the often utilitarian portrayal of communist agents. Almost as importantly, the Bond films were full of sex, reflecting the headlines of the spy scandals and the growing promiscuity of British society.

As the Cold War progressed, the Bond films adapted, mirroring shifting political tides. By the late 1970s and early 1980s, as détente first took hold and then broke down, Bond's antagonists reflected the changing threats of the era. *The Spy Who Loved Me* (1977) depicted the threat of nuclear annihilation, while *Octopussy* (1983) delved into nuclear smuggling, a nod to the arms race that had defined decades of superpower rivalry. The villains in these films evolved from communist operatives to megalomaniacal individuals, subtly echoing Western optimism about the ideological victory over communism, while acknowledging that the threats to peace had become more diffuse. With the fall of the Berlin Wall in 1989 and the collapse of the Soviet Union two years later, the Bond series shifted yet again, this time reflecting a post-Cold War landscape. *GoldenEye* (1995) addressed the aftermath of the Cold War and the emergence of rogue factions, a nod to the uncertain and fragmented world that followed the Soviet Union's dissolution. By the time the film series got around to adapting *Casino Royale* in 2006, the series had evolved into sophisticated action movies, divorced from any geopolitical reality at all, with spying taking a backseat to super heroics.

The Faultless gas pen was a proprietary self-defence device manufactured in the United States. Designed to resemble a fountain pen, it discharged tear gas from a .38 calibre cartridge.

This 1960s miniature spy camera manufactured by Minox was used for covert espionage photography. It was popularised following its appearance in the 1969 Bond adventure, On Her Majesty's Secret Service.

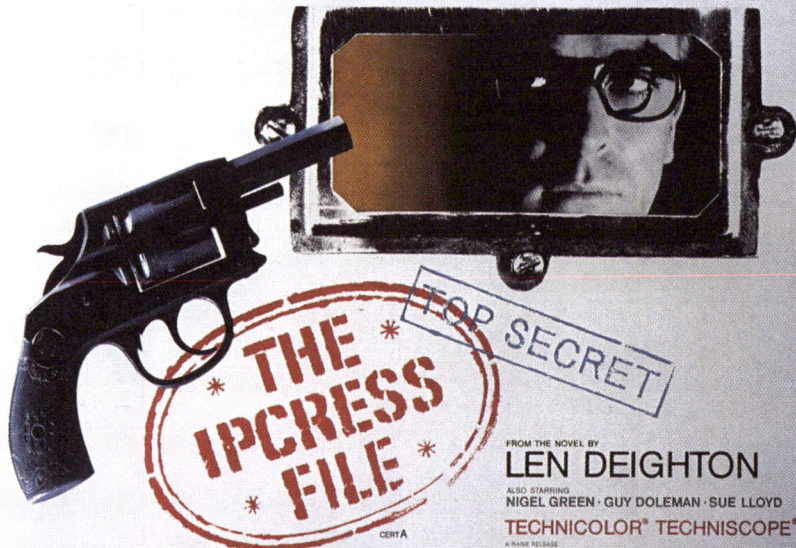

The Ipcress File *was, in many ways, the anti-Bond.*

Bond's set stood in contrast to the subdued, realistic espionage worlds depicted in *The Ipcress File* and the novels of John le Carré. In *The Ipcress File* (1962), Len Deighton introduces an unnamed protagonist, who is cynical, weary of bureaucracy, and sceptical of his superiors. The Cold War world he inhabits is mundane, more defined by government paperwork and office politics than by glamour. This approach strips espionage of its glamorised appeal, presenting a version of spy work that involves as much deception within one's own organisation as against the enemy. This was underscored further by Michael Caine's bespectacled and low-key portrayal of the character, now christened Harry Palmer, in the 1965 film adaptation.

The BBC television adaptation of Tinker Tailor Solder Spy *is often regarded as the definitive on-screen le Carré, with Alec Guinness giving an indelible performance as George Smiley.*

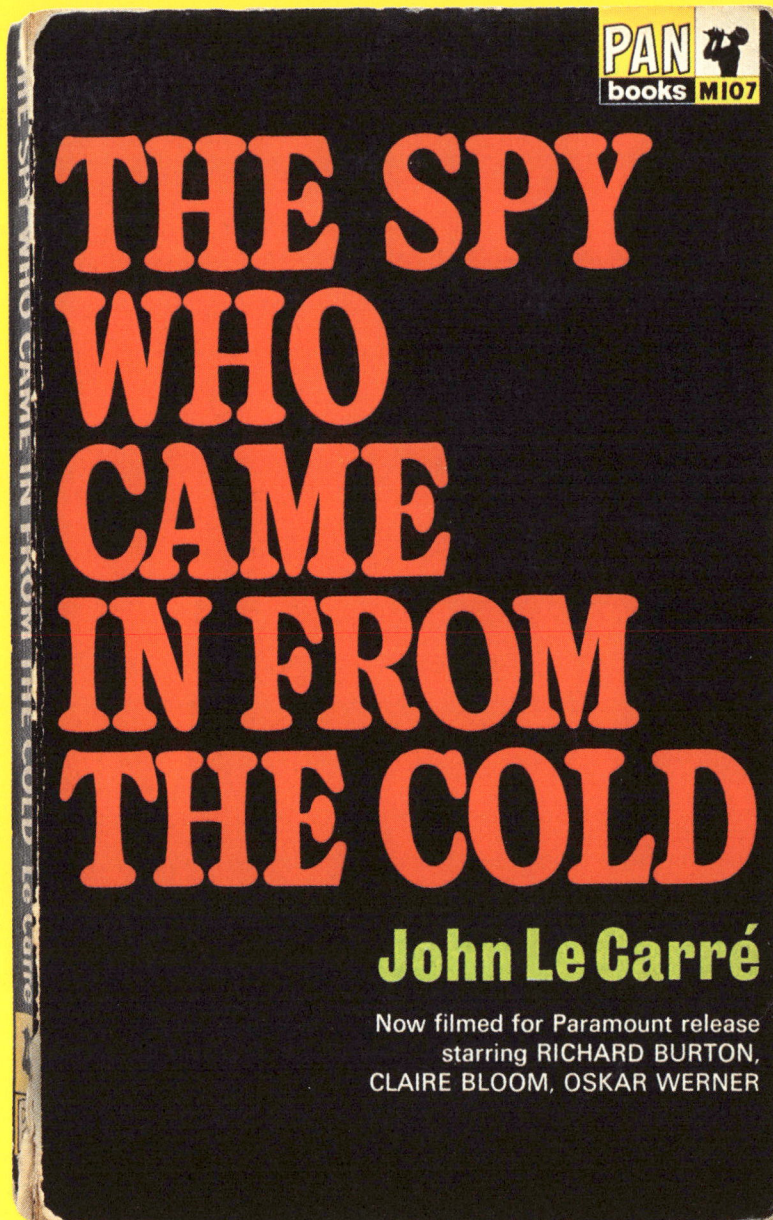

THE SPY WHO CAME IN FROM THE COLD

PAN books M107

John Le Carré

Now filmed for Paramount release
starring RICHARD BURTON,
CLAIRE BLOOM, OSKAR WERNER

The novels of John le Carré, including The Spy Who Came in
from the Cold, *are grounded, realistic depictions of spying
drawn from the author's own background in espionage.*

The novels written by John le Carré take this a step further, delving deeply into the psychological and moral conflicts that define the world of intelligence. Le Carré was a pseudonym for David Cornwell, a genuine intelligence operative who worked for both MI5 and MI6 in the 1950s and 1960s. Cornwell wrote his first spy novels while still in the employ of the security services, hence the very real need for a penname. His career as an agent was ended due to the hysterical suspicion around spies' double lives, brought to the fore by Kim Philby, leading le Carré to a full-time literary career.

In novels such as *The Spy Who Came in from the Cold* (1963) and *Tinker Tailor Soldier Spy* (1974), le Carré's protagonists, Alec Leamas and George Smiley, are haunted by their roles. They lack Bond's self-assurance, often facing disillusionment with both the West and the Soviet bloc. Le Carré's espionage landscape is one of moral ambiguity, where alliances and loyalties are constantly shifting, and victories are rare and hollow. Smiley faces adversaries who are reflections of himself: ordinary men and women caught up in a game dictated by ideology, loyalty, and often betrayal by their own side. Unlike Bond, who is celebrated for his resourcefulness and charm, le Carré's spies endure isolation, manipulation and betrayal, emphasising that even 'success' in espionage comes at a personal cost.

Like Fleming and Deighton, le Carré also saw his novels adapted for the screen. *Tinker Tailor Solider Spy* most closely resembles the betrayals of the 1960s, especially that of Philby, which led to the end of le Carré's career in espionage. The contrast with Bond is obvious, and it is even more pronounced in Alec Guinness's portrayal in the acclaimed BBC dramatisation. Yet it is the onscreen version of Leamas by Richard Burton in the adaptation of *The Spy Who Came in from the Cold* (1965) that offers the most striking comparison. Himself a one-time Hollywood pin-up, Burton plays a weary, haggard, and depressed drunkard. Burton's burned-out British spy is given a final mission to frame East German intelligence officer Mundt as a British double agent. He pretends to defect, sinking into layers of deception. Along the way, he forms a genuine bond with Nan, a Communist Party member, but soon discovers she is also part of the trap set by his superiors. In the climax, Leamas and Nan try to escape to West Berlin

but are betrayed. As they attempt to cross the Berlin Wall, Nan is shot dead, and a disillusioned Leamas chooses to die beside her, realising the brutal futility of his spy work.

Ultimately, the Bond films provided an escapist adventure steeped in glamour and excitement, a relief from the disheartening realities of Cold War espionage. While Bond offers audiences a reassuring hero in a dangerous world, Deighton and le Carré's spies pull back the curtain to reveal a grittier, morally ambiguous world. They ask us to question the very nature of that world and the true cost of loyalty, secrecy, and sacrifice. Taken as a whole, though, these spy novels and films highlight the pervasive fascination with espionage throughout the Cold War, reflecting in their own way the very real stories of spying, sex, and scandal that often dominated the headlines. While critics and scholars may have preferred the gritty realism of George Smiley, the public flocked to see Bond, revelling in each new adventure as he kept Britain safe and stopped the Cold War becoming a Hot War.

Ring of Spies – *a dramatisation of the Portland Spy Ring scandal – was another in the cycle of spy movies in the 1960s. Pictured is actress Nancy Nevinson as Helen Kroger.*

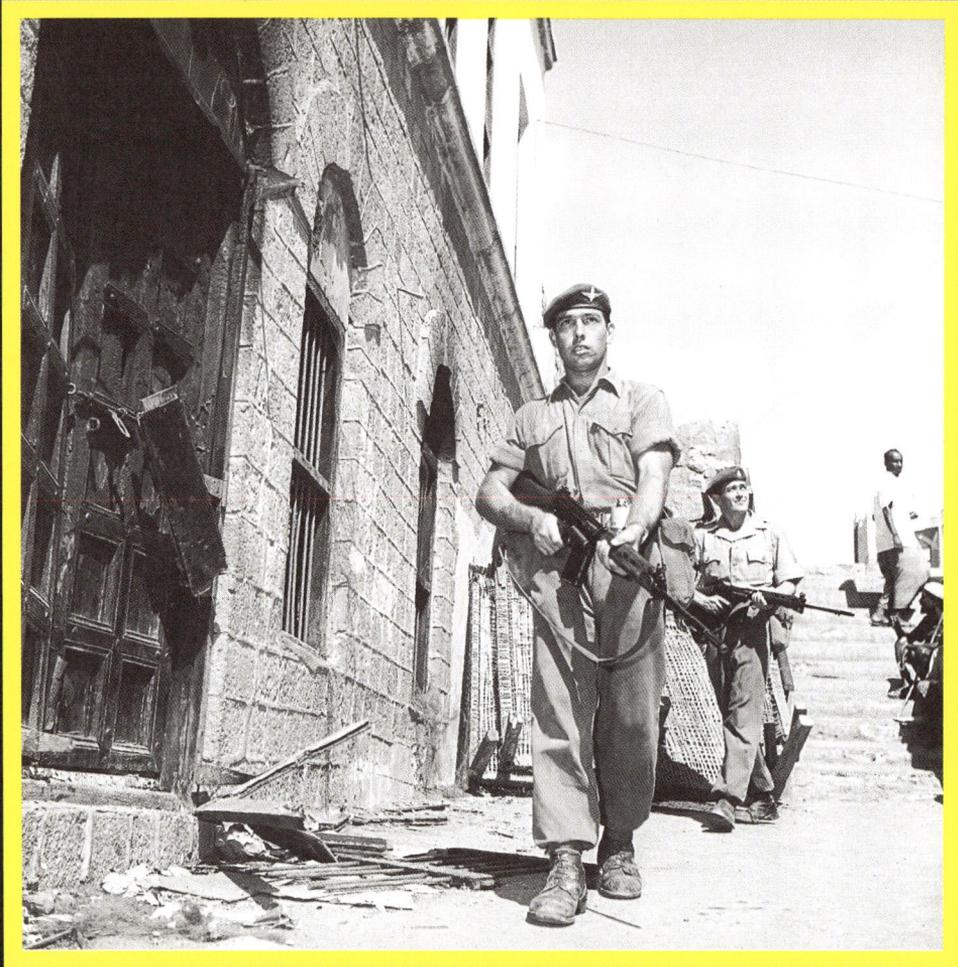

Parachute Regiment Lance Corporals, Michael Langdon and David Mitchell, patrol outside the charred remains of the synagogue in the Crater area of Aden, which was set on fire during rioting.

CHAPTER 4
HOT
WARS

For most Britons, spies were the subject of paperback thrillers, blockbuster movies, and salacious tabloid headlines. For a select few, though, spying was a very real fact of life. Most spies undertook their work professionally, with precision, and secretly. Equally, for most British people, the Cold War is not remembered as a time of war. For all the fear engendered by nuclear weapons, there was no mass conflagration between nations like that of the Second World War, which was still very much part of living memory. Yet two groups of British military personnel served a vital, long-running, and now largely forgotten role, on the very frontline of the Cold War.

BRIXMIS, the British Commanders'-in-Chief Mission to the Soviet forces in Germany, operated from 1946 until the end of the Cold War in 1990. Established under reciprocal post-war agreements, BRIXMIS represented a unique arrangement, allowing British forces to maintain a military liaison in the Soviet-occupied zone of Germany. Though officially a diplomatic link between the two sides, BRIXMIS was, in reality, an intelligence-gathering operation tasked with observing Soviet activities in East Germany.

Soviet soldiers spot a BRIXMIS patrol.

Its work involved daring and often dangerous reconnaissance missions. Teams regularly ventured into East German territory, using unmarked vehicles and covert photography to capture images of Soviet military hardware – tanks, aircraft, and communication systems – essential for understanding the scale and capabilities of the Soviet military. Such activities, though technically allowed under the liaison agreement, carried significant risk. Encounters with Soviet or East German forces could lead to vehicle-ramming, detainment and harassment, and BRIXMIS personnel were trained to avoid detection and capture.

Despite the ever-present threat, BRIXMIS provided NATO with vital intelligence, informing the West's understanding of Soviet advancements. The information gathered by BRIXMIS directly informed military tactics and strategic decisions, contributing to NATO's overall deterrence posture throughout the Cold War. Intelligence was not the only feature of the British presence in Germany. As the epicentre of East–West tensions, the divided nation was for many the de facto Cold War frontline, and as with any frontline, there were armed troops stationed there.

The second group was the British Army of the Rhine (BAOR), a critical component of Britain's Cold War strategy, tasked with defending Western Europe against the threat of a Soviet invasion. Formally established in 1945, the BAOR was initially an occupation force tasked with overseeing reconstruction, demilitarisation and de-Nazification in the aftermath of the Second World War. As Cold War tensions mounted, however, it evolved into a frontline deterrent, stationed at the heart of NATO's European defences. Throughout the Cold War, the BAOR became both a symbol of Britain's commitment to collective security, and a formidable military force in its own right. The BAOR was restructured to serve as Britain's main contribution to NATO's defence of West Germany, standing as the first line of defence along the strategically critical Fulda Gap, one of the most likely routes for any potential Soviet military advance.

A major cause of alarm came in August 1961 when East German authorities, under Soviet direction, began constructing the Berlin Wall, a physical barrier that divided East and West Berlin. Erected almost overnight, the Wall was built to stop

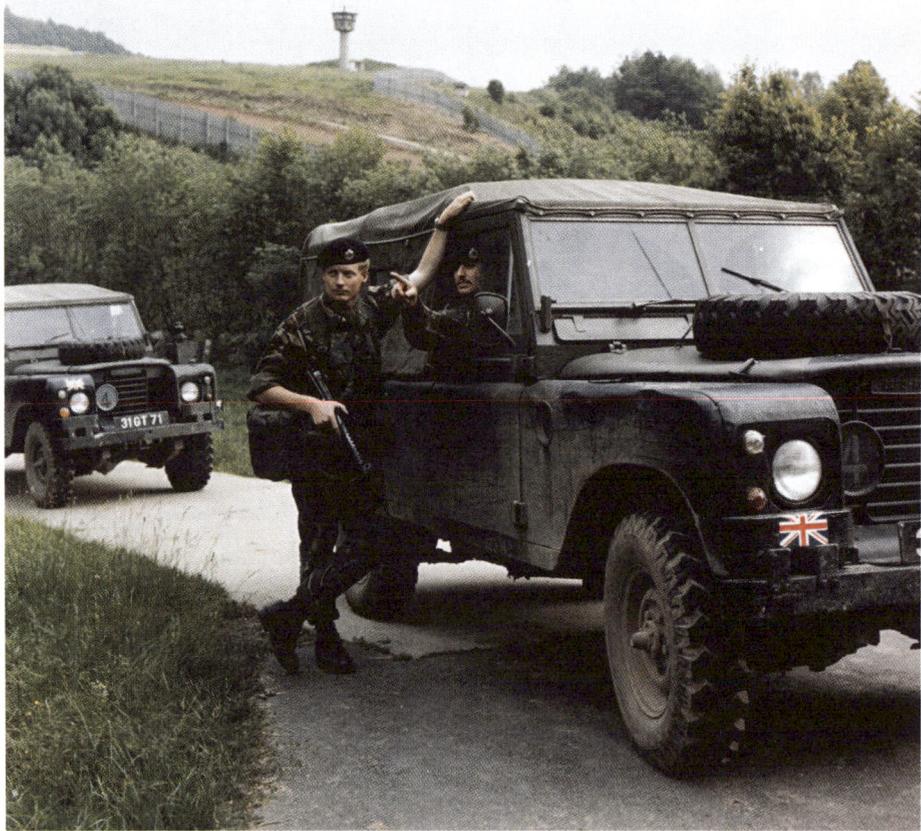

Two British Army Land Rover vehicles patrol the border between East and West Germany. An East German watchtower and border fencing can be seen in the background.

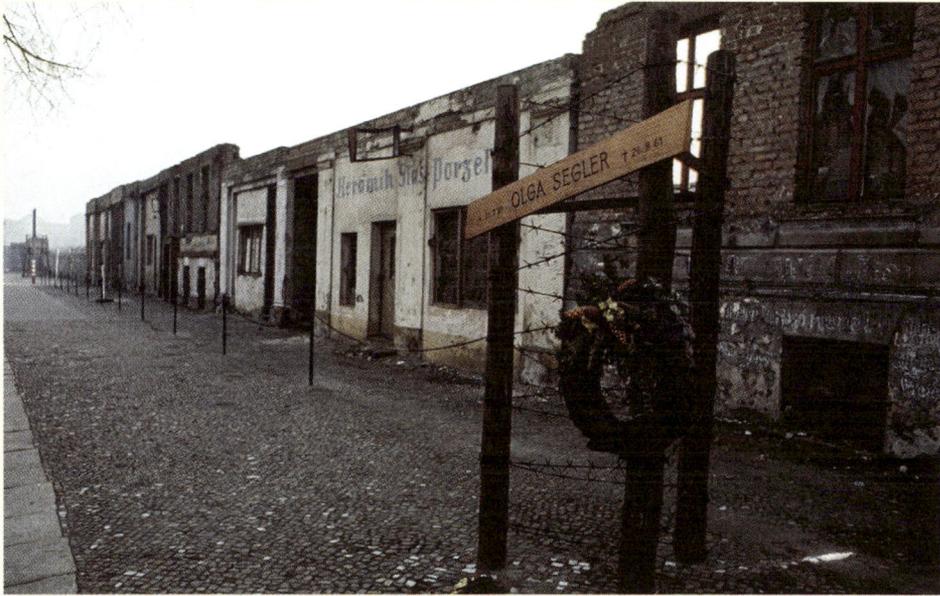

Shops cut off to make the Berlin Wall, with just the facades left standing in Bernauer Straße in the French sector. In the foreground is a memorial to a woman killed while trying to cross from East to West Berlin.

the flow of East Germans fleeing to the West, a mass exodus that highlighted the growing discontent with life under communist rule. Guarded by armed patrols and lined with barbed wire, the Wall quickly became a stark symbol of the Cold War divide, separating families, friends, and lives. British leaders, including Prime Minister Harold Macmillan, were quick to condemn the Wall's construction as a direct violation of post-war agreements. While Britain's response was largely diplomatic, focusing on international forums such as the United Nations, it also reinforced its military presence in West Berlin – the British Berlin Brigade – as a signal of commitment to the city's security. After 20 years as a separate force, the British Berlin Brigade was brought under the umbrella of the BAOR in the 1980s.

At its height, the BAOR comprised around 55,000 personnel, a mixture of infantry, armoured divisions, and artillery units, with the highly mechanised 1st British Corps as its backbone. Equipped with Chieftain tanks, armoured personnel carriers, and a formidable array of artillery, the BAOR was a key deterrent, signalling to the Soviet

Union that any attempt to breach Western Europe would meet immediate and determined resistance. At the same time, it underscored Britain's commitment to the NATO Alliance and reinforced the Special Relationship with the United States. Strategically positioned, the BAOR participated in extensive training exercises such as *Operation Lionheart* with American, German and other NATO forces, fostering a spirit of interoperability that would be essential in any potential conflict.

The BAOR also left a significant social and cultural impact, as generations of British soldiers and their families lived in Germany, fostering connections between British and German communities. This seeped into popular British television programmes of the period, particularly the ITV comedy-drama, *Auf Wiedersehen, Pet* (1983–86), which depicted a group of British construction workers who are forced to find employment overseas. With the fall of the Berlin Wall and the end of the Cold War, the BAOR's mission was ultimately declared complete. Britain

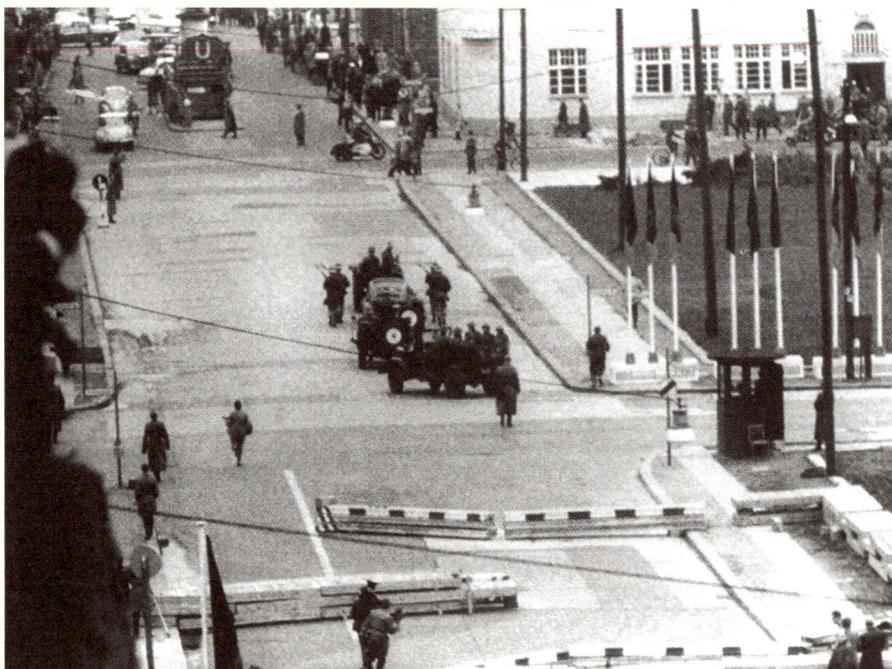

For the duration of the Cold War, Berlin was a heavily militarised city with, from 1961, the Berlin Wall at the centre of it.

Members of the British Army of the Rhine driving a Sultan ACV (Armoured Command Vehicle) on exercise in West Germany.

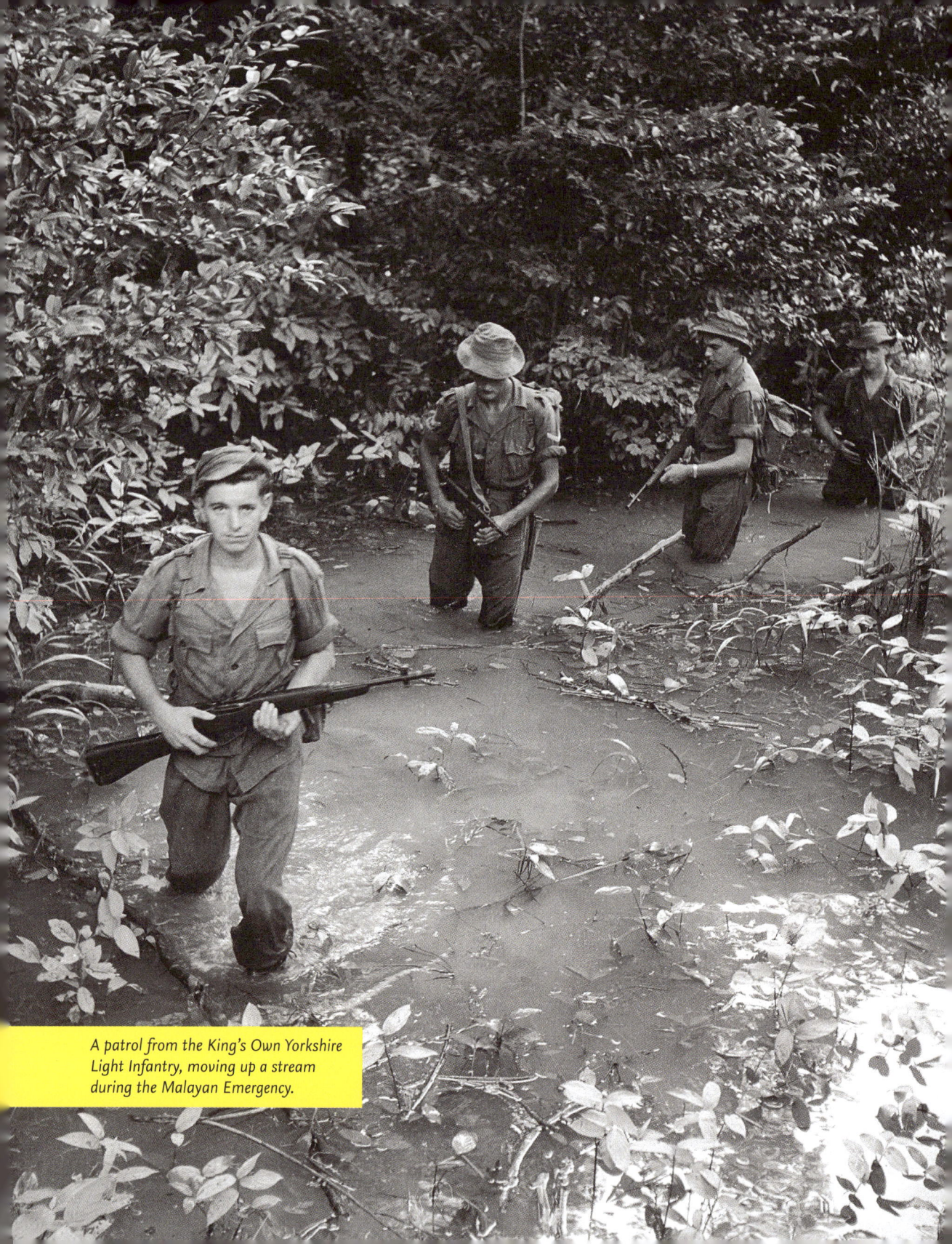

A patrol from the King's Own Yorkshire Light Infantry, moving up a stream during the Malayan Emergency.

gradually reduced its forces in Germany, and the BAOR was formally disbanded in 1994, but its legacy endures as a testament to Britain's role in NATO's Cold War defence of Western Europe.

Further afield than Western-Central Europe, Britain's empire was in decline in the aftermath of the Second World War. As the Cold War intensified, Britain found itself balancing its legacy of imperialism with its commitment to countering the spread of communism, particularly in regions still under its influence or recently independent. Throughout the Fifties and Sixties, Britain's involvement in conflicts across the globe served not only to protect its economic interests but also to bolster the Western bloc against a rising tide of Soviet-aligned forces. However, unlike the situation in West Germany, tense as it was, other British military entanglements were decidedly less 'cold'.

The Malayan Emergency was Britain's first significant military engagement of the era and despite more famous regional conflagrations, still stands as one of the most pivotal Cold War conflicts in Southeast Asia. As Britain's colonial interests in the economically vital Federation of Malaya faced rising resistance, the Malayan Communist Party (MCP) sought to seize control, establishing the Malayan National Liberation Army (MNLA) as its military wing. This communist insurgency erupted into open conflict in 1948, challenging British authority and threatening to tip the region towards Soviet influence.

To counter the insurgents, in an effort to maintain control over lucrative resources such as tin and rubber, Britain deployed a combination of military and political strategies, embracing a 'hearts and minds' campaign to win local support. Key to this approach was the Briggs Plan – the forced resettlement of rural communities, a controversial policy which denied the communists access to resources and shelter in Malaya's dense jungles but left 500,000 Malayan villagers in internment camps called 'new villages'. At the same time, Britain strengthened local governance, presenting itself as a stabilising political force. The Emergency officially ended in 1960, with British and Commonwealth troops emerging victorious. The success in Malaya became a model for counter-insurgency efforts in later conflicts,

A Douglas Dakota CI leads a Percival Pembroke C.I,
Scottish Aviation Twin Pioneer CCII, and Scottish Aviation Pioneer
CC.I over a river winding its way through the Malayan jungle.

but it also foreshadowed the difficulties Western powers would face in the ideological battlegrounds of Asia. In suppressing the MCP, Britain effectively curbed communist expansion in Southeast Asia, yet the broader struggle for independence in the region continued. Over 500 British servicemen lost their lives in Malaya, while other Commonwealth troops also suffered casualties. At least 11,000 Malayans were killed.

If the Malayan Emergency was a relic of Britain's imperial battles, the Korean War marked a critical turning point in Britain's post-war foreign policy, solidifying its role as a committed player in Cold War conflicts. When North Korean forces crossed the 38th parallel on 25 June 1950, launching a full-scale invasion of South Korea, the international community quickly recognised the threat posed by communist expansion in East Asia. Within days, the United Nations Security Council called

Two-inch mortars in use by men of the King's Own Scottish Borderers during the Korean War. In the pit is Private Tom Lapere, with Private Alec Ewan directing the fire.

upon its member states to defend South Korea, and Britain responded without hesitation. Despite the strains of post-war austerity and the demands of maintaining its empire, Britain joined the UN-led coalition, contributing ground, naval, and air support to one of the first major conflicts of the Cold War.

Britain committed substantial land forces to the Korean Peninsula, dispatching units from the British Army under the 27th British Commonwealth Infantry Brigade. British soldiers joined troops from South Korea, the United States, and other UN nations to form a united front against the North Korean People's Army. For British troops, the Korean terrain presented an extreme environment of freezing winters and rugged mountains, conditions that would prove challenging for even the most seasoned soldiers. Among the British forces' key engagements was the Battle of the Imjin River in April 1951, a defining moment for Britain in the Korean War. Facing overwhelming Chinese forces, the 29th British Brigade, which included troops from the Royal Ulster Rifles, the Gloucestershire Regiment, and Belgian and Filipino allies, defended its position while heavily outnumbered, inflicting serious casualties on the advancing Chinese troops and delaying their push towards Seoul. The Gloucestershire Regiment's stand became legendary. Despite being cut off and ultimately captured, they fought tenaciously, earning respect and recognition for their resilience.

Britain's substantial naval presence in Korean waters was a cornerstone of its military contribution. The Royal Navy deployed an array of vessels, including aircraft carriers, cruisers, and destroyers, to support UN forces, secure maritime routes, and blockade the North Korean coast. The light cruiser HMS *Belfast*, one of the few remaining major British warships from the Second World War, was recommissioned in 1950 specifically to join the forces in Korea, where she frequently served as the flagship for British and Commonwealth naval contingents. The Royal Navy's ships were often involved in bombardments of coastal positions, using their heavy guns to destroy enemy artillery and disrupt supply lines. In addition to conventional fire support, British naval vessels were responsible for protecting United Nations transport ships and amphibious landings, including the pivotal Inchon Landing in September 1950. This high-stakes assault, led by

HMS Belfast in service during the Korean War.
An American S-51 helicopter flies overhead as
the ship patrols the Yellow Sea in 1951.

*Walking along a typical Korean hillside trench
is Private Jack Crawford of Company A,
3rd Battalion, Royal Australian Regiment.*

US General Douglas MacArthur, allowed UN forces to reclaim Seoul and marked a turning point in the conflict.

Though the Royal Air Force itself did not play a frontline role in Korea, British pilots contributed to air operations through the Fleet Air Arm, operating from British aircraft carriers. The Fleet Air Arm conducted both reconnaissance and ground-attack missions, striking North Korean and Chinese positions, disrupting supply lines, and reducing the pressure on UN troops. Operating from cramped carrier decks in harsh conditions, British aviators demonstrated exceptional skill and adaptability. Their contribution underscored Britain's versatility and commitment to supporting UN forces from multiple fronts.

Beyond the battlefield, Britain's political and diplomatic engagement in the Korean War reflected its nuanced approach to Cold War conflicts. Dependent on American financial aid, and keen to share nuclear secrets, Prime Minister Clement Attlee's government faced the challenge of supporting American-led efforts without compromising Britain's interests or risking further escalation with the Soviet Union or China, particularly given China's entry into the war in late 1950. In private discussions with US President Harry S. Truman, Attlee urged caution. His diplomatic approach sought to temper the more aggressive strategies favoured by some US officials, highlighting Britain's role as a stabilising influence within the alliance. Britain's emphasis on caution in Korea would become characteristic of its Cold War diplomacy, with British leaders often acting as mediators between the US and other powers.

The British government was deeply invested in maintaining cohesion within the Commonwealth. Encouraging participation from other Commonwealth nations, Attlee's government helped build a multinational force that included troops from Canada, Australia, New Zealand, and South Africa. This Commonwealth contribution reinforced Britain's influence within the United Nations coalition, underscored its commitment to collective security, and justified the long-term approach of balancing alignment with the United States and maintaining long-held ties with former colonised nations.

Of the nearly 100,000 British servicemen deployed over the course of the war, 1,100 were killed, and over 3,500 wounded or taken prisoner. Yet, the heroism displayed at battles like the Imjin River, the effectiveness of British naval forces in blockade and bombardment, and the tenacity of British pilots has often been forgotten. Indeed, in Britain, America, and in South Korea itself, the war is sometimes referred to as the 'Forgotten War', overshadowed by subsequent conflicts. But the Korean War should be remembered for its lessons in resilience, diplomacy, and the strategic importance of alliances. Today, British veterans of the Korean campaign are honoured for their contributions, and the conflict remains a significant, if understated, part of Britain's Cold War legacy.

Men of the 1st Battalion, Dorsetshire Regiment with South Korean soldiers during the handover of the 'Lozenge' position to the 4th ROK Infantry Division.

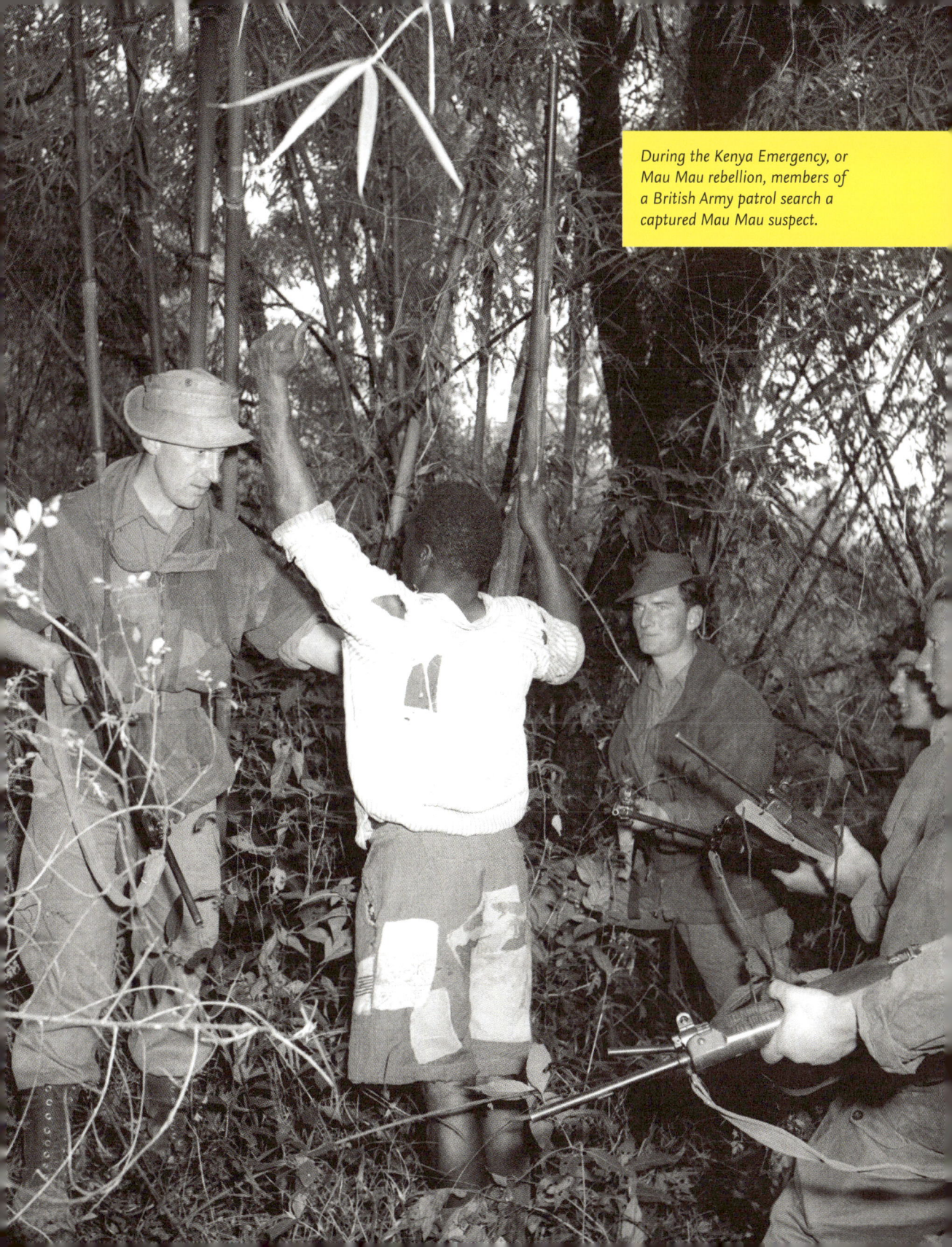

During the Kenya Emergency, or Mau Mau rebellion, members of a British Army patrol search a captured Mau Mau suspect.

Further 'hot wars', concerning both Britain's imperial interests and its international alliances, would follow. In 1952, the British colony of Kenya faced an uprising from the Kikuyu people, led by the Mau Mau movement. Rooted in issues of land ownership, economic inequality, and political disenfranchisement, the uprising reflected a deep-seated resentment against colonial rule. For Britain, this conflict posed both a colonial and ideological challenge, as the uprising quickly garnered international attention and cast a spotlight on the imperial system's inherent tensions. Britain responded with a repressive military campaign and the establishment of detention camps for thousands of suspected Mau Mau sympathisers, where evidence of torture, abuse, and severe maltreatment emerged. While Britain ultimately suppressed the uprising, the campaign's brutality left a

Operation Black Mac: Corporal Tom Westcott of the 2nd Battalion, The Parachute Regiment, crouches beside the opening in the floor of a kitchen in a Cypriot mountain village house, which leads to an underground room where six terrorists are hiding.

lasting legacy of trauma and controversy, and exposed the underlying instability of British colonial rule in Africa, where anti-colonial sentiment was gaining momentum. By 1963, Kenya gained its independence, part of a broader wave of decolonisation across the British Empire.

The Cyprus Emergency, a struggle for independence and national identity, saw Britain grappling with similarly complex issues, only this time in Europe. In 1955, the Greek Cypriot nationalist group EOKA launched a campaign for enosis (union with Greece), challenging Britain's colonial rule. For Britain, Cyprus was more than a colonial holding; it was a strategically valuable location, essential for military operations in the Eastern Mediterranean and a critical component of NATO's defence network. Greece and Cyprus had, of course, been central to Churchill's machinations with Stalin years earlier, for similar reasons. Britain's response to the insurgency involved both military action and political negotiation, aiming to dismantle EOKA's network while balancing the competing interests of the island's Greek and Turkish communities. The insurgency escalated into a

National servicemen of the 1st Battalion, The Royal Ulster Rifles, search a bus at a roadblock during the EOKA Emergency in Cyprus.

full-blown conflict, testing Britain's ability to maintain control without alienating either community. In 1959, the Zurich and London Agreements granted Cyprus its independence, though Britain retained sovereign base areas crucial to its strategic interests. Tensions in the region persisted between the Greek and Turkish populations, leading to serious conflict in 1964, before a Greek-backed coup overthrew the Cypriot president in 1974, leading to Turkish invasion and the partition of the island that remains in place today.

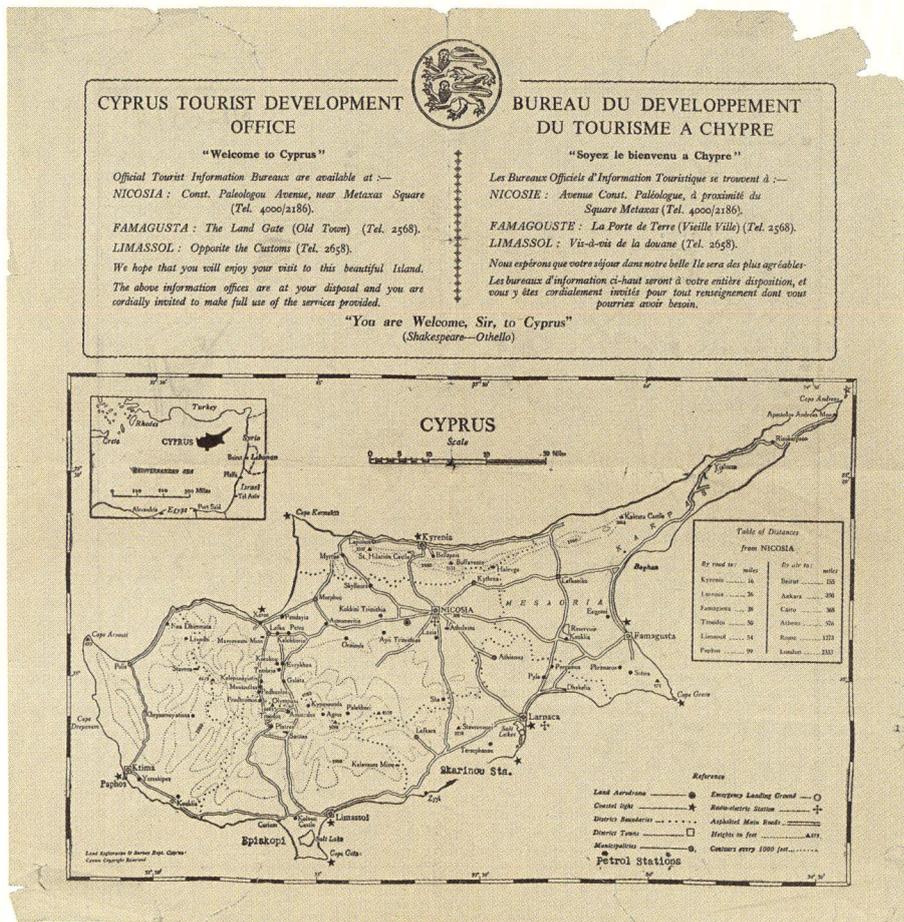

This map belonged to a member of 3 Commando Brigade involved in anti-terrorist operations during 1956–57.

THE BRITISH EMPIRE IN EGYPT

From the mid-nineteenth century, Britain's interest in Egypt was driven by its vital location along the route to India, and grew exponentially following the completion of the Suez Canal between the Mediterranean and the Red Sea in 1869. Initially, Britain's role in Egypt was indirect, marked by economic influence rather than formal control. Following the construction of the Suez Canal, Egypt's mounting debt eventually prompted Britain and France to intervene further, taking full control of Egypt's economy in the 1870s.

By the early 1880s, resentment at this financial domination erupted into a nationalist uprising. In 1882, British troops defeated the forces of Colonel Ahmed Urabi at the Battle of Tel el-Kebir and established a de facto occupation. Though Egypt remained nominally part of the Ottoman Empire, it was effectively governed as a British protectorate.

Under British control, Egypt became a cornerstone of imperial strategy. British administrators focused on securing the Suez Canal and maintaining stability, often at the expense of social reforms or addressing local grievances. The economy was reorientated to benefit imperial interests, with cotton production dominating agriculture to supply British textile mills.

In 1914, as the Ottoman Empire joined the Central Powers in the First World War, Britain formally declared Egypt a protectorate and deposed the ruling khedive, replacing him with a sultan loyal to British interests. Egyptian resentment reached boiling point during the First World War, culminating in revolution in 1919. While Britain granted Egypt nominal independence in 1922, real power remained in British hands, particularly over foreign policy, defence, and the Suez Canal.

The interwar years saw growing nationalist agitation, but Britain maintained a military presence and used Egypt as a base during the Second World War. By the 1940s, tensions between Britain and Egyptian nationalists flared again. The rise of the Free Officers Movement, led by figures such as Gamal Abdel Nasser, signalled a new era of anti-colonial resistance.

LAND AND
SUEZ CANAL
PEOPLE : 6

HERE is something different in the Pictorial Review series. This time we want YOU to answer the following questions :—

Q. On what strategic basis was the canal first conjectured and by whom ?
Q. What obstacles were met with in realising this project ?
Q. Who eventually planned and carried out this vast undertaking ?
Q. What was the initial British attitude towards the project ?
Q. How long did the Canal take to build and when was it opened for navigation ?
Q. Who owns the Suez Canal and to what extent is Britain involved ?
Q. How is the Canal financed ?
Q. Indian Army and Canadian War Memorials are erected on the banks of the Canal—why ?
Q. Can two ships pass each other in the Canal ?
Q. About how long does the passage of the Canal take by a steamship ?

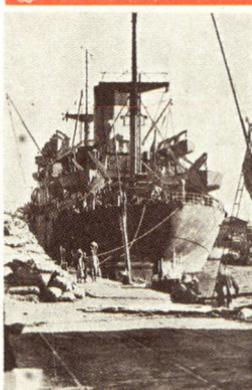

THE
SUEZ CANAL
COMPANY'S
MAP
OF THE
CANAL

PLAN
GÉNÉRAL
DU CANAL

Pictorial Review
No. 86
Crown Copyright Reserved
Army Education, M.E.L.F.

Printed by The Printing and Stationery Service, M.E.L.F. 8-47

Although Egyptian-owned, Britain had maintained control over the Suez Canal in one form or another since 1888.

This confluence of Cold War geopolitics and the rising tide of anti-colonial nationalism is best illustrated by one of Britain's most misbegotten military escapades. The Suez Crisis of 1956 marked a profound turning point in British foreign policy and irrevocably revealed the limits of Britain's influence in a Cold War world dominated by superpower politics. At its core, the crisis stemmed from Britain's longstanding control over the Suez Canal, a crucial maritime route linking Europe to the oil-rich Middle East and Asia. The canal was not only economically vital for Britain, but also symbolised its remaining imperial power. By the mid-1950s, however, nationalist movements were on the rise across the colonial world, and Egypt, under the leadership of President Gamal Abdel Nasser, stood at the forefront of this wave.

The spark for the crisis came on 26 July 1956, when Nasser nationalised the Suez Canal, following the American withdrawal of funding for his prized Aswan Dam project. Nationalisation removed control of the waterway from the British and French government-backed companies who owned it. For Britain, this was an affront to its prestige and to its economic interests. At the time, roughly two-

The Royal Navy's LST 3513 moves into Port Said during the landings of 6 November 1956.

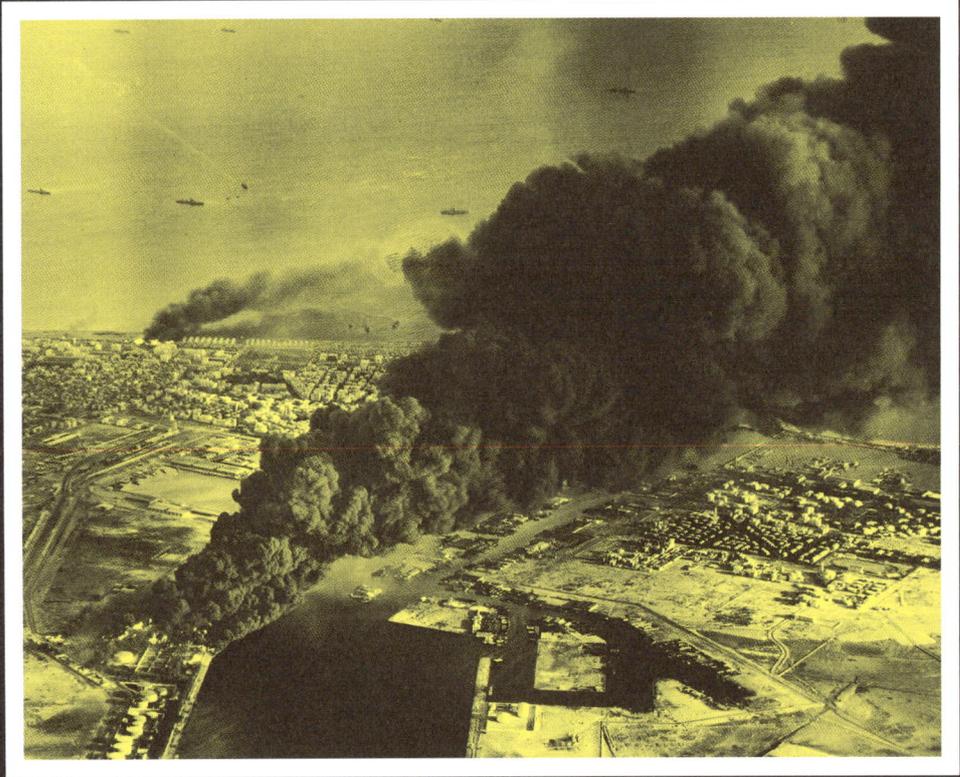

Smoke rises from oil tanks beside the Suez Canal, hit during the initial Anglo-French assault on Port Said, 5 November 1956.

thirds of Western Europe's oil passed through the Suez Canal, and British leaders feared that losing control over this route would jeopardise their economy and position in the Middle East. Prime Minister Anthony Eden was also deeply concerned that Nasser's actions would inspire other nationalist leaders across the Arab world and encourage Soviet expansionism in the Middle East, further threatening Western access to oil. Serious tensions had also developed between Egypt and Israel, centred around Egypt's military build-up of Soviet-supplied weaponry, vocal support for Palestinian militant attacks, and Nasser's anti-Israeli rhetoric. Acting in concert, Britain, France, and Israel concocted a plan to handle their mutual enemy.

On 29 October 1956, Israeli forces moved into the Sinai Peninsula, swiftly advancing towards the canal. Britain and France issued an ultimatum, and when Egypt predictably refused, British and French forces began bombing Egyptian positions around the canal. However, the intervention quickly attracted international condemnation. The US President Dwight D. Eisenhower viewed the operation as

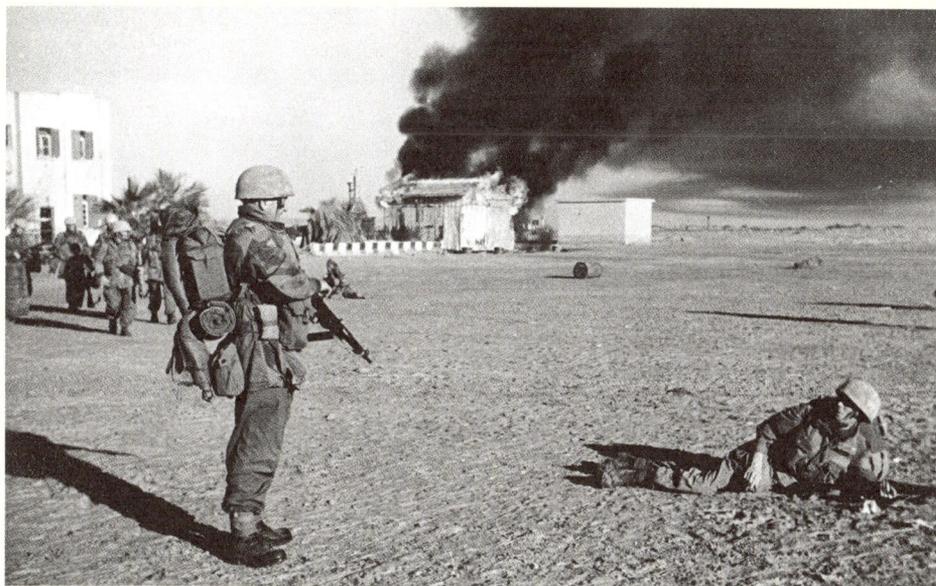

Men of 'A' Company, 3rd Battalion, The Parachute Regiment, after taking the buildings on El Gamil airfield.

a reckless colonial adventure that risked destabilising the region and distracting from the broader Cold War objectives. Eisenhower was particularly incensed at being kept in the dark by Britain and France, and he worried that the crisis could push newly independent nations towards the Soviet camp.

Under pressure from both the United Nations and the United States, Britain and France faced a humiliating diplomatic backlash. The US threatened economic sanctions against Britain, including potentially destabilising the British pound, which left Eden's government with little choice. Despite the Special Relationship, one nation was without doubt the senior partner. Britain agreed to a ceasefire and withdrew its forces by the end of 1956. Across the brief military engagement, 16 British soldiers and airmen had been killed, ultimately for a political folly. On 9 January 1957, Eden resigned. Publicly citing ill health as the reason, the damage to his reputation and the strain from the Suez Crisis were widely understood to be the principal factors leading to his decision. For the man who had been Churchill's protégé, it was an embarrassing, ignominious end to a distinguished career. For the country more broadly, the Suez Crisis was a stark and lasting reminder of Britain's diminished power in a bipolar world and marked the end of its imperial influence in the Middle East.

Britain would be drawn again into the region in 1963 when a grenade attack by nationalists at Aden Airport killed a British official, sparking a broader anti-colonial uprising. Two rival groups, the National Liberation Front (NLF) and the Front for the Liberation of Occupied South Yemen (FLOSY), waged a guerrilla campaign against British forces, employing bombings, ambushes and assassinations, fuelled by external support from the Soviet Union and Egypt. British forces, including the SAS, launched counter-insurgency operations, but urban unrest and mountainous terrain gave insurgents the advantage, while the rivalry between NLF and FLOSY complicated the conflict further. By 1967, increasing casualties, local unrest, and pressure to decolonise led Britain to withdraw, ending 130 years of colonial rule. The People's Republic of South Yemen, a Marxist state aligned with the Soviet bloc, emerged soon after.

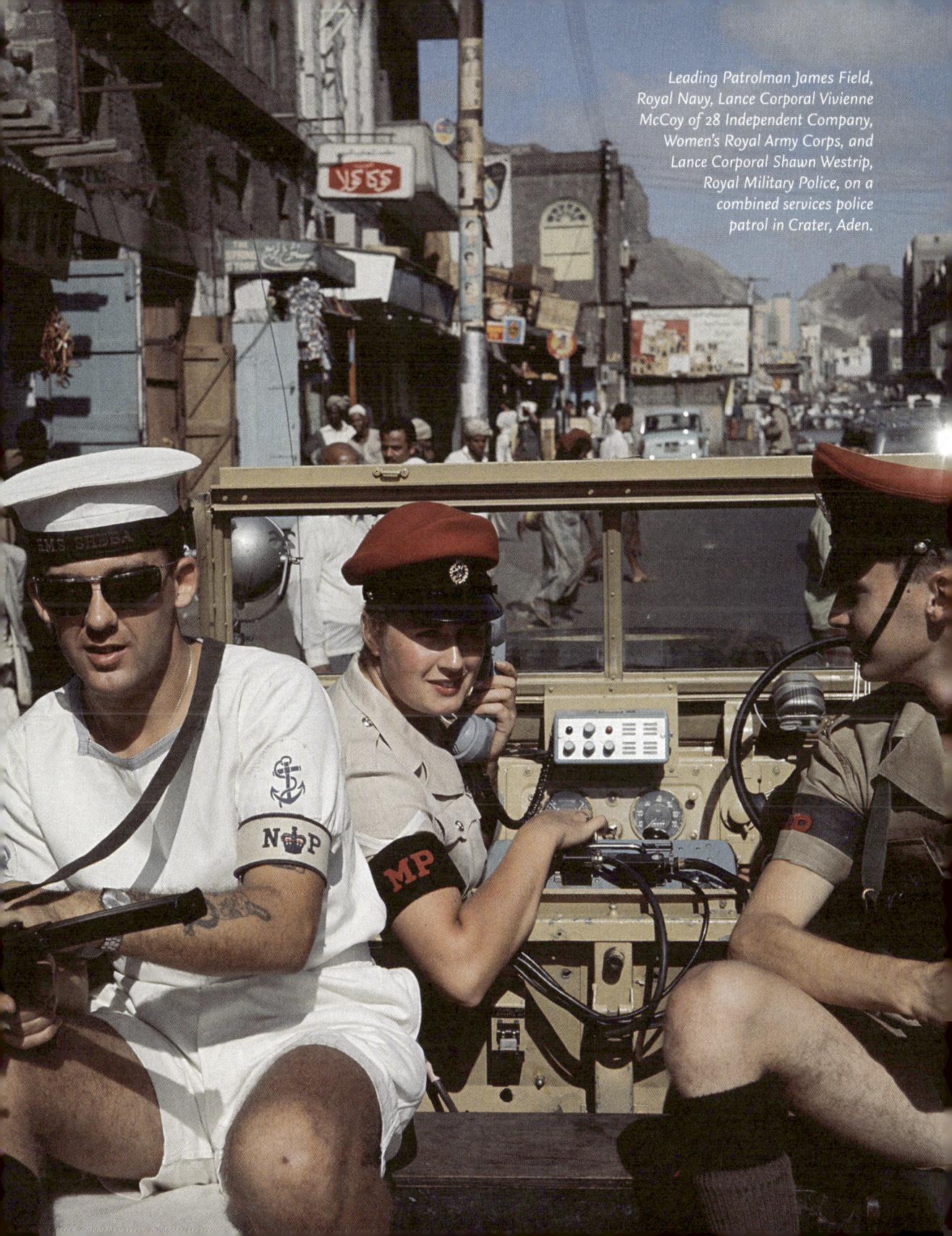

Leading Patrolman James Field, Royal Navy, Lance Corporal Vivienne McCoy of 28 Independent Company, Women's Royal Army Corps, and Lance Corporal Shawn Westrip, Royal Military Police, on a combined services police patrol in Crater, Aden.

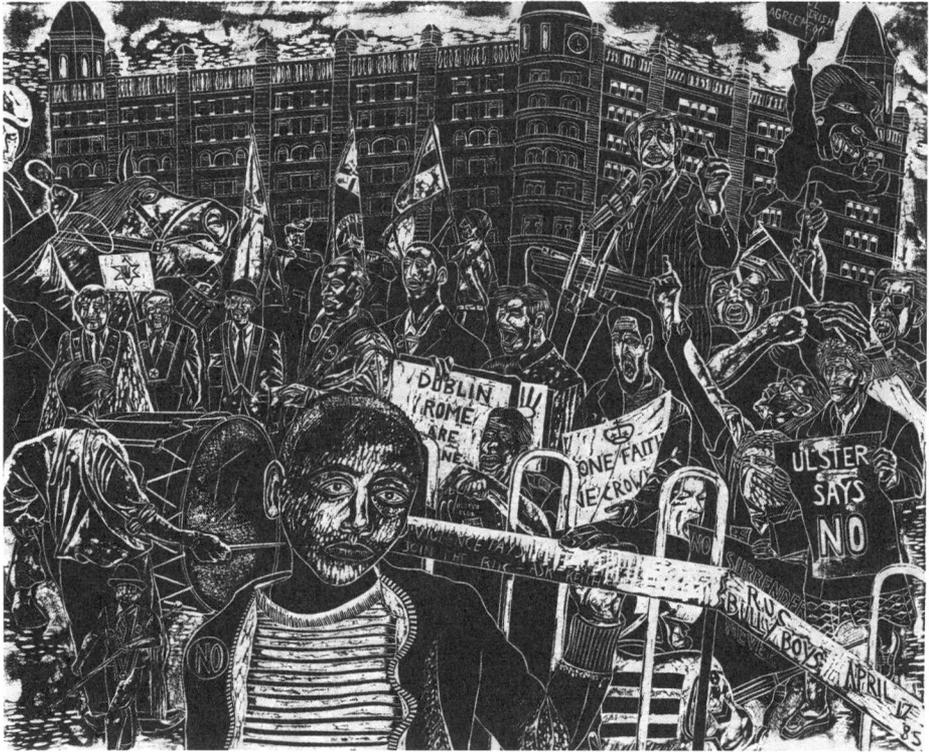

*Anthony Davies' stark black-and-white artworks made during
the Troubles remain striking depictions of the period.*

The conflicts in Malaya, Korea, Egypt, Kenya, Cyprus, and Aden all took place far from British shores and marked the end of an empire that many Britons had ceased caring about. In fact, most of these engagements failed to last in the popular memory. By the late 1960s, however, Britain was engaged in a violent conflict on its own doorstep, one that would dominate the public consciousness throughout the next 30 years. The Troubles in Northern Ireland, spanning from the late 1960s to 1998, were rooted in complex political, ethnic, and religious tensions, but they unfolded against the backdrop of the Cold War, intertwining with the global ideological struggle in nuanced ways, and influenced actions on both sides of the East–West standoff.

At the heart of the Troubles was a nationalist push for independence from Britain, spearheaded by groups like the Irish Republican Army (IRA), and especially its offshoot the Provisional IRA. While the IRA's mission was driven by nationalist motivations, rather than communist, the conflict resonated with anti-imperialist and left-wing movements worldwide. Tactically, the methods employed by the IRA would have been remarkably familiar to British soldiers who had served in Malaya and Cyprus. The car bombs, attacks on public meeting places such as pubs, and violent reprisals against suspected collaborators mirrored the guerilla tactics employed in these and other conflicts. Despite their experience of similar scenarios, the British were unprepared to face such action on domestic streets that looked like their own, and the force of violence and loss of life accelerated throughout the early years of the Troubles, culminating in the bloodshed of 1972. This was the deadliest year of the entire conflict, with 479 people killed across events such as 30 January – 'Bloody Sunday' – in Derry/Londonderry, and the Belfast bombings of Bloody Friday, 21 July.

The IRA found sympathy and occasional financial and logistical support from elements within the Soviet bloc and from left-wing organisations abroad that viewed Britain's presence in Northern Ireland through an anti-colonial lens. One of the clearest examples of IRA access to Soviet weaponry came via Libya. The Libyan leader, Muammar Gaddafi, provided the IRA with considerable arms shipments during the 1970s and 1980s, including AK-47 rifles and RPG-7 rocket launchers.

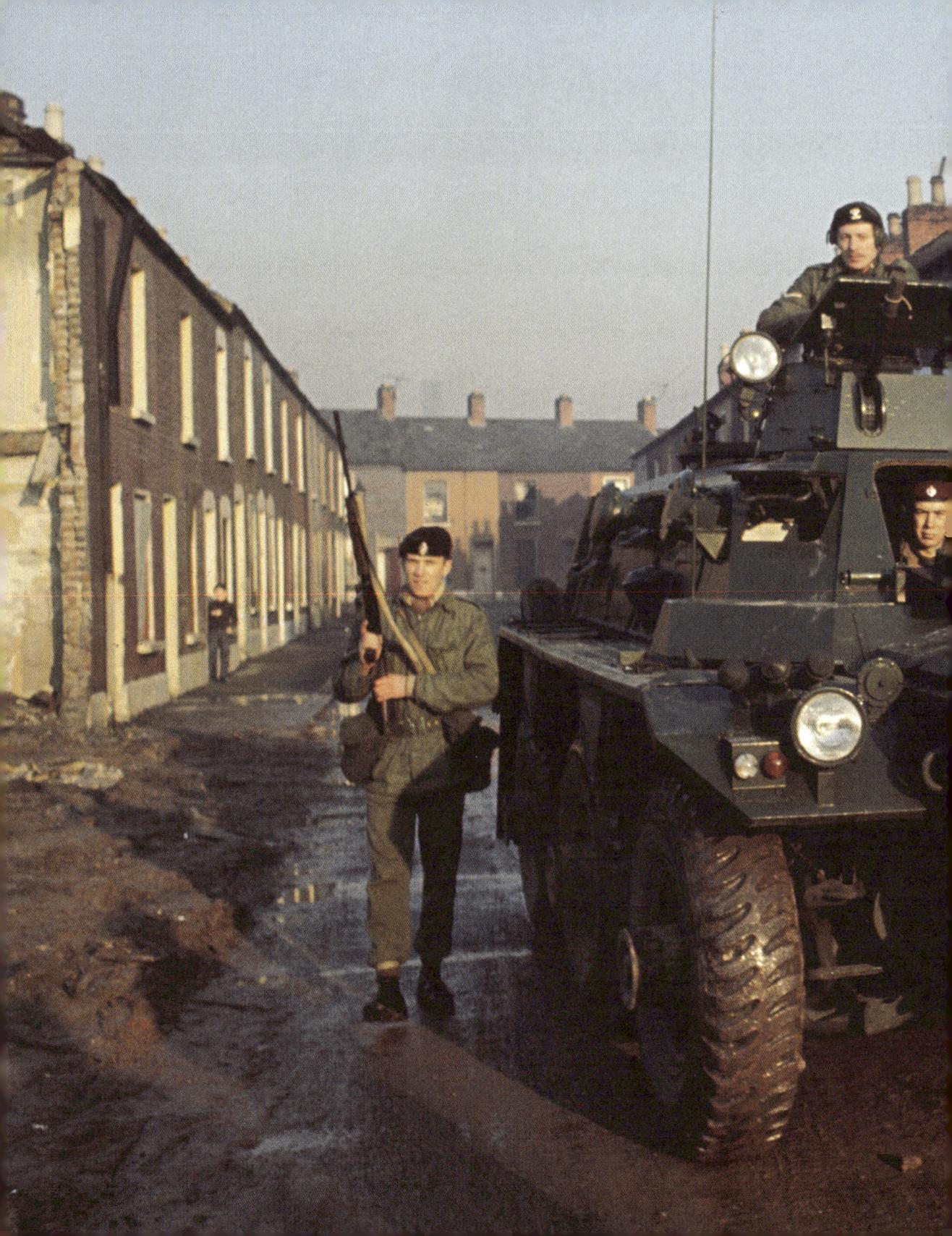

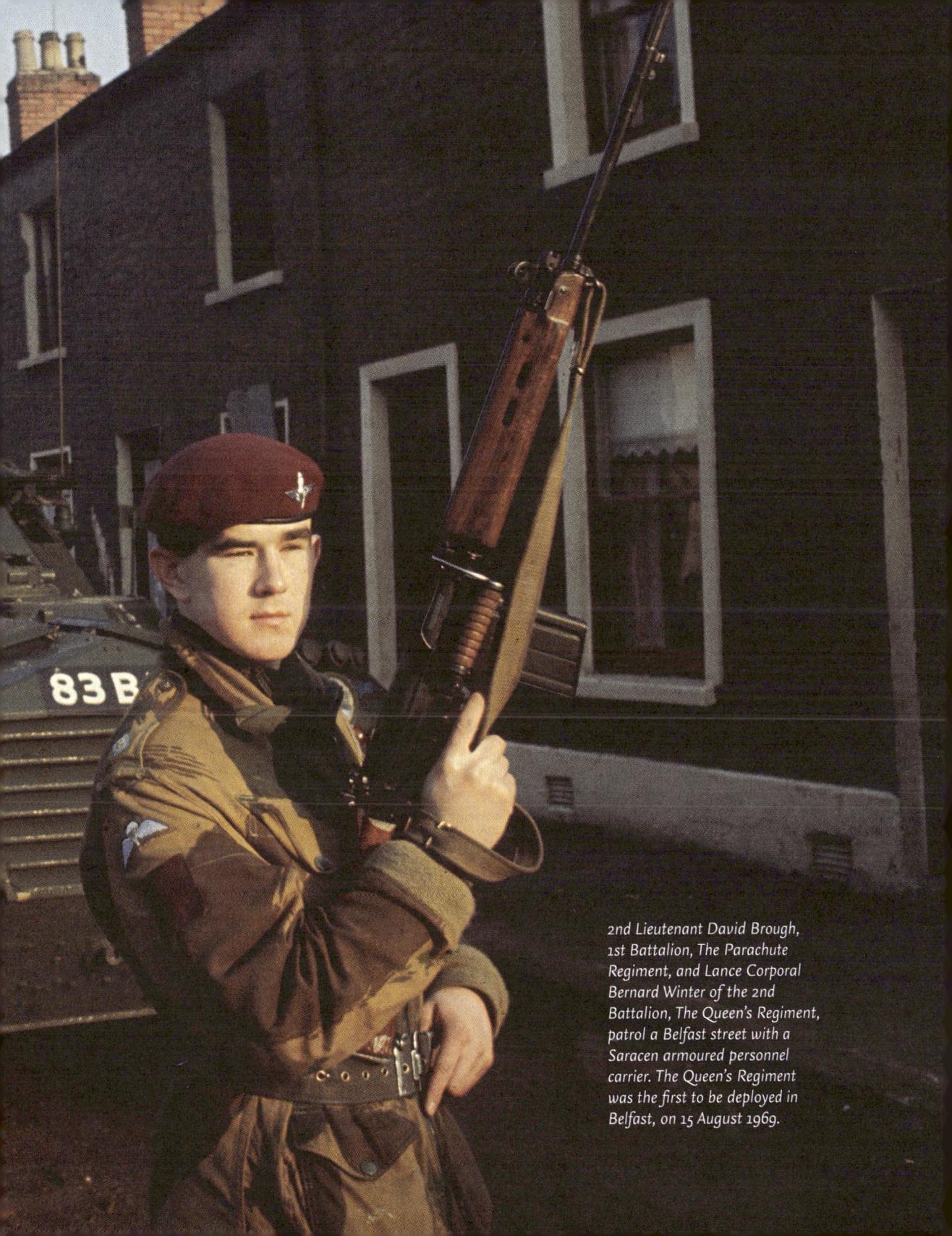

2nd Lieutenant David Brough, 1st Battalion, The Parachute Regiment, and Lance Corporal Bernard Winter of the 2nd Battalion, The Queen's Regiment, patrol a Belfast street with a Saracen armoured personnel carrier. The Queen's Regiment was the first to be deployed in Belfast, on 15 August 1969.

Czechoslovakia, meanwhile, was a significant producer of Semtex, which found its way to Northern Ireland via intermediaries and black market routes.

Similarly, some groups in the United States, especially within the Irish American community, saw the struggle in often romanticised terms as part of a broader fight against imperialism, which highlights how Cold War ideology occasionally infused this otherwise regional conflict. American sympathisers provided the IRA with Armalite rifles, a lightweight and easily transportable weapon popular among American gun owners. The phrase 'the Armalite and the ballot box'

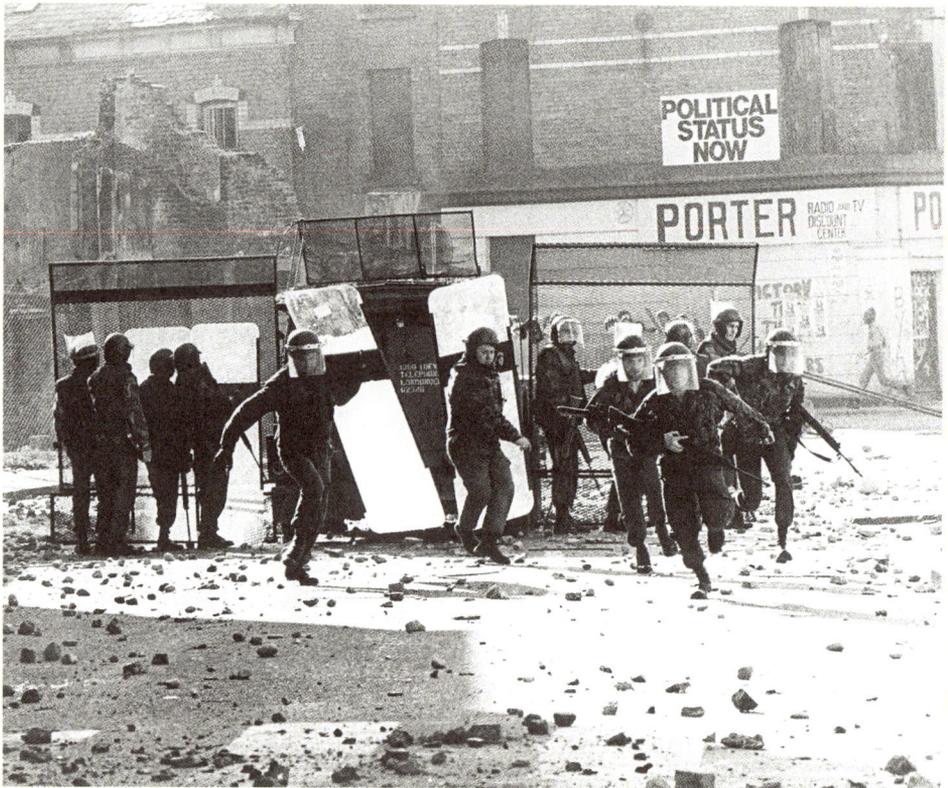

Troops of the 2nd Battalion, Royal Anglian Regiment,
charge rioters in the Bogside area of Derry/Londonderry,
Northern Ireland, during the hunger strike riots which
took place over the Easter weekend of 1981.

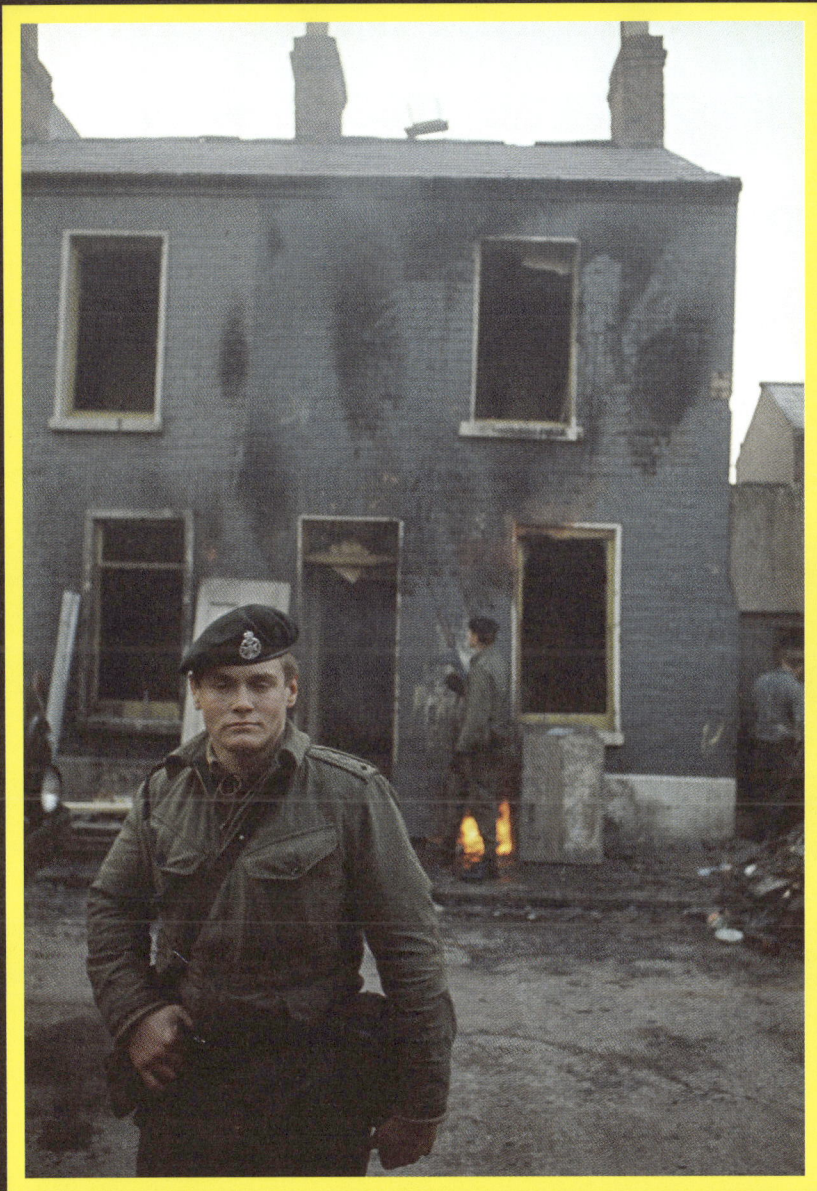

2nd Lieutenant Robin Martin and Rifleman Andy Walker of
1st Royal Green Jackets in front of a burned-out house in
Belfast during the battalion's first tour of duty in Northern
Ireland. The tour lasted from 20 August to 18 December 1969.

became a metaphor for the IRA's dual strategy of armed resistance and political engagement. In 1984, the fishing trawler *Marita Ann* was intercepted by Irish authorities off the coast of Kerry carrying a large shipment of weapons, including M16s, rifles, and ammunition, supplied by Irish American networks.

For successive British governments, Cold War anxieties meant the Troubles presented a security threat that extended beyond Northern Ireland's borders. As a principal NATO power, Britain was deeply engaged in countering Soviet influence in Europe and viewed unrest in Northern Ireland as a potential vulnerability. Intelligence agencies such as MI5 and MI6 closely monitored the IRA and other factions, wary of any Soviet attempts to exploit the conflict to destabilise Britain or fuel internal discord. The fear was that unrest in Northern Ireland could become a pressure point, distracting British resources and complicating their broader Cold War strategy.

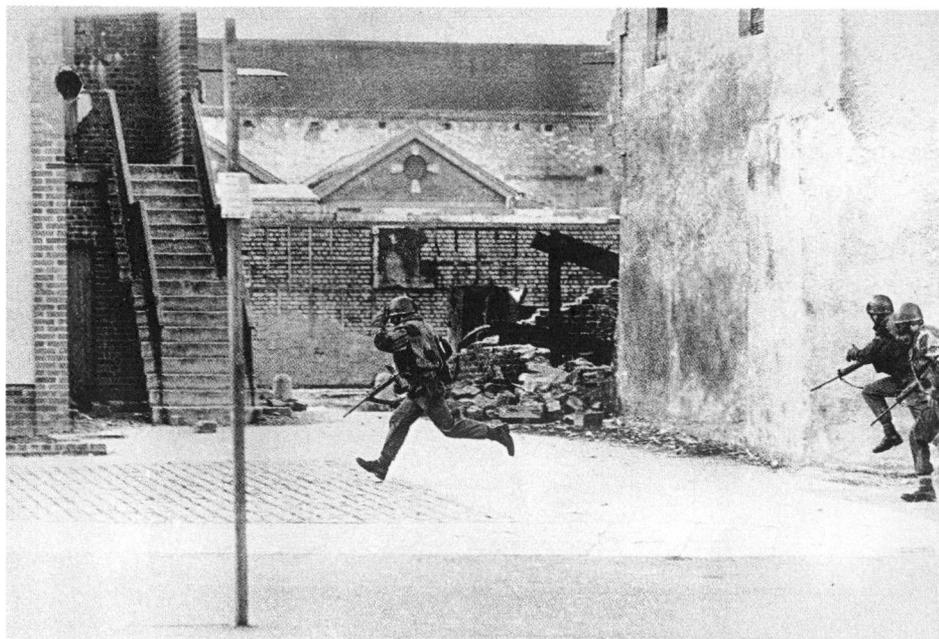

Members of the Support Company, 1st Battalion, The Parachute Regiment, pictured in action in the Bogside area on Bloody Sunday, 30 January 1972.

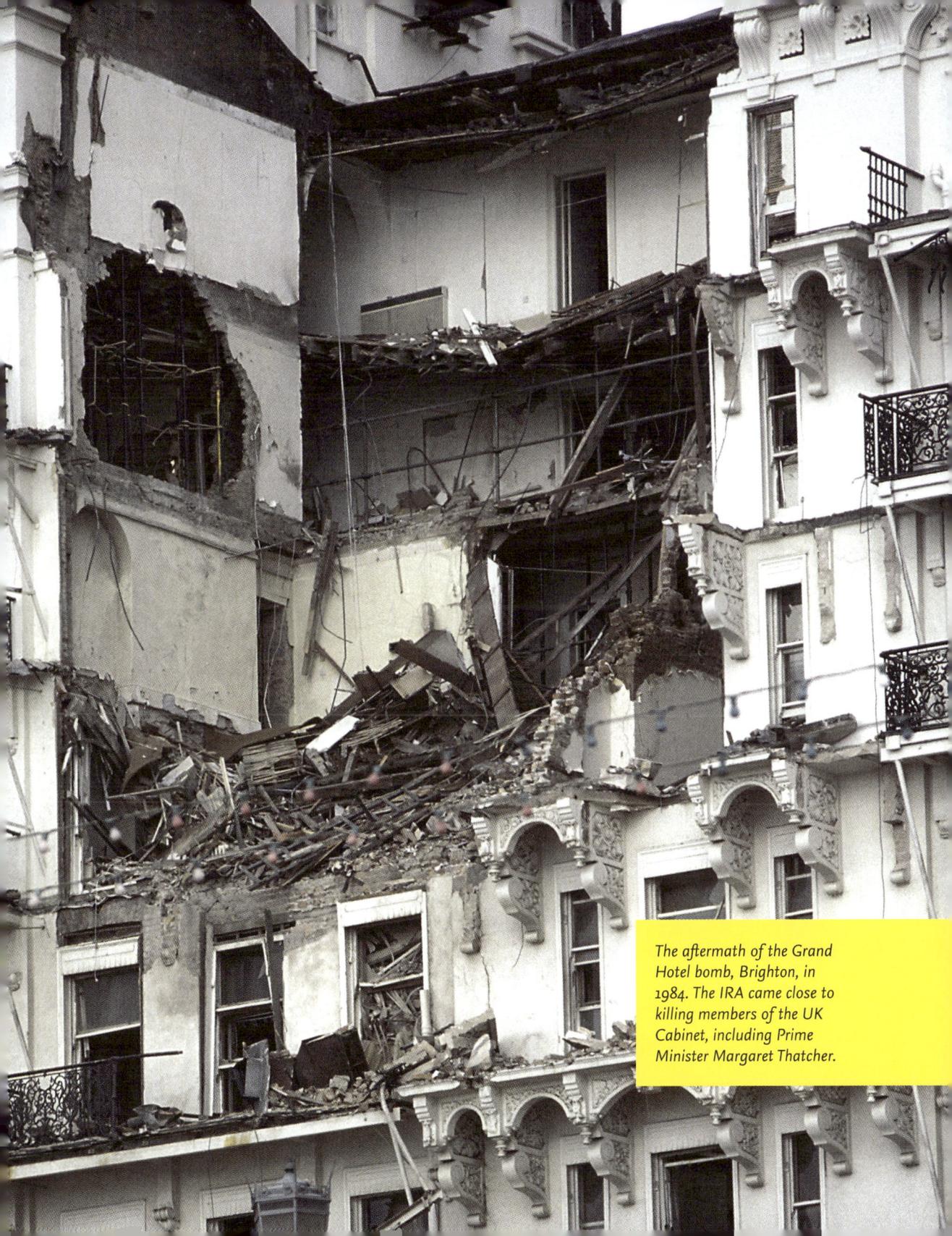

The aftermath of the Grand Hotel bomb, Brighton, in 1984. The IRA came close to killing members of the UK Cabinet, including Prime Minister Margaret Thatcher.

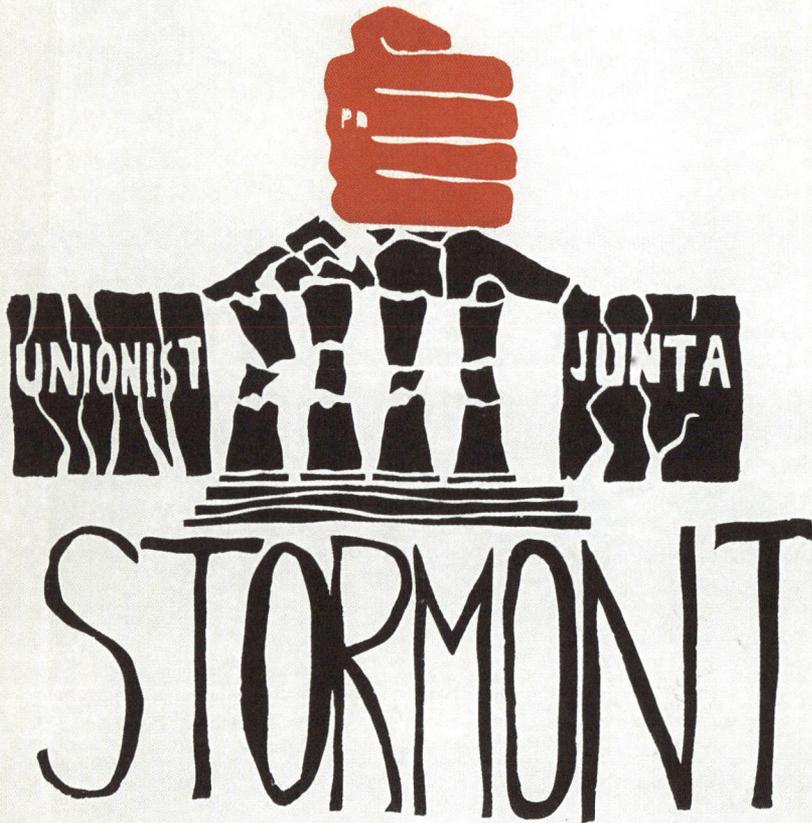

Nationalist poster calling for the end of the
Unionist-controlled government at Stormont.

The Troubles also found their way into the Cold War's global propaganda war. The Soviet Union frequently used the violence in Northern Ireland to criticise British imperialism, portraying the unrest as a human rights failure and a symptom of Western hypocrisy. In turn, Britain framed its counter-insurgency operations in Northern Ireland as part of its commitment to democracy and stability. The United States, meanwhile, found itself in a delicate position, navigating between Cold War alliances and domestic pressures. With a significant Irish diaspora among its population, the US experienced an internal pull from Irish American organisations that supported Northern Ireland's nationalist cause. Officially, however, US policymakers remained neutral, understanding the importance of maintaining strong ties with Britain, while shipments of arms donated by Irish American communities were successfully disrupted by FBI raids. The Troubles thus became another theatre in the ideological battle, where each side used the situation to bolster its worldview and discredit the other.

Northern Ireland was not the only global issue over which the British and Americans disagreed. The Falklands Conflict of 1982, a brief but intense collision between Britain and Argentina over the disputed Falkland Islands, strained Britain's Special Relationship with the United States. As the Cold War neared its climax, the conflict added an unexpected layer of tension to Western alliances, with Britain fiercely determined to defend its sovereignty while the US grappled with balancing its strategic interests in Latin America against its commitment to its closest ally.

The roots of the Falklands Conflict lay in a longstanding dispute over the islands, located in the South Atlantic. Argentina, claiming what they call Las Malvinas as part of its territory, had a nationalistic fervour surrounding the issue, viewing British control as a vestige of colonialism. In April 1982, Argentina launched an invasion, seizing control of the Falkland Islands and prompting an immediate British response. For Prime Minister Margaret Thatcher, the invasion was a direct affront to British sovereignty and a challenge that could not go unanswered. Within days, Britain assembled a task force and set sail to reclaim the islands, 8,000 miles away from the British mainland.

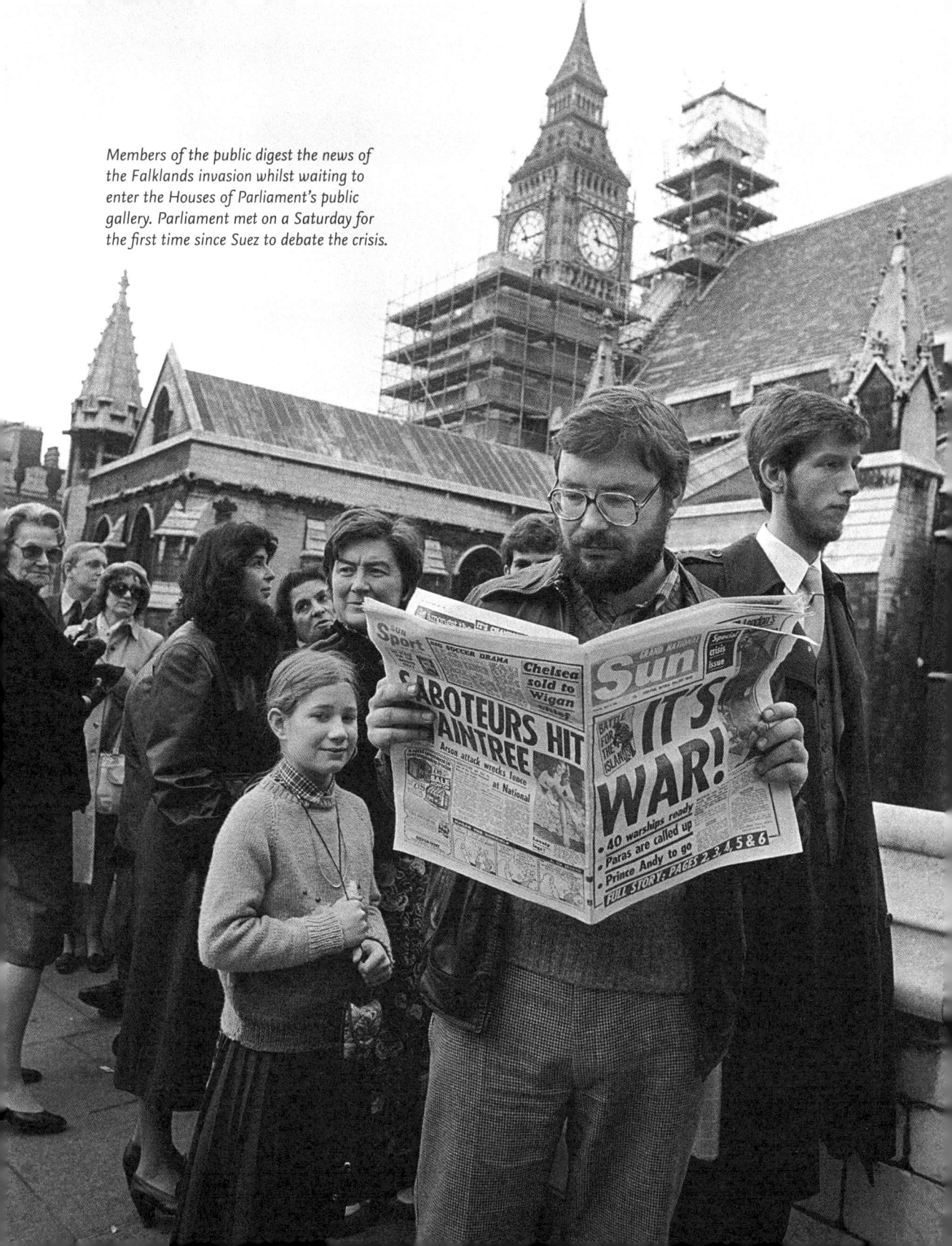

Members of the public digest the news of the Falklands invasion whilst waiting to enter the Houses of Parliament's public gallery. Parliament met on a Saturday for the first time since Suez to debate the crisis.

In the early 1980s, Cold War dynamics weighed heavily on US foreign policy, particularly in Latin America, where Washington was deeply concerned about Soviet influence. Argentina was governed by a right-wing military junta and was viewed as a counter-balance to communism in the region. Argentina also had significant energy resources, particularly in Patagonia. With energy security a global priority for both superpowers, this untapped potential made Argentina valuable to Western economic strategies. The country also provided agricultural products (like beef and grain) that were vital for Western food security and trade, and it was a key voice in the Organization of American States, another tool used to counter Soviet influence in the Western Hemisphere.

US Secretary of State Alexander Haig tried to broker a compromise between Britain and Argentina over the Falklands Conflict.

As such, strategic partnership with Argentina was important to American regional interests. Some US officials feared that supporting Britain in the Falklands might drive Argentina closer to Soviet influence, disrupting America's anti-communist strategy. Ronald Reagan's administration attempted to broker a peace deal, with Secretary of State Alexander Haig flying between London and Buenos Aires in an unsuccessful diplomatic effort. As Britain's fleet drew closer to the Falklands, however, it became clear that talks could not prevent the conflict. Thatcher, adamant about Britain's right to the islands, rejected compromise, asserting that the invasion could not stand and that the islands' British inhabitants should remain under British rule.

Vulcan aircraft of No. 44 Squadron, RAF, carried out five bombing missions codenamed 'Black Buck' over the Falklands during the conflict. The missions, to disable the runway at Port Stanley and various Argentine radar installations, achieved mixed success. However, their strategic and propaganda value was considerable.

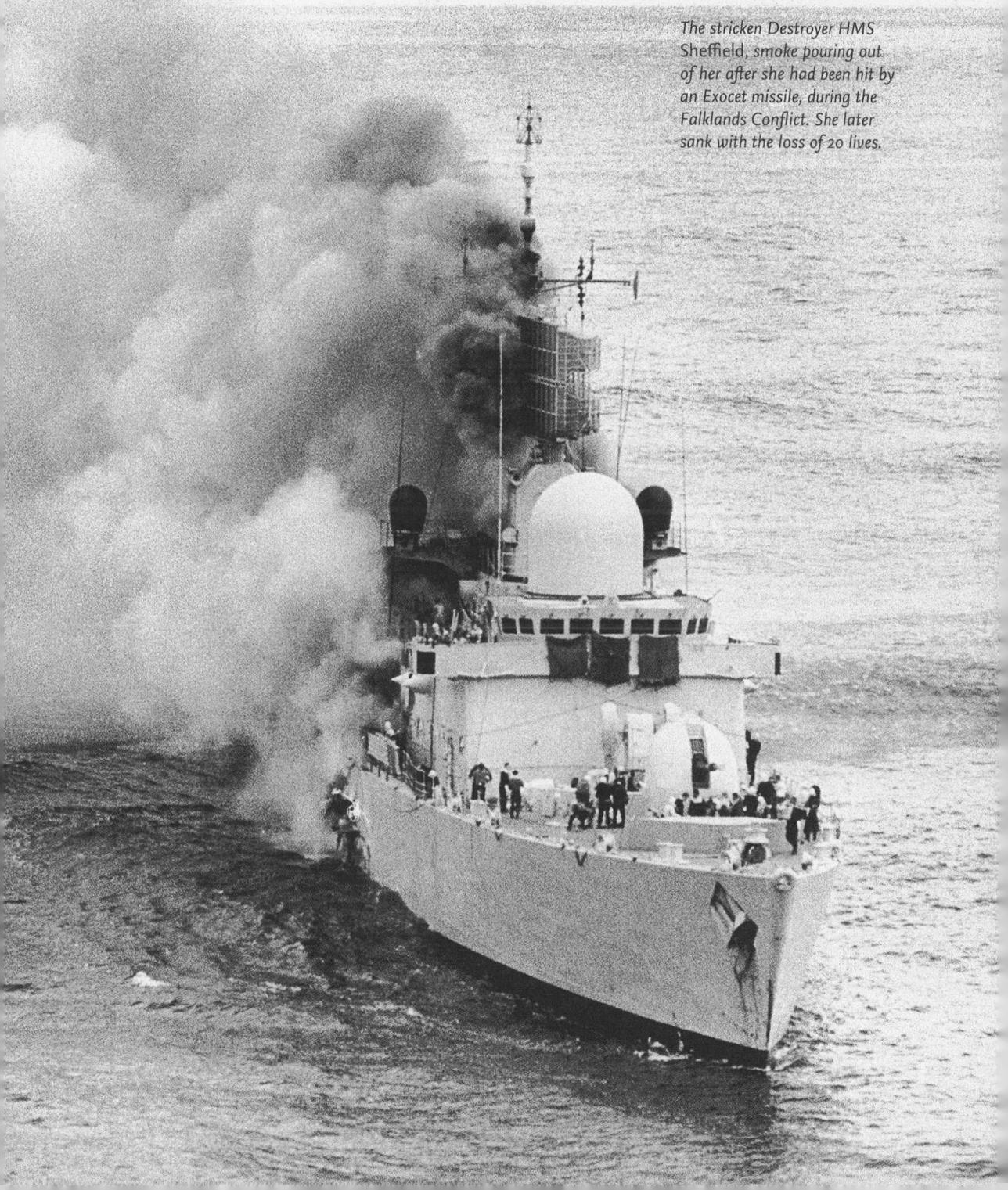

The stricken Destroyer HMS Sheffield, smoke pouring out of her after she had been hit by an Exocet missile, during the Falklands Conflict. She later sank with the loss of 20 lives.

Thatcher was incensed by Washington's initial hesitation, viewing it as a betrayal of both the Special Relationship, and of the one she had cultivated with Reagan. The British government expected unqualified support, especially given Britain's role in NATO and its consistent alignment with US Cold War priorities. As the British task force approached the islands, however, US sentiment began to shift. Reagan, aware of the risk to transatlantic unity, ultimately sided with Britain, supplying critical logistical and intelligence support that proved essential to the British war effort. Crucially for Britain's role in the denouement of the Cold War, the warm relationship between Reagan and Thatcher was maintained.

The Falklands Conflict highlighted the tensions between Cold War strategy and traditional alliances. America's initial reluctance revealed the complexities of US policy, torn between regional alliances in Latin America and its relationship with Britain. The war underscored Britain's determination to defend its territories, even as a declining power, and demonstrated that the Special Relationship could

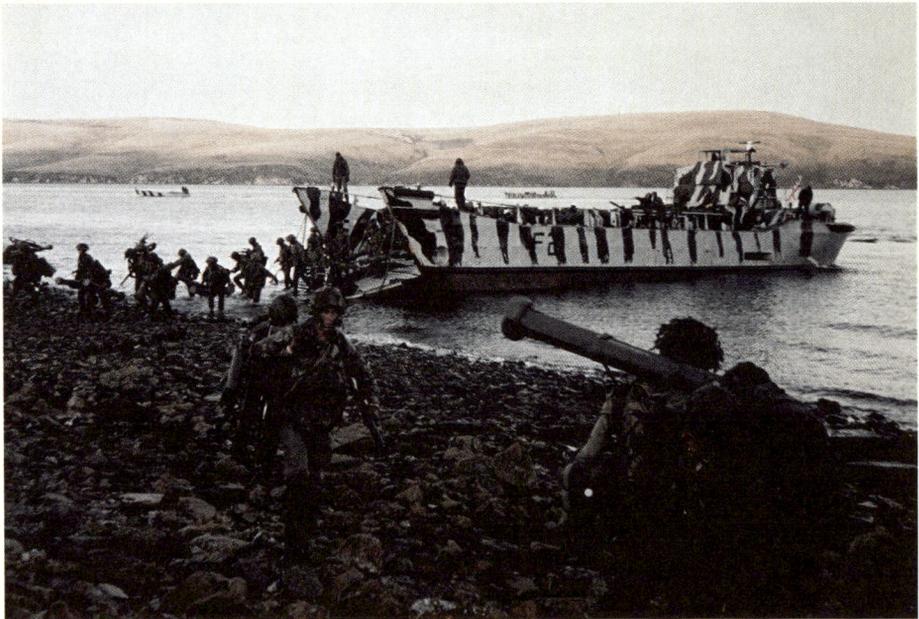

Soldiers from the 3rd Battalion, The Parachute Regiment,
disembark from a landing craft during the landings at San Carlos.

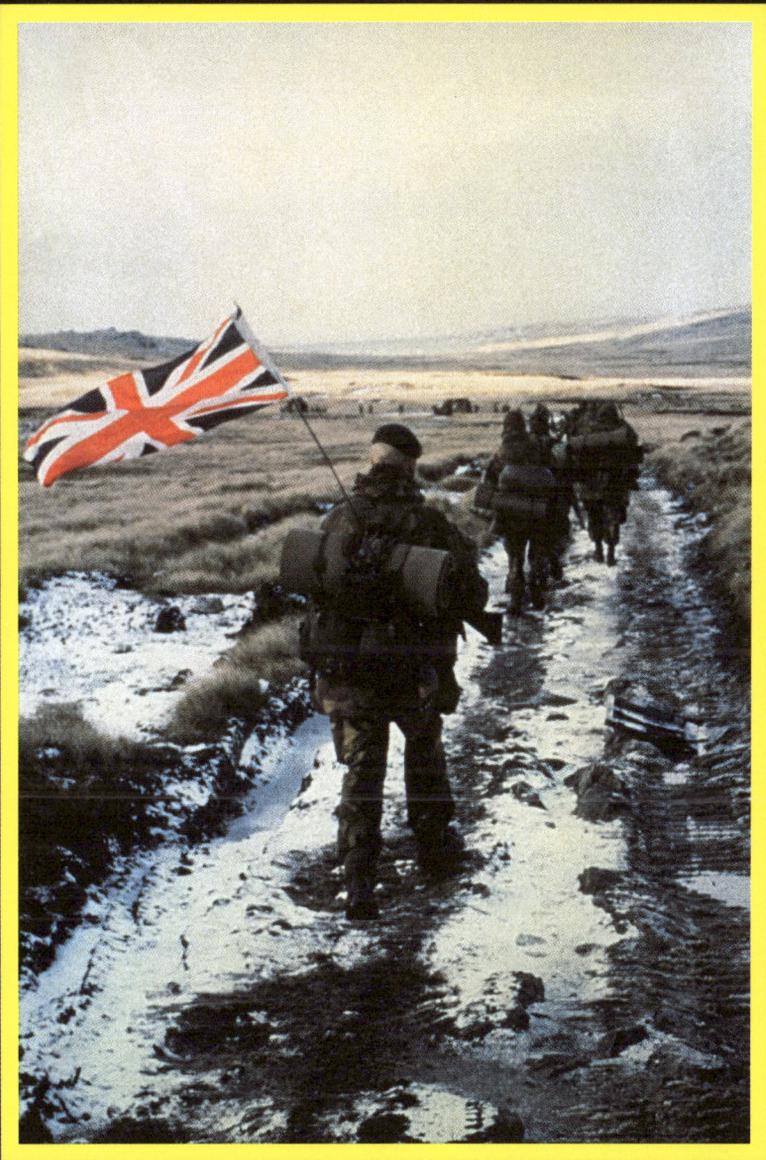

Commandos from 40 Commando Anti-Tank Troop march towards
Port Stanley. Royal Marine Peter Robinson, carrying the Union Flag
attached to the aerial of the radio he is carrying, brings up the rear.
The flag was owned by Marine John 'Snowy' Snowden who was
unable to attach the flag to his backpack so he passed it to Robinson.

HMS Conqueror *returning to Faslane on 3 July 1982 after*
her deployment to the South Atlantic during which she sank
the Argentine cruiser General Belgrano *on 2 May 1982.*

endure moments of disagreement. By the conflict's end on 14 June 1982, Britain had successfully reclaimed the Falkland Islands, reaffirming its sovereignty and strengthening Thatcher's domestic political position. In just 10 weeks, 255 British servicemen had lost their lives repelling the Argentine forces.

In the Cold War context, the Troubles and the Falklands Conflict underscored the fragility of alliances when national interests and regional strategies collided. Yet they also illustrate that the ultimate shared value of anti-communism could trump more prosaic strategic concerns. The most violent conflict, however, that perhaps best symbolises the Cold War was one in which Britain took no part.

The Falklands Conflict was represented in much British popular culture of the 1980s. Exocet by Jack Higgins fuses the real-world conflict with a sex-and-spying romp.

There was much rejoicing at the return of the British taskforce. In his painting, With Singing Hearts and Throaty Roarings...., 1983, Scottish artist Jock McFadyen depicts this whilst hinting at the cost in lives.

THE VIETNAM WAR: ORIGINS AND ESCALATION

The Vietnam War began as a nationalist movement for independence from French colonial rule but evolved into a battleground for the competing ideologies of communism and capitalism. Vietnam's struggle for independence from France culminated in the First Indochina War (1946–54). Supported by the Soviet Union and China, the communist-nationalist Viet Minh under Ho Chi Minh, the founder and father of modern Vietnam, defeated the French at Dien Bien Phu, and the Geneva Accords in 1954 temporarily divided Vietnam along the 17th parallel.

North of this line, a communist-led regime was established, with a non-communist government in the South. Promises of national elections to unify the country by 1956 went unfulfilled, with the United States, wary of a communist victory, propping up the southern government of Ngo Dinh Diem. His regime faced mounting opposition due to its authoritarian governance, religious discrimination, and failure to address widespread poverty. The National Liberation Front (NLF), or Viet Cong, emerged in the late 1950s as a formidable insurgent force in the South, backed by the North Vietnamese government under Ho Chi Minh.

The United States' involvement in Vietnam was driven by the domino theory – the belief that the fall of one nation to communism would trigger the collapse of others in the region. Under President Dwight D. Eisenhower, American advisors were sent to train South Vietnamese forces, a policy that expanded under his successor, John F. Kennedy. By the early 1960s, the US had committed thousands of military advisors and significant resources to prop up the Diem regime, though dissatisfaction with Diem's leadership grew both domestically and abroad. This gradual escalation was hastened by the Gulf of Tonkin incident. These alleged attacks on US Navy ships by North Vietnamese forces in August 1964, led the US Congress to pass the Gulf of Tonkin Resolution, escalating American involvement in the Vietnam War as President Lyndon B. Johnson authorised a massive bombing campaign and the large-scale deployment of American soldiers on the ground.

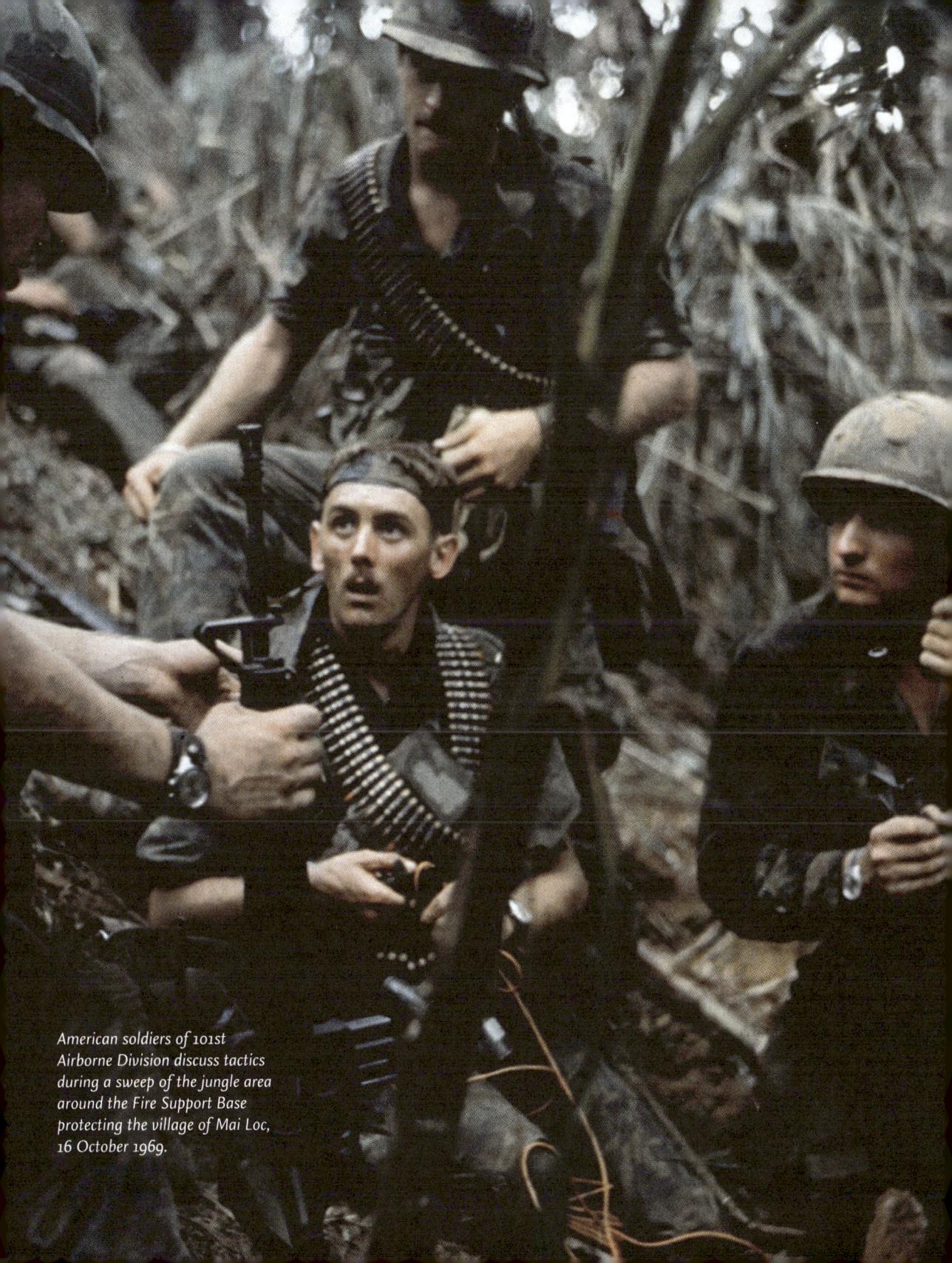

American soldiers of 101st Airborne Division discuss tactics during a sweep of the jungle area around the Fire Support Base protecting the village of Mai Loc, 16 October 1969.

United States UH-1D helicopters of No. 217 Assault Helicopter Squadron in flight on a mission to pick up South Vietnamese soldiers of 14 Regiment, 9 ARVN Division, in the Mekong Delta, 25 March 1970.

America's involvement in Vietnam began as part of its broader Cold War strategy to contain communism. After the Second World War, communist forces led by Ho Chi Minh fought a war of independence in Vietnam, which was then a French colony. The United States, fearing a domino effect of communist expansion in Southeast Asia, provided financial and military support to the French, contributing nearly 80 per cent of their war costs by the early 1950s.

The war ended with the 1954 Geneva Accords, which divided Vietnam at the 17th parallel (the line of latitude 17° N) between the communist North, led by Ho Chi Minh, and the pro-Western South, led by Ngo Dinh Diem and heavily supported by the United States. The Accords called for nationwide elections in 1956 to unify the country, but Diem, backed by the US, refused, fearing a communist victory. In the late 1950s and early 1960s, the North Vietnamese supported the formation of the Viet Cong, a communist insurgency in the South. To combat this, the Americans escalated their involvement under the Eisenhower and Kennedy administrations, sending advisors and aid to strengthen Diem's regime. Diem's unpopular policies and autocratic rule fuelled unrest, however, leading to his assassination in an American-backed coup on 2 November 1963. Just 20 days later, President John F. Kennedy himself was assassinated while on a campaign trip to Dallas, Texas, his Vice-President Lyndon B. Johnson succeeding him.

The pivotal event came on 2 August 1964, when the US destroyer USS *Maddox* was reportedly attacked by North Vietnamese forces in the Gulf of Tonkin. A second alleged attack on 4 August (though later disputed), led Congress to pass the Gulf of Tonkin Resolution, granting President Johnson broad powers to wage war in Vietnam. This marked the formal beginning of large-scale US military involvement. By the end of 1965, the United States had 184,000 troops in Vietnam.

As the Vietnam conflict escalated in the 1960s, the US urged allies to bolster the anti-communist fight in Southeast Asia. For Washington, Vietnam was a key front in containing communism, and Johnson expected committed support from Britain. However, Prime Minister Harold Wilson chose not to send British troops, a decision driven by Britain's limited resources and a political climate marked

by deep anti-war sentiment. Wilson's government faced economic challenges and a host of post-imperial commitments, not least the conflict in Aden. Wilson recognised that joining the conflict would not only strain Britain's finances but also risk significant public backlash, which would complicate his domestic agenda.

This reluctance led to tensions between Wilson and Johnson. Johnson saw Britain's hesitation as a lack of commitment to the anti-communist cause and repeatedly pressed Wilson to contribute militarily, suggesting that even a token British force, or a military band, might lend legitimacy to US efforts in Vietnam. Yet, Wilson remained firm, making only symbolic gestures, such as public statements and diplomatic support that backed America's goals. Privately, he expressed doubts about the US strategy, fearing that the conflict was unlikely to produce the results Johnson hoped for, and could destabilise Southeast Asia. Matters were further complicated by the presence of troops from Commonwealth nations, notably Australia and New Zealand, who lost almost 600 soldiers between them.

Wilson's choice to avoid open criticism of the war showed his understanding of the Special Relationship despite British and American differences. Both leaders recognised the broader significance of their alliance within Cold War geopolitics, and the relationship endured, bolstered by careful diplomacy and Wilson's efforts to maintain US ties without compromising his position on Vietnam.

The Vietnam War remains a scar on modern American history. Over 58,000 Americans died, to say nothing of the millions of Vietnamese military and civilians on both sides. It derailed and ultimately ended the presidency of Lyndon B. Johnson, and dominated US foreign policy for the next quarter-century. Although there are significant differences between the two conflicts, not least Britain's role as an imperial power, it has been argued that the United States could have learned much from Britain's war in Malaya, which demonstrated that counter-insurgency success relies on understanding local contexts, prioritising social reform, and adopting tactics that fit guerrilla warfare. While the US did attempt certain hearts-and-minds programmes, a deeper commitment to these principles might have offered a more sustainable path to stability in Vietnam.

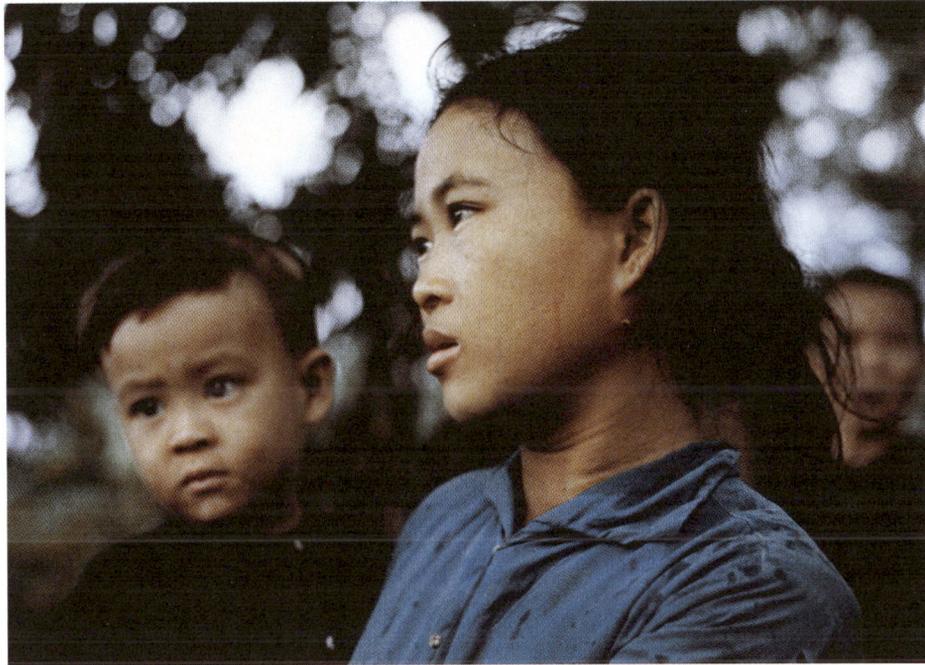

*Vietnamese children watch anxiously as US soldiers of the 1st Cavalry
(Air-mobile) Division, search a village near An Khe, in the central
highlands for contraband, 15 October 1965.*

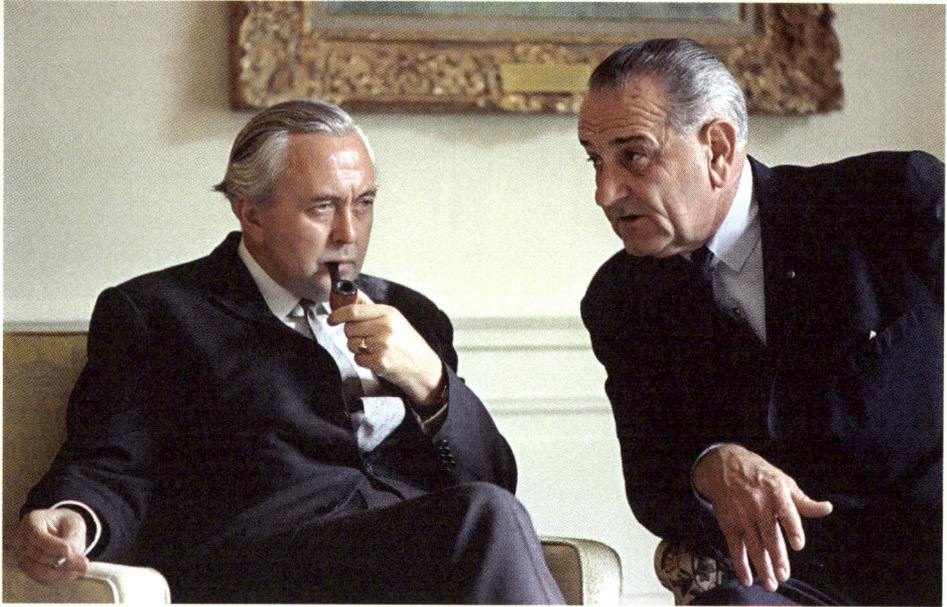

Harold Wilson (left) came under enormous pressure from Lyndon B. Johnson to send even nominal British personnel to Vietnam. Wilson resisted.

Of course, by the mid-1960s, when the Vietnam War exploded into popular consciousness, the world had changed. The media, and people in general, were less deferential, and it is likely that US involvement in Southeast Asia would still have been met with waves of protest at home. The social and cultural revolutions of the 1950s and early 1960s were coming to full fruition, and just as in America, the British public would respond to the Cold War in myriad ways.

Designed by activist Kiyoshi Kuromiya in 1968, the 'Fuck the Draft' poster protested against the Vietnam War draft. Despite being arrested for distributing it via mail, Kuromiya circulated 2,000 copies at the Democratic Convention in Chicago, cementing its place as a symbol of anti-war resistance.

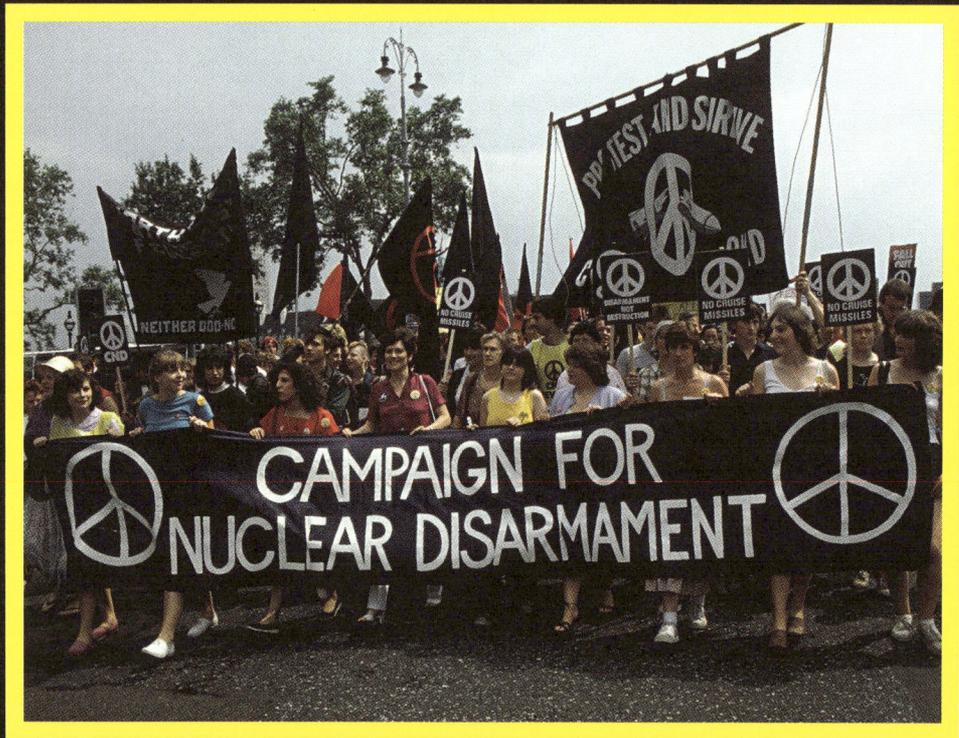

Protesters march against cruise missiles in a powerful show of solidarity during a 1982 CND demonstration. Their call for peace and nuclear disarmament resonated with the public backlash against the government's 'Protect and Survive' information campaign.

CHAPTER 5

PROTEST AND POPULAR CULTURE

By 1968, the Vietnam War had become a focal point for global protest, including in Britain. On 17 March 1968, thousands of demonstrators converged on Grosvenor Square, home to the American Embassy in London, to voice their opposition to the escalating conflict. The protest was organised by the Vietnam Solidarity Campaign (VSC), a radical left-wing group that viewed the war as a symbol of American imperialism and a humanitarian crisis.

The march began peacefully, with banners, chants, and speeches from prominent figures such as activist Tariq Ali and actor Vanessa Redgrave. However, as the crowd swelled to an estimated 10,000 people, tensions rose. Protesters clashed with a heavy police presence, resulting in outbreaks of violence and over 200 arrests. Images of demonstrators grappling with uniformed officers made front-page headlines.

The Grosvenor Square protests symbolised a broader discontent with Britain's complicity in US Cold War policies, including hosting American military bases on British soil. For those coming of age in the late 1960s, these protests marked a pivotal moment in British activism, reflecting the radicalisation of a younger generation disillusioned with both domestic and foreign policy. Yet the Grosvenor Square riots were merely the latest in a tradition of British anti-Cold War activism.

Despite Britain staying out of the Vietnam War, there were significant protests against the US government's prosecution of the war, and the perceived tacit British support for it.

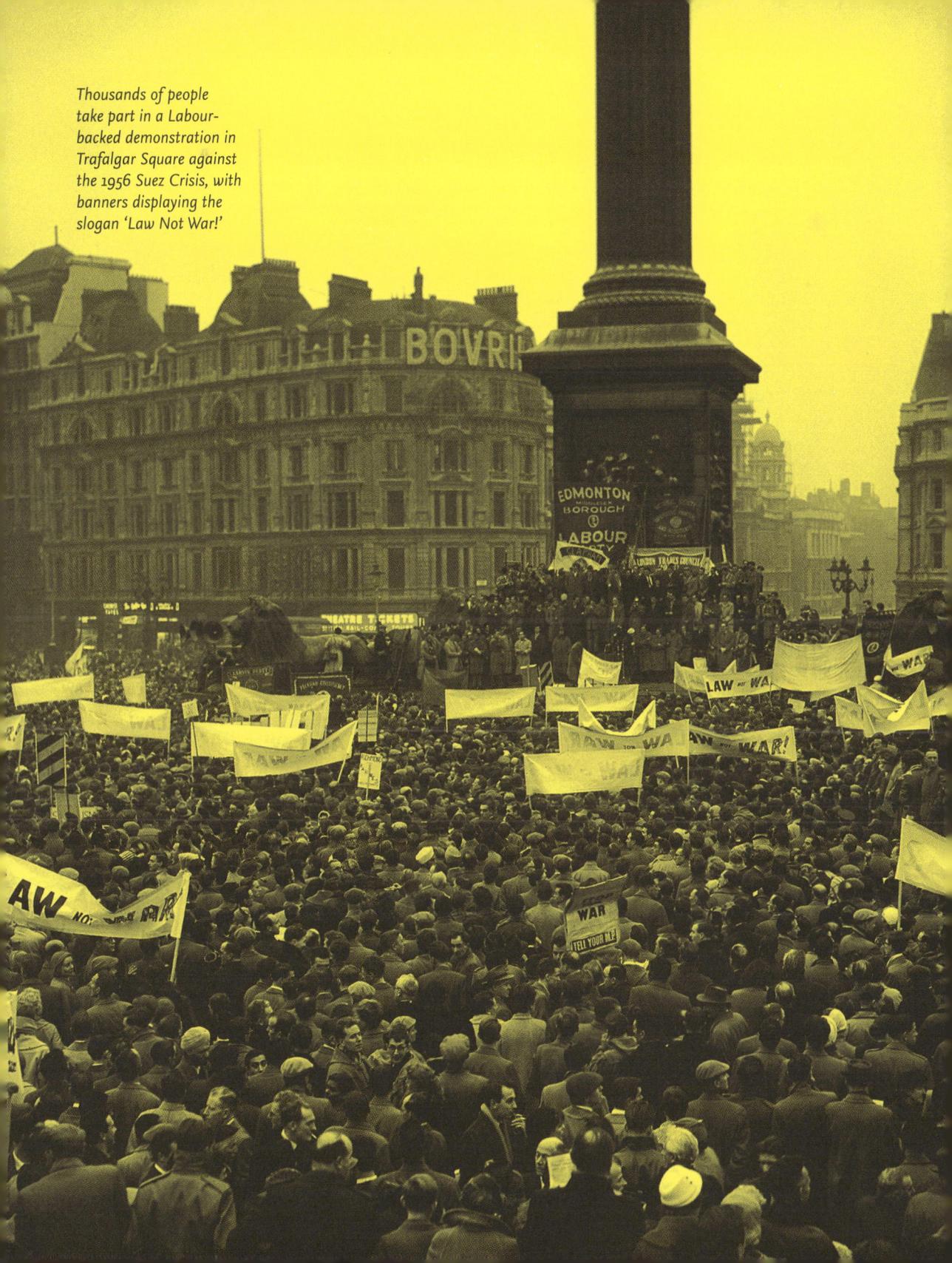

Thousands of people take part in a Labour-backed demonstration in Trafalgar Square against the 1956 Suez Crisis, with banners displaying the slogan 'Law Not War!'

The Suez Crisis over ten years earlier sparked significant public outrage and attracted protests from students, trade unionists and anti-imperialists. One of the largest demonstrations took place in Trafalgar Square, where thousands gathered to demand an end to the military campaign. Organised by the Communist Party of Great Britain and what would soon become the Campaign for Nuclear Disarmament (CND), these protests linked the Suez Crisis to broader critiques of British imperialist foreign policy, and Prime Minister Anthony Eden's refusal to heed international opinion. The protests served as a precursor to the larger peace movements of the Sixties, although future protests would be decidedly more anti-American than the Suez demonstrations.

The Campaign for Nuclear Disarmament would prove to be pivotal to the development of the British protest movement. CND was formed in 1958 by notable figures such as philosopher Bertrand Russell, priest Canon John Collins, and writer J. B. Priestley, to campaign for an end to Britain's nuclear weapons programme and advocate for unilateral disarmament. Its message resonated with a nation still haunted by newsreel footage of the devastation of Hiroshima and Nagasaki, as well as the escalating arms race between the United States and the Soviet Union.

One thing that helped CND to gain recognition was its iconic logo, designed by artist Gerald Holtom for the first march from London to Aldermaston in 1958. Holtom created the emblem by combining the semaphore signals for 'N' (nuclear) and 'D' (disarmament) within a circle, symbolising Earth. He described it as a gesture of despair, reminiscent of the individual pleading with outstretched arms before a firing squad in Francisco Goya's 1814 painting *The Third of May 1808*. Initially intended for the British anti-nuclear movement, the symbol transcended its origins to become a universal icon of peace.

Holtom's symbol was unveiled in front of 10,000 people who had walked the 52 miles from London's Trafalgar Square to the Atomic Weapons Research Establishment (AWRE) in Aldermaston, Berkshire. Bringing together an eclectic mix of participants – students, clergy, trade unionists, intellectuals, and pacifists

Poster for the 1972 CND march to Aldermaston,
featuring Gerald Holtom's iconic logo.

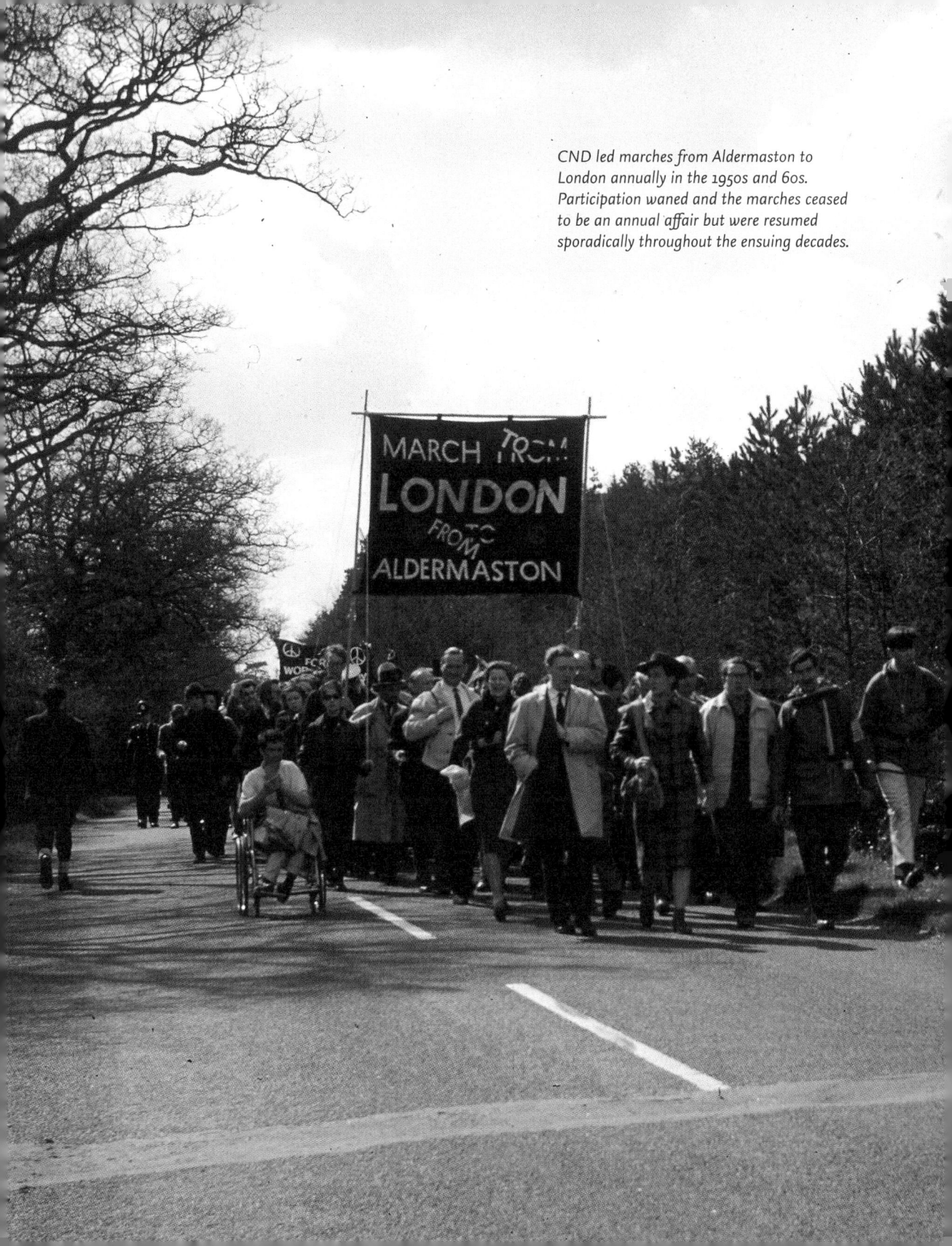

CND led marches from Aldermaston to London annually in the 1950s and 60s. Participation waned and the marches ceased to be an annual affair but were resumed sporadically throughout the ensuing decades.

– the marches became an annual Easter tradition, although subsequent events started in Aldermaston and ended in London. Each year, the marches became bigger, attracting international attention and reinforcing Britain's role as a leader in the global anti-nuclear movement. They were characterised by their carnival-like atmosphere, with banners, music, and chants, but also by the serious moral urgency of their message.

The Aldermaston demonstrations also chimed with the changes afoot in British society. For many young people, coming of age in the 1950s meant living in 'The

Easter March 1966 poster produced for CND to promote a march between High Wycombe and central London. It was designed by Ian McLaren, whose abstract imagery reflected both the era and the practical need to avoid overtly political imagery so as to be permitted for display at London Transport sites.

'No' poster designed by Ian McLaren for CND in 1967. The mushroom cloud image, impactful slogan, anti-nuclear symbol and text comparing the economic cost of nuclear weapons to things like schools and roads were all key parts of anti-nuclear messaging.

Affluent Society', marked by rising living standards and increased consumerism. Britain's economy was booming, bolstered by increased industrial output, stable employment, and greater disposable income. The average working-class family now enjoyed access to amenities once considered luxuries, such as televisions, refrigerators and motor cars. This new-found prosperity extended to teenagers, and fostered a distinct youth culture, separate from their parents' wartime values of thrift and sacrifice, and underscored by the creeping influence of American culture on Britain.

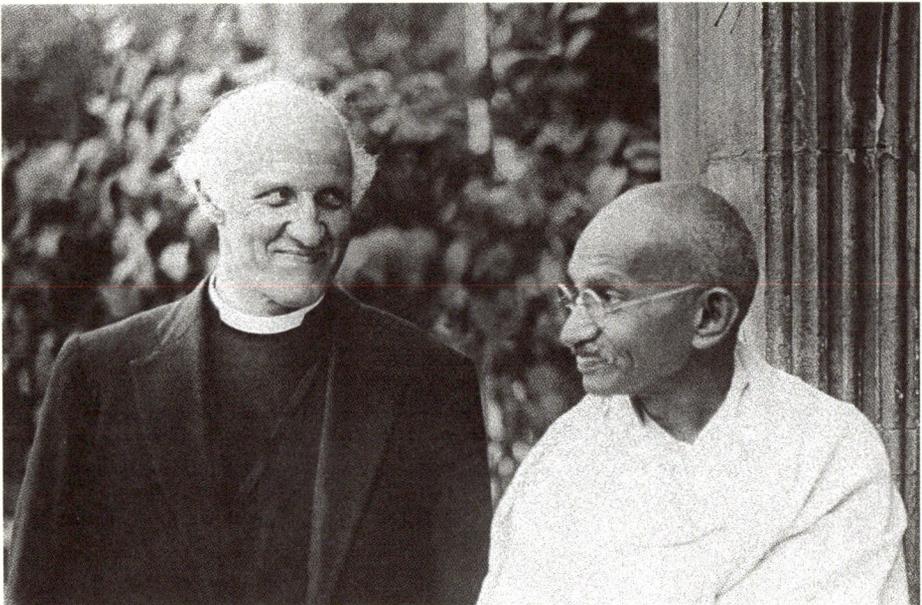

Hewlett Johnson, Dean of Canterbury Cathedral, welcomes Mohandas Gandhi to Canterbury in 1931. Johnson was a fervent supporter of the Soviet Union and nicknamed 'the Red Dean'.

There were also high-profile instances of admiration and affection for the Eastern bloc. One particularly outspoken proponent of Soviet communism could be found preaching its virtues from the pulpit of one of Britain's great cathedrals. Reverend Hewlett Johnson, 'the Red Dean of Canterbury', was one of Britain's most controversial religious figures during the Cold War. While he never joined

the British Communist Party himself, Johnson gained notoriety for his outspoken support of socialism and the Soviet Union, beliefs he saw as aligned with Christian principles of justice and equality. In 1951, he was an early recipient of the International Stalin Peace Prize (later renamed after Lenin), an accolade he shared with other prominent sympathisers such as Bertolt Brecht, Pablo Picasso, and Paul Robeson. Upon Stalin's death, Johnson produced a flattering tribute largely plagiarised from Soviet propaganda. Johnson's views placed him at odds with much of the Anglican Church and the wider British Establishment, who considered his admiration for Stalinist policies and refusal to condemn Soviet atrocities deeply troubling.

Across the Atlantic, anti-communism became an all-consuming hysteria. The 'Red Scare' of the 1950s represented a period of heightened anxiety about communist subversion in the West. Official investigations took place into alleged communist influence within the government, the military, and Hollywood, with Senator Joseph McCarthy becoming the face of this anti-communist fervour. Anti-communism in Britain, while present, lacked the intensity and paranoia seen in the United States. British society remained sceptical of McCarthy-style witch hunts. This was despite the Cambridge Five revelations, and the production of British anti-communist propaganda films, like *Conspirator* (1949), starring a young Elizabeth Taylor. An espionage thriller depicting a young woman marrying a British war hero who turns out to be a Soviet agent, *Conspirator* was not a hit, perhaps indicating that the British public of the late 1940s still retained some affection for their wartime allies.

The positive relations from the wartime alliance lingered in a few other areas of British culture, and in 1956 the world-renowned Bolshoi Ballet undertook a highly successful residency at London's Royal Opera House. The visit of the world's greatest ballet company had been a year in the planning, and was greeted with a rapturous reception, playing to over 55,000 spectators and receiving rave reviews. As the residency concluded in November, however, the mood changed. The British public reacted with outrage to the brutal suppression of the Hungarian Uprising, which saw Soviet tanks crush a popular revolt against communist

rule. Newspapers were quick to denounce the USSR's aggression, with images of the violence in Budapest shocking readers. In the face of this brutality, the British public expressed strong sympathy for the Hungarian people, with many supporting the influx of refugees who fled to the West. Charitable efforts were launched, and communities rallied to provide aid to those displaced.

Soviet projections of soft power never again reached the heights of the Bolshoi visit, but there were continued instances of exchange. The visit of composer Dmitri Shostakovich to the Edinburgh International Festival in 1962 was well received, and English translations of Soviet literature, including works by Boris Pasternak and Aleksandr Solzhenitsyn, became widely available in Britain.

BBC Director of Television Gerald Beadle presents a bouquet to Bolshoi Ballet prima ballerina Galina Ulanova to mark the last performance of the company's tour. As the tour ended, Soviet tanks rolled into Budapest to supress a student-led revolt.

Soviet cosmonaut Yuri Gagarin visited London and Manchester after becoming the first man in space. Enthusiastic crowds greeted him as a hero for all humankind.

Poland: LOT Air Routes to Non-Communist Countries, March 1977

Tourism between East and West was rare but not
unheard of. This map from 1977 shows LOT Polish
Airlines routes to non-communist countries.

Perhaps more influential were the Soviet Union's technological achievements. The launch of Sputnik – the first artificial satellite to orbit Earth – in 1957 sent shock waves through Britain, igniting both admiration and fear. Newspapers speculated about the military implications of Soviet missile capabilities, while government officials warned of the need to accelerate Britain's own space and defence programmes. Yet, for the public, Sputnik also inspired wonder. It marked the dawn of the Space Age, a moment when science fiction became reality.

Yuri Gagarin made more history on 12 April 1961 as the first human to journey into space, aboard the Soviet spacecraft *Vostok 1*. His 108-minute orbit of Earth marked a groundbreaking achievement in the space race, solidifying his place as a global icon and a symbol of humanity's pioneering spirit. That July, he visited Britain for a tour, invited by the Amalgamated Union of Foundry Workers. Gagarin arrived to a hero's welcome as crowds thronged the streets up and down the country to catch a glimpse of the man who had ventured into space. In London, he was hosted by both Queen Elizabeth II and Prime Minister Harold Macmillan, who balanced diplomatic politeness with the geopolitical tensions of hosting a Soviet figurehead. By all accounts, his warm smile and approachable demeanour won over even the staunchest critics of the Soviet Union.

Gagarin's celebrity was a propaganda coup for the Soviet Union, showcasing their supremacy in the space race. The mutual respect and warmth that characterised Gagarin's interactions with the British public softened some of the sharp edges of political rivalry. By the end of his four-day tour, Gagarin had left an indelible mark. His ability to bridge ideological divides through personal charm and universal awe at his achievements made his visit a defining moment of Cold War history. For many, he wasn't just the face of Soviet space triumphs; he was a symbol of humanity's boundless potential and an enduring reminder of the shared wonder of space exploration.

There is no doubt, however, that Brits were far more influenced by their Atlantic cousins than by any Russian comrades, largely due to the preponderance of a popular culture which shared a common language. Hollywood cinema soon

*Members of the US armed forces serving abroad were
often entertained by celebrity guests from back home.
Here, members of the USAF are treated to a performance
from Sammy Davis Jr at RAF Lakenheath in Suffolk.*

outstripped homegrown fare, while American consumer products became ever more prevalent and desirable. It is perhaps the developments in popular music that best exemplify the cultural element of the Special Relationship. Jazz had been popular in Britain since the 1920s, and by the 1950s British artists such as Ronnie Scott and Chris Barber were household names. The new bohemian 'beat' subculture of New York and San Francisco made its way to London, along with the burgeoning coffee shop scene that sustained the poets and singers who frequented them. Venues such as the 2i's Coffee Bar in Soho were key to the development of Britain's folk music revival, as well as the growing popularity of American folk music.

Protests against the presence of American forces at RAF Lakenheath took place in the 1980s.

Folk fused with the established taste for trad jazz and newly acquired African American blues recordings to create a particularly British take on an American musical form: skiffle. This grassroots music phenomenon transformed Britain's cultural landscape and was defined by its simple, do-it-yourself ethos. Bands often used makeshift instruments such as washboards, tea chests, and acoustic guitars, making the genre accessible to the working-class youth. In the United States, the folk revival had its roots in left-wing politics, personified by the likes of Woody Guthrie and Pete Seeger. In Britain, despite drawing on many of the same songs, skiffle artists such as Lonnie Donegan instead pointed the way towards rock and roll; the genre's exponents included future stars such as John Lennon, Paul McCartney, Van Morrison and Jimmy Page.

A skiffle band pose in a British front room. With roots in early twentieth-century America, skiffle experienced a revival in 1950s Britain and helped create the first generation of homegrown rock and roll stars.

THE COLD WAR AND CIVIL RIGHTS

The US Civil Rights Movement and the Cold War intersected in complex ways, influencing global perceptions of democracy, freedom, and justice. From a British perspective, the movement's struggle for racial equality revealed contradictions in America's self-proclaimed role as the leader of the 'free world', and provided a lens through which it could critique and reflect upon its own issues of race and immigration, particularly during a period when it was grappling with decolonisation and an influx of Commonwealth migrants.

British media highlighted events such as the Montgomery Bus Boycott, the Freedom Rides, and the March on Washington, juxtaposing these with the ideals that the US claimed to champion abroad. Cultural exchanges provided another way of highlighting the growing awareness of racial issues, as shown by Sammy Davis Jr's 1960 trip to Britain. Davis, a prominent African American entertainer and member of the Rat Pack, received an overwhelmingly positive reception and was celebrated as a symbol of the success achievable within American society. He made a television special, played at many prestigious theatres, and entertained American airmen stationed at RAF Lakenheath. On the other hand, his presence in Britain highlighted the racial prejudice he faced at home, underscoring the unresolved contradictions in American democracy.

The British craze for American blues and jazz music throughout the period led to further interplay between the Civil Rights Movement, Cold War dynamics, and transatlantic cultural exchange. Musicians like Muddy Waters and Sister Rosetta Tharpe gained significant followings in Britain, inspiring The Rolling Stones, The Beatles, and The Yardbirds. Blues music in particular resonated with British audiences. This fascination with African American music often carried an implicit critique of US racial politics, as many Britons admired the artistic achievements of Black Americans while lamenting the discrimination they endured.

John Lennon and Yoko Ono stage their 'bed-in for peace' at Queen Elizabeth Hotel in Montreal in 1969. The Beatles had moved far past their moptop beginnings, with Lennon in particluar taking an increasing part in anti-war and countercultural activism.

The activists marching from Aldermaston to London were more likely to be singing folk songs of resistance than early rock and roll hits, but the 1960s would see the pop song become the prime form of cultural expression for young people. While protest marches and public demonstrations captured significant attention, they were not the primary mode of dissent for most Britons. Instead, many expressed their unease and opposition to war through cultural consumption, particularly music. Anti-war sentiment permeated the work of bands like The Beatles, whose lyrics and ethos resonated with a population weary of conflict, generally affluent, and disinclined to take to the streets. The Beatles' evolution from bubble-gum pop to politically aware musician activists mirrored the shifting attitudes of the public. Tracks like *All You Need is Love* (1967) and *Revolution* (1968) reflected the zeitgeist. Both records were extremely popular, reaching number one (*Revolution* as the B-side to *Hey Jude*).

In many ways, The Beatles defined Sixties Britain. The sunny optimism of their early pop hits reflected the post-war affluent society, while by the mid-60s the band's music had grown more complex, reflecting the world in which it was produced. By 1970, the band was finished, split by a combination of fame, excess, and greed. Solo records by the band's former members would be as much inward looking as outward, echoing a nation preoccupied with crises at home rather than the distant chessboard of global Cold War politics. While the tension between the United States and the Soviet Union loomed in the background, domestic concerns ranging from economic turmoil to the ever-worsening violence in Northern Ireland dominated news headlines and dinner table conversations. Declining industrial output, rising unemployment, and rampant inflation culminated in the infamous Winter of Discontent in 1978–79, while strikes by miners, dockworkers, and other members of trade unions became emblematic of a nation struggling to adapt to a changing economic landscape.

The 1980s, however, saw a resurgence in Cold War tensions. Sparked by NATO's decision to deploy 96 American cruise missiles at RAF Greenham Common in Berkshire, the move escalated tensions in Europe and provoked widespread fears of nuclear conflict. In response, the Greenham Common Women's Peace Camp

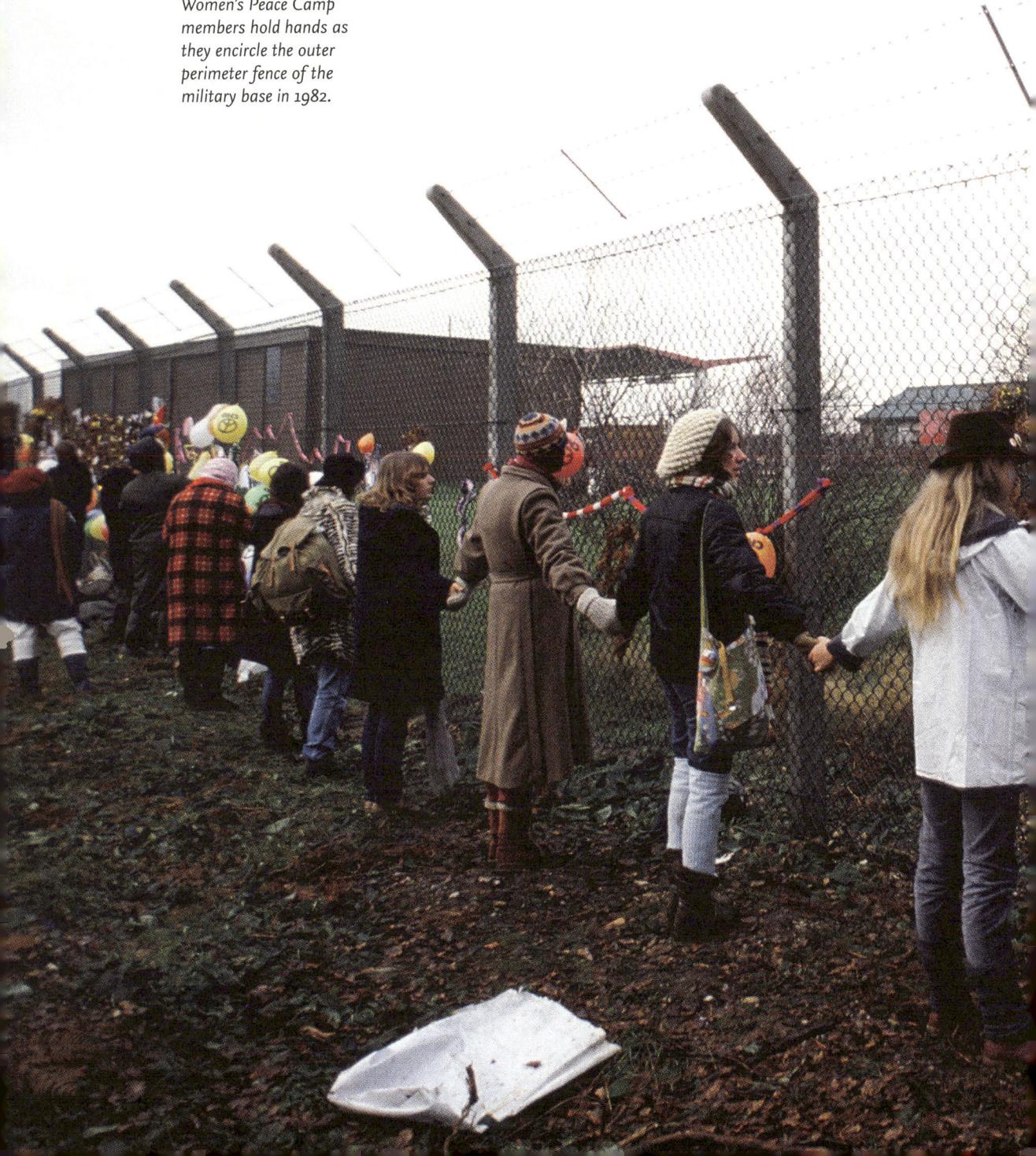

Greenham Common
Women's Peace Camp
members hold hands as
they encircle the outer
perimeter fence of the
military base in 1982.

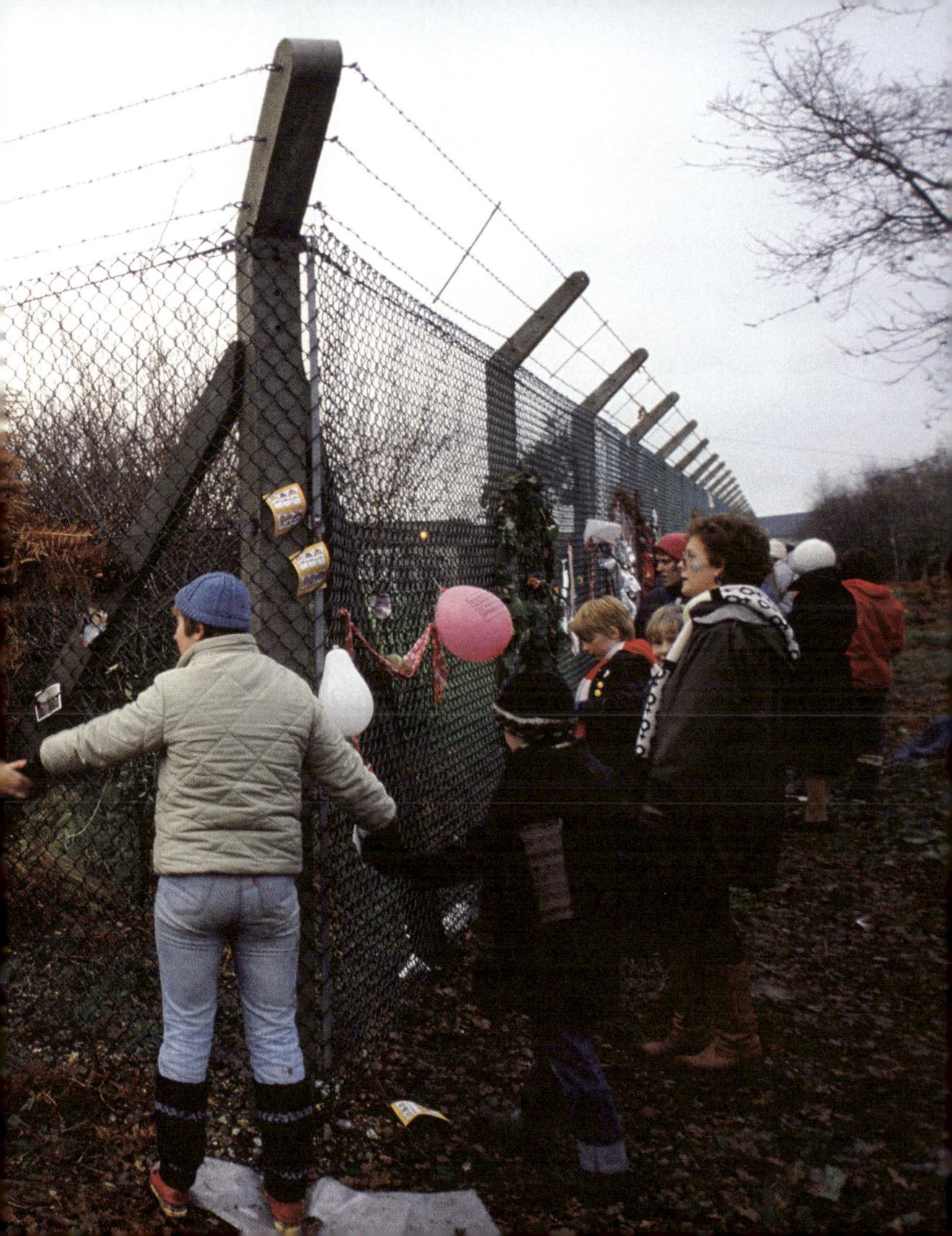

was established on 5 September 1981, and was one of the most significant and enduring protest movements in British history. The movement began with a march organised by the Women for Life on Earth group, which travelled from Cardiff to Greenham Common. Originally intended as a single demonstration, the protest evolved into a permanent encampment when a group of 36 women chained themselves to the base's perimeter fence, refusing to leave until the missiles were removed. Their action resonated widely, and the camp soon became a focal point for anti-nuclear activism.

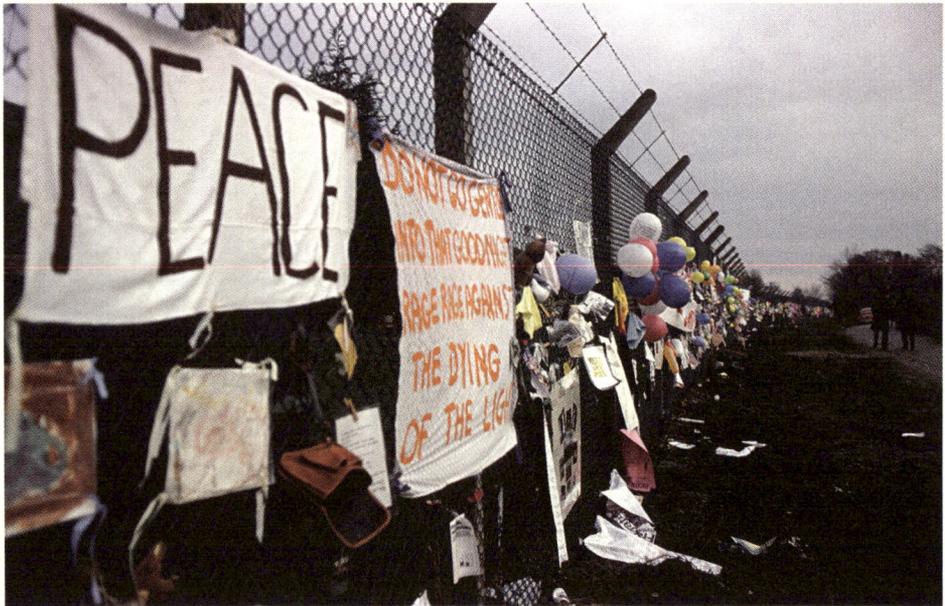

Peace movement banners left on the perimeter of Greenham Common USAF base, home of the Greenham Common Women's Peace Camp.

The Greenham women were united by their commitment to non-violent resistance. They adopted creative and symbolic forms of protest, including linking hands around the base in a human chain, tying ribbons to the fence, and staging 'die-ins' to represent the victims of nuclear war. The camp faced significant opposition from the authorities. Despite frequent arrests and dismantling of the camps, the women's commitment only deepened. Their resilience drew

international attention, and Greenham became a symbol of solidarity, inspiring similar protests across Europe and beyond.

This activism challenged traditional protest methods, centring women's voices and rejecting hierarchical leadership structures. This feminist approach emphasised the link between nuclear militarism and patriarchal systems of power, making Greenham Common a unique and transformative movement. The protests also highlighted the shifting role of women in public life. Participants were drawn from diverse backgrounds and included mothers, students, and working-class women, who rejected traditional domestic roles to engage directly in political action. One of the camp's most notable actions was the 1983 'Embrace the Base' demonstration, where over 30,000 women encircled Greenham Common in a powerful visual statement of resistance.

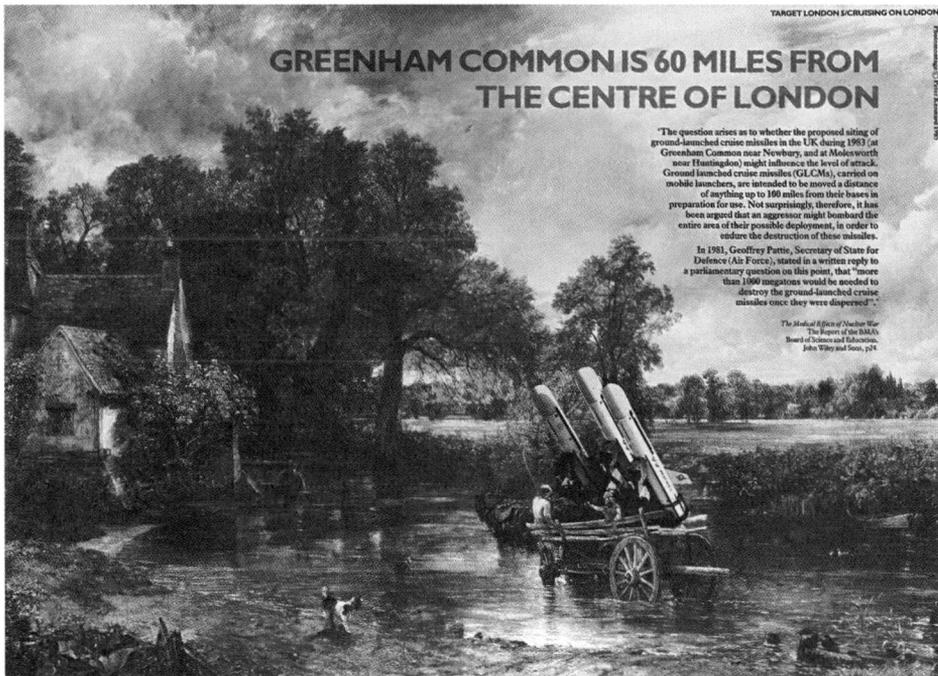

Peter Kennard's work is synonymous with British Cold War protest. One of his key works – Haywain with Cruise Missiles – juxtaposes John Constable's idyllic rural scene with the nuclear weapons posing an existential threat to humanity.

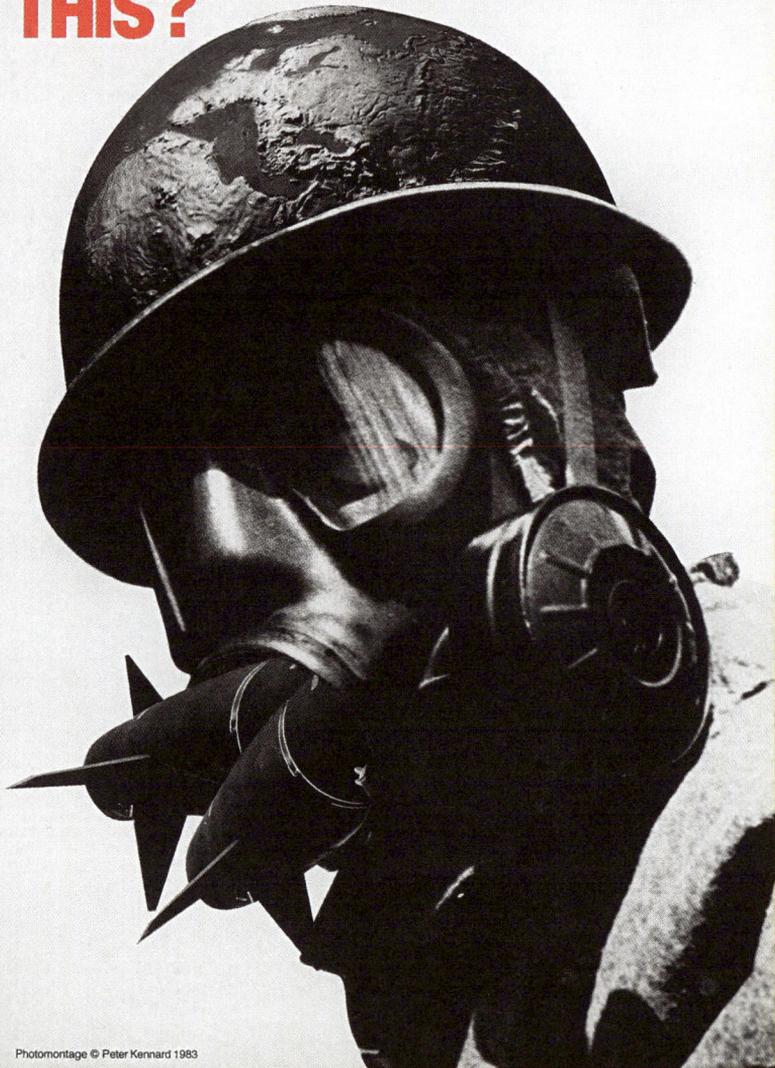

COULD YOU STOMACH THIS?

Photomontage © Peter Kennard 1983

Some of Peter Kennard's work, such as this poster, use the grotesque and the horrifying to increase the impact of the message.

CND also experienced a resurgence in popularity in the 1980s and achieved greater visibility thanks to the popular art of creatives such as Peter Kennard. Kennard's poster art became iconic for its ability to distil complex global issues into stark, confrontational imagery. One of his most famous works, *Broken Missile* (1980), features a photograph of a nuclear warhead split in two, superimposed on a black-and-white landscape. The image is simple yet powerful, symbolising both the destructive potential of nuclear weapons and the hope for disarmament. Another notable piece, *Haywain with Cruise Missiles* (1980), juxtaposed John Constable's idyllic pastoral scene with cruise missiles. This highlighted the intrusion of global conflict into the nation's cultural and physical spaces, provoking a sense of unease and urgency.

Kennard's work rejected abstraction, instead delivering direct visual commentary that resonated with a broad audience. His posters were displayed at protests, in magazines, and on walls across Britain, reaching people who might not have otherwise engaged with traditional political discourse. His art was symptomatic of a reigniting of British cultural responses to the Cold War in the 1980s, reflecting a fear of nuclear annihilation not seen since the days of the Cuban Missile Crisis. Ironically, this engagement was largely driven by a leaked government civil defence initiative.

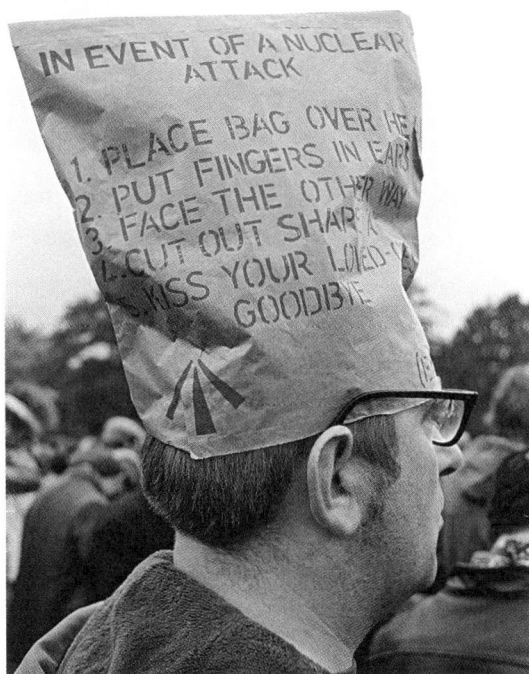

Photographer Edward Barber captured some of the most striking images of the anti-nuclear movement in the 1980s. This photograph was taken at a CND rally in Hyde Park in 1981.

'Protect and Survive' was a campaign developed by the Home Office as part of a broader civil defence strategy under the Conservative government of Edward Heath and later expanded during the Labour governments of Harold Wilson and James Callaghan. It centred around a series of leaflets and public information films detailing practical advice for surviving a nuclear strike. Topics included how to create improvised fallout shelters, the importance of stockpiling food and water, and methods for disposing of the dead. The information was stark, often unsettling, and designed to convey the gravity of nuclear conflict.

The materials, which were only intended to be distributed if the government deemed nuclear war imminent, were leaked to the public in 1980, prompting significant backlash. Critics argued that the advice offered a false sense of security and did little to address the catastrophic reality of what a nuclear war would be.

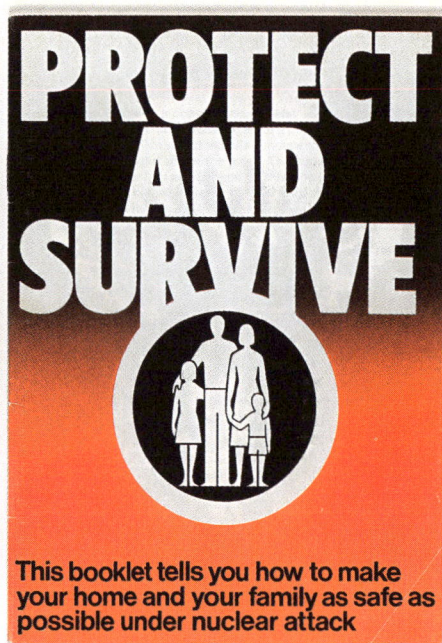

Released to the public in 1980, Protect and Survive *caused fear in some quarters, ridicule in others, and is an indelible piece of British Cold War iconography.*

Challenge to survival

1

Everything within a certain distance of a nuclear explosion will be totally destroyed. Even people living outside this area will be in danger from –

HEAT AND BLAST

FALL-OUT

Heat and Blast

The heat and blast are so severe that they can kill, and destroy buildings, for up to five miles from the explosion. Beyond that, there can be severe damage.

5

The public-information television films adapted from the guide were classified, but following a leak some were broadcast by the BBC's Panorama *programme.*

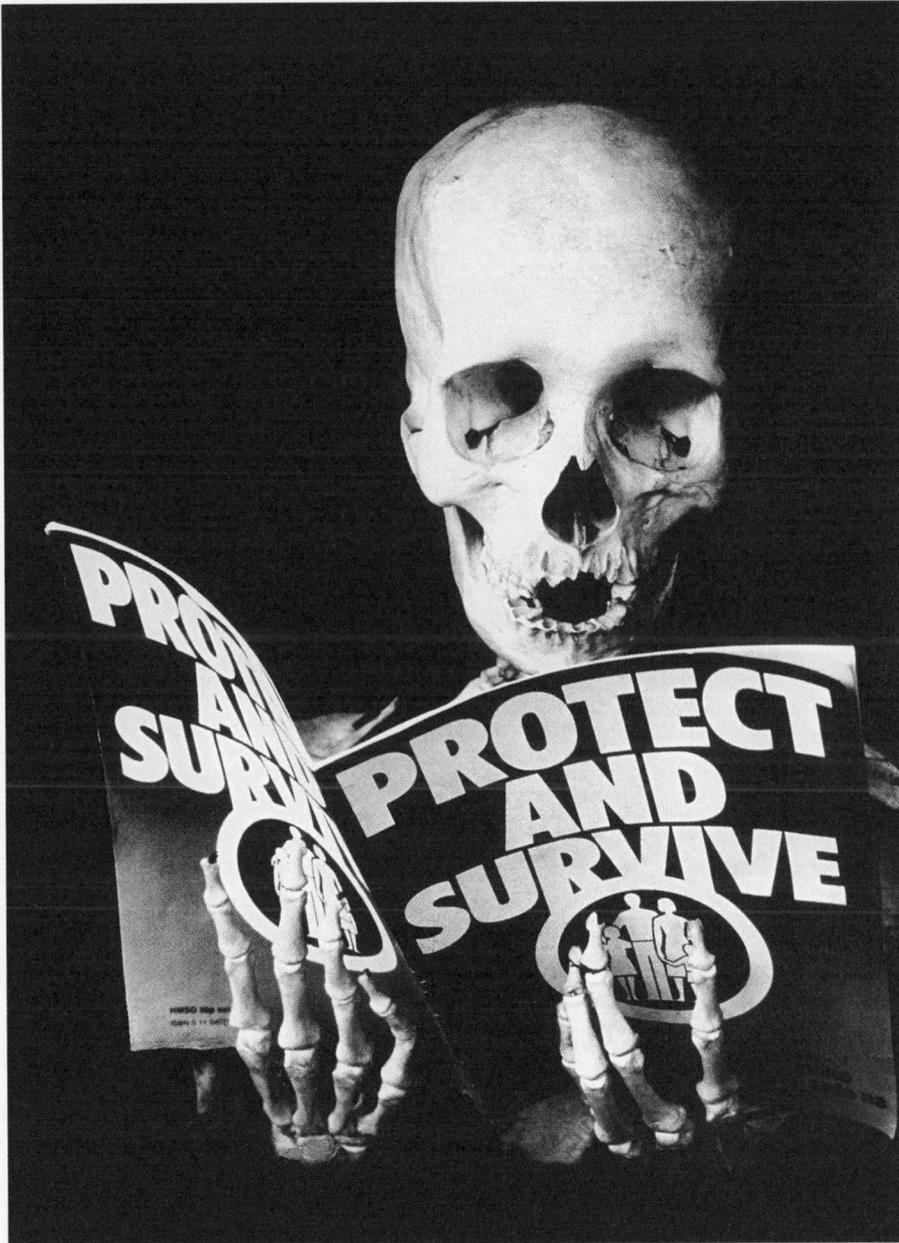

One of Peter Kennard's most iconic works uses the Protect and Survive
booklet ironically to highlight the futility of nuclear civil defence.

The suggestion to shelter under doors propped against walls or to whitewash windows to reflect the heat of a nuclear blast seemed woefully inadequate given the scale of destruction such an event would cause. The tone of the 'Protect and Survive' campaign also came under scrutiny. The instructional films, narrated in a calm yet sombre voice, presented a dystopian vision of life during a nuclear attack. Phrases like 'remove flammable materials' and 'lie face down' were difficult for the public to digest. For many, the campaign epitomised the bleakness of the late Cold War, where the government's planning appeared disturbingly detached from the realities of modern warfare.

Amid a climate of growing public awareness of nuclear weapons' devastating power, fuelled by events such as the Three Mile Island nuclear accident in Pennsylvania in 1979, satirical interpretations abounded. Kennard produced

Belying its cartoonish appearance, Raymond Briggs's When the Wind Blows *is a powerful and moving story of an elderly couple and their experience of a nuclear attack on Britain.*

a piece, also titled *Protect and Survive* (1980), depicting a skeleton perusing the booklet. More famous still was Raymond Briggs's graphic novel *When the Wind Blows* (1982), which depicted an elderly couple naively following similar government advice, only to succumb to radiation sickness. Punk rock bands, such as Crass, used the campaign's themes to critique government policy and nuclear brinkmanship. This wave of creative output reflected a broader cultural scepticism towards governmental authority and nuclear strategies. Yet for all that punk had been perceived to be the vanguard of social revolution, it was a theatrical and flamboyant pop band that would use the material most impactfully.

Two Tribes: *a politically provocative dancefloor-filler.*

Released on 4 June 1984, *Two Tribes* was the follow-up to Frankie Goes to Hollywood's controversial debut single, *Relax*. The song's title referenced the binary opposition of the Cold War superpowers, and lyrics critiqued the absurdity of mutually assured destruction. Lines like 'When two tribes go to war, a point is all that you can score' echoed the zero-sum mentality of the era's nuclear

THE ROYAL OBSERVER CORPS

The Royal Observer Corps (ROC) played a crucial yet often overlooked role in Britain's Cold War defence strategy. Formed in 1925, the ROC's mission during the Second World War had been to identify and track enemy aircraft over British airspace. With the advent of radar technology, the nature of air defence changed dramatically. Nevertheless, between 1947 and 1992, the Corps was a key component of the United Kingdom's civil defence system, monitoring potential aerial threats and preparing to record nuclear fallout in the event of an attack.

The ROC was integrated into the UK Warning and Monitoring Organisation (UKWMO). Volunteers were trained to operate a network of over 1,500 monitoring posts and control centres designed to track nuclear explosions and measure radiation levels. From small, claustrophobic concrete bunkers typically staffed by teams of two or three observers, the ROC would record data on the location, intensity and fallout patterns of nuclear detonations, relaying this information to centralised control centres for analysis and response coordination.

ROC personnel were trained to recognise the signature characteristics of nuclear explosions using specialised instruments such as the Ground Zero Indicator (GZI) and the Bomb Power Indicator (BPI). In a nuclear strike scenario, the ROC's role was to provide the vital data needed to assess damage and guide emergency services in their response efforts.

The essential work of the ROC was psychologically demanding for volunteers, who were civilians with day jobs but who underwent regular training and exercises. Despite their readiness, the Cold War ultimately remained a war of deterrence, and the ROC's services were never needed in a real nuclear event. With the end of the Cold War in 1991 and the reduction in the perceived threat of nuclear conflict, the ROC's role was deemed redundant. The Corps was stood down in 1992, marking the end of an era of volunteer civil defence.

brinkmanship. The *Annihilation Mix*, the 12" extended version of *Two Tribes*, took the song's apocalyptic themes to new heights. Clocking in at over nine minutes, it amplified the tension with additional samples, prolonged instrumental breaks, and a more pronounced sense of chaos.

Its most striking element, however, was the inclusion of public service announcements voiced by actor Patrick Allen, who had narrated the *Protect and Survive* public information video. These chilling interjections, urging citizens to prepare for nuclear attack, added a layer of dark humour and social critique. Fearful of breaking the Official Secrets Act by sampling Allen's narration directly from the source, producer Trevor Horn had the actor re-record his lines. Additional dialogue was provided by comedian Chris Barrie, imitating Ronald Reagan, while the music video depicted Reagan and Soviet leader Konstantin Chernenko in a wrestling match. Somewhat inevitably, the video was banned by the BBC. Perhaps with equal inevitability, the song went to number one in the UK charts.

This sweet-sounding pop song by West German band Nena, a worldwide hit in both German and English, was in fact an anti-war plea.

Two Tribes was one of many anti-war songs to trouble the charts in the mid-80s. *Seconds* (U2), *Hammer to Fall* (Queen), and *The War Song* (Culture Club) were all released in this period, and all by highly popular acts. Bigger than most of these was *99 Luftballons* by the West German new-wave band, Nena. In the lyrics, red helium balloons playfully released into the sky by the narrator are mistakenly identified by a malfunctioning early warning system as hostile threats. This error triggers panic, escalating into a chain of events that ultimately leads to nuclear war. The song concludes with the narrator walking through the post-nuclear desolation and finding a single remaining balloon.

As with music videos, more traditional television genres were reflecting Cold War anxieties in Thatcher's Britain. Ironically, one of the most powerful of these had been produced during the 1960s but was not seen by television viewers for another 20 years. Peter Watkins' *The War Game* was commissioned by the BBC as a dramatised pseudo-documentary exploring the aftermath of a nuclear strike on

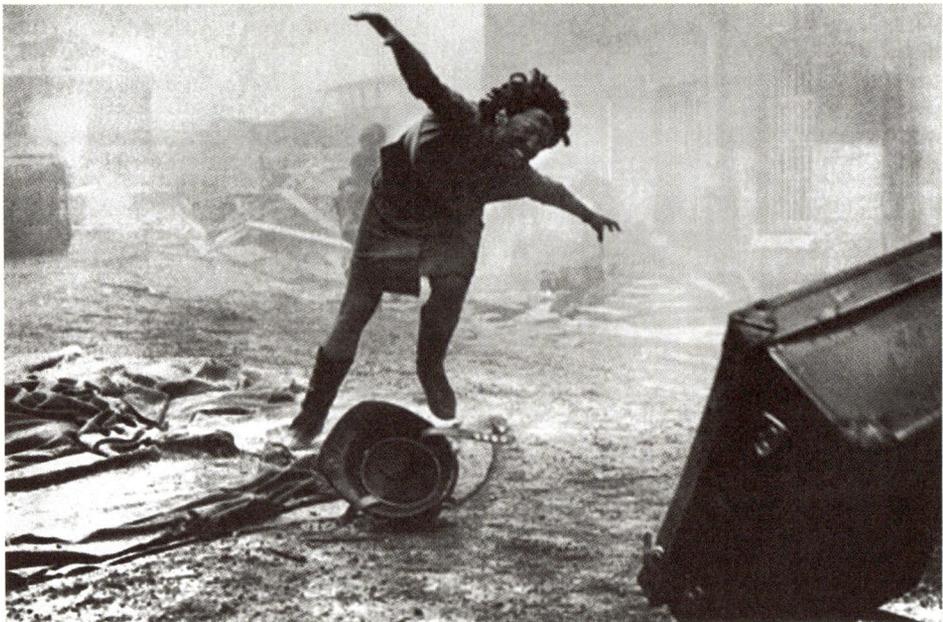

The War Game *was deemed too horrifying for the general British public and its broadcast on television was delayed by 20 years.*

Britain. Filmed in black and white for heightened effect, it depicted the devastating effects of a nuclear attack on Kent, focusing on societal collapse, widespread panic, and unimaginable human suffering. Interviews with actors portraying survivors, local officials, and emergency responders lent the film a chilling authenticity.

Upon completion, the BBC deemed *The War Game* too disturbing to broadcast, claiming it would alarm the public and potentially undermine faith in civil defence, although the decision was widely regarded as political. The film did, however, achieve global recognition after a limited cinematic release, winning the Academy Award for Best Documentary Feature in 1967. When it finally aired in 1985, during a period of renewed nuclear anxiety, *The War Game* had lost none of its power. Its stark images of civilian suffering and the collapse of law and order resonated deeply, reinforcing the argument for nuclear disarmament and leaving audiences profoundly shaken.

Barry Hines' *Threads*, also produced by the BBC, pushed the boundaries of nuclear war's portrayal even further. First broadcast on 23 September 1984, just months after *Two Tribes* had topped the pop charts, *Threads* depicted not only the immediate impact of a nuclear strike but also the long-term effects of nuclear winter, radiation sickness, and social disintegration post-detonation.

Set against the backdrop of growing international hostility, *Threads* begins by showing ordinary life in Sheffield, focusing on two working-class families: the Kemps and the Becketts. The film's early scenes are deliberately mundane, contrasting sharply with the unfolding geopolitical crisis, which escalates from news bulletins in the background to the horrifying detonation of a nuclear bomb over the United Kingdom. The central event – a one-megaton nuclear strike – marks the turning point in the film. Sheffield is obliterated, and the resulting scenes of destruction and chaos are graphic and unflinching: fires rage across cities, infrastructure breaks down, and survivors descend into disease, madness and disorder. The nuclear winter devastates agriculture and plunges survivors into a grim struggle for subsistence. The haunting final scenes remain some of the most disturbing in television history.

Threads *was*
The War Game
*for the 1980s —
and even more*
horrifying.

For many, *Threads* crystallised the existential horror of the nuclear arms race, serving as both a rallying cry for disarmament and a stark condemnation of the illusion of preparedness. It was popular with audiences, with 6.9 million watching the original transmission on BBC2, and it was repeated the following year on BBC1 as part of a series of programmes marking the 40th anniversary of the atomic bombing of Hiroshima and Nagasaki. This same programming saw *The War Game* make its television debut.

ITV's satirical puppet show, *Spitting Image*, was also debuted in 1984. With its grotesque caricatures, the show fearlessly lampooned political leaders, celebrities, and cultural figures of the time. Central to *Spitting Image*'s sharp commentary on the absurdities of Cold War politics and the nuclear arms race were its portrayals of key global leaders. Ronald Reagan, depicted as a bumbling, senile figure prone to catastrophic mistakes, embodied the show's critique of American foreign policy, while Mikhail Gorbachev was shown as a beleaguered reformer struggling to manage the collapsing Soviet Union. The show's undoubted star, however, was Margaret Thatcher. Cast as a domineering, militaristic leader who cowed her cabinet into submission, *Spitting Image* reflected British anxieties about her unyielding alliance with Reagan and her support for nuclear deterrence.

The nuclear arms race provided *Spitting Image* with fertile ground for humour. Its sketches portraying leaders as childish or reckless in their pursuit of military superiority were hugely popular with audiences, with 15 million viewers tuning in at its peak. Equally popular was the BBC's much-loved sitcom, *Only Fools and Horses*, which dedicated an episode to Cold War paranoia. In 'The Russians Are Coming', the Trotters prepare for nuclear war by building a fallout shelter. Blending slapstick comedy with biting social commentary, the episode mocks the government's civil defence strategies. More subversively, *The Young Ones* approached the same material with a more anarchic bent, while even the most popular of programmes, *Coronation Street* and *EastEnders*, would reference the conflict, even if only as background.

The Cold War was so frightening, that for many it was better to focus on the absurdity of it all. Spitting Image was hugely popular with British television audiences.

In contrast to the harrowing realism of *The War Game* and *Threads*, the 1986 animated feature-film adaptation of *When the Wind Blows* used a more stylised and darkly satirical approach to explore similar themes. As with the graphic novel, the film tells the story of Jim and Hilda Bloggs, an elderly working-class couple living in rural England. Voice performances by acting royalty John Mills and Peggy Ashcroft helped retain the poignancy of Raymond Briggs's work, and the film boasted a haunting score by Pink Floyd's Roger Waters. The title song was provided by David Bowie, whose music dealt with Cold War themes on numerous occasions. But the world was changing quickly, and Bowie soon provided what would prove to be a harbinger of the end of the 50-year standoff.

Raymond Briggs's book When the Wind Blows *was adapted into an animated feature film in 1986.*

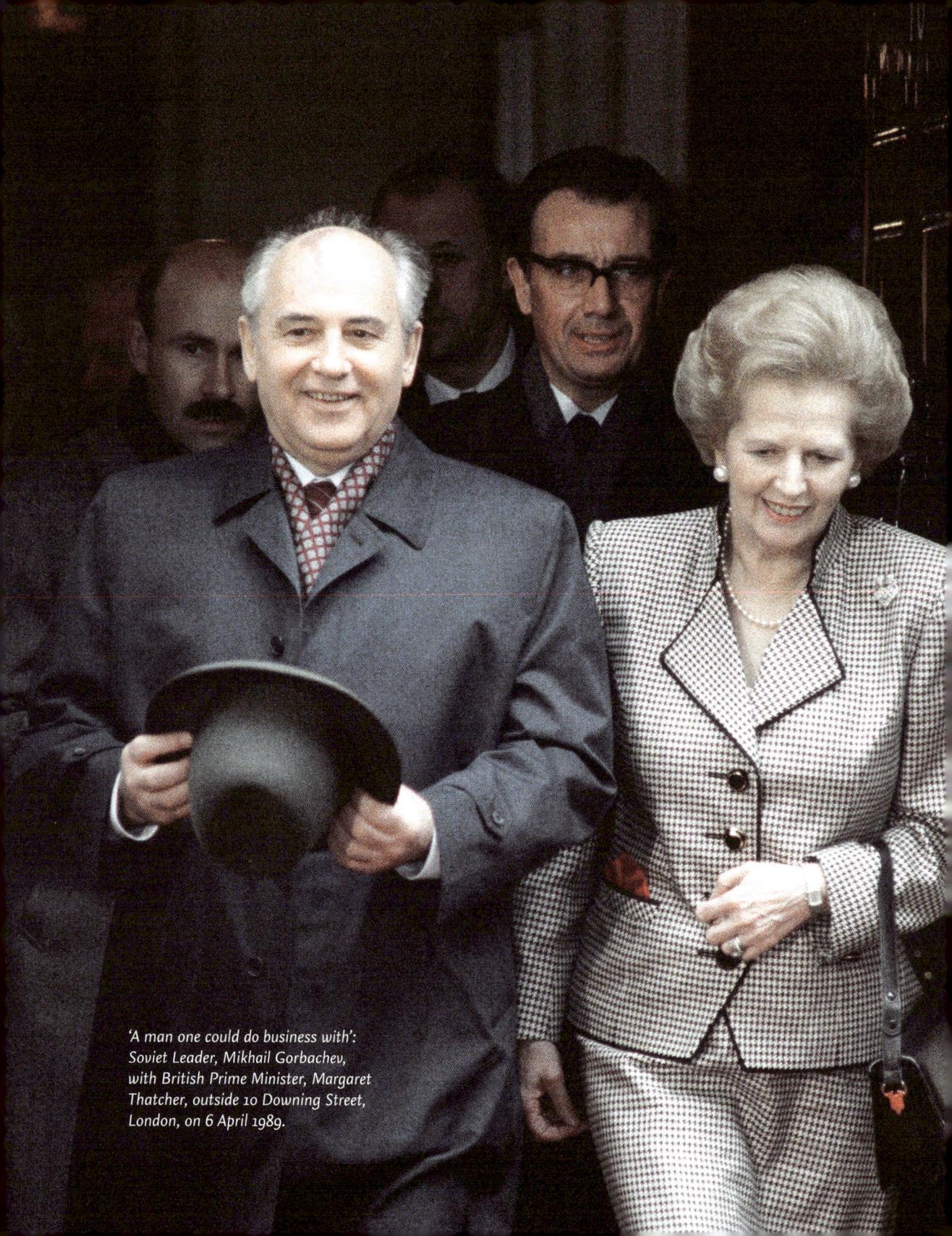

'A man one could do business with':
Soviet Leader, Mikhail Gorbachev,
with British Prime Minister, Margaret
Thatcher, outside 10 Downing Street,
London, on 6 April 1989.

CHAPTER 6

BRITAIN'S COLD WAR LEGACY IN A CHANGING WORLD

On 6 June 1987, David Bowie returned to Berlin, a city that had been pivotal to his evolution as an artist a decade earlier. In the late 1970s, he had shared a Schöneberg apartment with fellow rock and roll icon Iggy Pop. He recorded three of his most celebrated albums in the city – the Berlin Trilogy that includes the album *"Heroes"* (1977). The title track to *"Heroes"* (stylised with quotation marks to underscore the irony of the triumphant music compared with the despairing lyrics) is one of Bowie's most beloved compositions. Bowie's lyrics reflect a real-life incident that occurred while the music was being recorded, the killing of 18-year-old Dietmar Schweitzer by East German border guards while he tried to flee west across the Wall.

British rock icon David Bowie performs near the Berlin Wall in June 1987. The concert was one of a series by Western artists that many see as propelling the events that would see the Wall come down.

Whilst David Bowie played on the Western side of the Wall, many thousands of East Berliners came to the other side to listen to the concert.

Now, Bowie returned to play a huge outdoor concert near the *Reichstag*, close to the Berlin Wall. He used the opportunity to emphasise the unifying power of art. Before playing *"Heroes"*, he addressed the East Berliners directly: 'We send our best wishes to all of our friends who are on the other side of the Wall.' His words sparked a spontaneous reaction. Over 200 East Berliners rushed towards the Wall, leading to confrontations with the authorities and arrests. A riot soon erupted, with demonstrators shouting, 'The Wall must fall!' and 'Gorby, get us out!'. These chants reflected the growing discontent in East Germany, becoming one of many acts of civil unrest that would culminate in the fall of the Berlin Wall in 1989. Just days after the concert, Ronald Reagan stood at the Brandenburg Gate and famously implored, 'Mr Gorbachev, tear down this Wall.'

Britain occupied a unique position in the waning years of the Cold War, deeply influenced as it was by its historical role as a staunch ally of the United States, its proximity to Continental Europe, and the leadership of Prime Minister Margaret Thatcher. Between 1985 and 1991, Britain helped to shape the narrative of the Cold War's end, not merely as a passive observer but as an active participant in the diplomatic, military, and ideological manoeuvres that defined this pivotal era.

By 1985, the Cold War had reached a critical juncture. The Soviet Union, under the leadership of Mikhail Gorbachev, was showing signs of economic and political strain. Britain, meanwhile, remained firmly aligned with the United States under President Ronald Reagan, with the Special Relationship at the heart of its foreign policy. The early years of Margaret Thatcher's premiership, which began in 1979, had already cemented her as a key figure in Cold War politics. Thatcher first emerged as a significant political figure in the mid-1970s, having given a speech denouncing the Soviet Union. She was famously nicknamed the 'Iron Lady' by the Soviet military newspaper *Red Star*. Intended as an insult, Thatcher embraced the moniker, and it stuck for the rest of her political life. She was a vocal advocate of Western ideological and military resistance to the Soviet Union, embracing Reagan's hard-line stance on communism and nuclear deterrence.

In December 1979, the Soviet Union invaded Afghanistan to support the pro-Soviet communist government of the People's Democratic Party of Afghanistan (PDPA) against Islamist insurgents, the Mujahideen. Moscow aimed to secure its southern border and uphold its strategic interests in Central Asia, while protecting the broader credibility of the Soviet Union as a reliable ally during the Cold War. Thatcher condemned the invasion as a violation of Afghan sovereignty and a breach of international law. With the 1980 Olympic Games due to be held in Moscow, the United States led a boycott that was joined by over 60 nations, including significant allies. Thatcher strongly supported the boycott, urging British athletes not to compete, but could not garner British support unilaterally. The independent British Olympic Association voted to send a team, leaving individual athletes to decide whether or not to participate.

Originally designed for the Christmas 1980 edition of the Socialist Worker, the paper of the Socialist Workers Party, this poster is a pastiche of the 1939 Hollywood epic, Gone With the Wind, *replacing the central lovers with Ronald Reagan and Margaret Thatcher.*

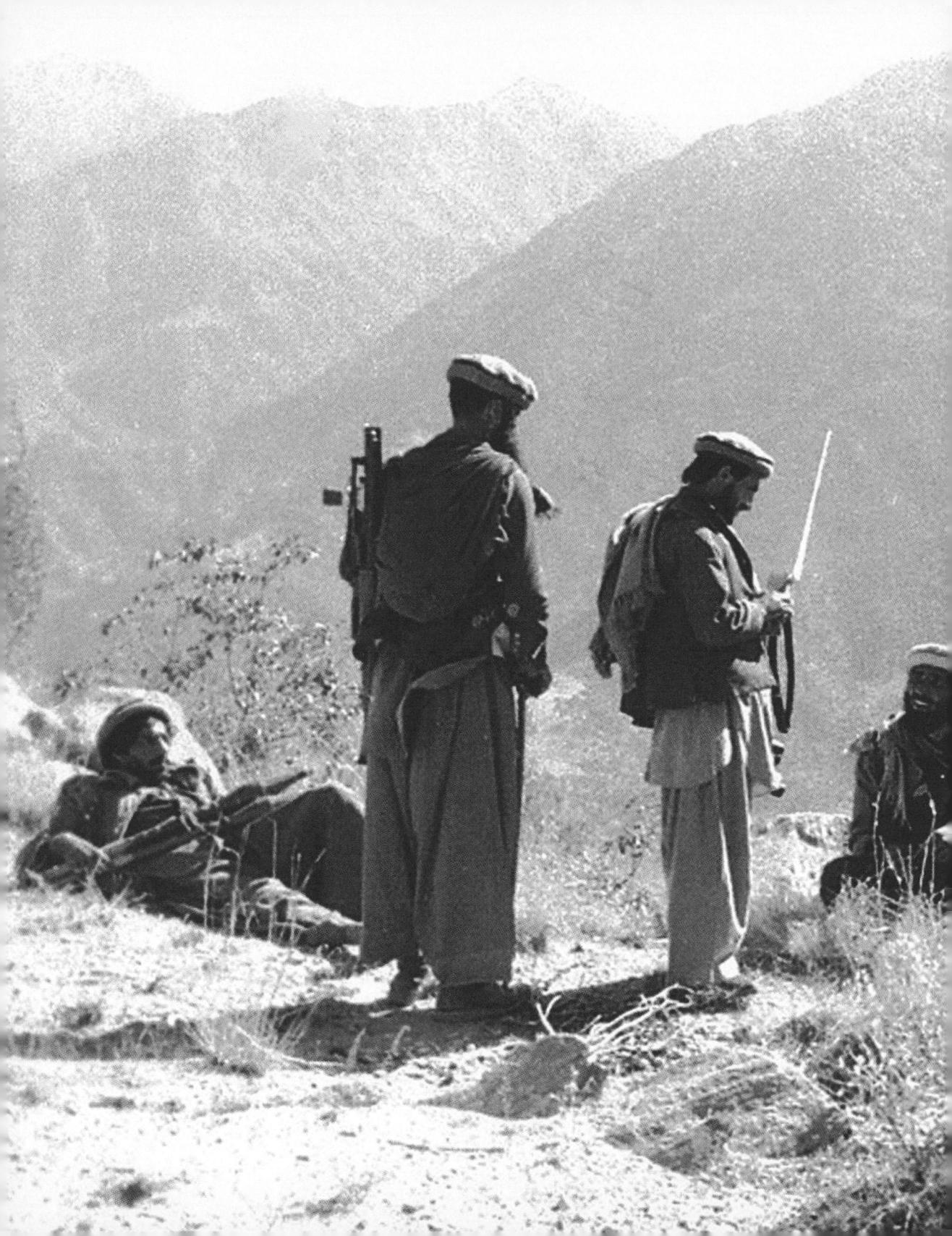

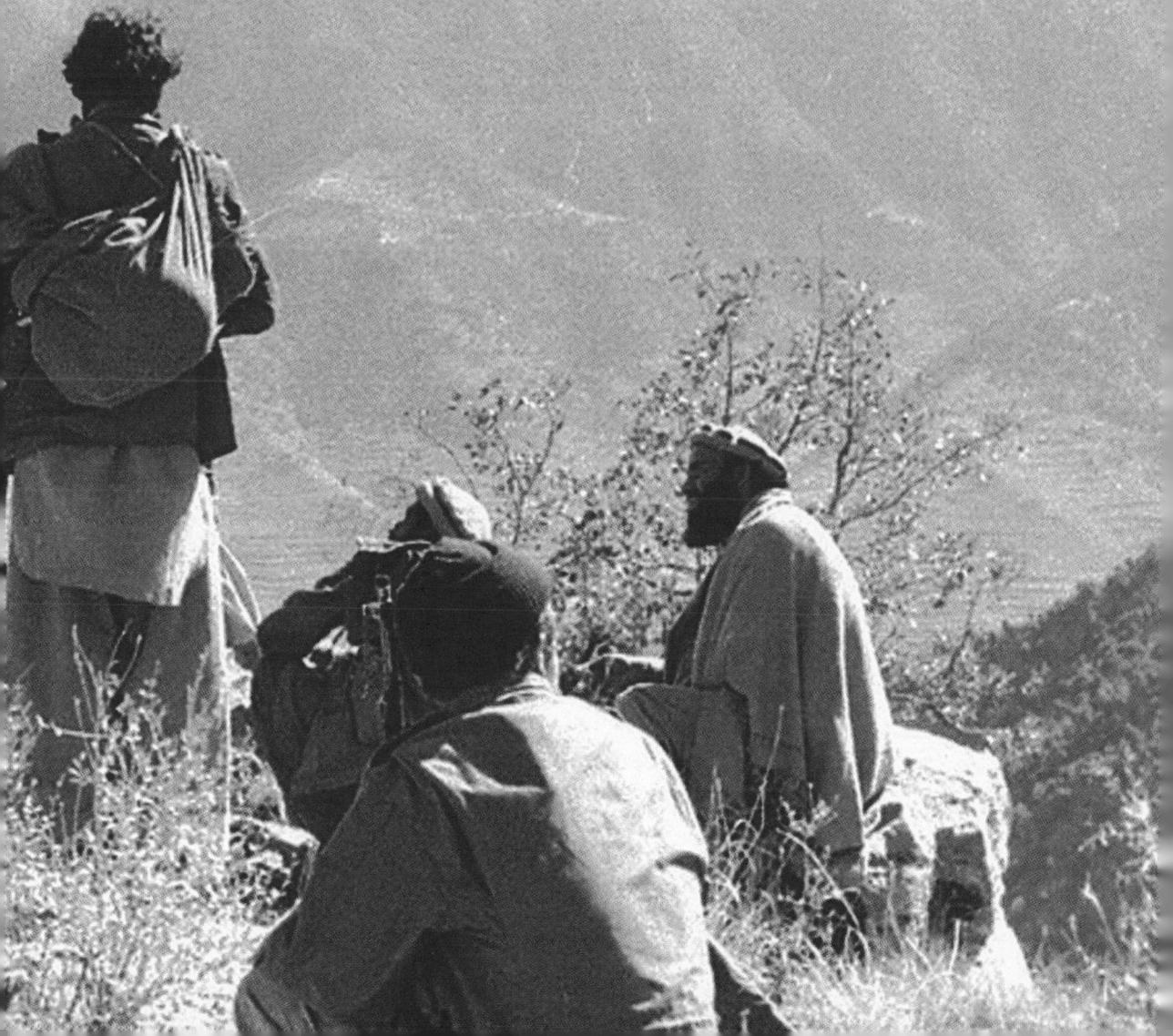

A Mujahideen mortar position in Kunar Province, Afghanistan. The group fighting to expel the Soviet Union would later evolve into the West's post-Cold War enemy.

THE SOVIET UNION IN AFGHANISTAN

The Soviet Union's involvement in Afghanistan was rooted in its broader Cold War strategy of supporting socialist regimes and suppressing perceived threats to its ideology and security. Intended to stabilise a faltering communist government, the invasion instead plunged the USSR into a gruelling decade-long conflict that revealed the limits of its military and political power.

Afghanistan became a Soviet concern after the 1978 Saur Revolution, which brought a communist government to power. The new regime's radical reforms alienated much of the population, sparking widespread resistance. Concerned about the rise of anti-communist insurgents, the USSR intervened directly in December 1979, deploying a peak force of over 100,000 troops to support the regime.

The war quickly devolved into a quagmire despite the Soviet Union's advanced weaponry. The Mujahideen – a diverse coalition of Islamic insurgents bolstered by covert support from the United States, Pakistan, and other Western allies – were better able to control the mountainous terrain. By the time the Soviet forces withdrew in 1989, the war had cost tens of thousands of Soviet lives and severely strained the nation's economy and morale.

This was the latest in a series of conflicts in which the Soviet Union engaged, either directly or indirectly, across the globe. Soviet troops had crushed uprisings in Hungary (1956) and Czechoslovakia (1968), while the USSR provided military and economic aid to North Vietnam during the Vietnam War. In Africa, the Soviet Union sought to expand its influence by supporting liberation movements and socialist regimes, notably in Angola, Ethiopia, and Mozambique.

From a Western perspective, these interventions were seen as aggressive attempts to spread communism, while for the USSR, they were framed as necessary acts of solidarity and defence against imperialist encroachment. Yet, by the 1980s, the economic and political costs of such involvement became increasingly unsustainable. The disastrous Afghan campaign in particular became a cautionary tale of imperial ambition, leaving a legacy of instability that persists to this day.

Sebastian Coe and Steve Ovett, Britain's top middle-distance runners, both chose to compete, symbolising the defiance of many athletes who prioritised sport over politics. Their rivalry became one of the defining features of the Games, capturing international attention and transcending the boycott narrative. Coe and Ovett, both already world-class athletes, faced off in two of the most anticipated events: the 800m and 1,500m races. Ovett won gold in the 800m, while Coe redeemed himself in the 1,500m, delivering an iconic performance under immense pressure. But amid a showcase of Soviet power and propaganda, with the USSR dominating the medal table, the absence of many Western athletes cast a shadow over the Games' wider legitimacy, tarnishing their global prestige. Despite the exploits of Coe, Ovett, and others, Thatcher emerged from the Games with her reputation as an implacable foe of the USSR intact.

A satirical cartoon by Nicholas Garland reflecting 1980s Cold War
tensions. The 1980 Olympic Games in Moscow became a subject
of intense debate, with the US team boycotting and the British
team resisting government pressure to do likewise.

It was, however, Thatcher's later, more pragmatic engagement with Gorbachev that would mark Britain's most distinctive contribution to the Cold War's endgame. Thatcher famously declared after her first meeting with Gorbachev

in December 1984, 'I like Mr Gorbachev. We can do business together.' This comment was not mere rhetoric. It reflected her recognition of Gorbachev's genuine reformist ambitions. Gorbachev's policies of *glasnost* (openness) and *perestroika* (restructuring), introduced in 1985, aimed to revitalise the Soviet Union's ailing economic and political structure. Thatcher saw in their architect a partner through whom the Cold War might be peacefully concluded.

Britain's role as a bridge between the United States and the Soviet Union became increasingly important during this period. Thatcher's close relationship with Reagan allowed her to act as a mediator of sorts, particularly in moments of tension or hesitation. While Reagan initially adopted a confrontational approach to the Soviet Union, typified by his 1983 'Evil Empire' speech, Thatcher's influence helped temper his rhetoric and encourage a more diplomatic stance. She had frequent private conservations with Reagan throughout the series of US–Soviet summits that began in Geneva in 1985, where Gorbachev and Reagan laid the groundwork for arms reduction agreements.

This mediating role was balanced by Thatcher's unwavering military commitment to NATO, typified by the deployment of US cruise missiles in Britain. Despite significant domestic opposition, Thatcher's government maintained that a strong nuclear posture was essential in counter-balancing the Soviet threat, continuing Britain's historical belief in the principle of deterrence.

As the 1980s progressed, ideological rigidity began to give way to a more nuanced understanding of the shifting global landscape. The signing of the Intermediate-Range Nuclear Forces Treaty in 1987, the first arms control agreement to eliminate an entire category of nuclear weapons, was a landmark moment in the thawing of East–West relations. Britain, while not a signatory to the treaty, was deeply involved in the negotiations. Thatcher's government worked closely with Reagan's administration to ensure the treaty's success, recognising that its implementation would reduce the immediate threat of nuclear confrontation in Europe.

Ronald Reagan and Margaret Thatcher were among
the most electorally successful politicians of their
respective nations' modern history. Yet both were
also ripe for caricature and satire.

The fall of the Berlin Wall in November 1989 was the most iconic moment of the Cold War's end. By the late 1980s, the cracks in the communist system were becoming increasingly visible. Economic stagnation, widespread corruption, and growing discontent among citizens weakened the Soviet Union's grip on its satellite states. The Chernobyl disaster of 1986 became a haunting symbol of the Soviet Union's decline, exposing the catastrophic consequences of systemic inefficiency, secrecy, and the crumbling infrastructure of a superpower in its final years.

Mikhail Gorbachev's reforms further emboldened calls for change. Across Eastern Europe, protests and uprisings gained momentum, with countries such as Poland and Hungary leading the charge towards democratic reform. In East Germany, mounting pressure from citizens demanding freedom and reform culminated in mass protests throughout 1989. The Monday Demonstrations in Leipzig, which began with a few hundred people, swelled to hundreds of thousands, demanding democratic rights and the opening of borders. The leadership of the German Democratic Republic (GDR, or East Germany), under Erich Honecker, initially

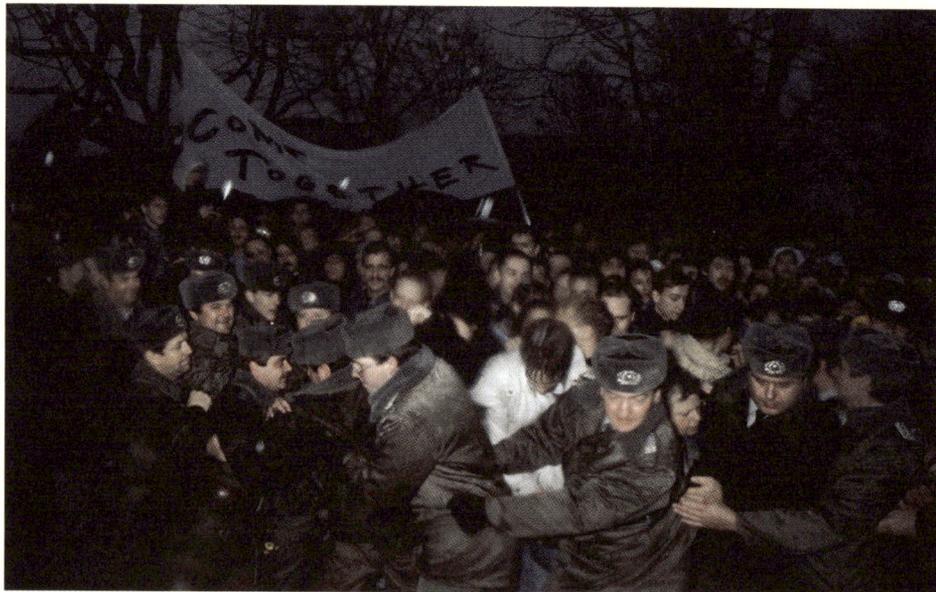

East German guards struggle to restrain a crowd of East Berliners at the fall of the Berlin Wall in November 1989.

CHERNOBYL: THE DISASTER THAT SHOOK THE WORLD

On 26 April 1986, one of the most catastrophic nuclear accidents in history occurred at the Chernobyl Nuclear Power Plant in Ukraine, then part of the USSR. Following a failed safety test on Reactor 4, a combination of a flawed reactor design and operator error resulted in a massive explosion of radioactive material that would cause shockwaves around the world.

The immediate effects were devastating. The blast killed two workers outright, and dozens of emergency responders succumbed to acute radiation sickness in the following weeks. Heavy contamination forced the evacuation of over 100,000 people from the surrounding area, which included the town of Pripyat, while a plume of radioactive dust spread across Europe.

The Soviet government's initial response was to attempt a cover-up, and it was only after Swedish scientists detected unusually high radiation levels that the Kremlin acknowledged the disaster, nearly two days after the explosion. This delay not only exacerbated the health risks for local populations but damaged the USSR's credibility on the global stage. For many, Chernobyl was emblematic of a regime characterised by suppression and the prioritisation of political expediency over human lives.

The long-term human cost is difficult to quantify, with estimates of fatalities from radiation exposure ranging from the dozens to the tens of thousands. Health impacts, including increased higher rates of cancer and other illnesses, persist to this day, and the exclusion zone around Chernobyl remains largely uninhabitable.

Domestically, Chernobyl eroded public trust in Soviet institutions and fed demands for greater transparency. Mikhail Gorbachev later cited the disaster as a catalyst for his reformist policies. Internationally, Chernobyl underscored the risks of nuclear energy and prompted safety improvements. The disaster has been immortalised in books, films, and television series that explore its human and environmental impact. Today, its legacy continues to shape debates about technology, governance and the environment.

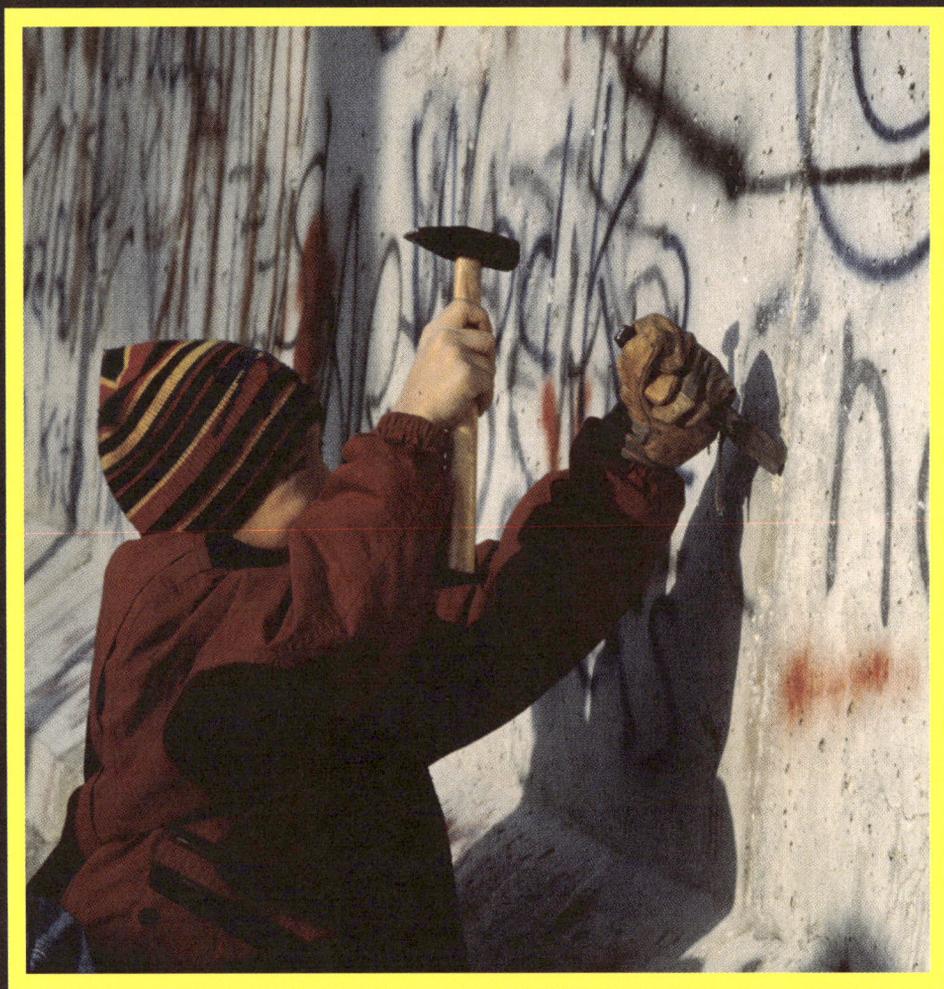

A child uses a hammer and chisel to remove a piece of the Berlin Wall after its opening by the East German government on 9 November 1989. By the end of 1990, much of the Wall had been demolished.

resisted change, but internal and external pressures made their position untenable. Honecker was replaced by Egon Krenz in October 1989, but the new leadership struggled to maintain control as the demand for reform became unstoppable.

On 9 November 1989, an extraordinary sequence of events unfolded. At a press conference, GDR official Günter Schabowski announced changes to travel restrictions for East Germans. When asked when these changes would take effect, he mistakenly replied, 'Immediately, without delay.' This statement triggered a flood of East Berliners to the border crossings, overwhelming unprepared guards. Faced with the sheer number of people, border officials ultimately opened the gates, and East and West Berliners surged through, meeting in scenes of jubilation and disbelief. Crowds climbed the Wall, chipping away pieces as souvenirs, and celebrated their newfound freedom.

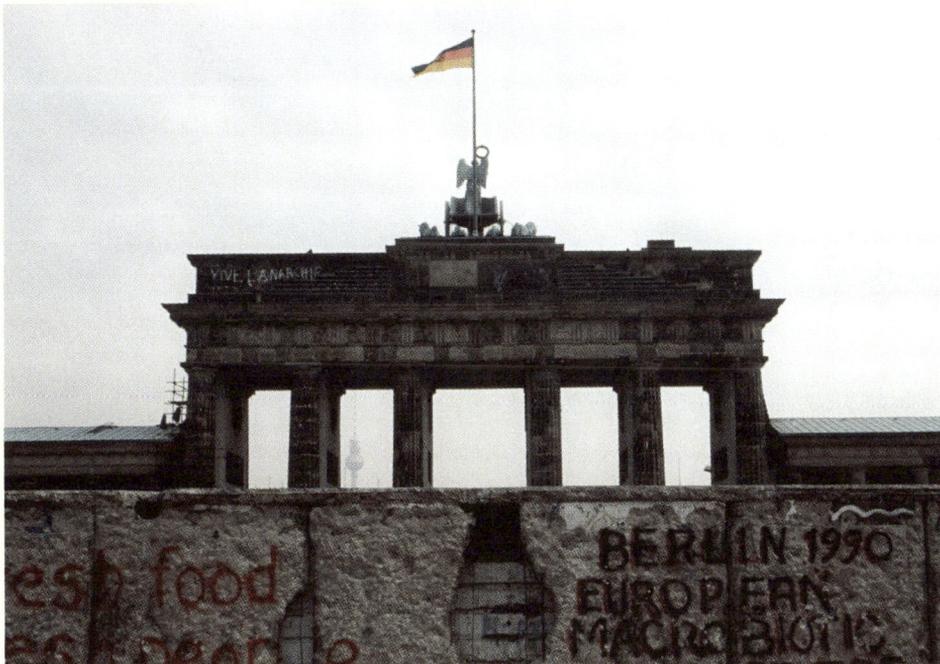

The West German flag flies over the Brandenburg Gate in early 1990, with a graffiti-covered section of the Berlin Wall in the foreground. The marks on the wall left by hundreds of Berliners chipping away at the concrete are clearly visible.

Thatcher's public response to the fall of the Berlin Wall was measured and supportive. As a staunch anti-communist, she recognised that the collapse of the East German regime was a significant blow to Soviet influence in Europe and a vindication of Western policies, but she also expressed caution about the implications of German reunification for the balance of power in Europe. In private conversations with French President François Mitterrand and Soviet leaders, she voiced her apprehensions about the potential resurgence of German dominance. Despite her reservations, Britain formally supported the process of German reunification, aligning with US President George H. W. Bush's vision of a peaceful and democratic Europe. British Foreign Secretary Douglas Hurd underscored the need for careful negotiation with both West and East Germany, ensuring Soviet cooperation while maintaining strong ties with Western allies. Britain's pragmatic approach reflected its desire to shape the post-Cold War order without risking conflict or upheaval.

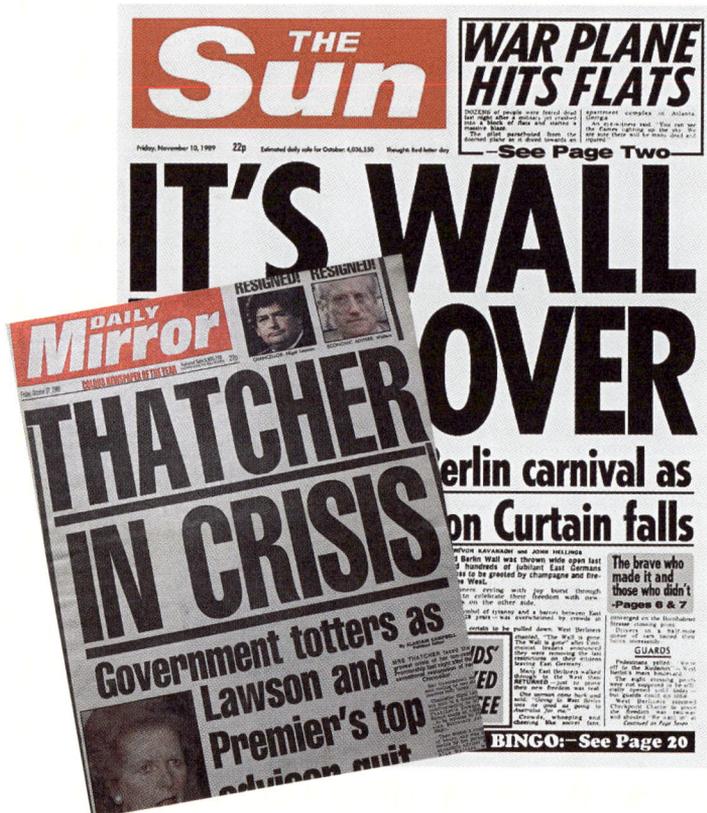

The Sun *proclaimed victory for the West, but perhaps Margaret Thatcher's lukewarm response to the fall of the Berlin Wall was because of the precarity of her own position. Just two weeks earlier, the tabloids had been awash with news of a government crisis that would go on to cause the demise of another Cold War icon a year later.*

Among the British public, the fall of the Berlin Wall was met with a sense of euphoria and hope. Media coverage in Britain amplified this sentiment, with live broadcasts and newspaper headlines capturing the historic moment. *The Guardian* proclaimed, 'A Wall Falls' while *The Times* described it as 'A New Dawn for Europe'. The sight of East and West Berliners dismantling the Wall symbolised the victory of Western values, and across the country, community events, rallies, and church services celebrated the symbolic end of division in Europe. For some, it also served as a reminder of the power of ordinary citizens to bring about monumental change. Today, fragments of the wall can be found all over the world, serving as enduring reminders of both the divisions of the past and the triumph of unity and freedom. A section now stands watch over the entrance to London's Imperial War Museum, with a graffitied epitaph: Change Your Life.

The section of Berlin Wall that is now outside the Imperial War Museum in London once stood on a street called Leuschnerdamm in the Kreuzberg district of Berlin. One side is covered by graffiti, including the 'Change Your Life' inscription by the artist Jürgen Grosse, known professionally as 'Indiano'.

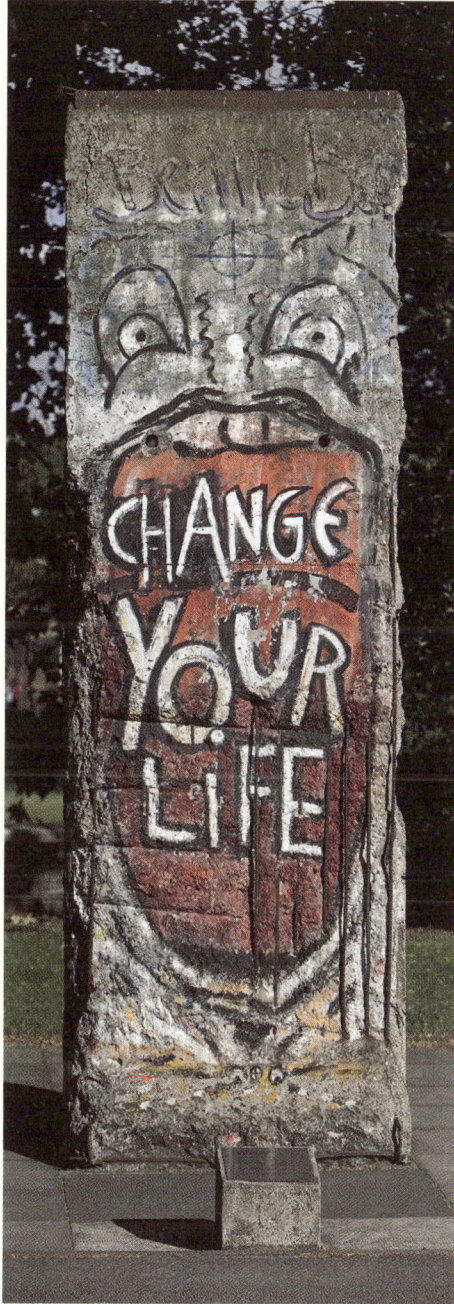

The early 1990s brought further dramatic changes. The dissolution of the Soviet Union in December 1991 marked the definitive end of the Cold War and reshaped the global political landscape. The British government, led by Prime Minister John Major, welcomed the dissolution of the Soviet Union as a historic victory for democracy and free market principles, and a validation of British Cold War policy, from the steadfast support of NATO to the maintenance of a nuclear deterrent. Thatcher, who had left office in November 1990, continued to defend her record, arguing that her government's policies had contributed to the West's victory in the ideological struggle against communism. It was under Major, however, that Britain was forced to adapt to the new geopolitical realities. The government supported initiatives to aid the newly independent states of the former Soviet Union, recognising the need to stabilise the region and prevent the proliferation of nuclear weapons.

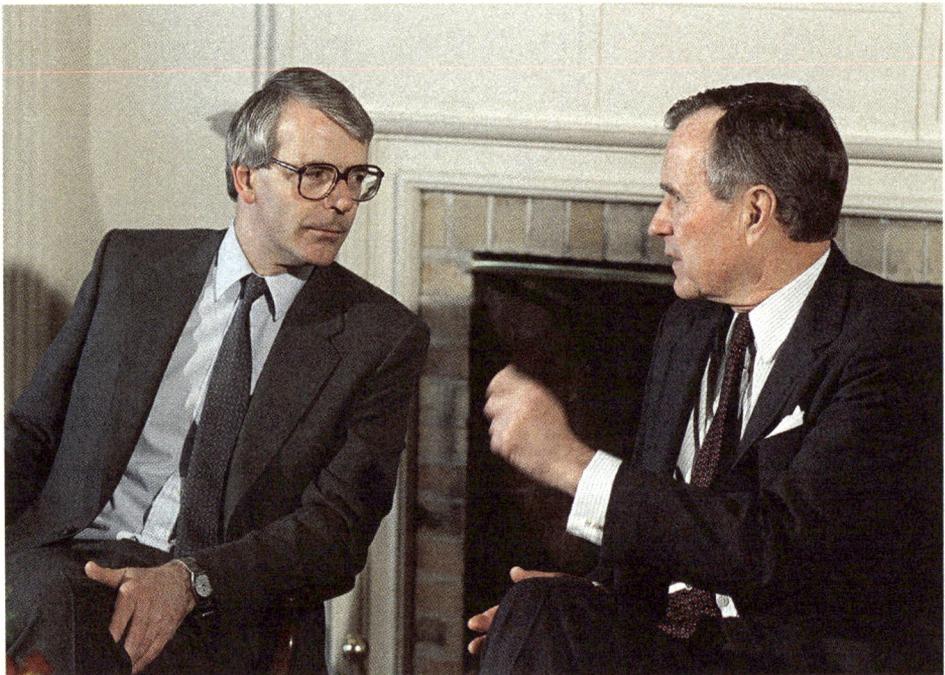

British Prime Minister John Major and US President George H. W. Bush confer in March of 1991. Thatcher and Reagan fought much of the end of the Cold War – it fell to their successors to manage the peace.

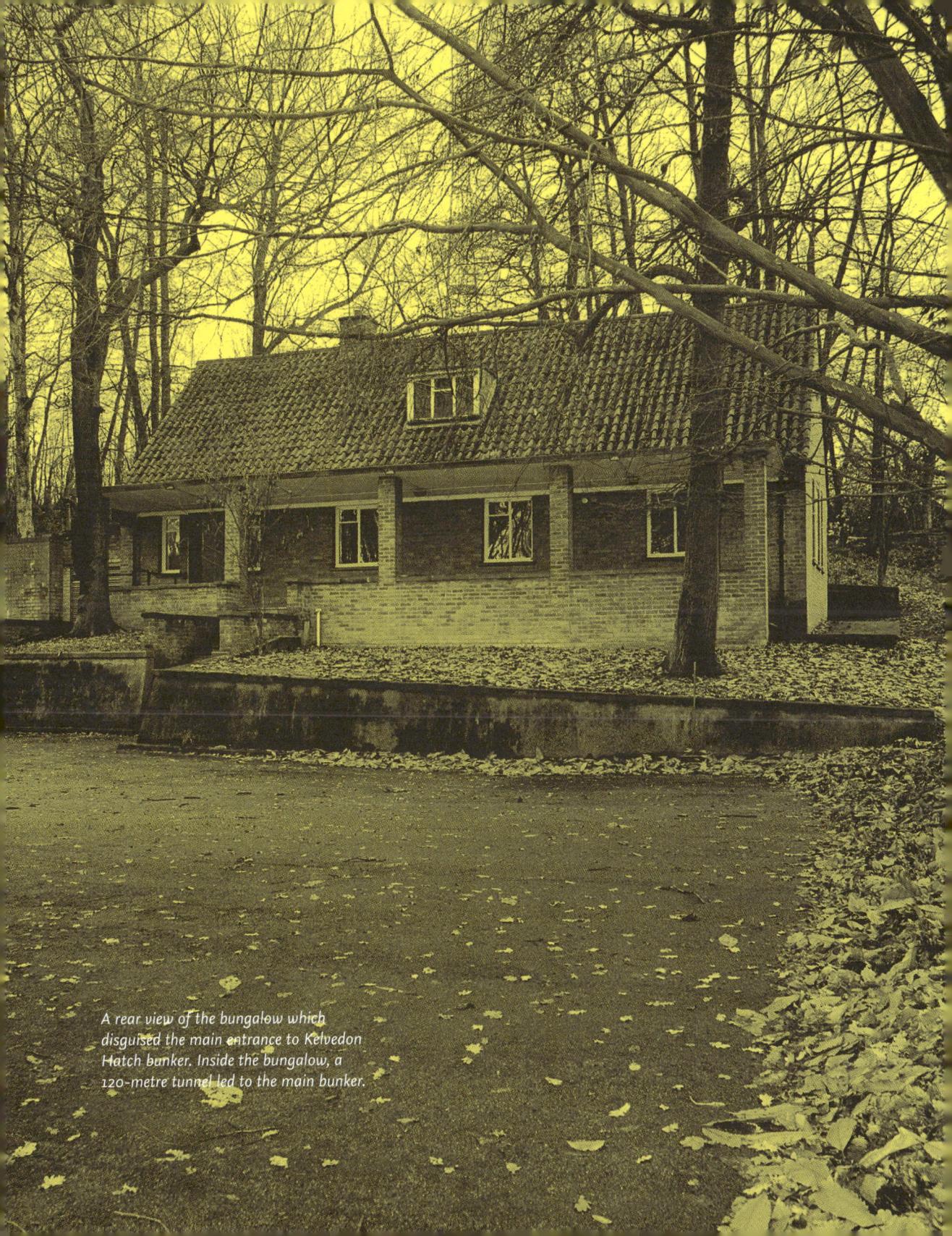

A rear view of the bungalow which disguised the main entrance to Kelvedon Hatch bunker. Inside the bungalow, a 120-metre tunnel led to the main bunker.

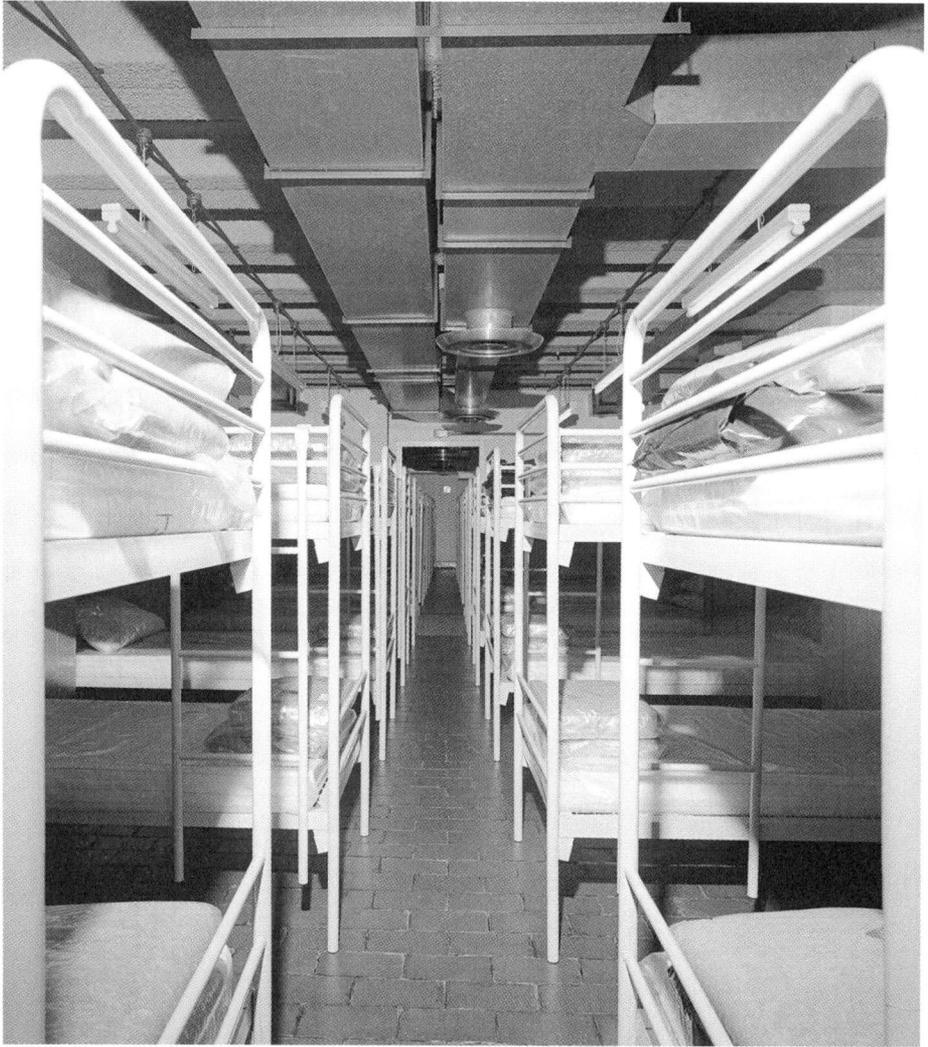

Dormitory facilities on the top level of the bunker.

As the pervasive fear of nuclear conflict, which had shaped much of the public consciousness during the earlier decades of the Cold War, began to recede, the existential anxieties of the nuclear age gave way to a focus on the opportunities and challenges of a globalising world. This had cultural and political impacts at home and prompted a re-evaluation of Britain's identity and role on the global stage. As the country moved into the 1990s, it faced questions about its relationship with Europe, its reliance on the United States, and its capacity to influence an increasingly interconnected world.

Britain began to reassess its defence posture, scaling back its military commitments in line with the reduced threat from Russia. Top-secret bunkers, such as Kelvedon Hatch in Essex, designed to protect local and national government in the event of nuclear war, began to be decommissioned, along with airfields and other military installations. Today, physical traces of 50 years of armament remain all across the UK. The withdrawal of the United States Navy from Holy Loch near Dunoon in 1992 marked a significant turning point in Britain's post-Cold War defence landscape. For over three decades, Holy Loch had been a pivotal site for NATO's nuclear strategy, as the home to US Navy ballistic missile submarines and support vessels, as well as being the focal point of both military strategy and anti-nuclear protests. For the local community in Dunoon, the base had been a source of economic activity and

international connections. The withdrawal left many residents grappling with the sudden loss of jobs and investment, exposing the area's dependence on the military presence.

View of the tunnel leading from the concealed entrance in the bungalow to the main bunker. Photographed by the Imperial War Museum upon decommissioning in 1992, these photographs provide an eerie glimpse into what might have been.

On the other hand, the consolidation of nuclear infrastructure at Faslane ensured its prominence in the UK's defence strategy, but it also became the singular focus of anti-nuclear protests in Scotland by CND and other activist groups. The early 1990s saw renewed vigour in the protest movement, fuelled by the belief that the end of the Cold War rendered the maintenance of nuclear weapons both unnecessary and unjustifiable. Faslane's role as the hub of Britain's nuclear weapons programme became a defining issue in Scottish politics. The Scottish National Party consistently pledged to remove nuclear weapons from Scotland, framing the issue as one of sovereignty and moral responsibility, and the 2014 referendum on Scottish independence brought the debate into sharp focus.

The Nineties marked the beginning of a broader reorientation of British foreign policy, as the country sought to navigate the challenges of a unipolar world dominated by the United States. Besides its local impact, the American retreat

A Royal Marine mans a General Purpose Machine Gun at sunset on board the frigate HMS Brave at sunset in the Gulf.

British Prime Minister Tony Blair at the opening of the 1998 European Conference in London. Relations between Britain and the European Union have been contentious and variable since the end of the Second World War.

from Holy Loch also underscored the UK's diminished role as a host for key NATO assets, raising questions about its position in the alliance. While Holy Loch and other American bases on British soil had been a tangible symbol of the US–UK Special Relationship, Britain now had to reckon with a recalibration of that dynamic, as the US pivoted towards other theatres of operation.

In the short term, Britain's role in NATO continued to dominate. The Gulf War in 1990–91 demonstrated the Western alliance's ability to act decisively in the absence of Soviet opposition, with Britain playing a key military role alongside the United States in repelling Iraq's invasion of Kuwait. This period also saw the expansion of NATO into Eastern Europe, a move that was welcomed by Britain as a means of securing stability in the region, but was viewed with deep suspicion by Russia, where leaders increasingly viewed NATO as a threat rather than a partner. Similarly, the European Union gradually expanded to include many former Warsaw Pact countries. This triggered concerns over Eastern European immigration, a fear that eventually helped lead Britain to leave the EU altogether, forcing a foreign policy agenda more firmly centred on transatlantic relations.

In 1989, the American political scientist Francis Fukuyama claimed that the end of the contest between communism and capitalism would signify 'the end of history'. This claim turned out to be remarkably short-sighted. The collapse of the Soviet Union, the Yugoslav Wars of the 1990s, and the rise of Islamic terrorism in the post-Cold War era may appear as distinct historical developments, but they are in fact deeply interconnected. These events, shaped by geopolitical shifts, ideological transformations, and the consequences of power vacuums, contributed to the emergence of a new global order and laid the foundations for the rise of Islamic terrorism as a significant threat in the late twentieth and early twenty-first centuries.

For all the horrors associated with it during the Cold War era, the Soviet Union had acted as a stabilising force across vast regions, exerting control over its satellite states and allies. Its dissolution created a geopolitical vacuum, particularly in Eastern Europe, Central Asia, and the Caucasus, allowing latent ethnic and religious tensions to resurface, often violently. In regions such as Chechnya, the weakening of central authority led to prolonged insurgencies. The Chechen conflict, which began in 1994, became a crucible for Islamist militancy, as foreign fighters and extremist ideologies penetrated the region. Simultaneously, the collapse of Soviet control facilitated the spread of black market weapons and criminal networks, resources that would later be exploited by emerging terrorist organisations. This post-Soviet instability provided fertile ground for the proliferation of radical ideologies, particularly those advocating global jihad.

The Yugoslav Wars of the 1990s, and particularly the Bosnian conflict between 1992 and 1995, were another pivotal moment in the rise of Islamic terrorism. As Yugoslavia disintegrated, ethnic and religious tensions erupted into violence, leading to mass atrocities, including the genocide at Srebrenica. The targeting of Bosnian Muslims by Serb forces galvanised Muslim communities globally and became a rallying point for Islamist militants. The genocide in Bosnia was seized upon by radical groups, framing the conflict as part of a broader jihad to defend oppressed Muslim populations.

Scottish painter Peter Howson was commissoned as an official war artist for the Bosnian War. In this piece, Entering Gornji Vakuf, 1993–94, an aid convoy of Red Cross vehicles proceeds along a winding road in a densely wooded valley, closely followed by a Warrior tank, in the foreground.

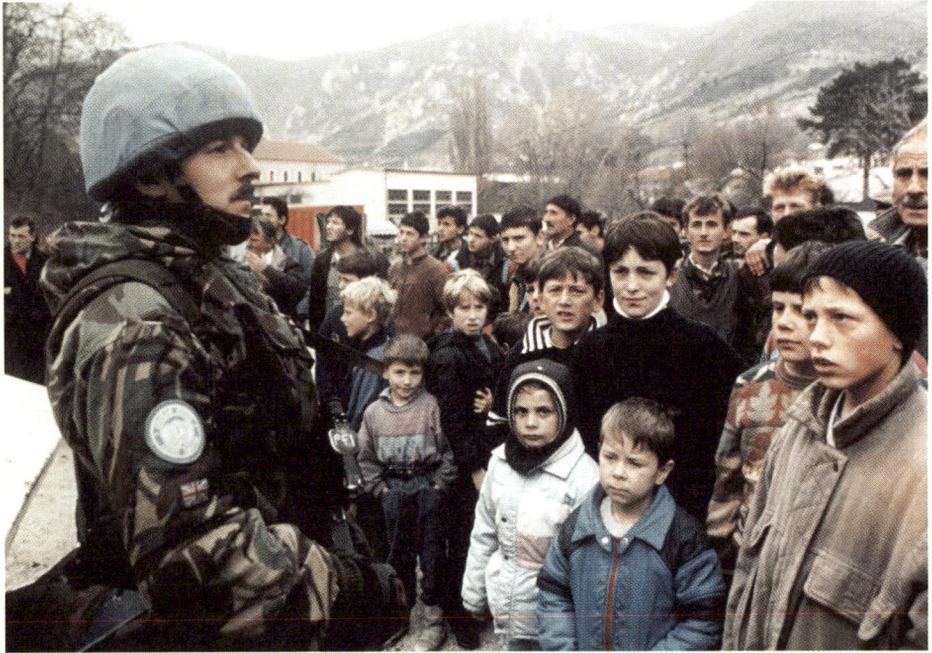

*Civilians, including children, cluster around a British
soldier of 1st Battalion, The Cheshire Regiment, at Travnik,
shortly after the arrival of British forces in Bosnia.*

Organisations such as al-Qaeda exploited the conflict, sending foreign fighters to join the struggle and establishing networks within Europe. These networks facilitated the recruitment of radicals and the dissemination of jihadist ideology. Furthermore, Islamic charities and organisations, ostensibly providing humanitarian aid to Bosnian Muslims, were sometimes co-opted to funnel resources to extremist groups. The experience gained by foreign fighters in Bosnia contributed to the operational expertise of jihadist organisations, which would later conduct large-scale attacks on Western targets. Jihadist veterans of the Soviet invasion of Afghanistan brought combat experience, organisational acumen, and ideological zeal to new conflicts. As the Soviet Union no longer existed to serve as a primary adversary, extremist groups shifted their focus to the United States and its allies, accusing them of perpetuating injustice in the Muslim world.

In Cleansed, 1994, Peter Howson depicts Muslim refugees who
had been driven at gunpoint from their homes by Croatians. They
were sheltered by a Muslim doctor before he was shot. Hungry and
desperate, they then sought refuge in a UN camp but were refused
entry and told to travel with a convoy of tanks to a safe district.

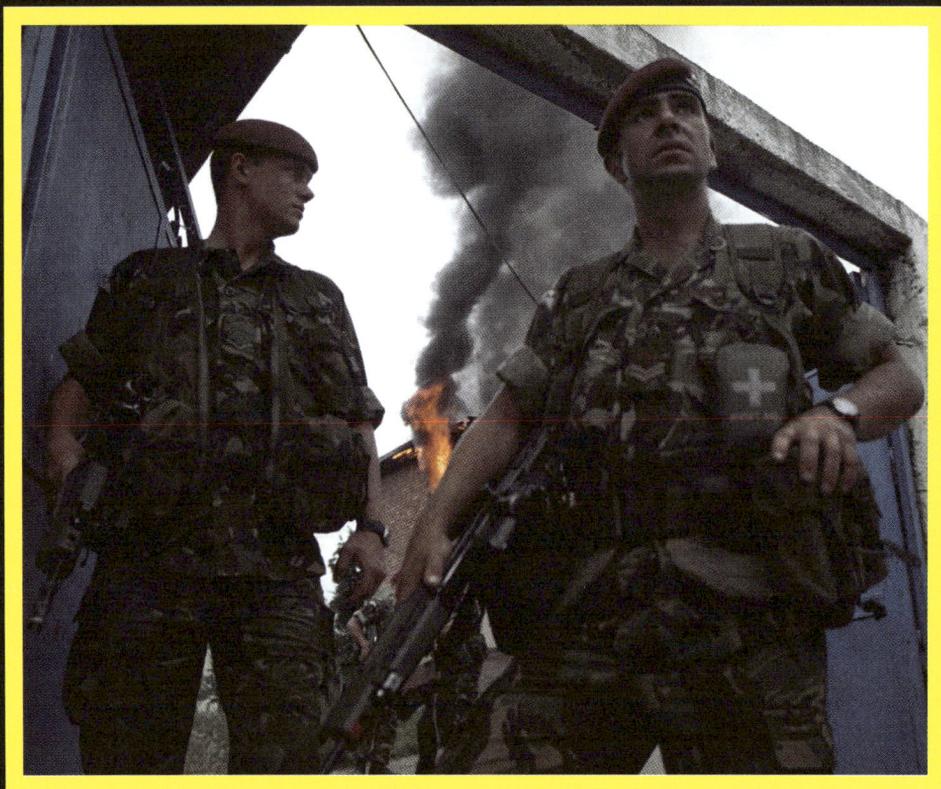

British NATO troops face one of the numerous fires that were burning all over Pristina, Kosovo in 1999. The fires were set to push Serbs and Romani out of Kosovo.

During the Yugoslav Wars, Britain was initially criticised for its cautious and limited response. Alongside other European powers, Britain hesitated to intervene decisively in the early stages of the conflict, reflecting broader uncertainty within the European Community and NATO about how to handle the disintegration of Yugoslavia. British policymakers were wary of becoming entangled in the complex ethnic and sectarian conflicts, particularly after the perceived failures of UN peacekeeping missions in Bosnia. Britain supported the imposition of arms embargoes and sanctions but resisted calls for more assertive military intervention, fearing escalation. As the humanitarian crisis in Bosnia deepened and reports of atrocities emerged, including the Srebrenica genocide, British attitudes began to shift. Under pressure from the public, media, and the United States, Britain played a more active role in the latter stages of the conflict. British forces contributed to NATO's Operation Deliberate Force in 1995, a campaign of airstrikes against Bosnian Serb positions, which helped to bring the warring parties to the negotiating table. Britain also supported the Dayton Accords, which ended the Bosnian War, and later committed troops to peacekeeping operations in the region under NATO and UN mandates.

Although serious issues remain, the Troubles in Northern Ireland nominally came to an end with the signing of the Good Friday Agreement in 1998. Any hopes that violent insurgencies could be confined to the twentieth century, however, would prove to be unfounded, as militant Islam would come to dominate the political discourse of the early twenty-first century. Following the attacks on New York City and Washington DC on 11 September 2001 ('9/11'), the United States embarked upon a global 'War on Terror'. Initially focused on finding the leader of al-Qaeda, Osama Bin Laden, in Afghanistan, this war was expanded into Iraq. Britain's Prime Minister Tony Blair became one of the most vocal international advocates for the US-led campaign, framing the fight as a moral, strategic, and defensive necessity. Britain played a central role in the invasion of Iraq in 2003 and subsequent efforts to stabilise the country. Domestically, Britain's role in the War on Terror led to significant policy changes, including the introduction of controversial anti-terror legislation and expanded surveillance powers. However, its close alignment with the US provoked widespread public opposition and damaged its international

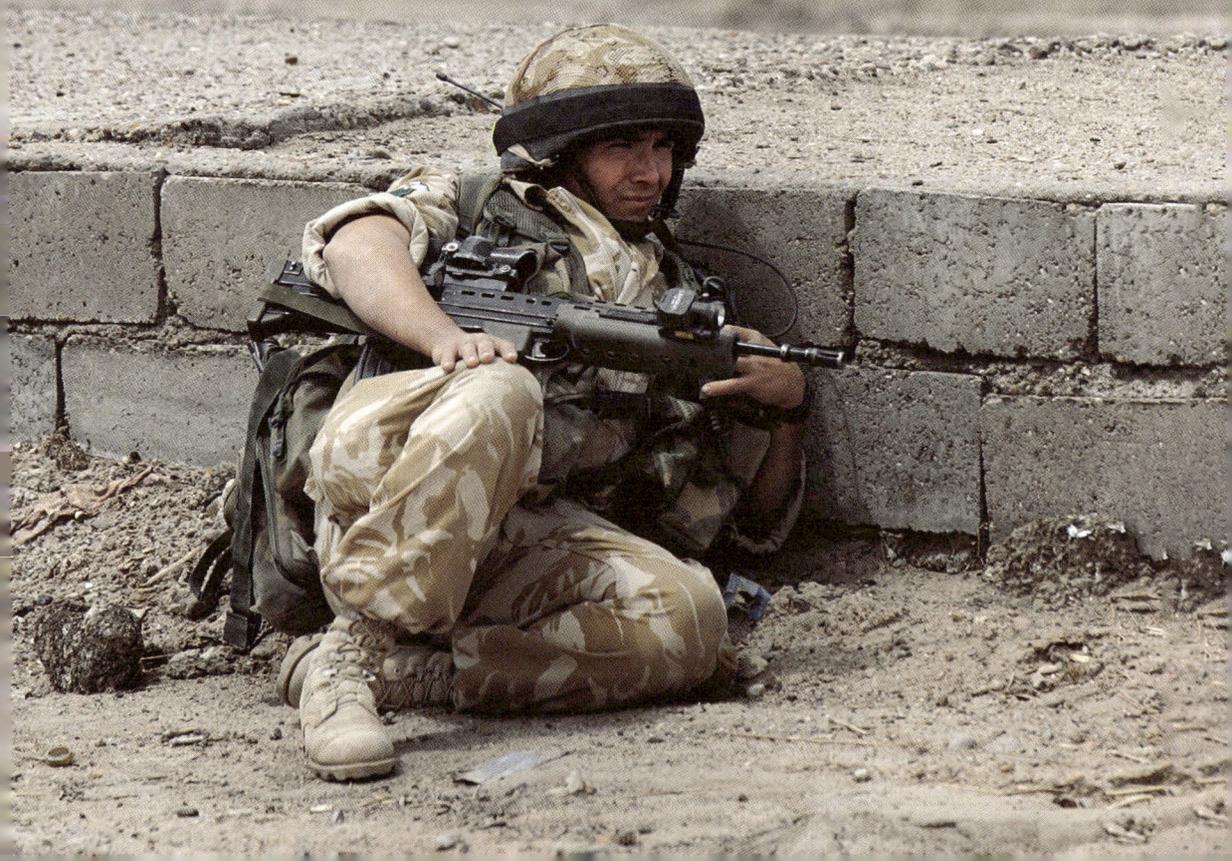

A British soldier takes advantage of the cover offered by a low wall as coalition forces advance on Basra.

reputation. The decision to join the Iraq War, justified at the time by claims about weapons of mass destruction, was later criticised as a strategic misstep that destabilised the region and contributed to the rise of groups such as ISIS (Islamic State of Iraq and Syria, also known as Daesh).

Russia also supported the War on Terror, especially in the immediate aftermath of 9/11. Russia provided critical support for the US-led invasion of Afghanistan in 2001 and allowed NATO to use airspace and military bases in Central Asia, where the country traditionally wielded significant influence. Russia shared intelligence and logistical assistance to aid the coalition's efforts against the Taliban and al-Qaeda, viewing the instability in Afghanistan as a direct threat to its own security, and comparing it to the Chechen Wars (1994–2009), which were themselves framed by the Kremlin as part of the broader global struggle against terrorism.

British infantry of the 1st Battalion, The Royal Irish Regiment, 16 Air Assault Brigade, silhouetted against the sky in Kuwait, as the troops prepare for operations in Iraq, 2003.

If the early 2000s saw hitherto unexpected military cooperation between Russia and the West, the connections ran deep in other areas too. The post-Cold War era brought significant economic transformation as new markets for British trade and investment opened up, particularly in Russia and Eastern Europe. During the 1990s, Russian oligarchs, flush with wealth having taken advantage of the rapid privatisation of state assets, established strong financial ties with Britain, particularly in London, which became known as the 'Londongrad' hub for Russian money. In 2003, the Russian businessman Roman Abramovich bought control of Chelsea Football Club, investing fortunes into making the club one of the biggest in world football. Abramovich, who was reported to have links to Russian President Vladimir Putin, became something of a celebrity in Britain.

While this influx of capital benefited Britain's economy, it also exposed the country to external influence and threats. One of the most chilling reminders of the enduring dangers posed by Russia occurred in November 2006 when Alexander Litvinenko, a former Russian intelligence officer turned dissident, was assassinated. Litvinenko, who had fled to Britain and become a vocal Putin critic, was poisoned in London with polonium-210, a radioactive substance. His death, which unfolded over several agonising weeks, was widely attributed to Russian operatives acting on orders from Moscow. A British public inquiry later concluded that Putin had probably approved the operation. The Litvinenko case was a stark reminder that the end of the Cold War had not brought an end to Cold War-era tactics, particularly from a resurgent Russia. It also marked a turning point in relations between the two nations, which were becoming increasingly strained as Britain sought to hold Russia accountable for its actions. Litvinenko is buried in Highgate Cemetery, his remains held within a lead-lined casket.

The 2010s saw further deterioration, most notably following the 2014 annexation of Crimea and the outbreak of war in eastern Ukraine. Britain condemned Russia's actions, supported sanctions imposed by the European Union, and provided military assistance to Ukraine. The Salisbury poisonings in 2018, widely recognised as an act of Russian chemical warfare on British soil, further soured relations. Sergei Skripal, a former Russian military intelligence officer turned

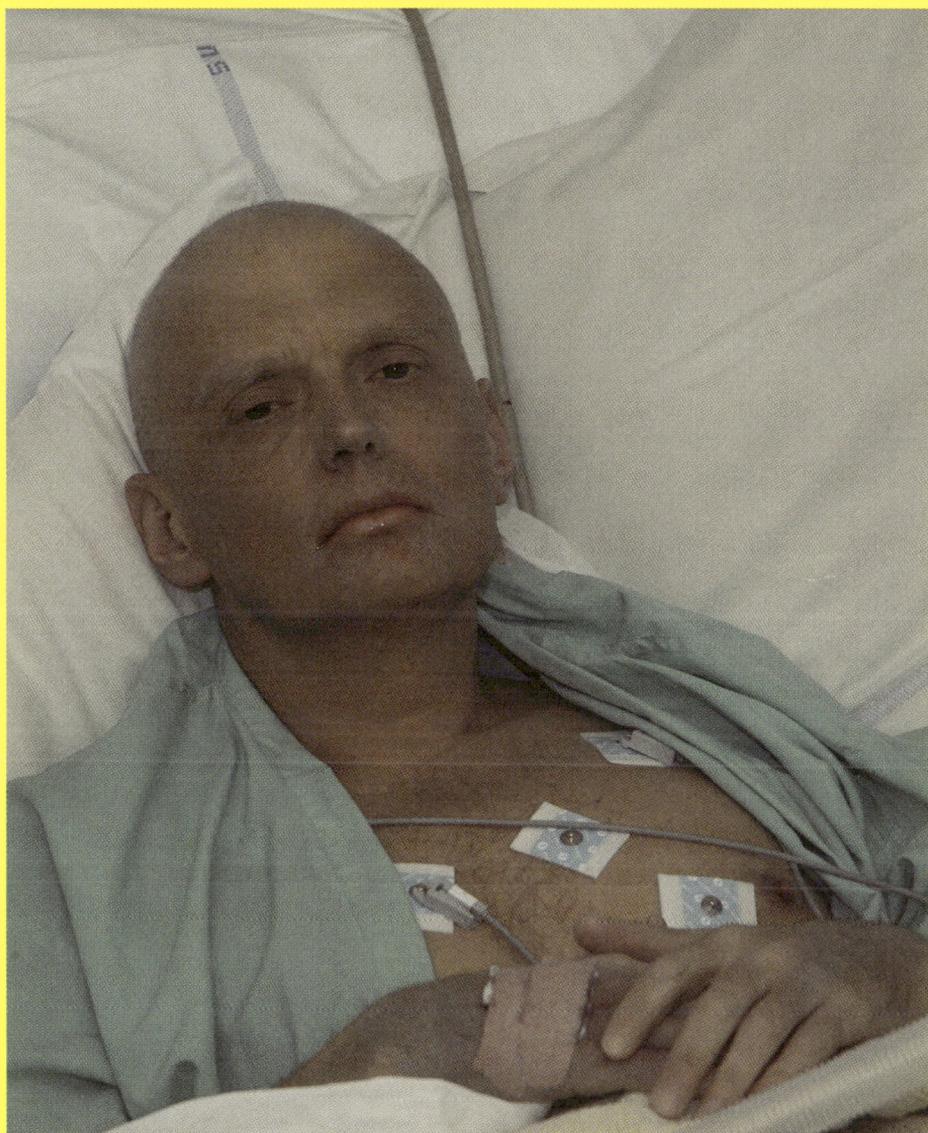

Alexander Litvinenko pictured at the Intensive Care Unit of University College Hospital, London, on 20 November 2006. The former KGB/FSB spy died three days later of poisoning from radioactive polonium-210, having accused Russian President Vladimir Putin of ordering his death.

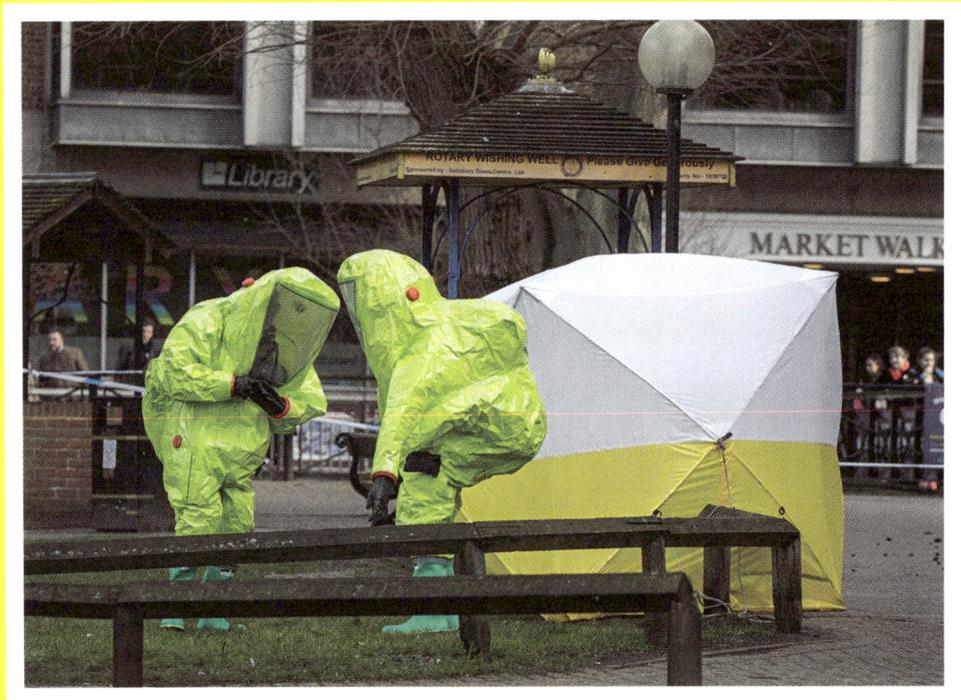

The attempt to assassinate Sergei Skripal by Novichok poisoning in Salisbury in 2018 was both reminiscent of Cold War tensions and indicative of the threats of the twenty-first century.

double agent for MI6, and his daughter Yulia were poisoned with a Novichok nerve agent in the quiet Wiltshire city of Salisbury. While they survived, the attack resulted in the death of a British citizen, Dawn Sturgess, who was accidentally exposed to the substance. The British government responded with a wave of diplomatic expulsions and intensified its rhetoric against Russian aggression, accusing the Kremlin of undermining international norms. Russia responded in kind, expelling foreign diplomats and suggesting that the attacks were part of a British false flag operation.

For many in Britain, the Salisbury poisonings brought back to the fore the ongoing threat posed by Russia under Putin – a former KGB intelligence officer whose leadership has been characterised by a blend of authoritarianism, nationalism, and hostility towards the West. Britain's stance towards Russia hardened further with the introduction of the Magnitsky Amendment, a measure to counter Russian interference by targeting individuals involved in corruption and human rights abuses. When Russia launched a full-scale invasion of Ukraine in February 2022, Britain emerged as one of Ukraine's most vocal supporters, providing military aid, imposing yet more sanctions on Russia, and leading efforts to rally international opposition to Putin's actions. The war underscored the enduring importance of NATO, with Britain reaffirming its commitment to the alliance and increasing its defence spending.

The Ukraine war also exposed the broader challenges of the post-Cold War order. The liberal international system, which had seemed ascendant in the 1990s, is increasingly under strain. Meanwhile, the rise of a different Cold War foe has emerged as another major factor reshaping Britain's global strategy. As China transitioned from a developing economy to a global powerhouse, its influence has extended across trade, technology, and international institutions. Still governed under a communist system, albeit one more open to foreign trade than the Soviet Union ever was, it remains as a bastion of ideological competition. For Britain, this opposition has been most sorely felt over the fate of Hong Kong, a former British colony handed back to China in 1997 with assurances that its democratic capitalist independence would be maintained. Those assurances

have been gradually eroded, with former British subjects increasingly appealing to their old colonial power for support.

Britain's post-Cold War trajectory highlights the evolving nature of global power dynamics and the challenges of adapting to a rapidly changing world. While the end of the Cold War brought new opportunities, it also brought new uncertainties. For Britain, these challenges have required a rethinking of its identity and role on the world stage, as it seeks to navigate a complex and often unpredictable international environment. The legacies of the Cold War remain visible, not only in the ongoing tensions with Russia but also in the enduring importance of alliances like NATO, and the ongoing discourse around the Special Relationship. Yet, as the twenty-first century unfolds, Britain's ability to adapt to these new realities will determine its place in a world where diplomacy is more critical than ever, as alliances continue to shift, and power vacuums open and rush to be filled. The comparative certainties – or at least, certain uncertainties – of the Cold War era are increasingly a thing of the past.

The end of the Cold War allowed for a fresh exploration of the era.
The German comedy-drama, Good Bye Lenin!, depicts a young
East German's attempts to conceal the fall of the Berlin Wall from
his mother, who has just awoken from a coma.

INDEX

ACKNOWLEDGEMENTS

My sincere thanks go to everyone involved in bringing this book to fruition. At HarperCollins, I gained editorial support from Harley Griffiths, Lauren Murray and Samuel Fitzgerald; the cover and internal designs were produced by Kevin Robbins, Gordon MacGilp and Sally Bond; and Rachel Weaver managed the book's production. Numerous colleagues at IWM lent the project their support and expertise, in particular Lara Bateman, Madeliene James, Craig Murray, and the Visual Resources team. Gratitude is also due to my IWM team – Emily, Mike, Claire, Sam, and Caroline – whose overwhelming competence allowed me to take time out to work on this project. Finally, thanks to my parents, for everything.

This book is for my son, Rowan.

PHOTO CREDITS

All images marked IWM are copyright © Imperial War Museums unless otherwise stated.

Front Cover Penta Springs Limited/Alamy Stock Photo

Back Cover and p213 IWM (PM011_20A) © Danielle Inge on behalf of the Edward Barber Estate

p4 Andy Soloman/Alamy Stock Photo

p6 (1st) IanDagnall Computing/Alamy Stock Photo; (2nd) Pictorial Press Ltd/Alamy Stock Photo; (3rd) Chronicle/Alamy Stock Photo; (4th) GL Archive/Alamy Stock Photo; (5th) World History Archive/Alamy Stock Photo

p7 (1st) IanDagnall Computing/Alamy Stock Photo; (2nd) Keystone Press/Alamy Stock Photo (3rd) World History Archive/Alamy Stock Photo; (4th) Photo 12/Alamy Stock Photo; (5th) ITV/Shutterstock

p8 1st Niday Picture Library/Alamy Stock Photo; (2nd) Associated Press/Alamy Stock Photo; (3rd) David Levenson/Alamy Stock Photo; (4th GL Archive/Alamy Stock Photo); (5th) Dennis Brack/Alamy Stock Photo

p9 (1st–4th) Shutterstock

p12 Keystone Press/Alamy Stock Photo

p16 DPA Picture Alliance/Alamy Stock Photo

p18 IWM (HU90534)

p19 Geopix Alamy Stock Photo

p20 IWM (A10846)

p22 PA Images/Alamy Stock Photo

p24 Hum Images/Alamy Stock Photo

p26 IWM (TR2828)

p27 IWM (BU8944)

p28 John Frost Newspapers/Alamy Stock Photo

p29 IWM (MH6809)

p30 IWM (Art.IWM PST 4006) © artist's estate

p31 PA Images/Alamy Stock Photo

p33 Smith Archive/Alamy Stock Photo

p34 PA Images/Alamy Stock Photo

p37 Smith Archive/Alamy Stock Photo

p38 CPA Media Pte Ltd/Alamy Stock Photo

p39 flab/Alamy Stock Photo

p41 Chris Howes/Wild Places Photography/ Alamy Stock Photo

p44 John Frost Newspapers/Alamy Stock Photo

p46 World History Archive/Alamy Stock Photo

p47 World History Archive/Alamy Stock Photo

p48 IWM (CT284)
p50 M&N/Almy Stock Photo
p51 INTERFOTO/Alamy Stock Photo
p52 IWM (FEW863)
p54 IWM (MH30697)
p55 IWM (HU36826)
p56 IWM (BER49-164-009)
p57 IWM (BER50-346-015)
p59 Associated Press/Alamy Stock Photo
p61 IWM (MH29427)
p63 IWM (Art.IWM ART 16787)
p64 Smith Archive/Alamy Stockp Photo
p67 IWM (FL3871)
p68 World History Archive/Alamy Stock Photo
p69 Chronicle/Alamy Stock Photo
p70 Skyscan Photography/Alamy Stock Photo
p72 (top) Smith Archive/Alamy Stock Photo;
 (bottom) Keystone Press/Alamy Stock Photo
p73 IWM (RAF-T1206) © Crown.IWM
p74 IWM (EPH3404)
p75 IWM (RAF-T5756)
p77 Keystone Press/Alamy Stock Photo
p78 IWM (GOV9123)
p80 (left) Album/Alamy Stock Photo; (right) BFA/
 Alamy Stock Photo
p81 IWM (TR65682B)
p82 IWM (RAF-T4143)
p84 IWM (A35276)
p85 IWM (HU98602) © Rights Holder
p86 IWM (TR20406)
p87 IWM (A34717)
p89 GRANGER - Historical Picture Archive/
 Alamy Stock Photo
p90 National Archives
p91 LANDMARK MEDIA/Alamy Stock Photo
p93 Collection Christophel/Alamy Stock Photo
p94 Photo 12/Alamy Stock Photo
p96 IWM (HU66565) © Rights Holder
p97 IWM (MH6810)
p98 IWM (Q(HS) 843)
p100 Associated Press/Alamy Stock Photo
p101 Smith Archive/Alamy Stock Photo
p102 Keystone Press/Alamy Stock Photo

p104 IWM (FAC10198/2017-08-07/2) © Rights
 Holder
p105 Yuril Moroz/Alamy Stock Photo
p107 News UK/News Licensing
p109 Chronicle/Alamy Stock Photo
p111 IWM (Documents.16602/B) © Rights Holder
p112 IWM (Documents.15200/E) © Rights Holder
p113 (top) Associated Press/Alamy Stock Photo;
 (bottom) Trinity Mirror/Mirrorpix/Alamy
 Stock Photo
p115 National Archives
p116 ANL/Shutterstock
p119 Maurice Savage/Alamy Stock Photo
p121 T Dixon/NewsUK/News Licensing
p122 Retro AdArchive/Alamy Stock Photo
p124 GRANGER - Historical Picture Archive/
 Alamy Stock Photo
p125 Collection Christophel/Alamy Stock Photo
p127 (top) IWM (FIR3683); (bottom) Ken
 Howard/Alamy Stock Photo
p128 Pictorial Press Ltd/Alamy Stock Photo
p129 TCD/Prod.DB/Alamy Stock Photo
p130 sjbooks/Alamy Stock Photo
p133 Keystone Press/Alamy Stock Photo
p134 IWM (ADN65/513/6)
p136 IWM (BRX90-4071-30) © Crown.IWM
p138 IWM (CT1216)
p139 IWM (TR30282-)7 © Crown.IWM
p140 IWM (HU99585) © Rights Holder
p141 IWM (CT1229)
p142 IWM (BF 10387)
p144 IWM (MAL 66)
p145 IWM (KOR 601)
p147 IWM (A31985)
p148 IWM (MH31539)
p150 IWM (CT1908) © Rights Holder
p151 IWM (MAU552)
p152 IWM (HU68967)
p153 IWM (HU52031)
p154 IWM (LBYK.14 / 601)
p156 IWM (Art.IWM PST 16949)
p157 IWM (MH23499)
p158 IWM (MH23509)